In loving memory of our respective fathers
Om Prakash Khurana and Hugh MacDonald

Geeta Mehta and Deanna MacDonald

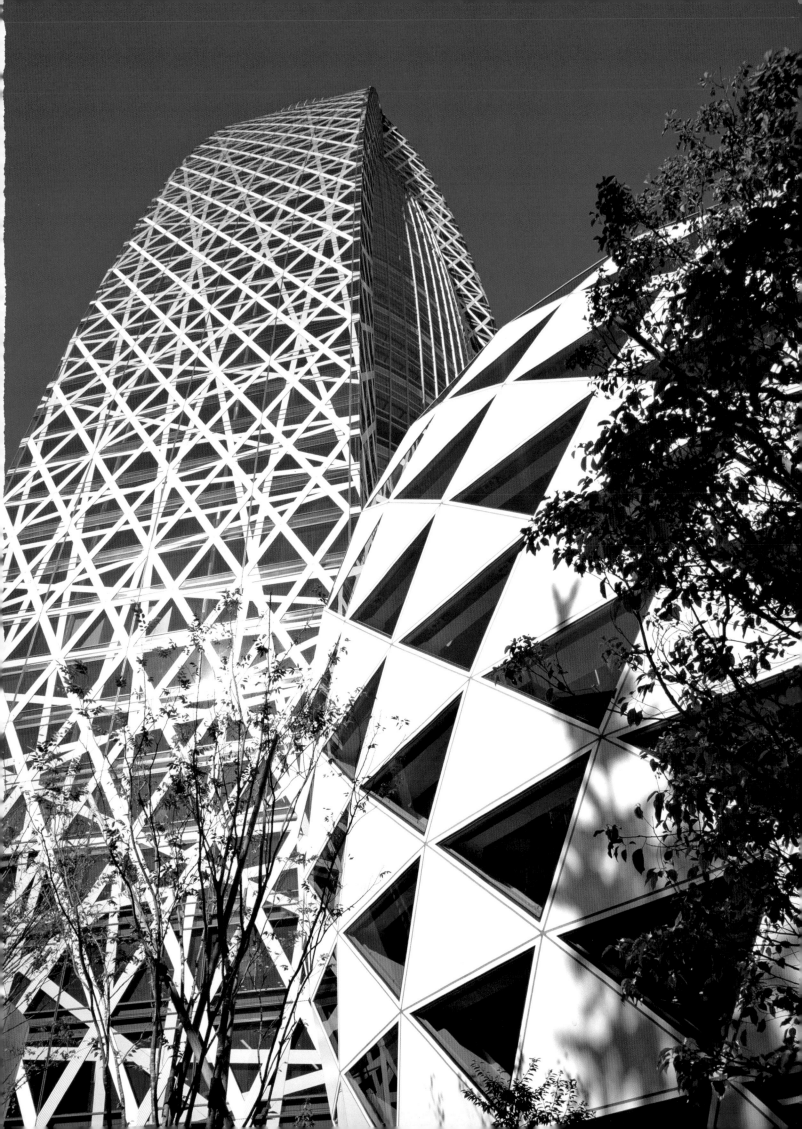

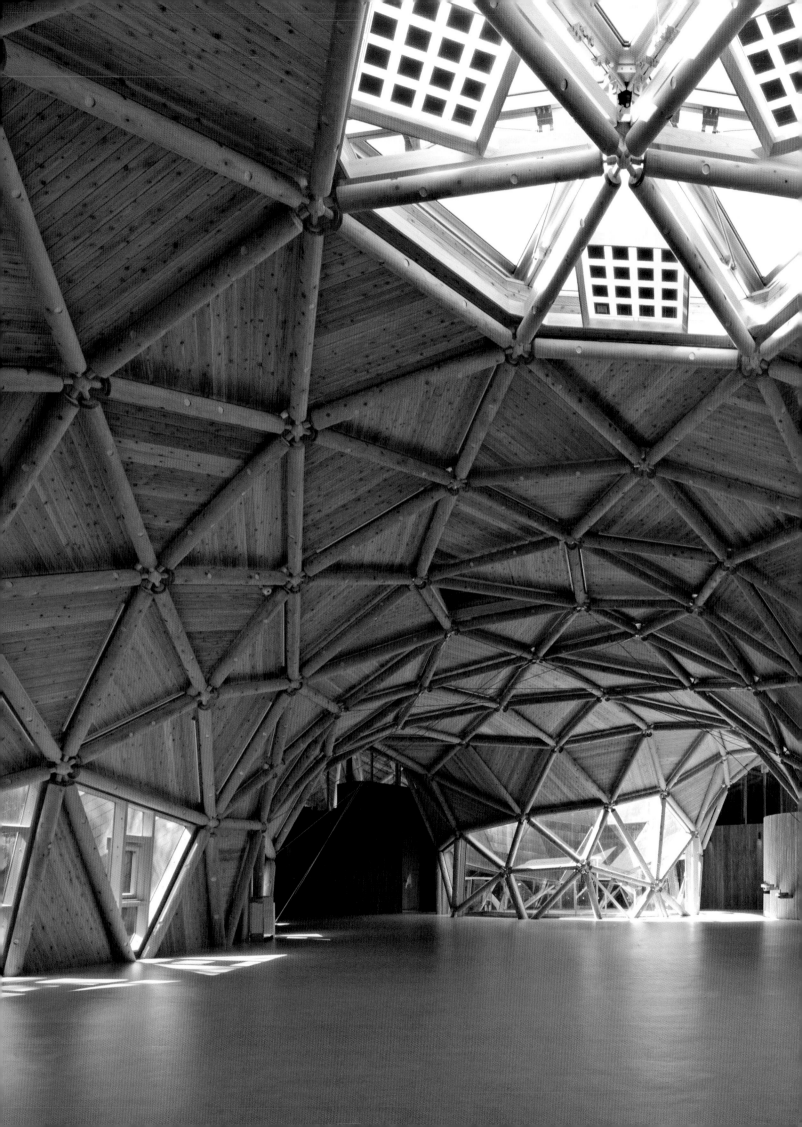

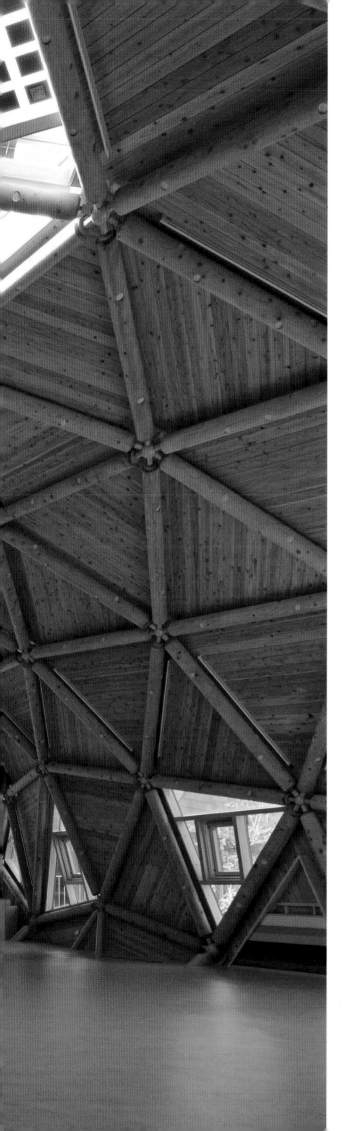

NEW JAPAN ARCHITECTURE

Recent Works by the World's Leading Architects

Geeta Mehta and Deanna MacDonald

Preface by Cesar Pelli

Foreword by Fumihiko Maki

TUTTLE Publishing

Tokyo | Rutland, Vermont | Singapore

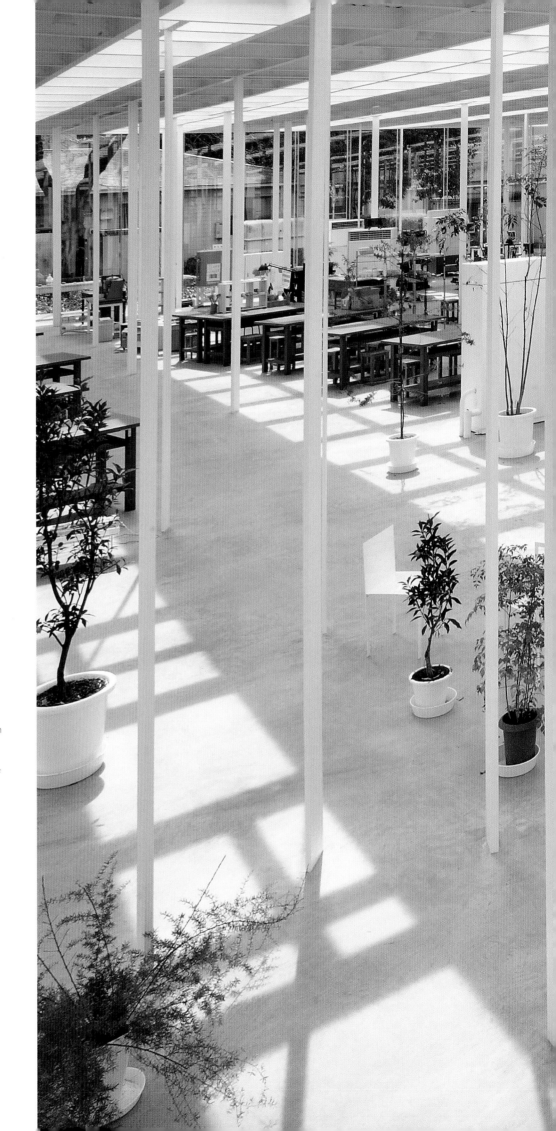

Published by Tuttle Publishing, an imprint of
Periplus Editions (HK) Ltd

www.tuttlepublishing.com

Copyright © 2011 Periplus Editions (HK) Ltd

ISBN 978-4-8053-0948-3

Distributed by

North America, Latin America & Europe
Tuttle Publishing
364 Innovation Drive, North Clarendon,
VT 05759-9436 USA
Tel: 1 (802) 773-8930; Fax: 1 (802) 773-6993
info@tuttlepublishing.com
www.tuttlepublishing.com

Japan
Tuttle Publishing
Yaekari Building, 3rd Floor, 5-4-12 Osaki
Shinagawa-ku, Tokyo 141 0032
Tel: (81) 3 5437-0171; Fax: (81) 3 5437-0755
sales@tuttle.co.jp
www.tuttle.co.jp

Asia Pacific
Berkeley Books Pte Ltd
61 Tai Seng Avenue, #02-12, Singapore 534167
Tel: (65) 6280-1330; Fax: (65) 6280-6290
inquiries@periplus.com.sg
www.periplus.com

15 14 13 12 11 10 9 8 7 6 5 4 3 2 1

Printed in Singapore

Front endpaper Opaque glass and fine slatted screens from
Ginzan Onsen Fujiya in Yamagata Prefecture, designed by
Kengo Kuma (page 214).

Back endpaper The nature-inspired undulating woven roof
of the top floor event room of the Nicolas G. Hayek Center,
by Shigeru Ban, is made possible by precision engineering
(page 188).

Page 1 The Mode Gakuen Cocoon Tower by Tange Associ-
ates is a dynamic addition in the otherwise conservative
architecture of western Shinjuku in Tokyo (page 142).

Pages 2–3 The geodesic-domed interior of Shuhei Endo's
Bubbletecture H is lightened with a large skylight and the
use of warm Japanese cedar (page 102).

Right Junya Ishigami has strived to create a feeling of
sunlight filtering through woods inside the KAIT Workshop
studio, located in the western suburbs of Tokyo (page 130).

Pages 6–7 An outdoor sculpture frames the gardens of the
Tokyo Midtown complex (page 160).

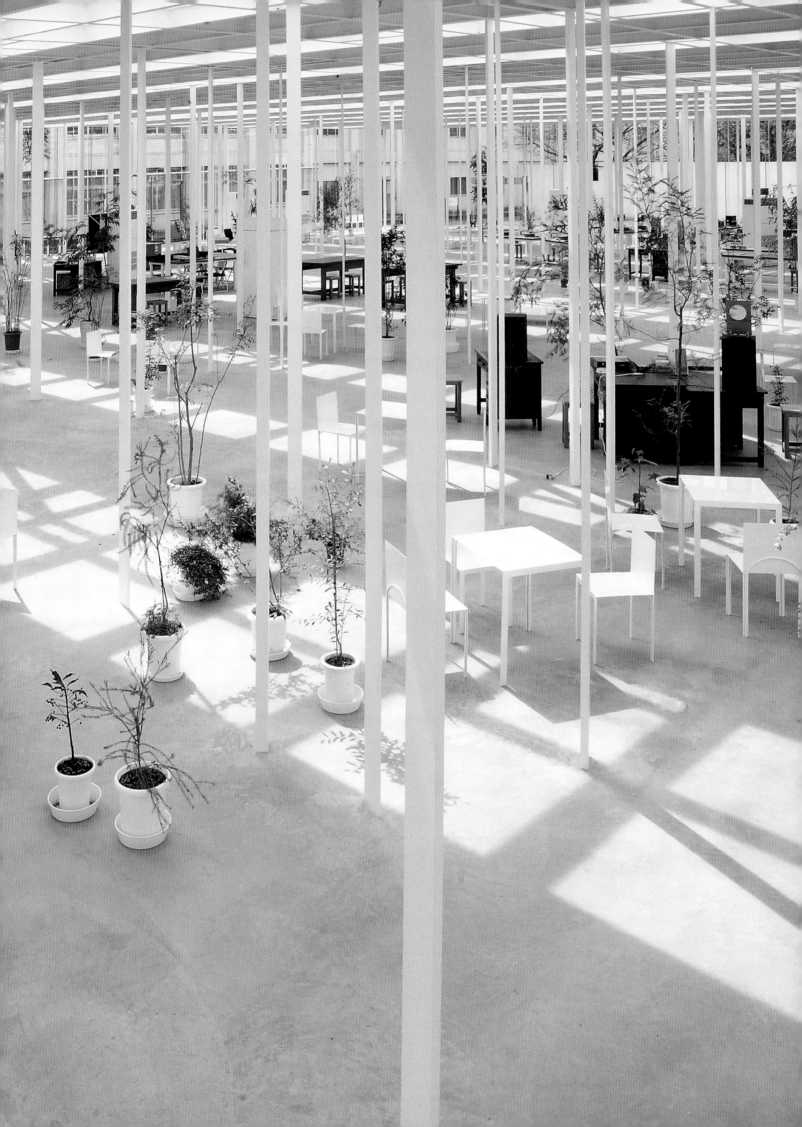

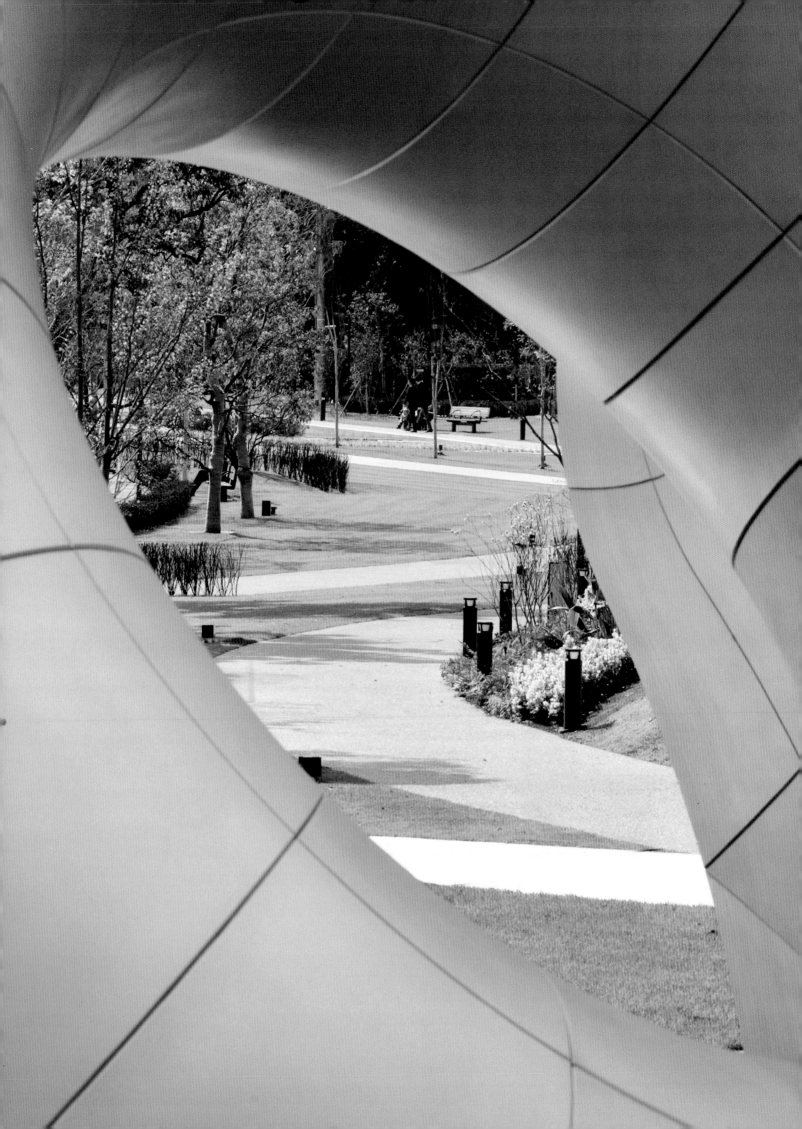

CONTENTS

AN INBORN SENSE OF BEAUTY AND CRAFT

I first visited Japan in early 1971. I had been selected by the Foreign Building Office of the State Department to design the Chancery Building, informally known as the Embassy of the United States, in Tokyo, on the site of the old one. I was then Partner for Design at Gruen Associates in Los Angeles. I went to Japan to visit the site and also to understand, as well as I could, the country, its people, and its architecture. I wanted to design a building that would represent the United States and that would also reflect the sensitivities of the country in which it was built. I knew much about Japanese traditional architecture because we had studied it in school and I admired its clarity, order, and beauty which, in many ways, prefigured the objectives and forms of the Modern Movement. I also admired the work of Japanese modern architects. It was very important to me to experience these buildings first hand.

That first trip to Japan was a major event in my life, and my memories of this experience remain very fresh in my mind. I visited much that was new in Tokyo, being particularly impressed by Kenzo Tange's designs for the Yoyogi National Gymnasium and Tokyo's former City Hall building (now replaced by a new City Hall building, also designed by Kenzo Tange). The Gymnasium was, and still is, a great work of modern architecture, unquestionably international in its forms, but it is also, to my eyes, very Japanese. This combination of qualities, international and local, has continued to animate the work of the best modern architects in Japan, such as those presented in this book. At that time, I also visited Kisho Kurakawa's Capsule Tower in Ginza, which was almost finished. It represented to me a bold attempt to capture the future. I read that it is going to be demolished soon, and I am sorry to see this example of an exciting moment in architecture pass.

I visited Kyoto, which I found much richer in architectural wonders than I had expected. I spent a week there visiting several temples each day, and I thought that it would be particularly difficult to be a contemporary architect in Japan with such high standards having been set for its culture. I was impressed with the pervasiveness of good design in all Japanese culture, from a *bento* lunch box to a modest house to a tea cup. The only other place in the world where I have seen the ordinary transformed in beauty is Italy, with a very different character, of course, and without the sophisticated craftsmanship one finds in Japan. That sense of beauty and craft that appears to be inborn in every Japanese is probably what also animates their architects, at least those that are able to be nurtured by its traditions.

Osaka's Expo 1970 was already closed when I visited it, but most of its buildings were still standing. It was a great display of technology, talent, and ingenuity. It was a unique opportunity for Japanese architects to show the world what they could do, but Expos are such an artificial environment that the best efforts turn shrill. I can say, though, that the result was more successful than in other expos I have visited since then.

I have returned some thirty times to Japan and I have had the privilege of designing buildings in Tokyo, Osaka, Fukuoka, Kurayoshi, and Hayama. Some of my trips have been purely for pleasure, which for me means visiting buildings and gardens. Every time I feel I understand a little more of Japanese architecture and its architects although a complete understanding remains elusive. Perhaps this is part of the great attraction that Japanese buildings have for me. The most sophisticated of its contemporary architects, such as Fumihiko Maki, Tadao Ando, and Kazuyo Sejima, are able to design very modern and beautiful buildings while imbuing in them a unique Japanese sensitivity. It is a sensitivity that I much appreciate and admire.

I have sensed a change since the 1970s in the focus of Japan's best architects. The earlier work, such as that of Kenzo Tange or the metabolists, appeared to be seeking to impress the viewer, and the critic, with its daring or its inventiveness or its muscle. Today's best work is distinguished by its refinement and sensitivity. This, I believe, is a reflection of greater assurance and self-confidence.

Since the Second World War, the work of Japanese architects has been among the best and most influential anywhere in the world. This book gives us an important sampling of their work.

Cesar Pelli
New Haven, CT

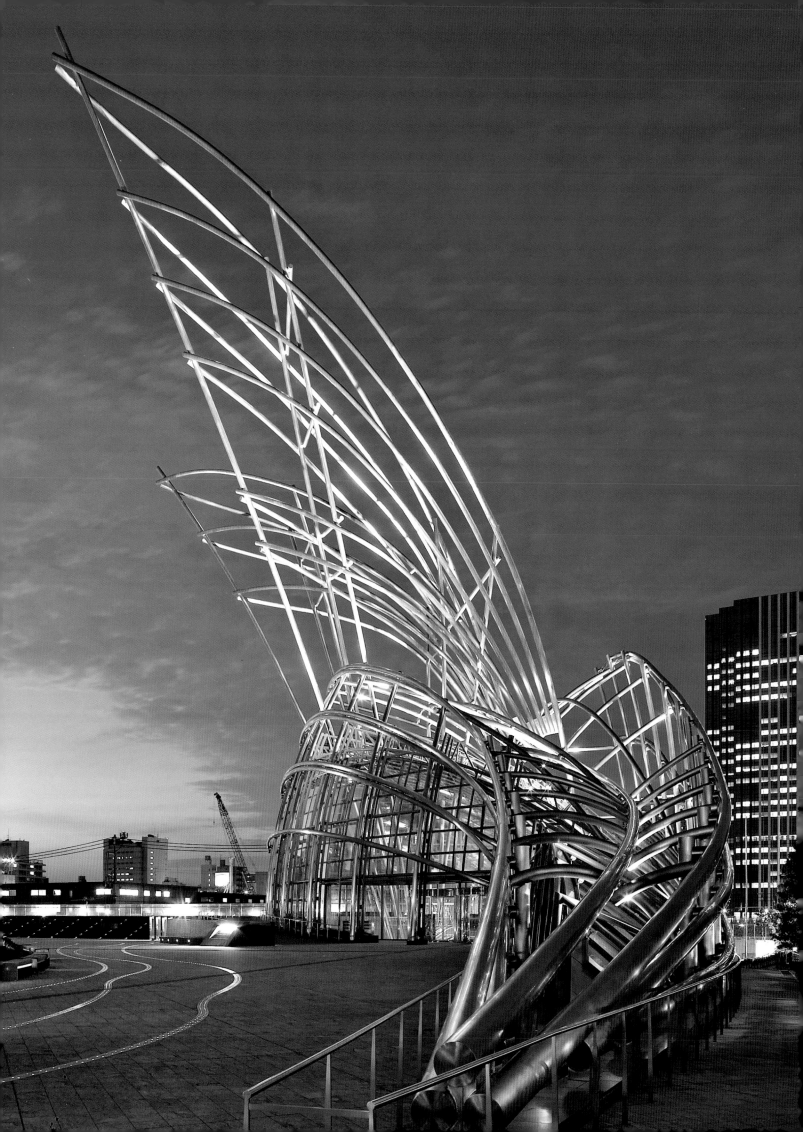

Page 9 The dramatic entrance of Pelli Clarke Pelli Architects' National Museum of Contemporary Art in Osaka leads to a mostly subterranean building (page 86).

Right View from Tange Associates' Mode Gakuen Cocoon Tower, Tokyo (page 142).

FOREWORD BY FUMIHIKO MAKI

ARCHITECTURAL MODERNITY AND THE CONSCIOUSNESS CALLED THE PRESENT

I have in front of me a secondhand book. Like Le Corbusier's *Oeuvre Complète*, *The New Architecture*, published in 1940, was a much-thumbed bible for those of us who were architecture students in the postwar era. It contains twenty works by architects active in the 1930s, beginning with Le Corbusier and Aalto, and includes Junzo Sakakura's Japan Pavilion for the Paris Exposition.

Recently, I had a sudden urge to look through this book once more, and immediately ordered it from Amazon. The book arrived a week later. Not including shipping charges, the cost was 1,500 yen. In all likelihood, it would have been difficult to come by had I scoured bookstores in Europe.

Alfred Roth, the author, was a well-known Swiss architect who had worked at Le Corbusier's atelier in Paris in the same period as Kunio Maekawa. In the introduction to the book, written more than a half-century ago, he characterized modernism in the following way: "Apart from the enormous innovation in technics and the change in social conditions, the awakening of the consciousness of one's own times stands in the foreground. The New Architecture in its present form is the immediate and clear expression of the meantime expanded consciousness of the times we live in."[1]

The Mexican poet Octavio Paz has described modernism as an expression by each individual of how he intends to live on his own "present." If that is so, then there are a thousand modernisms for every thousand persons, and in this century modernism will no doubt continue to be the mode by which we express the "present" in which we live.

Glenn Murcutt, the famous Australian residential architect, maintains a one-man office. He has neither a secretary nor a computer. Nevertheless, he lectures and teaches all over the world throughout the year. Last year, I met him in Glasgow, where we were both speakers at an architectural conference, and I asked him what happens to jobs in progress when he is away. He answered matter of factly that they come to a halt in his absence. According to him, a number of clients are waiting for his design, even so.

He is probably the only architect I know who insists on doing everything himself; his designs are entirely his own. At the opposite end of the scale are large architectural offices with hundreds, if not thousands, of personnel. If one thinks about it, however, a project is always carried out by a small group of people, however large the office or the project. My own office is of

medium size, and no more than seven people are ever involved in any one project, the exception being Makuhari Messe, in which about fifteen people participated at the peak of activity. Of course, many other people who provide support, such as expert consultants, circle this group like a cluster of planets on the edge of the solar system. However, the more complex the scale of a project, the closer must be the coordination and fancier must be the footwork of the small group at the core, all the more so today when so much work is a race against the clock. The truth of that has been brought home to me through experience working with groups and "planetary clusters" of various sizes and character over the past half-century. That is, architecture ultimately depends on the consciousness of the individuals.

The "present" for me over the last half-century can be divided, I think, into several periods. The first period, from the end of the Second World War into the era of intensive economic growth, was the period of my youth, when I was full of confidence that tomorrow would always be better than today. However, the student protests that began with the May Revolution in Paris in the late 1960s, and the oil crisis of the early 1970s, undermined that optimism from both within and without. That gave rise to a consciousness that anxiety will forever be a part of the "present."

Nevertheless, as Franz Kafka's dictum, "anxiety is at the core of existence," suggests, anxiety provides an opportunity for further growth. Throughout the world, including Japan, and in both cities and countrysides, the social and formal foundation on which works of architecture, singly and in groups, had historically existed has been lost; place can no longer indicate the way architecture ought to be. The environment in that sense no longer exists *a priori*, but that also means the architect can now construct a new landscape through his imagination.

Around this time, I wrote: "I have infinite love for the city, the generator, and the foundation of architecture. If I am allowed to design a building, I do not care if it is in a beautiful townscape or the back of some abandoned switchyard. Whether the place is old or new, beautiful or ugly, is beside the point. I have dreams for, and wish to enter into a dialog with that corner of the city that will be the scene of my operations, the subject of my thoughts, and the place where I must actually build something." Today's young architects no doubt think the same way.

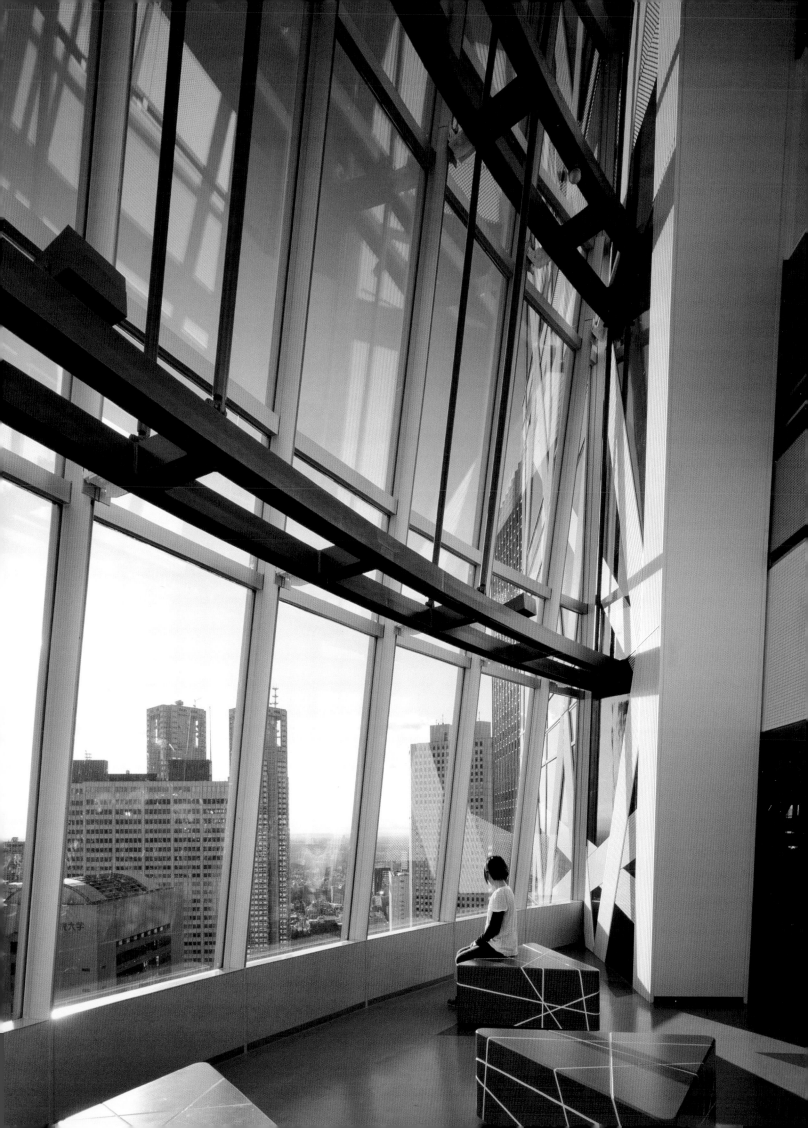

Anxiety awakens a desire to create something certain in architecture. It encourages one to attempt to create something that cannot be entirely consumed, even in a mass consumer society like ours, using materials and technologies available to us today. There are always only two paths open to architecture—one outward and the other inward. Development, for example, is an outward-oriented act; preservation and recycling are inward-oriented.

Then there is the "present" since 1990. The "present" of the 1980s was brought about by the tearing down of the Berlin Wall, which was also the tearing down of the wall of capital, information, and desire on a worldwide scale. The disappearance of the Soviet Union made inevitable the transformation of China into a capitalist state. That this period coincided with a revolution in information technology was pure happenstance, yet important nevertheless. It was also around this time that we introduced computers into design. The spatial and temporal dimensions of our world expanded all at once. The buildings we currently create in Japan are hybrids of materials and products from around the world. The design process, too, is undergoing an international division of labor. The concentration of capital is giving rise to strangely shaped cities, such as Dubai. The excessive liquidity of capital in search solely of profit is behind such phenomena. We no longer consider it strange that a hundred *sushi* restaurants have opened in New York or that colonial-style houses are selling briskly in a suburb of Tokyo.

Under such circumstances, how is the "present" now perceived? The term *ambivalence* refers to a psychological state in which a person has two mutually contradictory feelings toward a subject. Accelerated increase in information or phenomena is generating hitherto unanticipated relationships at diverse levels in our world. We are currently heading toward a world full of even greater contradictions, such as globalization and locality, progress and ecological equilibrium. These circumstances are calling into question the nature of architectural design. In the past half-century, I have experienced "presents" filled with such desires, anxieties, and contradictions. In the end, these "presents" cannot be clearly divided into different periods; instead, they have always been intertwined.

I have been fortunate to be involved in a project like Hillside Terrace. This project, which has lasted over thirty years, has passed through diverse "presents." Even today, I continue to be involved in the preservation of the old Asakura Residence and to participate in local activities, such as the preservation of the environment of the old Yamate Dori district. Before the Industrial Revolution, architects and master carpenters were the community architects of the districts in which they lived. They learned the essential nature of architecture through the slow, steady passage of time. From working in Daikanyama and having some members of my family live there, I have come to think of the buildings I design there as extensions of myself. What is the nature of an urban community today? How does human behavior respond to space? Where do buildings first begin to deteriorate? Working here provides me with daily opportunities to learn answers to such questions. As buildings become bigger and projects become more dispersed over the globe, architectural experience such as those I have had in Daikanyama become ever more valuable. It is in such experiences that both love of and fear for architecture are born.

The unique nature of modernist architecture in Japan has its origin in the special character of Japan's historic culture, and cannot be considered apart from the geo-cultural character of an island nation situated off a continent. Its actions are similar to the way shellfish living at the mouth of a river ingest and excrete nutrients from upstream. This is apparent in the process by which Japan, in assimilating Western culture from the 1850s, carefully observed both Germanic and Latin cultures and selected and absorbed features that were optimal for its own culture. Of course, this was made possible by the fact that at the time Japan was one of the few countries in Asia that was not under colonial rule. Japan adopted the system of architectural education of German technical institutes instead of the Beaux-Arts system of France. Whereas the harmful influences of the French Academy, coupled with Japan's *iemoto* system, have continued to hobble the education and development of art in Japan, an educational system of architecture that emphasized technology, integrated with Japan's traditional culture of craftsmanship, has led to today's high standard of building engineering and the emergence of an architecture of unparalleled precision.

However, Japan did not assimilate merely technology. Instead, from the very first stages of modernization, there has been interest in and exploration of the issue of Japanese tradition versus Western styles. This can be seen in early Meiji-period works in the so-called "veranda colonial" style, first introduced by Terunobu Fujimori in his *Nihon no kindai kenchiku* ("Japan's Modern Architecture"), or in Shimizu Kisuke's series of pseudo-Western buildings, like the Tsukiji Hotel. In the 1960s, when I began my architectural activities in Japan, critics and architects, including Kenzo Tange, were engaged in a "Tradition Debate." This theme continues to be explored today by diverse architects, within the framework of the more ambiguous and complex question of global versus local. As I have already stated, the one thing that is certain is that the consciousness of the "present" possessed by individual architects is the foundation for all their actions and designs. Several years ago, the architect Hiromi Fujii made the following statement at a symposium on views of modern architecture: "Certainly, today, when the values have diversified and confrontation between various fragmented philosophies is deepening the divide among them, the role of modernism as an art of denial may already be at an end. However, the spirit of a modernism that seeks freedom of the human spirit, that rejects a standardization which would integrate everything into one tendency, will live on."

The development of modernism is not dependent on a unilateral elimination of the past. In this, it resembles waves on the sea. Different waves collide and interfere with one another. Some waves disappear and others become even larger than before. The modality of modernism is the sum total of all these waves, large and small. Japan today is one of the international epicenters from which waves emanate; no doubt it will continue to transmit new ideas in the immediate future. The consciousness of the "present" of architects in the aggregate is what makes this possible.

I had an opportunity to revisit the recently renovated Crown Hall at the Illinois Institute of Technology. I was moved by this work's grace and nobility. I also visited the Church in Firminy in central France, which was completed in October—based on models and drawings left behind by Le Corbusier, more than forty years after he drowned at Cap Martin. Natural light entering through numerous small round windows gives the interior space of this soaring concrete church enormous presence. These are two completely different modernist buildings, but in them I re-encountered history and was made aware of how modernity is compatible with timelessness.

A work of architecture takes on a life of its own the moment it is created. The ideal work is one that accurately expresses (by its modernity) the particular "present" in which it was constructed, yet is able to transcend that time and continue to exist. That is because time alone is the final judge of the value of any work of architecture.

[1] Alfred Roth, *The New Architecture*, Zurich: Editions Girsberger, 1951, p. 8.

Opposite Detail of Kumiko Inui's Pavilion 2008 Monument at Shin-Yatsushiro, Kyushu (page 202).

NEW JAPAN ARCHITECTURE: FROM WABI SABI TO WHITE CUBES, GREEN INTENTIONS, AND THE WOW FACTOR

I have had the opportunity to learn, teach, and practice architecture in Japan for the past twenty-three years, and I continue to be delighted, surprised, and perplexed by it. Architecture has also been the prism through which I have tried to understand Japan's culture, history, politics, and economic systems. As we present architectural projects built over the last five or so years in Japan, this introductory piece is one more attempt to communicate my deep appreciation for Japanese architecture, and the people involved in creating it.

As in most facets of Japanese life, the history of Japanese architecture has many contradictions, moving as it does from the restrained aesthetics of *wabi sabi* to the consumerist high-tech architecture of today. However, both extremes are but moments in a long history of dynamic changes in a country where aesthetics are the elemental components of collective national identity. To understand Japan's contemporary architecture scene, and to see where it might be going, it is important to examine where it has come from.

WHERE WE HAVE COME FROM

Wabi sabi is an aesthetic concept as old as Japan itself. Its minimalist sensibilities are evident in early pottery and Haniwa dolls dating to the prehistoric Jomon period. However, its ideals of rusticity and simplicity blossomed along with Zen Buddhism in the Muromachi (1336–1573) and Momoyama periods (1573–1603), and continued to develop through the Edo period (1603–1868).

Besides rusticity and minimalism, *wabi sabi* is also about harmony with nature, and the rejection of the ostentatious, the gaudy, and the willful. Yet, it has room for innovation and playfulness. The imperfections of the material are understood, expressed, and even celebrated. It is also a concept about time that encourages appreciation of the vulnerability and fragility of things. The beauty of short-lived cherry blossoms and humble materials as they deteriorate is a reminder that we are all mortal, and that is all right, even beautiful. In space-constrained, populous pre-modern Japan, *wabi sabi* also made a virtue of frugality. Things were used till they wore out, and their worn-out state was also respected.

Foreign influences have played a large part in the development of Japanese aesthetics. With the arrival of Buddhism in the middle of the sixth century, Japan became infused with ideas from Korea, China, and as far away as India in religion, arts, technology, architecture, and literature. Through successive eras—the Buddhist fervor of the Nara period (710–84), the court elegance of the Heian period (784–1185), the emergence of the shogunate and *samurai* arts in the Kamakura period (1185–1333), and on through the self-imposed isolation of the Edo period, the Japanese arts were refined and defined. A momentous break in traditions of architecture as well as arts,

science and governance, came with the Meiji Revolution in 1868, when Japan embarked on a policy of "uncompromised Westernization."

According to Frank Lloyd Wright, Japanese architecture met with Western architecture like a beautiful work of art meets with a terrible accident. After 1868, Japan rushed to Westernize its architecture, initially to create stage-sets for renegotiating disadvantageous treaties that the Shogun had signed with foreign powers, and then in an effort to catch up with its new trading partners. Development those days, and some times even today, is mistaken for Westernization. Though Japan was indeed inspired by the West in its efforts to industrialize and strengthen its educational facilities and army, its architecture and culture, developed and refined over centuries, were needlessly targeted for an overhaul. Universities were prohibited from teaching Japanese arts, and any building with government funding was built in a Western style. This resulted in a flurry of pseudo-Western buildings, which were soon followed by Victorian or Queen Anne-style buildings designed by capable architects like Josiah Condor, who started the first school of architecture at what is now the University of Tokyo.

Westernizing trends continued into the Taisho period (1912–26), when Frank Lloyd Wright and Le Corbusier's followers, such as Kunio Maekawa, amongst others, ushered in modern architecture. However, it was not until Japan's rise after the massive destruction of the Second World War that modern architecture really took strong roots throughout the country. Japan's architectural past was left behind in favor of a new modern future.

The Japanese economy and its architectural confidence grew by impressive leaps and bounds all the way through the economic bubble of the 1980s, producing an urban Japan whose neon billboards and futuristic designs became a global image of the city of the future. Though the growth of the 1990s and 2000s was more modest, the architectural scene remained vibrant, fueled by new technology, growing globalization, and noteworthy talent that was acknowledged by three coveted Pritzker Prizes going to Japanese architects—Fumihiko Maki in 1993, Tadao Ando in 1995, and SANAA (Sejima and Nishizawa and Associates) in 2010.

WHERE WE ARE GOING

So where are we now, post-industrialization, postwar, with democracy, unprecedented prosperity, and globalization firmly in place despite the recent economic crisis? What is the architectural and aesthetic construct now?

Contemporary Japanese architecture is anchored around several trends. These include the search for the ultimate white cube—epitomized by SANAA's ethereal Dior Building; the showman-like search of the wow factor, exemplified by Herzog and De Mueron's Prada Aoyama Epicenter (page 180); and green intentions with concern for sustainability. A new urge to look to

Opposite Herzog & de Meuron's prismatic Prada Aoyama Epicenter in Tokyo is composed of flat, concave, and convex diamond-shaped glass planes (page 180).

Japan's past to find answers for its future is also evident, with leading architects like Terunobu Fujimori (page 21) and Atelier Tekuto (page 62) reinventing traditional architecture in a contemporary light. The spirit of *wabi sabi* and Zen minimalism also endures in the works of well-known architects such as Tadao Ando and Kengo Kuma. According to Kuma, traditional Japanese architecture "was in great contrast to twentieth-century architecture that placed importance on the monumentality of architecture and the individual signature of the architect, often times in contradiction to what the natural environment offered" (page 109). He strives to do otherwise.

THE WHITE CUBE

For those pursuing the white cube road to nirvana, the goal is to create a pure form, uninterrupted by construction details or the nuisance of functional programs. In a Zen-like quest for nothingness, large uninterrupted forms are created in contrast to the cacophony of the Japanese high street, and the magical effect of glass and translucent surfaces, often layered, is deployed. The search for this pure form is usually an intellectual and aesthetic pursuit on the part of the architect and the owner, unhindered by the need to be practical, frugal, or environmentally sustainable. On the contrary, this is the "aesthetics of plenty" in the hands of a people who, after thousands of years of practicing the virtues of frugality, now throw away things just as they start becoming unfashionable. There is a relentless search for the perfect, the new, and the branded. It is the aesthetics that may remind you not of mortality, but of the eternal. Instead, the reminder of mortality of all things is *tatekae*, or the constant tearing down and reconstruction of buildings in Japan. At their best, the white cube spaces overcome materiality itself, with a singular focus on aesthetics. The architect can be an artist again.

While many architects worldwide aspire to create the pure white cube, its development is most firmly rooted in Japan, and developed probably from two sources. The first is an understandable reaction to the cacophony of the Japanese urban and rural environment. Yes, rural and suburban areas are just as cacophonic, with none of the advantages of big cities to redeem them. It is no wonder that young people are abandoning their farms and old networks and moving to big cities. Another inspiration for the white cubes are the buildings under construction, repair or destruction, that are completely covered over with elegant and mostly white veils, creating pure geometric forms with uninterrupted surfaces. These veils are often made of plastic net, and are therefore translucent. These look a lot more distinguished and high-design compared to their neighbors, or the buildings that emerge after the veils are taken down, their perfection giving way to things with windows, pipes, and signs of life within. The characteristic efficiency with which Japanese construction companies put a veil around buildings, and get their tiny cranes inside the veil to destruct and construct buildings without causing dust or inconvenience to the pedestrians passing by, is a science and an art in itself. These veiled buildings have probably been a source of inspiration for the white cubes of SANAA for Dior, Jun Aoki for SIA (page 166), or Taniguchi for the Tokyo Club. White is historically also used to symbolize plenty, and cleanliness. White socks under *kimono* distinguished people who did not need to walk on unpaved streets. White gloves on taxi drivers in Tokyo are an apt symbol of their spotless service, truly unmatched in the world.

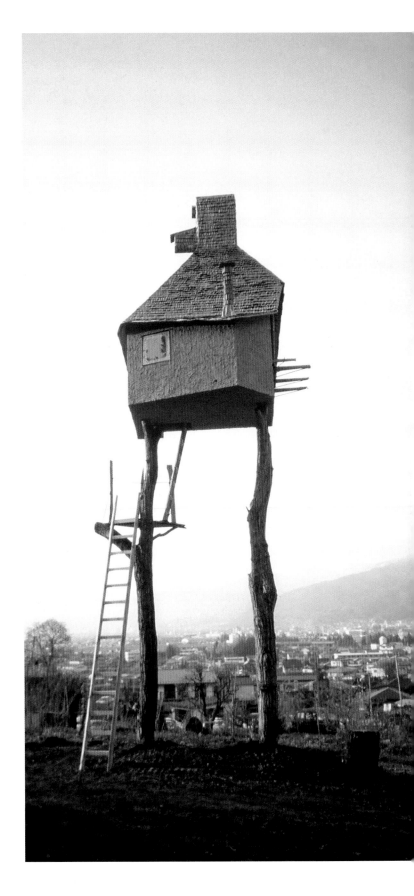

Right Terunobu Fujimori's *Takasugi-an* ("Too High Tea House"), sitting upon two chestnut trees, is meant to evoke questioning.

White cubes in the sense discussed here are neither always white, nor always cubic, and are unrelated to the White Cube art galleries. This system of aesthetics can be applied to any material or form. Rusted steel and concrete can be rough in other places, but have been used to express the white cube aesthetics in the hands of Japanese craftsmen and architects such as Tadao Ando. Steel is pre-rusted evenly, and concrete is poured into waxed molds and emerges with a skin as smooth as polished stone, and is waxed periodically to maintain its finish.

The history of architecture is the history of the search for that divinely satisfying moment when form and function meet in perfect beauty. Pure geometrical forms have been considered the way to this absolute beauty since before Plato, but the logistics and structural requirements always got in the way. The details of resting the roof on the walls or columns, the plumbing, heating, fire escapes, and such interfered. For hundreds of years architects tried to hide these details behind decorative fascias, or make a virtue of them by articulating them, and tried every other way possible around this dilemma. Not any more. The pure white cube is now technically possible, and indeed a reality, often employed to woo and entertain the jaded consumer, and then knocked down and rebuilt to entertain and amuse some more. Where it is hard to hide all the details, architects wrap up the building in a second skin, citing energy saving as its *raison d'etre*. This second skin can be pure, transparent, and wicked, creating a *trompe l'oeil*, blurring the line between perception and reality.

The search for the white cube is perhaps a universal search of our time. The monolith in the Space Odyssey 2001, the Seagram Building, and the Sears Tower were all black. The mysterious monolith of Space Odyssey 3001 will perhaps be white, like the ones that OMA is designing with Porsche Design Studio, Curiosity's glowing C-1 house (page 66), and Yamamoto's futuristic Namics Techno Core (page 156). Will this lead to the tyranny of the white cube, and have to be shaken up with learning from Las Vegas, Mumbai, or the Akihabara district of Tokyo all over again? Meanwhile, the Japanese architects are not questioning the pristine white cube—they are simply making the best white cubes around.

In many ways, the aesthetics of the white cube, as well as that of *wabi sabi* architecture, are the aesthetics of the shy designer, who wants to remove as much of his or her subjectivity from the object being designed. This is achieved by removing all aspects of scale, ego, and symbolism from the design. Antonym Raymond, who came to Japan with Frank Lloyd Wright in 1920, was soon disillusioned with his master's "intent to create monuments only to himself." Raymond said that Wright's motives for creation were mean and petty compared to that of a Japanese craftsman whose only motive is to create the best object possible, without getting his own ego in the way. A true craftsman thinks with his arm, Raymond said.

In the age of "starchitects" and iconic buildings, what might be the noble motive of the architect? Many architects discussed in this book set out to create white cubic space or a totally natural "green machine" for their projects, so the presence and the will of the architect could be rendered insignificant. Such architecture may then have the same quantity of absolute truthfulness as a well-crafted bamboo basket. In a way, this is the proverbial "elimination of the inessential" that is central to Zen thinking. Jun Aoki said that his initial intention in designing the SIA Aoyama building (page 166)

was to create a space that would be as close to a blank slate as possible. The intent was that the tower's tenants would have greater freedom to customize the space as they saw fit, and viewers a greater freedom to interpret it. Yet, the "truthfulness" of architecture can take many forms. Terunobu Fujimori has written that he strives for an "architecture of humankind," with his only rules for building being that his design must resemble no other, and natural materials must be a visible aspect of the structure. With Fujimori, the truth is not white but earthy, fertile, and green.

THE QUEST FOR THE WOW FACTOR

At the beginning of this introduction, it was proposed that the white cube aesthetics also has counterpoints in "green" architecture and the architecture of "wow." The appetite for wow buildings developed in Japan during the economic bubble of the 1980s, when starchitects were invited from around the world and build aggressively eye-catching buildings with oversized budgets. Now this counterpoint is all over the place, literally and figuratively, and harder to define. Buildings in this category are billboards of the big name brands as well as the architects who build them. Post-modernism produced crazy buildings, but they had a thin thread of philosophic logic, in that they were trying to break the tyranny of modernism. Wow buildings have no such agenda or excuse. According to Toyo Ito, "Architecture has to follow the diversity of society, and has to reflect that a simple square or cube can't contain that diversity" (page 126). While some architects work diligently to express the diversity while meeting the programmatic needs of the project, many slip into the Gehry-like architectrobatics.

The places to understand how far the search for wow can go start with Bilbao, and stretch to Dubai, Shanghai, London, Mexico City, and beyond. Ultimately, cities are built not from need, but from the dreams and aspirations of the people who build them. During the 1990s, cities vied with each other to build "picture postcard" buildings that would give them a competitive edge in attracting the next large corporation to help the city secure its tax base. This struggle was all the more intense in Japan, where smaller cities have been losing young population to bigger cities, and the graying of Japan and its declining birthrate pose long-term problems of survival for small cities and towns. A large number of museums and amusement parks were thus built even in remote towns during the 1980 and 1990s. Itsuko Hasegawa's Shonandai Culture Center typifies the eccentric buildings that this trend resulted in.

However, even the wow buildings in Japan show more restraint than in emerging markets such as Shanghai and Dubai, where there is a sense of near desperation about architecture, and the search is not for the quiet white cube but for the loudest siren. In these places, architecture is not a response to the market demand, but a pawn in the financial game and political propaganda. The architects are hired to produce a spectacular scale model of the building by the trade show next week or next month, the flashier the better, with the space program to follow later. There is little time to consider the issues of ecology, site specificity, or social impact of architecture. Dubai set off to become like Singapore—a tax haven to multinational companies in the East and West. Each building was leveraged to build the next and the dream given credibility via iconic buildings and the world's tallest tower. It is well to remember, though, that the now classical Greek and Roman temples, Baroque churches, Japanese castles, and palaces around the world

were also built with power agendas. This was also the case in Japan during the Meiji period, when Japan was eager to look developed and Westernized. However, architecture in Japan at present does not have to dance to another agenda. It is in a very comfortable moment where it can just *be* architecture. Contemporary Japan does have its share of façadetechture and starchitects, but architecture here generally has more time, space, and grace.

There is dignity in even the wow buildings in Japan, perhaps due to the tradition of understatement, high quality materials, and workmanship here. Japan is at the leading edge in the architecture of consumerism. The wow here is also about the speed with which buildings are torn down and rebuilt. Many of the fashionable brands on Omotesando (see pages 181–8) have built their flagship stores on short-term leased land. Since Omotesando is one of the most important high-fashion destinations and its real estate prices continue to grow, landowners prefer to lease land only for the short term. Thus, many of the glass and stainless steel marvels on this street are temporary. The fashion houses are proponents of this since "brandtechture" is not just about architecture, but just a small element in the larger brand strategy of a company, or even the city, possibly to be discarded or rebuilt when the brand needs a makeover. These buildings are designed to engage the consumer willing to play and pay into the romance of the brand. The Japanese consumer has journeyed from the philosophy of "elimination of the inessential" to the "celebration of the inessential," moving an ever-increasing number of items from the inessential to the must-have category.

THE GREENING OF JAPANESE ARCHITECTURE

The other important trend in Japan is centered on environmental sustainability, a much-needed movement that has been gathering steam around the world. Over 48 percent of all carbon emissions in the world are attributable to construction and operation of buildings. While this is more than the carbon emissions from automobiles, the use of cars is also driven by urban planning and real estate decisions that send people to energy-inefficient, low-density urban sprawls. Urban planning and architecture therefore have a major role to play in the matter. The LEED (Leadership in Energy and Environmental Design) system in the USA, India, and some other places, as well as the CASBEE (Comprehensive Assessment System for Built Environment Efficiency) system in Japan encourage environmentally sustainable buildings, but are still inadequate and voluntary. Also, no matter how green a building is, it is not really green if it is oversized for its program, or part of the disposable architectural trend. Modern Japanese architecture has gone too far away from the sustainable buildings of old Japan, when only what was essential got built, was energy efficient, and 100 percent recyclable and biodegradable. Restoration projects such as at the International House of Japan (page 210) and the *minka* (historic folk architecture) restorations by architects like Atelier Tekuto are part of a welcome trend in this direction.

A paragon of all things modern, urban Japan is also beginning to reconnect to its traditional roots. Japanese traditions from crafts to architecture were not "cool" during the drive for modernity of the later twentieth century. But, as growing urbanization eats up the countryside and pollutes Japan's once-famous natural beauty, a loss is being noticed. Among the young, old things are becoming cool and are being mixed with the hottest color of the day—green. These ideas are particularly regaining importance with a new

generation of architects, for example, NAP Architects (page 50) and Hiroshi Sambuichi (page 112), as well as some older architects, such as Kengo Kuma and Terunobu Fujimori. Says Kuma, "In my work I attempt to bridge the traditional and the innovative, as well as the local and the global" (page 216). While architects of Kenzo Tange's generation were deeply conscious of their role as spokespersons of Japan on the world stage, and often pointed to the Japanese tradition-inspired details in their modern buildings, these features were not centered on materiality and sustainability issues, as they are this time around. Japan's pre-modern architecture was contextually sensitive, naturally biodegradable and recyclable, and is beginning to inform the twenty-first century architectural vocabulary.

THE LOCAL AND GLOBAL CONTEXT OF ARCHITECTURE IN JAPAN

Most of the green buildings, the white cube buildings, and the wow buildings being built in Japan today do not engage with the city. The Renaissance passion for molding the city's public spaces by architecture around it gave way to the modernist aloofness to the street level and urbanism. This standoffishness still endures in today's architectural objects. Urban design is still not taught in schools of architecture in Japan, most of which are under the faculty of engineering. This engineering bias is apparent in buildings in Japan, and in between the buildings. You see spaces without a sense of place or a program for public purpose. In brandteculture, concept comes first, the program comes later, and the urban context barely noticed. The work of Fumihiko Maki (page 91) is an exception in this regard. However, one hopes that as the younger generation in Japan looks more deeply at traditional Japanese buildings, the emphasis on user-friendly urban design will also re-emerge. One also hopes that the Japanese public will become active participants in urban development, helping to envision positive change rather than simply being passive beneficiaries of urban development.

The architects featured in this book are well known, but before many of them were acknowledged around the world, their work was suspect at home. Most of them are boutique architects, who cannot compete with the juggernaut of the Japanese construction industry, and have learned to live with it. Five of the largest general contractor firms, called *genecon* in Japan, build about 90 percent of all that is put up, subcontracting large parts of the work to smaller construction companies. Compared to the offices of the boutique architects that usually hire fewer than thirty people, the *genecon* have hundreds, or sometimes thousands, of architects and engineers on their staff. Even on projects that carry their names, the boutique architects typically only do the concept and design development work, and the general contractor takes responsibility for the working drawings, specifications, and site supervision. The design phase of the buildings is under-prioritized in Japan compared to the construction phase. Many of the steps that are developed in the architect's offices elsewhere are done by the contractors in Japan. The construction companies also have a long history of being in collusion with each other and with the government. Since the infamous Aneha scandal and many others of lesser magnitude made their way to the popular press, the construction business in Japan has been changing, but very slowly, like most things in Japan.

While Jun Aoki thought of the sleek white surfaces he wanted for the SIA Aoyama building (page 166), it was the *genecon* Kajima Construction

Opposite The seamless brick and glass surfaces of Fussa City Town Hall designed by Riken Yamamoto blur the boundaries between landscape and architecture.

Corporation that worked for six months to develop a uniformly smooth exterior—"like a polished rock" of reinforced concrete by hiding all construction details and services. The contractors also do much of the detailing that SANAA is known or blamed for. Many architects work cooperatively with the *genecon* to develop the details, some of them on site while the building is under construction. This is attributable to the craftsman-like attitude of the construction companies proud of their craft, equal respect for the craftsman and the artist through Japanese history, and a relatively small number of lawyers. *Genecon* also sign the drawings, take legal responsibility for the projects, and make most of the money. Fresh architecture graduates often work for very little or no salary when they work for starchitects. They may have to live with their parents for several years after graduating before they can afford to set up their own homes, unless they work for a larger company. According to Ove Arup & Partners Consulting Engineers, who have thirty-seven offices worldwide, the design fees for a typical project in Japan are half of what they are in US or UK, so their firm does less work for smaller fees when working in Japan.

One change on the construction scene in Japan is the arrival of the developer. Recent large mega block projects, such as Roppongi Hills and Tokyo Midtown (page 160), have been "produced" by developers. Whereas the construction companies think of themselves as "makers of a product," the developer is a pure businessman, ready to treat the building as a product to be traded, securitized, and profited from. This can be a good thing in challenging the hegemony of the *genecon*, but only if the public authorities assume their role of representing the public interest more actively, and that will happen only if the public demands it.

How do trends in contemporary Japanese architecture relate to those around the world? One aspect of the current globalization is that local and global influences have become intermingled and are difficult to tell apart. While architectural trends travel across the world and symbolize today's transnational dreams, desperations, and joys, building laws are not quite as portable. Zaha Hadid's Channel Mobley Art Pavilion is a case in point. Reflecting the curves and obtuse angels one has come to expect from her, this project was designed using British building standards, constructed in Japan, and was meant to travel to eleven cities around the world. However, several materials specified were not certified by Japanese law, and could

not meet the stringent fire-testing regulations here. If it had been built to conform to Japanese regulations, it would have had to be rebuilt several times during its journey around the world, and was thus abandoned after just three city stops.

Whether we consider white cubes, green buildings, *nouveau wabi sabi* or wow buildings, we are witnessing a very confident period in Japanese architecture today, and a period of cultural blossoming. The bubble period of the 1980s was a heady time, and the energy then generated liberated creativity, making Japan a major global cultural force today, with its cultural exports breaking all records, in spite of the slower economy. The Japanese (except for politicians and bureaucrats) have started to think of the building as an "out-of-the-box" box, and view themselves as world actors.

As the world moves into the second decade of the twenty-first century, it is clear that the West no longer has all the answers. Japan has moved beyond the need to mimic the West. Foreign trends are rejected or accepted on one's own terms, and Japan's own heritage is again becoming a point of reference in Japan and beyond. The white cube, the wow, the green buildings, and the *nouveau* Zen may also be happening elsewhere, but the white cube is at its whitest in Japan, the wow has more poetry, the green and Zen are on their home turf. Being itself is what Japan does best—in a Zen sort of way.

Deanna MacDonald joins me in inviting you to enjoy the architectural projects featured in this book. We have endeavored to select diverse works that represent various building typologies, design thought, and geographical locations to give you a glimpse into the vibrant architecture scene in Japan today.

Geeta Mehta

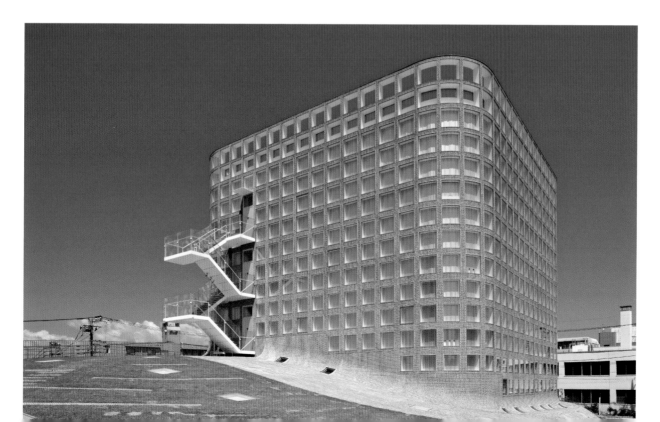

architecture for living

When it comes to contemporary house design, the Japanese can be fearless, and willing to forego comforts dear to most of us in order to live in a work of art. Shigeru Ban once remarked that he loved working for clients in Japan because they were willing to take a design further than any Western client. Perhaps it is a reaction to the often-crowded, irregular building sites, or the knowledge that buildings rarely stand more than twenty or so years before being torn down in the endless cycle of scrapping and rebuilding (known as *tatekae*). While strict on earthquake and fire safety, Japanese building codes are also more liberal on other safety issues that usually reign in creativity elsewhere. In any case, the architecture of living in Japan looks like nowhere else.

The projects in this chapter stand out in Japan's urban/suburban landscape of endless nondescript low- and mid-rise apartment blocks or cookie-cutter houses. Their mix of tradition and modernity, pure design and pragmatism, often leads to a home that is both unique and welcoming.

Small spaces are ingeniously expanded in Kazuyo Sejima's curving Okurayama Apartments, while difficult spaces are employed to creative effect in Suppose Design Office's Zen-like house on a sloping hillside in Kitakamakura. Public and private spaces intersect in a surprising way in Sou Fujimoto's playfully porous House H and the glass partitions of TNA's Passage House. Age-old traditions, such as sliding *shoji* screens and *fusuma* doors, are modernized to suit contemporary lifestyles, as in Waro Kishi's Glashaus apartments and the frosted glass exterior of Edward Suzuki's House Like a Museum. A highly experimental new environmentalism is leading to innovative designs that look for solutions both in the past—as in Terunobu Fujimori's charmingly "primitive" Coal House that explores Japan's traditions of craftsmanship and natural materials—and the present, as in Atelier Tekuto's environmentally friendly aluminum A-Ring House.

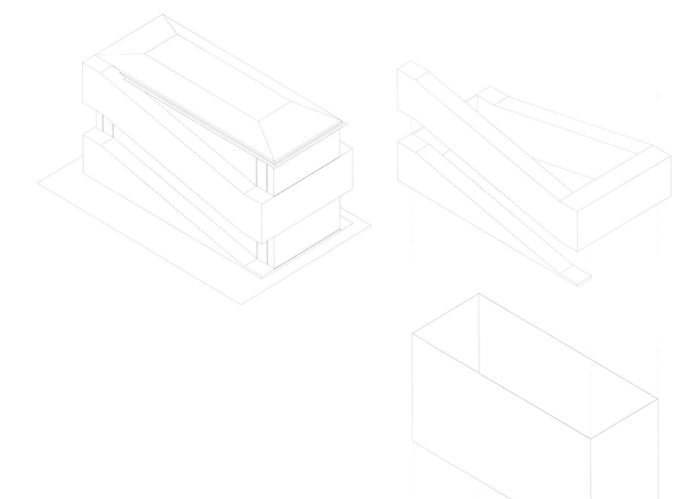

PASSAGE HOUSE

Architect **TNA—Takei Nabeshima Architects**
Location **Miyota, Nagano Prefecture**
Completion **2007**

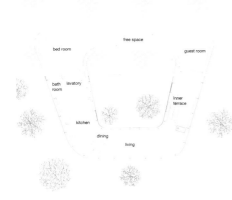

Passage House is the third house that the
Tokyo-based architects Makoto Takei and Chie
Nabeshima (otherwise known as TNA) have
designed in Karuizawa. This historically fashion-
able resort area in the mountains near Nagano
is the preferred place for well-to-do Tokyoites to
build a second home due to its verdant moun-
tains and easy access via the Shinkansen or car.

TNA has earned a reputation for sensitive and
resourceful use of difficult sites. For Passage
House, they were presented with the unlikely
site of a steep hillside. They responded to this
challenge by designing a house in the form of a
doughnut-shaped passage, which emerges from
the hillside and returns into it, forming a complete
circle anchored to the hill. The contact between
the house and the land is minimal in order to not
obstruct the uphill view. Explained Takei: "The

Above The rectangular spiral plan is anchored into the side
of a steep hillside.

Right This otherwise challenging site does provide the house
with spectacular views over the hills of Karuizawa, a popular
resort area in the Japanese Alps.

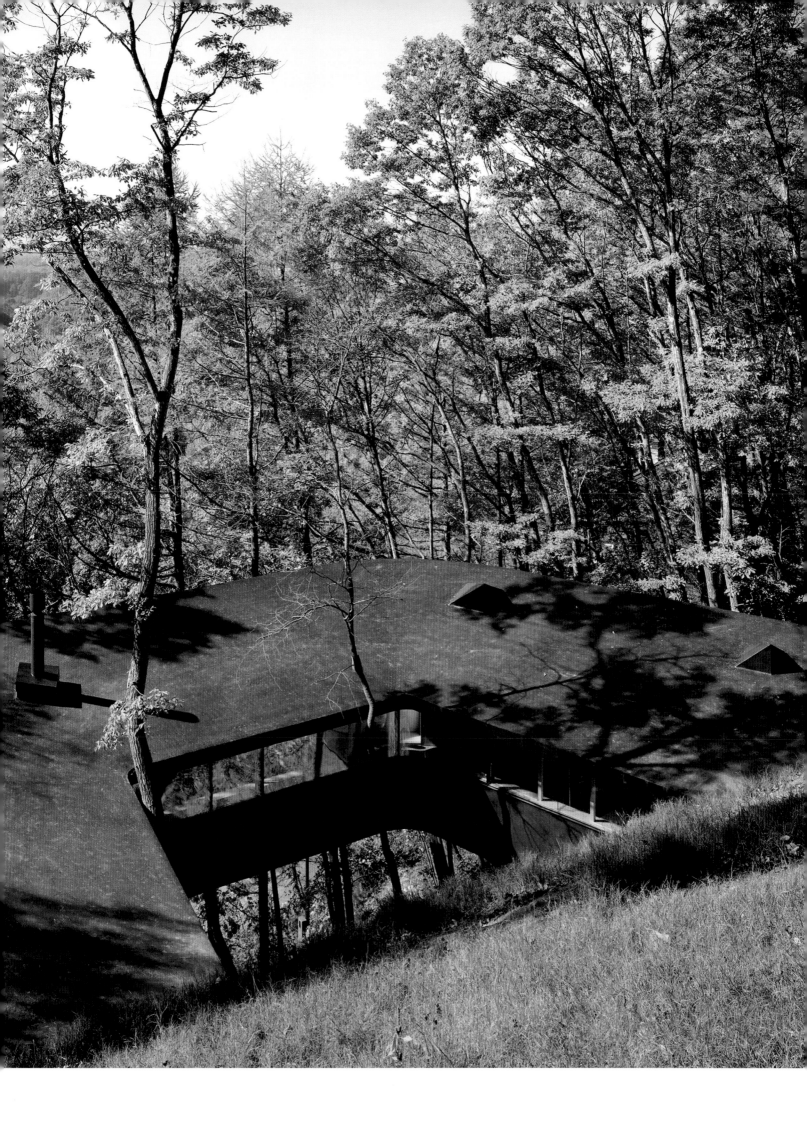

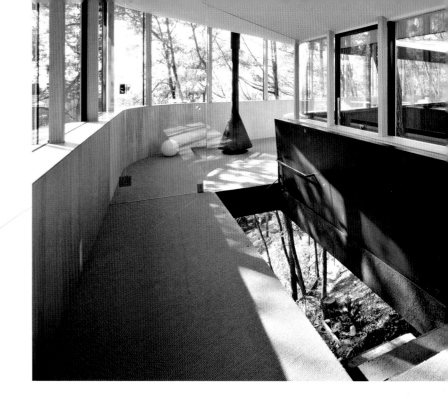

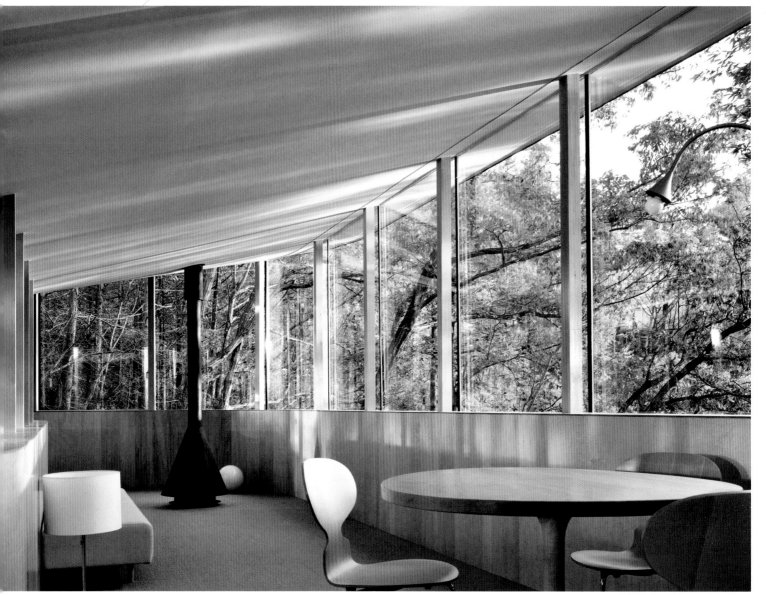

Top Minimizing the impact on the natural surroundings, the plan incorporated extant trees.

Above Inside, a pale wood decor expands and lightens the space, creating a comfortable complement for the verdant exterior views.

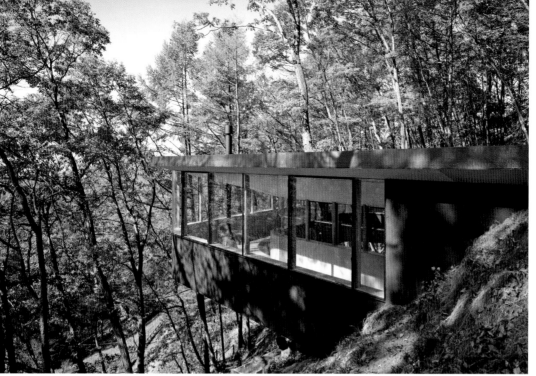

Center left The house is approached from underneath via narrow stairs that lead to a trapdoor in the floor.

Left Painted black, with a horizontal band of windows that curve with the house, the exterior has crisp modernist lines.

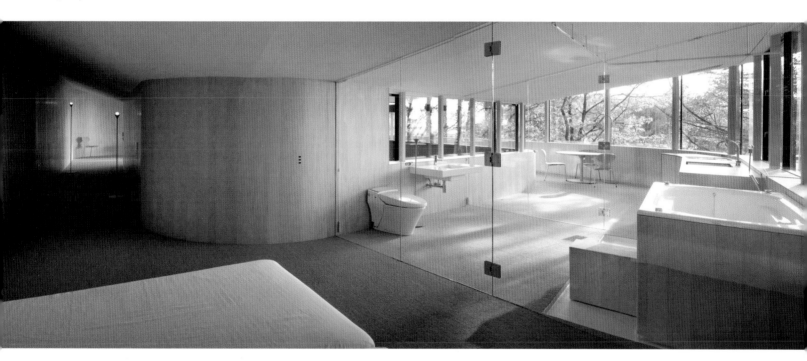

highest point of the site is a mountain ridge and we thought it important to leave the skyline as clear as possible."

The exterior of the Passage House is a painted black concrete ring, with a horizontal band of windows that curve with the house. Its crisp lines have a modernist feel, and the exterior has been likened to a slender circular bridge and even to a ring-shaped UFO rammed into the hill face.

The house is approached from underneath via narrow stairs that lead to a trapdoor in the floor. Once inside, it is the views of the surrounding forest that dominate the interior. According to Nabeshima: "Though the shape is simple, the atmosphere indoors is rather complex. Sometimes we can see the hillside, and sometimes we simply enjoy the feeling of balancing on a slope."

Like many of TNA's works, Passage House blends daring and practicality, bright and dark surfaces, and open and closed spaces. It has a

dark exterior, but the white ceiling and pale wood expand and lighten the space inside. A bedroom, guest room, and free space are built into the hill. The extended portion features an inner terrace to one side, a bathroom and kitchen to another, and the living/dining room at the front. Furnishings, all designed by the architects, are minimal so as not to distract from the picturesque views.

Not a house for the misanthropic, all partitions in this house are made of glass, including those of the bedroom, the bathroom, and the kitchen. The only hidden feature is the trapdoor, which when closed blends into the pale flooring. The focus of the house is not privacy, but a design that makes the experience of nature the experience of the house.

Above The focus of the design is not privacy, but the experience of nature. All partitions are transparent, even in the bathroom and bedroom.

Below The contact between house and land is minimal in order to not obstruct the uphill view.

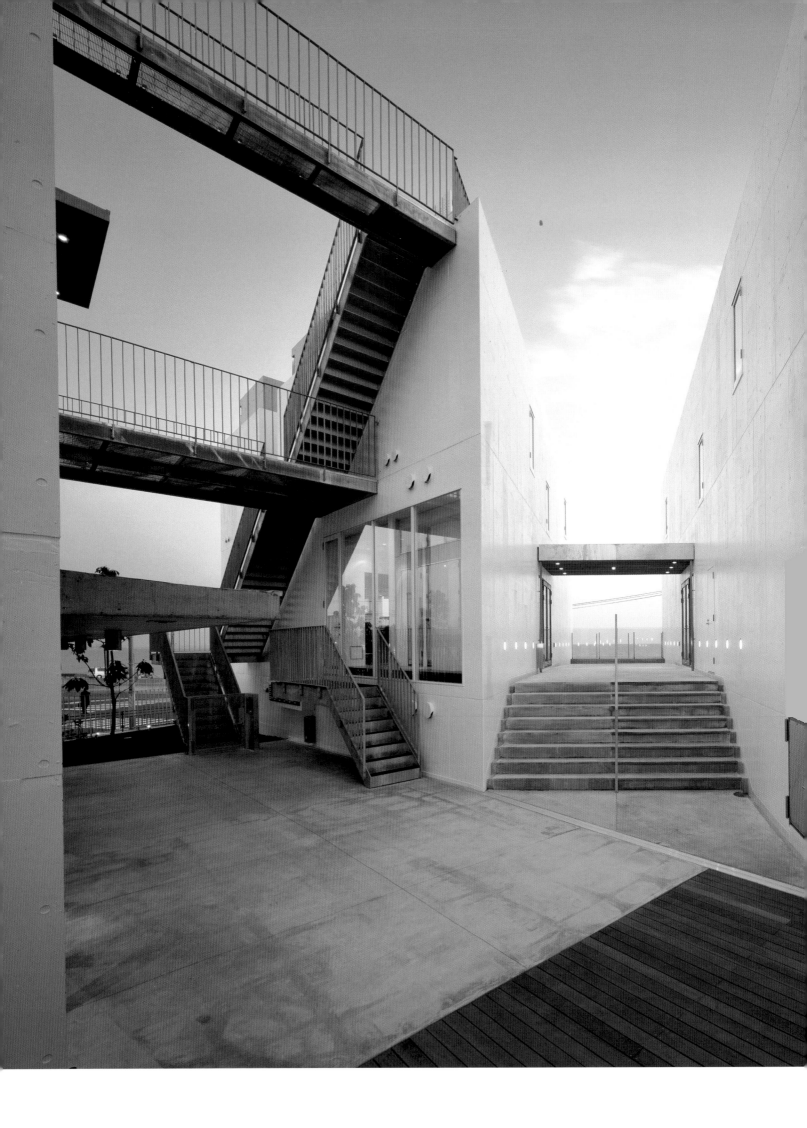

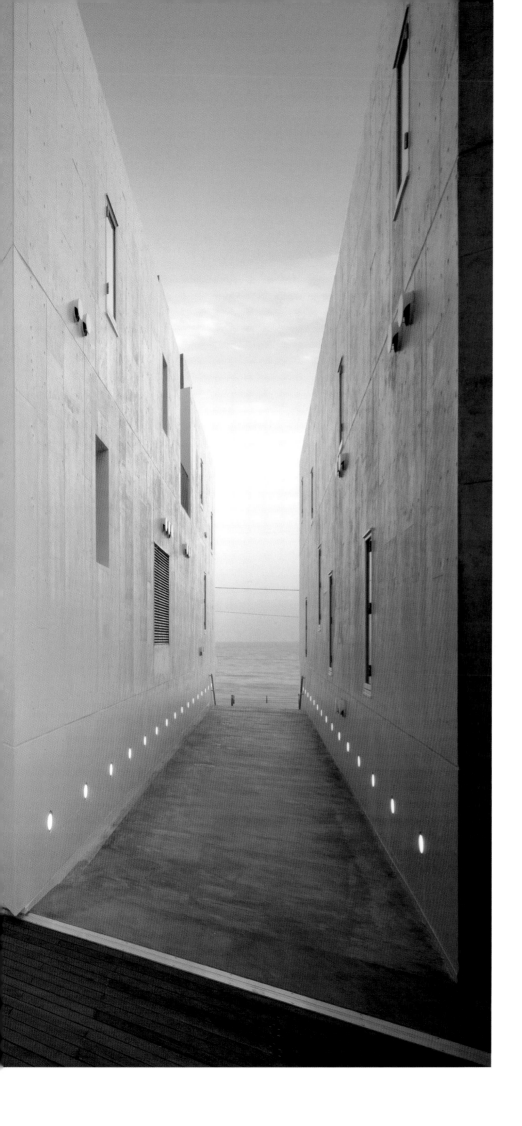

WEEKEND HOUSE ALLEY

Architect **Chiba Manabu Architects**
Location **Kamakura, Kanagawa Prefecture**
Completion **2008**

Kamakura is one of Japan's most historic cities. The Shogun's capital from 1192 to 1333, Buddhist temples and Shinto shrines still dot its wooded hills. But modern Kamakura is much more than a memory of a glorious past. It is one of the most desirable residential and tourist destinations in Tokyo Metropolitan area, surrounded by rolling hills and set by the sea. Visitors to Kamakura today will find not only robed monks and Zen gardens, but also fashionable shops, elegant homes, and surfers waxing their boards at the beach.

In designing the Weekend House Alley, a mix of condominiums and commercial spaces in a highly desirable area next to the Shichirigahama beach, Chiba Manabu Architects set out to fit this contemporary complex into the urban fabric of a multifaceted historic city.

Well-known for his single-family homes as well as his "designer" rental apartments and cooperative housing, Chiba always strives to contextualize his designs, as well as link the interior and exterior spaces.

The design of Weekend House Alley carefully balances the views from each residence, the programmatic requirements of the businesses, and the regulations relating to the site.

The main features of the design are the passageways that divide the complex into seven irregularly shaped volumes. These radiating communal corridors provide access to private and commercial units situated in these seven volumes. They also create vistas of the coastline and neighborhood in a manner that echoes the ancient paths that crisscross the hills of Kamakura.

Left The angular complex is a mix of condominiums and commercial spaces on the seaside at Shichirigahama beach.

Above The complex is scaled to blend with the surrounding buildings and follows the irregular street line. Visible details have been kept to a minimum.

Below A level of fluidity and flexibility is created by leaving the interiors as open as possible.

Weekend House Alley is designed with the intention of interacting with and enlivening its surroundings, rather than blocking out the urban context, as many recent projects tend to do. Its two- and three-story buildings are dotted with large windows allowing spectacular vistas of the sea and surroundings, making the exterior neighborhood part of the interior experience. Parking is provided in the basement level. The complex is scaled to blend with the buildings around it. It follows the irregular street line, and keeps details to a minimum. The result is a contemporary complex that nevertheless possesses an air of familiarity and belonging.

A level of fluidity and flexibility is built into the complex by leaving the interiors as open as possible. The apartments within the complex can be used either as residences or weekend homes, and commercial space can be utilized as offices or shops. Chiba also strove to reconstruct the live/work paradigm of historic *machiya*, traditional Japanese merchant houses, where residential spaces were situated behind or above the business areas. Such combinations are once again in demand by small entrepreneurs in post-industrial information societies around the world.

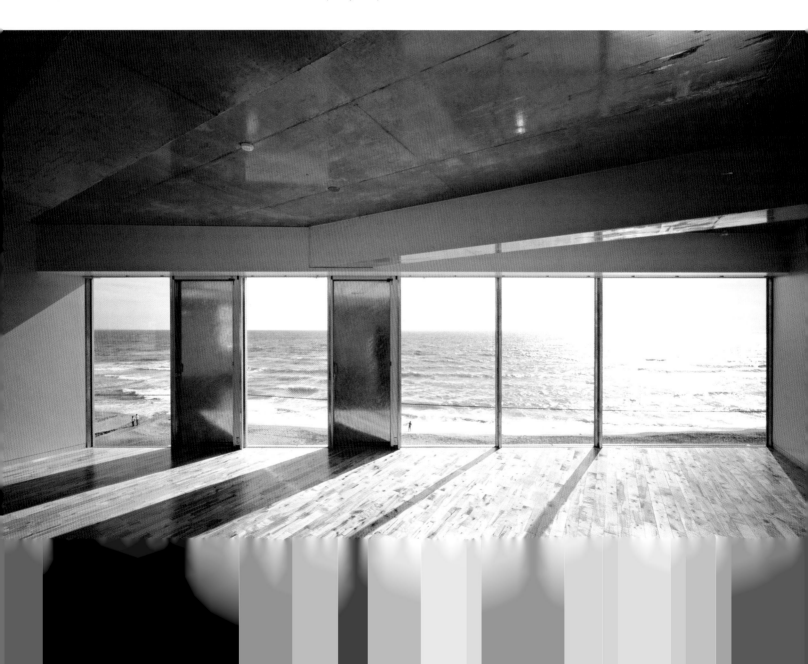

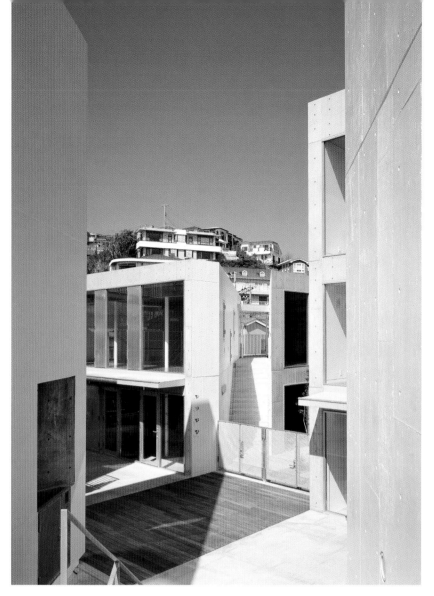

Left With large windows and communal passageways, the plan connects interiors and exteriors.

Below The design revolves around passageways that divide the complex into seven irregularly shaped volumes.

Bottom left Unlike many recent designs, this building aims to interact and enliven the surroundings, rather than block out the urban context.

Bottom right The passageways create vistas of the coastline and neighborhood in a manner that echoes the ancient paths that crisscross the hills of Kamakura.

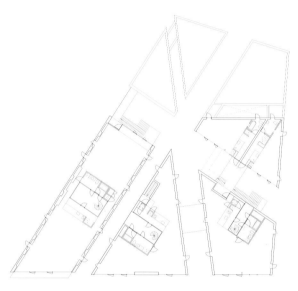

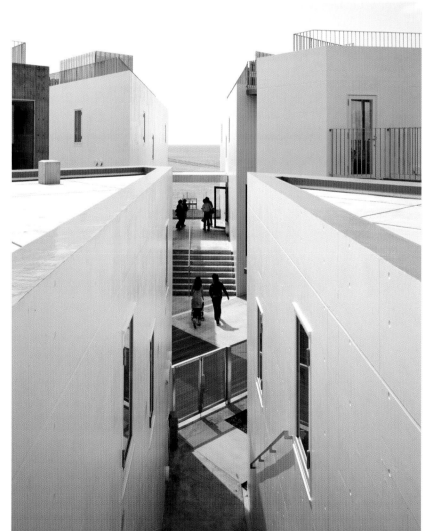

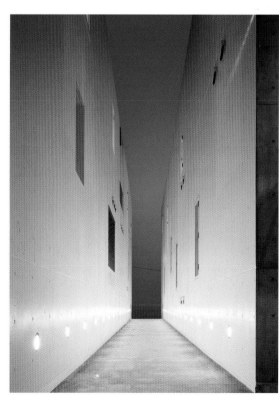

HOUSE IN KITAKAMAKURA

Architect **Suppose Design Office**
Location **Kitakamakura, Kanagawa Prefecture**
Completion **2009**

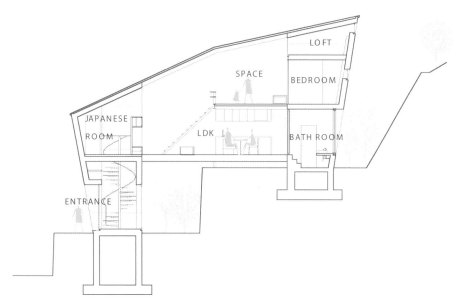

Some of Japan's most important Zen Buddhist monasteries and temples dating back to the thirteenth century are located less than an hour from Tokyo in the leafy hills of Kitakamakura. Today, this historic town, well connected to Tokyo by suburban trains, is also a highly desirable address, and modern homes are found in between the temples and retreats. Unsurprisingly, land for development in Kitakamakura is scarce. Thus, even the most unlikely sites are considered for construction.

When Suppose Design Office was asked to design a house on a 164-square meter plot on the side of a hill, the firm responded with a unique plan which takes a Zen approach to its limited site, finding beauty in the most unexpected places. This young Hiroshima-based firm had already gained a reputation for dealing creatively with issues arising form Japan's characteristically small, often irregular sites. Since launching his own firm in 2000, the firm's principal, Makoto Tanijiri, has rarely shied away from more difficult projects, such as this house in Kitakamkura: "If you think positively about a difficult problem," he has said, "you will find a way to solve it."

Tanijiri's designs do not favor any one style,

school, or material. This may have to do with his relatively unorthodox beginnings as an architect: after attending a two-year technical college, Tanijiri worked for a design firm where he learned enough construction basics to qualify for his architect's license. This is not the average route for Japanese architects who almost always follow a prestigious university degree by an apprenticeship with an established office.

For this project, the design anchored the house into the hill with a steel frame held in place by two concrete shafts, meeting Japan's rigorous seismic resistance rules. The plan also links the structure to its surroundings, using the beauty

of the surroundings and the retaining wall on the steep hill as part of the architecture. Tanijiri says that his design philosophy revolves around the idea of "borderlines" or, more precisely, the dissolution of borders between interior, architecture, and context: "We imagine architecture that exceeds itself and moves closer to nature."

The multilayered house has a footprint of only 60.2 square meters but provides 113.62 square meters of living space within. Outside, the gap in between the lower and upper shafts creates a space that can be used as a private garden beneath the house and a bath terrace.

The entrance is located at the lowest level and opens to a spiral staircase leading up to a large second-level central space that includes the living and dining room, the kitchen, a glass-walled bathroom, and the Japanese room. The bedroom is on the next level, with a small loft above it. Placing the bedroom and the bathroom on different levels is not uncommon in such small sites in Japan.

Inside, walls of smooth concrete are accented with pale wooden detailing, including simple stairs and beams running along the ceiling tapered at different angles, giving the highly contemporary interior a Japanese feel. This modern space is then opened to the greenery around it by a wall of windows that open at the lower level like sliding doors. A simple, elegant house, it fits well into its hillside as well as into its Zen neighborhood.

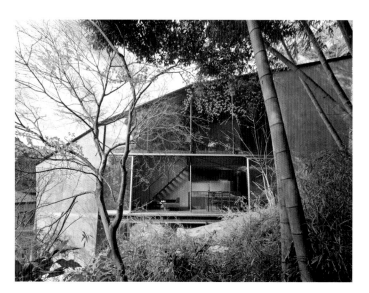

Top left The design anchors the house into the hill with a steel frame held in place by two concrete shafts.

Left A wall of windows at the lower level opens like sliding doors.

Right The multilayered house has a footprint of only 60.2 square meters but provides 113.62 square meters of living space within.

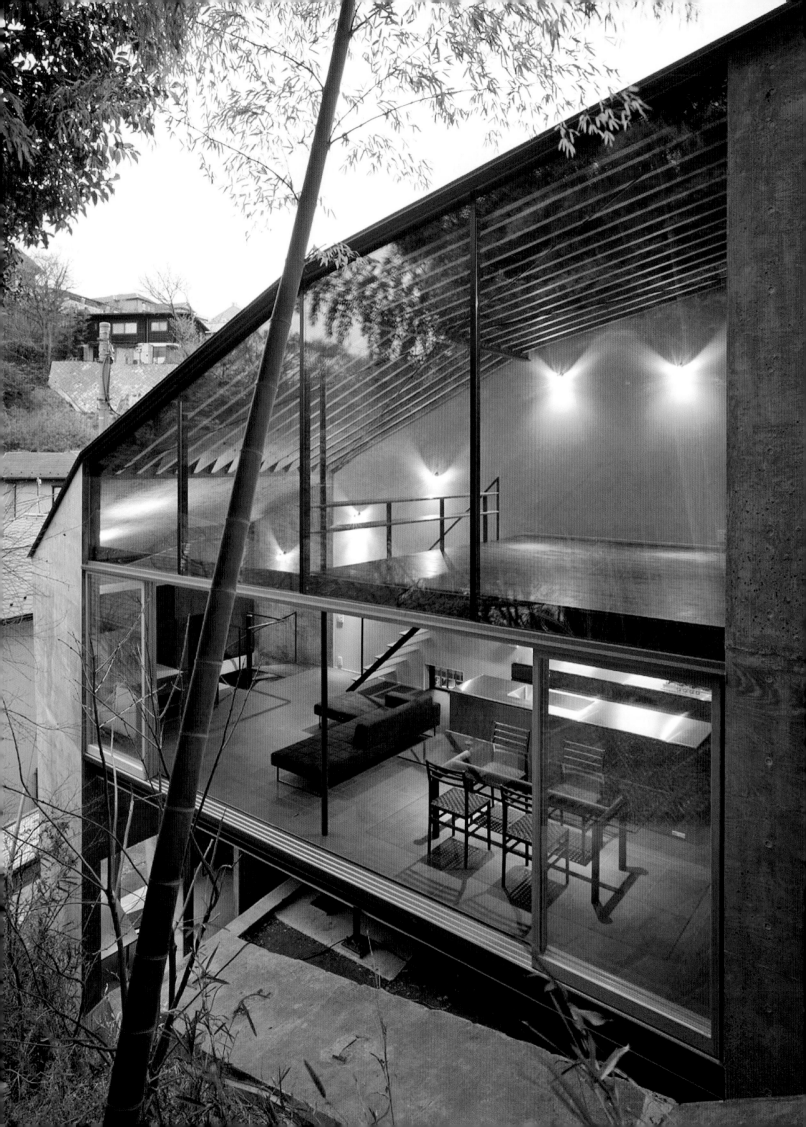

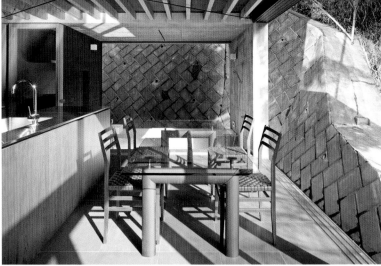

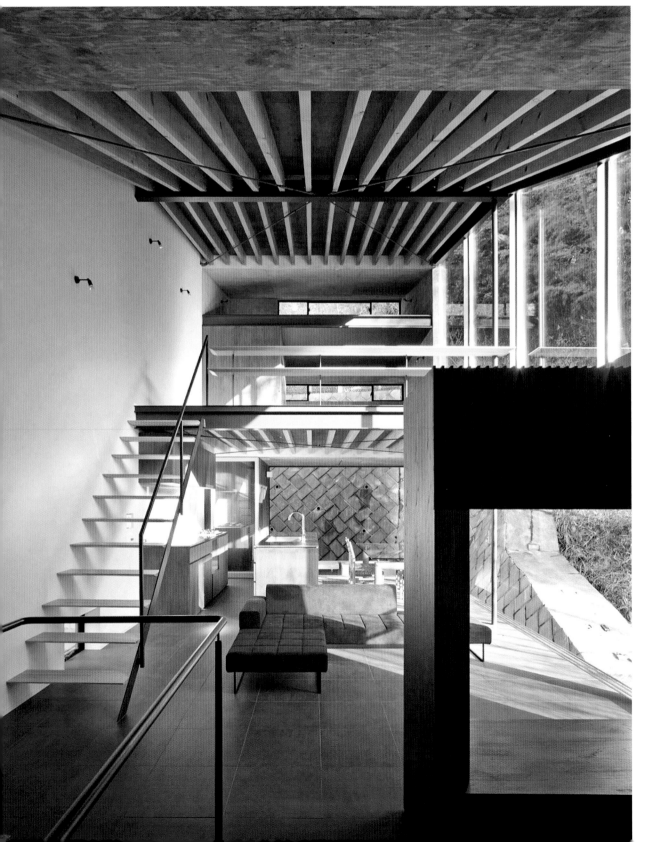

Above left With an entire wall opening onto a green hillside, the interior is afforded natural light and verdant views.

Above right The retaining wall on the steep hill is used as part of the architecture.

Left Walls of smooth concrete are accented with pale wooden detailing, with simple stairs and beams running along the ceiling tapered at different angles.

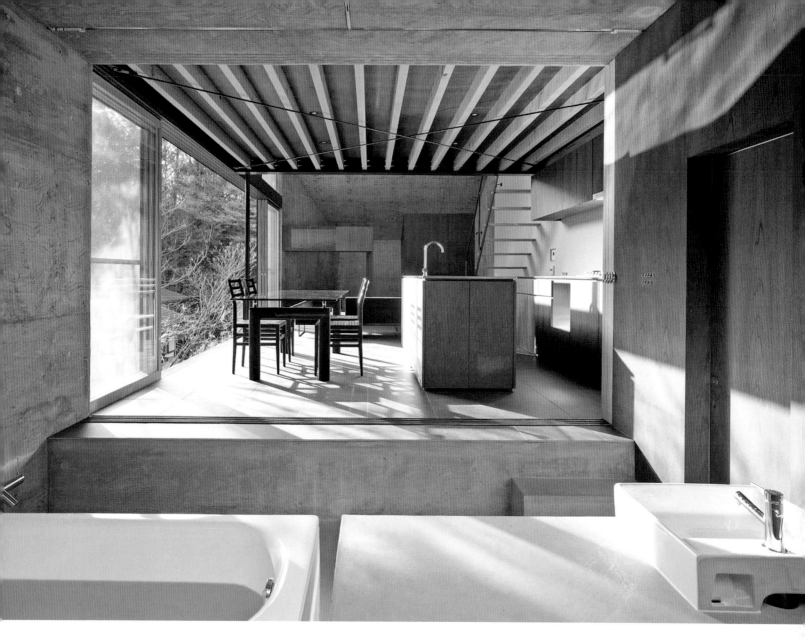

Left A rectangular layout and retaining walls define the house's form.

Above The more private space close to the hillside has been used for the glass-walled bathroom.

Below The large second level includes the living and dining room and kitchen, with stairs leading up to the bedroom and upper loft.

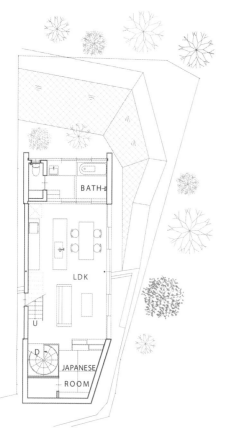

BATH

LDK

U

D

JAPANESE

ROOM

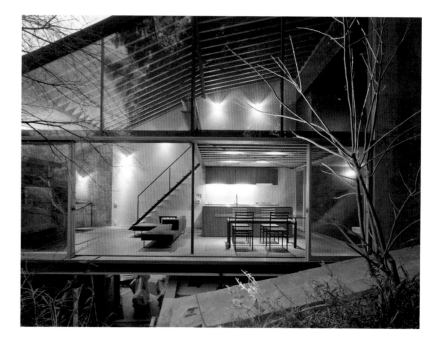

HOUSE LIKE A MUSEUM

Architect **Edward Suzuki Associates**
Location **Kamakura, Kanagawa Prefecture**
Completion **2008**

As its name suggests, House like a Museum is not only a family home but also a place for displaying the owner's large art collection. With 538 square meters of living area, it is almost big enough to be a museum, especially when you consider that the average size of a Japanese home is about 100 square meters.

The house is located not far from the main train station in the town of Kamakura in a mixed commercial and residential area. Architect Edward Suzuki had earlier designed the "go in to go out" home for another client in a similarly crowded area, ideas from which he further developed here. The design looks inwards on to itself rather then out into the surrounding neighborhood, creating a domestic oasis in the middle of a busy town.

The house's street façade is basically a flat wall punctuated at one point by an entrance foyer and at another by a two-car garage (a rare luxury in Japan). To unify these volumes and create a more dynamic façade that better interfaces with the street, a two-level wall of dot-point, double-tempered frosted glass runs the length of the upper façade. The lower layer curves out to wrap around the garage, forming a gap through which bamboo from a small garden playfully grows. Reminiscent of traditional Japanese paper *shoji* screens, the frosted glass effectively covers the façade while allowing soft natural light through.

Utilizing the maximum permissible area of the 776-square meter site, the basic plan is a rectangle with a 15-meter diameter circular *naka niwa*

Left A two-level wall of dot-point, double-tempered frosted glass runs the length of the upper façade, and adds an element of privacy while permitting soft natural light to come within.

(inner garden) cut into its center. As the internal circle is made almost entirely of glass, every room in the two-story house has views on to this garden, which features a contemporary sculpture from the owner's collection and a deciduous tree that rises above the house's highest level.

On the first floor, the entrance foyer opens on to a gentle sloping corridor, designed for displaying works of art, which leads to a large living room area. This area continues around the inner circle to an open dining room and kitchen. From here, another sloping corridor leads to the master bedroom and bathroom, coming almost full circle. This corridor echoes the concept of *engawa*, the peripheral transitional corridor connecting the interior and exterior in a traditional Japanese home. Just off of the entrance foyer is the owner's private office, with a Japanese-style *tatami*-matted guest room up on a low mezzanine next to it.

A staircase near the kitchen leads up to the second floor containing a family room/home theater along with four bedrooms and a family bathroom, all along the north side of the house. All five rooms open on to a terrace that continues around to a large garden terrace on the south side. The terrace is scattered with plants and

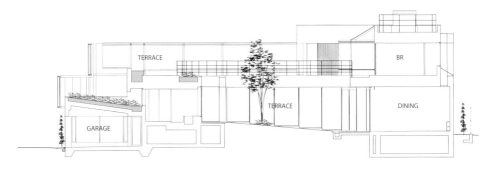

bordered on one side by the frosted glass façade.

The interior décor maintains a Japanese simplicity, with walls and ceilings of white stucco paint and floors of bamboo or limestone. The bamboo laminate, chosen for its more environmentally friendly characteristics, is also used for all built-in and moveable furniture. Other energy-efficiency features include the mix of evergreens and other plants on the roof garden for natural insulation.

In this highly contemporary home, the design nevertheless incorporates the essential spirit of traditional Japanese architecture. Suzuki is known for his flair for successfully incorporating local vernacular ideas anywhere he works. While in Japan he has modernized traditional concepts

Above With 538 square meters of living area, the house is luxurious by Japanese standards.

Below Both floors revolve around a 15-meter diameter inner courtyard, affording every room a view.

such as *engawa*, *naka niwa*, *tsuboniwa* (tiny patios), *hisashi* (roof overhangs), and *tsuufuu* (cross-ventilation), his work in Africa empathizes with the local traditions there. This acute sense of contextuality makes his designs more comfortable, elegant, and naturally efficient.

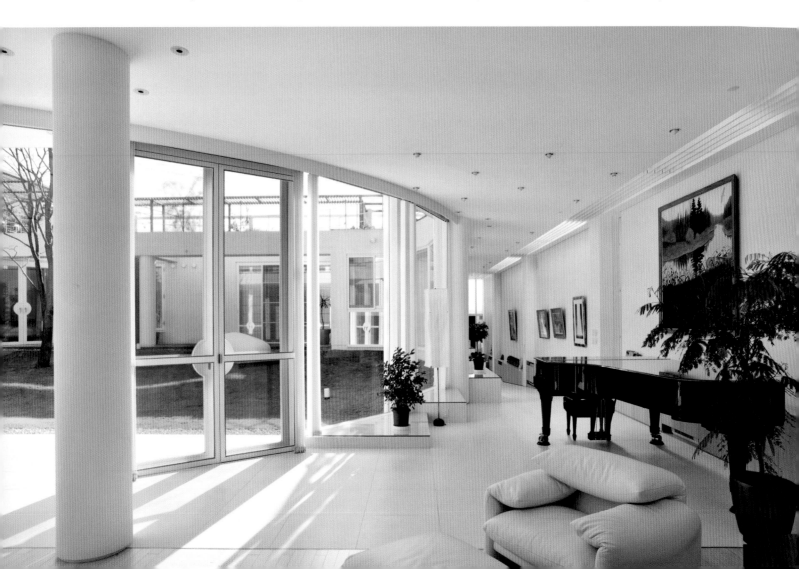

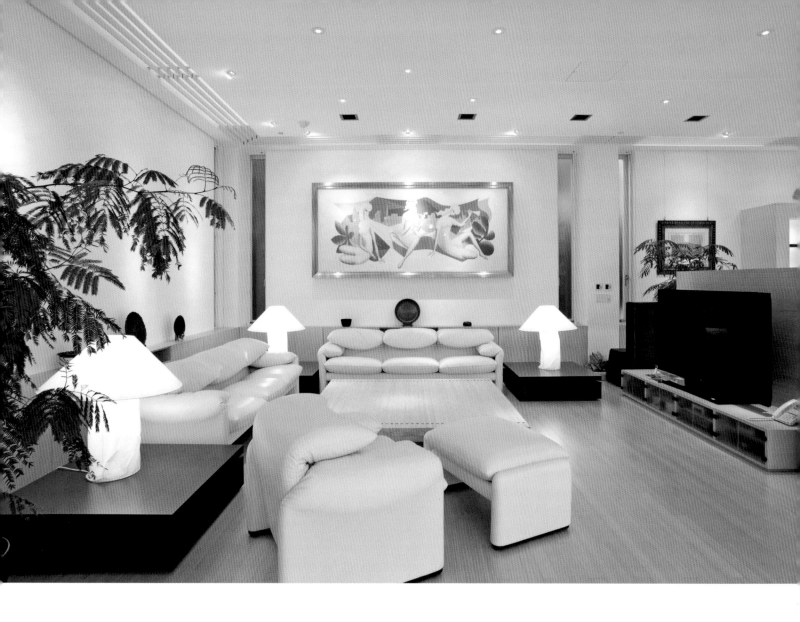

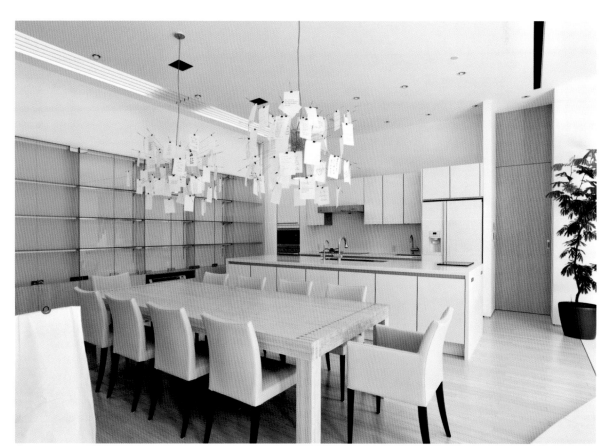

Above The house is not only a family home but also a gallery for displaying the owner's large art collection.

Right The interior décor maintains Japanese simplicity, with walls and ceilings of white stucco paint and floors of bamboo or limestone.

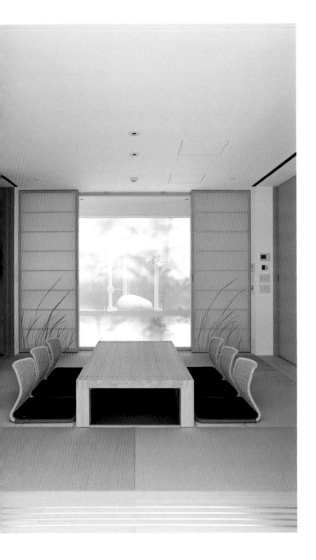

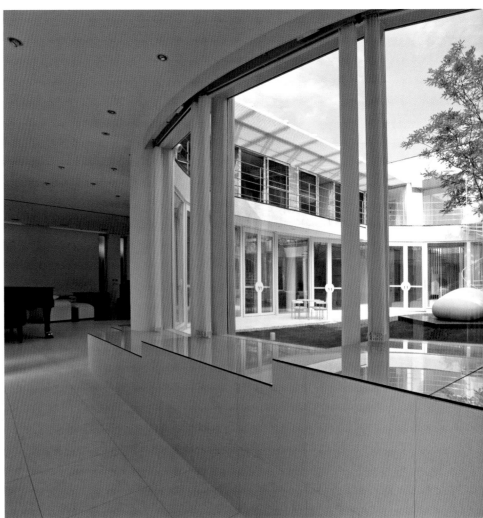

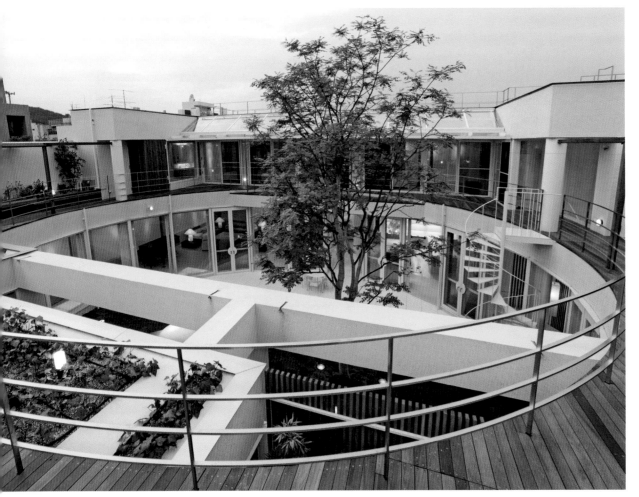

Above left A traditional *tatami* mat guest room features *shoji* screens.

Above right The garden features a contemporary sculpture from the owner's collection, and a deciduous tree that rises above the highest level of the house.

Left All rooms on the upper level open on to a terrace scattered with plants and bordered on one side by the frosted glass façade.

Right Looking in on itself, the house is literally an oasis of calm in the busy city neighborhood.

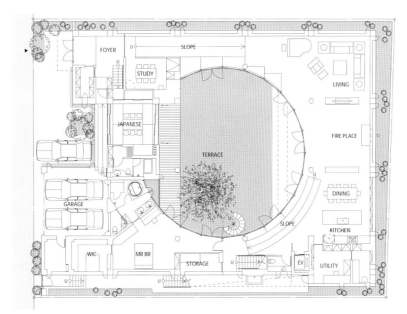

Above A circle within a square defines the ground floor plan.

Above right Bamboo laminate, chosen for its more environmentally friendly characteristics, is used for all built-in and moveable furniture.

Right A tub made of Japanese cedar is an essential feature of a luxurious Japanese-style bath.

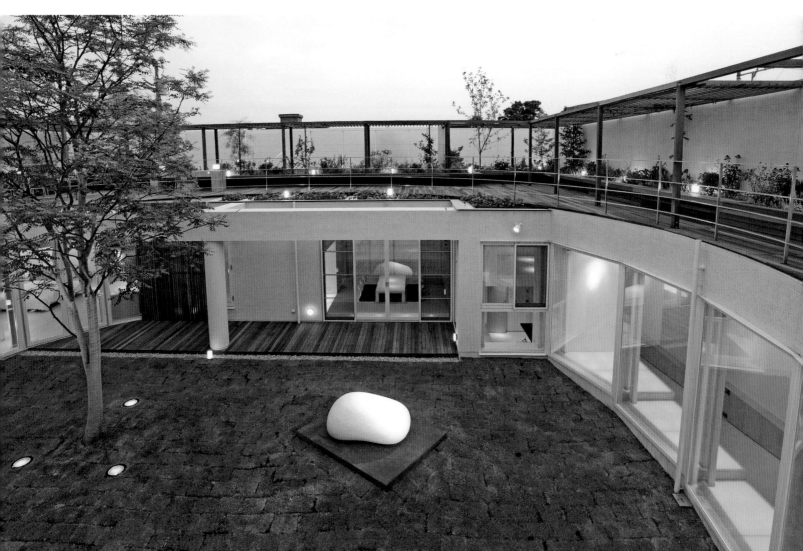

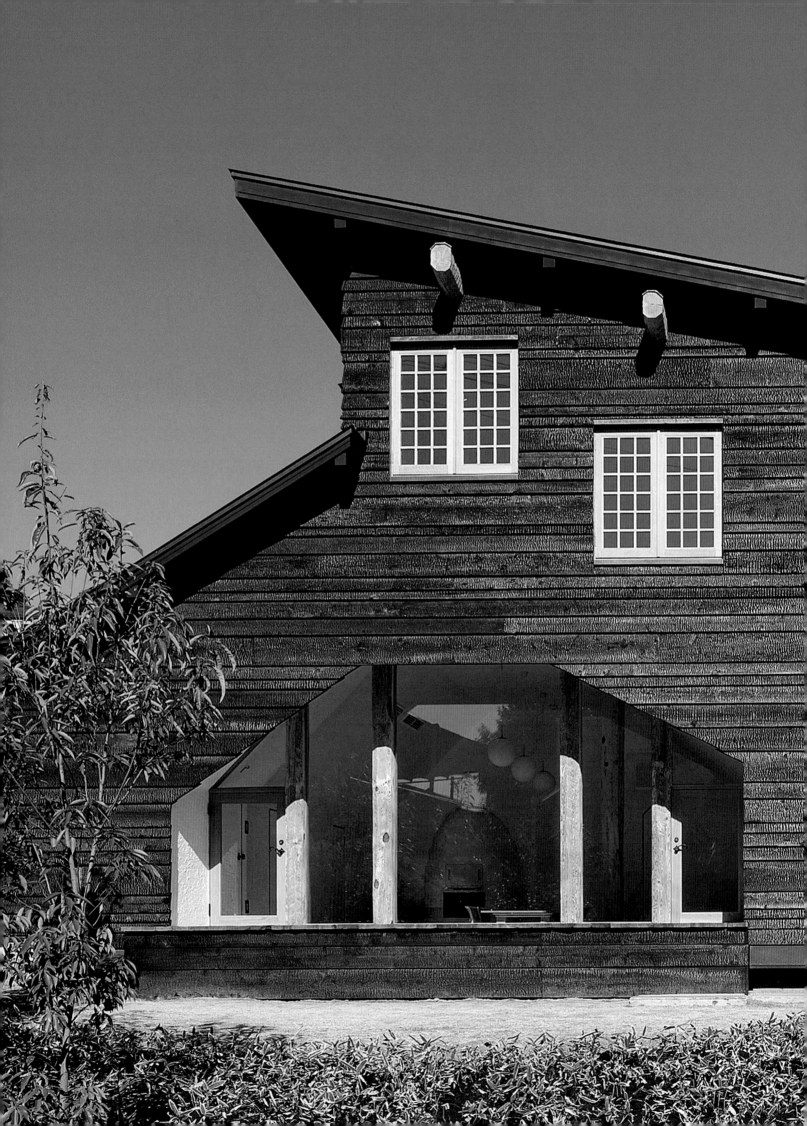

COAL HOUSE

Architect **Terunobu Fujimori**
Location **Kiyosumi, Japan**
Completion **2008**

2008.4.9.

When asked to participate in the Sumika Project in which Tokyo Gas enlisted four architects (Toyo Ito, Taira Nishizawa, Sou Fujimoto, and Terunobu Fujimori) to each design a home based on "primitive" living, Fujimori took his inspiration from what he considered the archetypal dwelling—a cave. The result was the Coal House, a characteristically Fujimori mix of playful experimentation, sophisticated craftsmanship, and a broad frame of reference, ranging from traditional Japanese architecture to the caves of Lascaux.

The first floor of the Coal House is organized around an open living/dining space measuring 3 x 3 *ken* (*ken* is a traditional Japanese unit of measurement equal to the length of a *tatami* mat, measuring 182 cm). A kitchen and a foyer are set on either side of this central space. The second floor consists of two bedrooms and a tearoom, the latter accessible via an exterior ladder. The living area echoes the form of a cave. From the large window opening, the floor drops about 20 cm towards a fireplace, which is, in fact, a Canadian gas-burning stove embedded into the wall like a Kiva fireplace. A hand-hued two-trunked pillar of Japanese red pine, felled by Fujimori near his home, extends from the floor to the arched ceiling, adding to the earthy quality. The wall is canted where the chestnut flooring meets hand-plastered walls. Doors are small to

Above Fujimori's conceptual sketches on the theme of a cave.

Left The expressive, charred cedar wood surface is made using an ancient Japanese technique, *yakisugi*, that protects the timber from rain and rot.

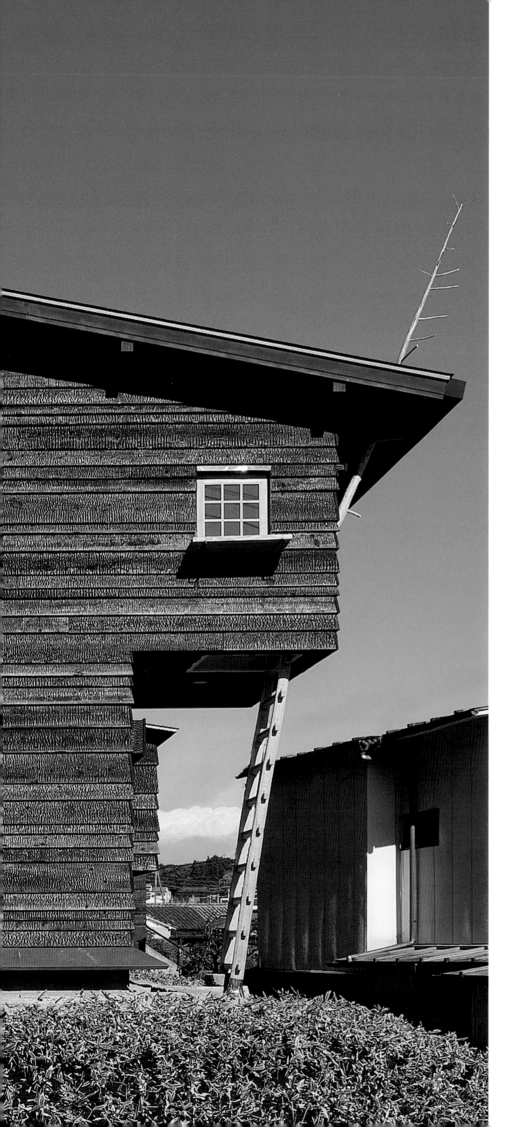

maintain the cave-like quality, requiring most people entering to duck. Small doors are also reminiscent of traditional Japanese tearoom entrances called *nijiriguchi*.

The exterior is clad in charred cedar wood made by an ancient Japanese technique called *yakisugi* that protects timber against rain and rot. The technique was traditionally used only for low-cost, low-status structures. But Fujimori uses the technique not only for its practical qualities but also for the resultant expressive patterned surfaces that shimmer in the sun. The result is essentially a house covered in a sort of charcoal.

Upstairs, Fujimori has included a *chashitsu* or tearoom, a common feature of Japanese noble homes during the Edo period. These rooms were used to entertain special guests or for the practice of tea, and employed the *wabi sabi* aesthetics of understatement, simplicity, and rusticity. Fujimori's five-square meter tearoom juts out from the side of this 100-square meter house, and is reached via a handmade ladder from outside and also through a door from the bedroom.

A respected architectural historian who designed his first building in 1990 at the age of forty-four, Fujimori's work offers a completely original take on contemporary Japanese architecture, and reflects his continual questioning of the relationship between human beings and architecture, nature, history, and the future.

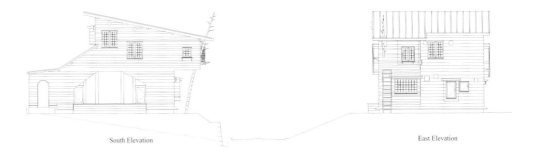

South Elevation

East Elevation

He has only two design rules:

His work should not resemble any other, past or present.

Natural materials must be used on the visible parts of the building, incorporating plants wherever possible.

In contrast to the highly polished seamless surfaces and forms common to contemporary architecture, Fujimori embraces the traditional and handcrafted construction methods, and finds ways to bring them into a modern context.

Though Fujimori's designs are ecologically sensitive and extremely energy-efficient, he does not consider himself a "green architect." He says that he designs "architecture that advances toward the past, pulling ideas from nature, the past and regional traditions as well as utilizing traditional techniques in modern structures." His work has been called "nostalgic,'" evoking

memories from a distant past even though they look like nothing anyone has seen before. These projects include a tearoom perched in a tree (see page 16), a house with a roof of dandelions and leeks, and a theater of bamboo and rope. His projects are usually constructed by a team of volunteers. Quite appropriately, his work has been referred to as "Yabangyarudo kenchiku'" (Barbaric avant-garde architecture). They are boldly situated between dream and reality and challenge all preconceptions about architecture.

Above left The distinctive profile of the south elevation is centered on the cave-like opening of the living room.

Above right The east elevation features the asymmetrical distribution of openings and the tree-like ladder to the *chashitsu*.

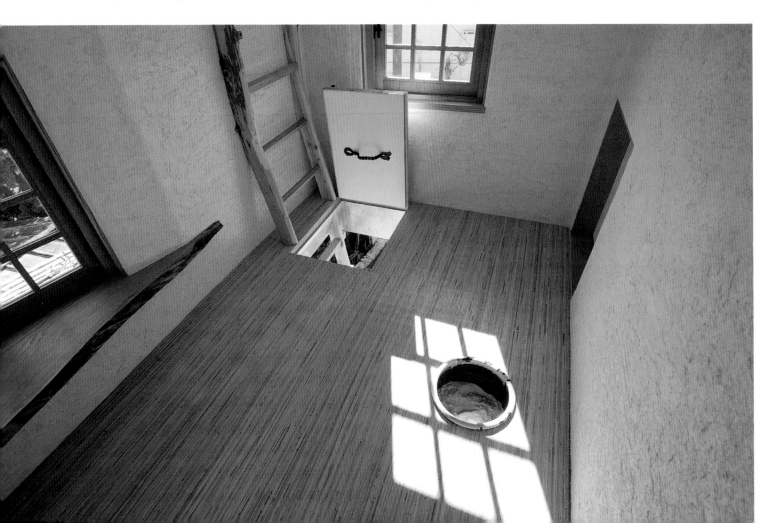

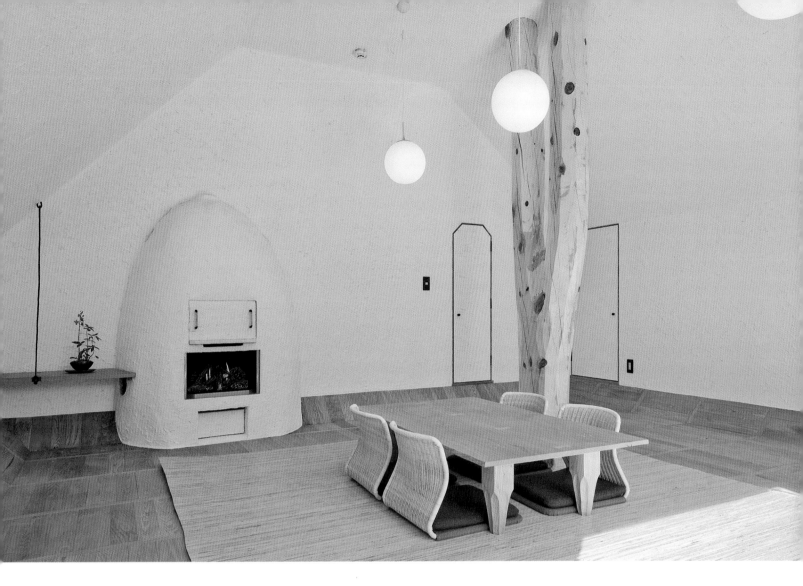

Above The living area slopes about 20 cm from the entrance to the gas-burning, Kiva-like fireplace, adding to the cave-like feel.

Left A trapdoor opens to the *tatami*-mat *chashitsu* finished with elegant *wabi sabi* aesthetics.

Right A hand-hewn wooden ladder leads to the tearoom and continues, transformed back into a tree, up through the wall and roof eave.

Above Though whimsical in concept, the plan includes everyday practicalities, from a laundry room to TV space.

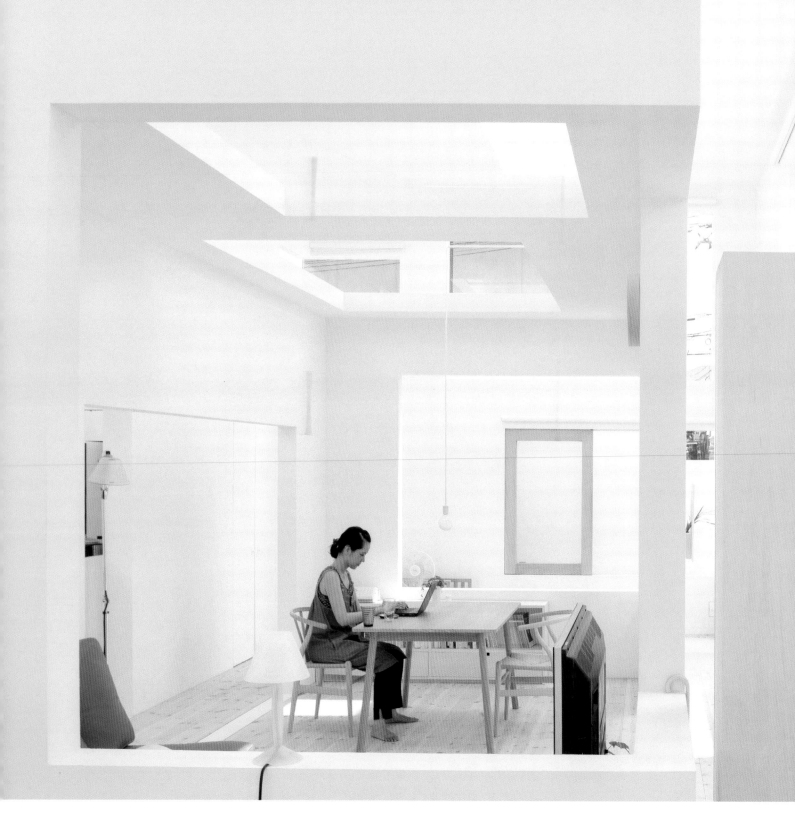

HOUSE N

Architect **Sou Fujimoto**
Location **Oita City, Oita Prefecture**
Completion **2008**

Privacy in Japan is a distinctive thing. A culture that for generations found seclusion behind paper *shoji* screens and today exists in some of the densest urban environments anywhere, has to develop a nuanced relationship between public and private space. Few buildings better reflect this fluid relationship than architect Sou Fujimoto's porous House N.

Located on a quiet residential street in Oita, a small city in the southern island of Kyushu, House N is an intriguing presence, demanding a second look of all passersby.

When Frank Lloyd Wright said he wanted to destroy the box, he might have meant something like House N. The structure is composed of three white boxes of reinforced concrete, nesting one inside the other, each dotted with rectangular openings. The white outer shell covers the entire site, while the second box defines much of the interior space. Yet, the boundaries between inside and outside, house and street, are unclear.

The façade is still and restrained, dotted with openings that are more like picture frames than windows, much like a gallery hung with scenes of greenery and elegant domesticity. Trees seem to grow within the house and form part of the

Above House N stands out on a quiet residential street in Oita, a small city in the southern island of Kyushu.

Left The house is composed of three porous white boxes, nesting one inside the other.

playful openings and closures that hide the inner life of the residence from the street, while letting natural light in and views out.

Sou Fujimoto, a Hokkaido-born architect with a thriving practice in Tokyo, is known for his unconventional approach to planning and space. In House N, he set out to "confuse inside and outside in a positive way." "My intention," he has said, "was to make architecture that is not about space nor about form, but simply about expressing the riches of what are `between' houses and streets."

The project began as the renovation of a thirty-year-old home on a 237-square meter site belonging to a retired couple ready to downsize. Fujimoto came up with the idea of incorporating a louvered wall that would both open and close on to an expanded garden. In the end, the clients decided to rebuild entirely and Fujimoto expanded this original idea into a compact, single-story, multilayered box-within-a-box plan.

The outer box measures 176 square meters and encompasses the "exterior" part of the house, an L-shaped garden, a deck, and a two-car parking area, as well as an enclosed space farthest from the street with the bathroom, toilet, and kitchen. The 59 square-meter middle box encloses the narrow entry foyer, the bedroom, and a *tatami*-floored guest area. Inside this is the smallest 18-square meter box holding the living/dining area.

This distinctive floor plan was worked out using cardboard models, taking into consideration three-dimensional massing as well as the composition of two-dimensional planes. While complicated in terms of structural design because of the separate systems supporting each box at weak spots, such as wall bases, the resulting space is simple and uncluttered.

The tallest box was based on the allowable height limit of 7.3 meters, then 4.3 meters for the middle box, and a more human-scaled 2.7 meters for the smallest box, fitting one volume into the next like Russian dolls. The result is an imaginative and natural division of the floor area into corridors and rooms.

The three shells are cut with forty-four rectangular window openings on walls and ceilings. Only the middle box has sealed openings, with wooden-framed, operable windows. The ratio of enclosure and opening is balanced with each box having three different-sized openings, all golden rectangles, designed to optimize site lines and sunshine. Inside, the space works almost like a loft; the only solid doors are to the toilet and the two street entrances. This is clearly a home for a couple with few secrets.

Fujimoto has stated that his "ideal" architecture is "roofless and garden-like" and he seems close to achieving this ideal in N House.

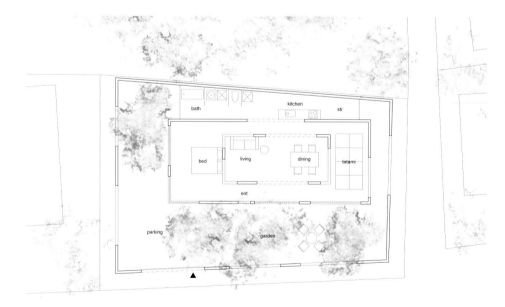

Above The plan shows how each box has varied openings and fits into the other to loosely define spaces.

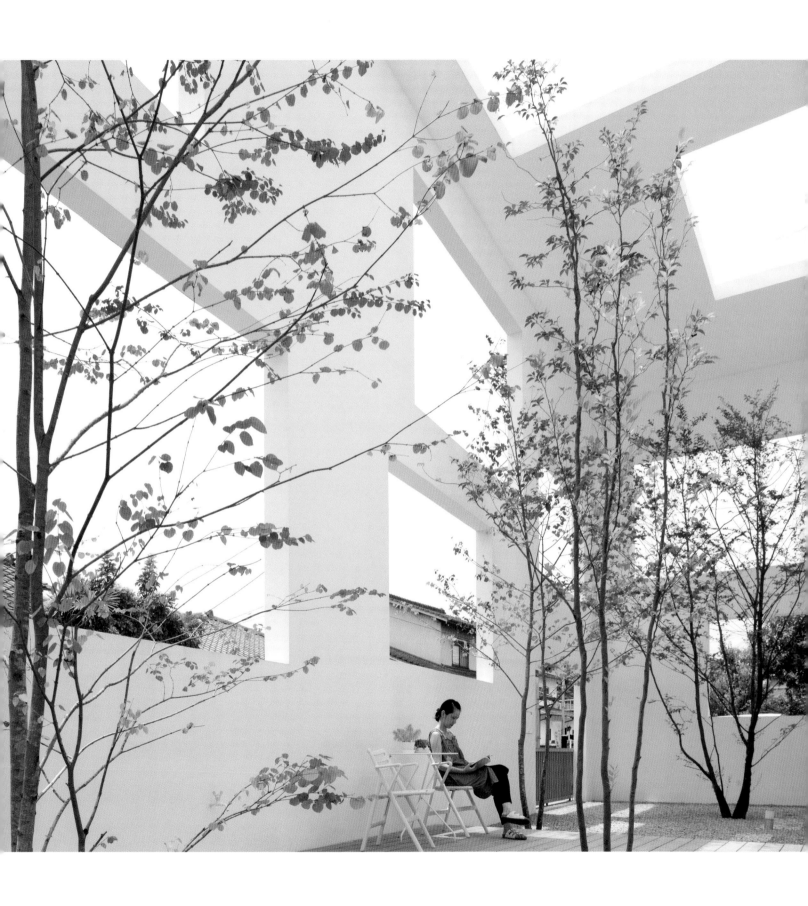

Above The garden space features trees that seem to grow within the house, and playful openings that blur the line between interior and exterior.

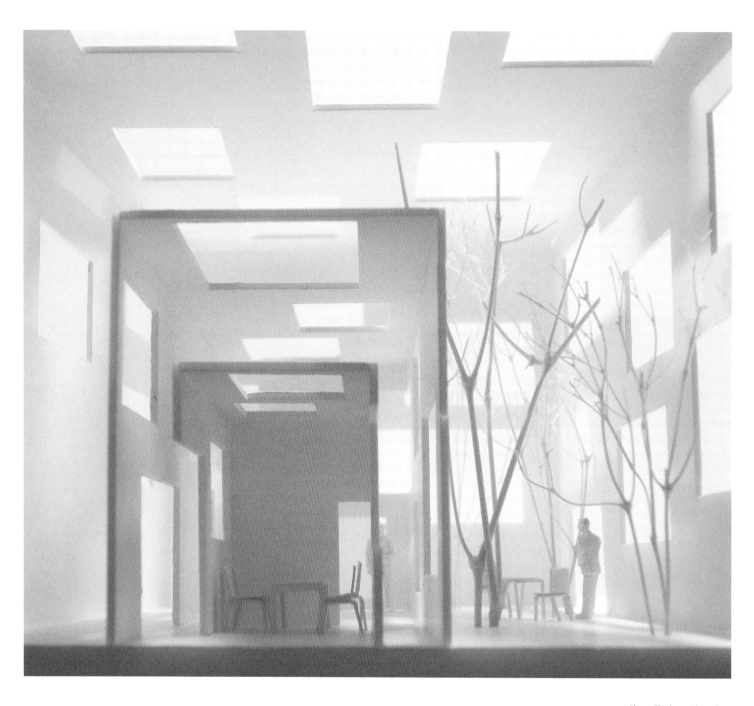

Above The box-within-a-box plan creates multiple layers in this compact, single-story house.

Left The tallest box is built up to the allowable height limit of 7.3 meters, the middle box to 4.3 meters and the smallest box to a more human-scaled 2.7 meters.

Right The distinctive floor plan was mocked up with cardboard models to fine tune the three-dimensional massing and the composition of two-dimensional planes.

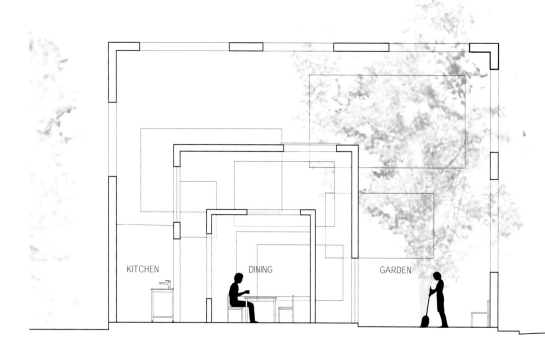

KITCHEN DINING GARDEN

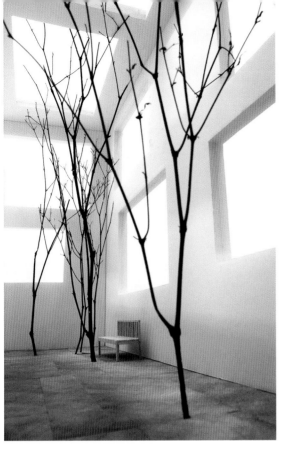

Right The ratio of enclosure and opening is balanced by each box having three different-sized openings, all proportioned to be "golden rectangles."

Left The shells are cut with forty-four rectangular window openings on walls and ceilings, all designed to optimize site lines and sunshine.

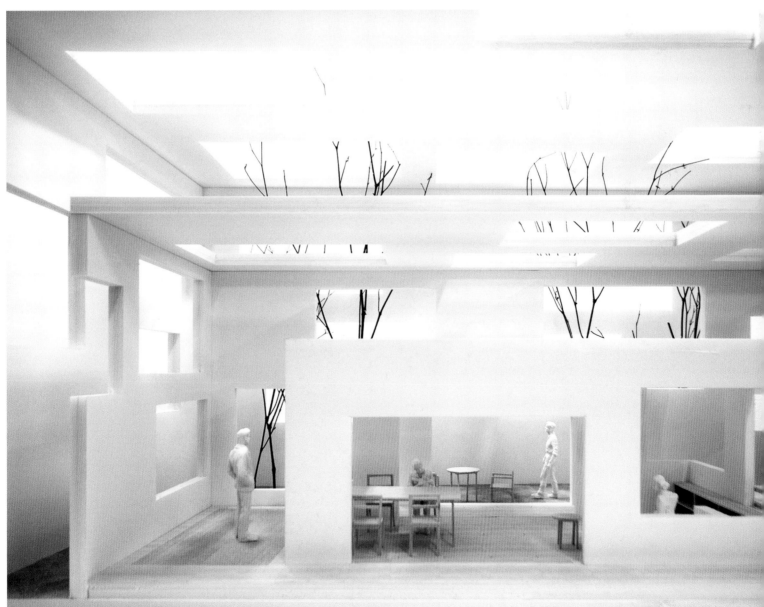

HOUSE C

Architect **Hiroshi Nakamura & NAP Architects**
Location **Chiba Prefecture**
Completion **2008**

According to Hiroshi Nakamura, House C will never truly be finished. Its earth-covered roof will grow, blossom, and wane, altering the house's profile with the seasons and the way the owners tend it. Its materiality will insure that the house will continue to evolve long after construction has stopped.

NAP Architects is a young firm that has already gained a reputation for versatility and an openness to new materials and forms. Architect Kengo Kuma, an admirer of their work, has said that Nakamura "falls in love" with materials, and this inspires his whole architectural process. Whether working in wood, steel, or—as in House C—earth, Nakamura delves intensively into the nature of materials, which in turn imbues his work with a freshness, creativity, and sincerity.

House C is a small family home, picturesquely set on a grassy plain between rolling hills and the ocean in Chiba prefecture. From the entrance, it looks a bit like a rectangular earthen arch leading to the sea. Its 102.71 square meters of living space are laid out within an extended rectangle, with the largest portion occupied by an open living/dining/kitchen area. This area opens to the hills on one side and to the sea on the other via floor-to-ceiling sliding glass walls. The wooden floor

Above The 102.71-square meter living space is laid out within an extended rectangle, with the largest portion occupied by an open living/dining/kitchen area.

Right House C underscores the recent trend in Japan to connect the contemporary with traditional materials and sustainable technologies.

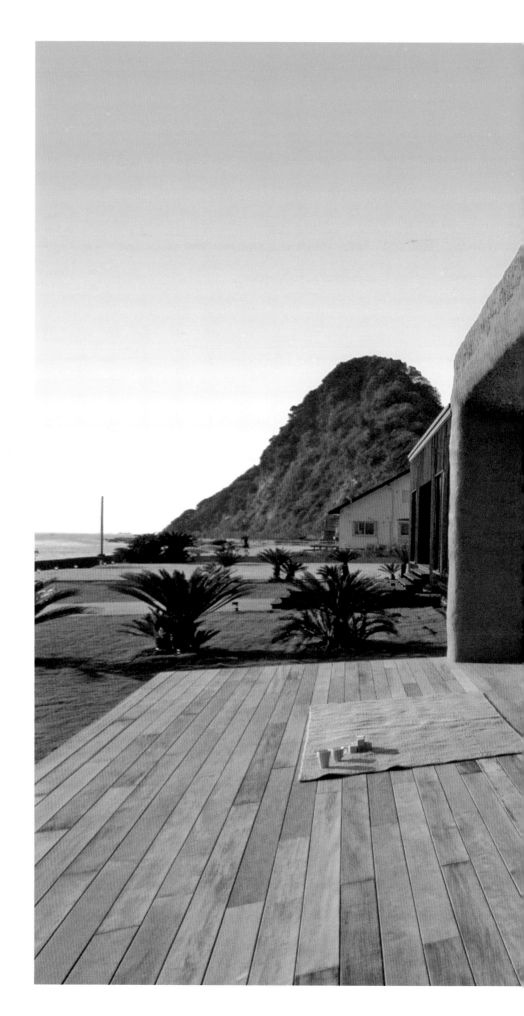

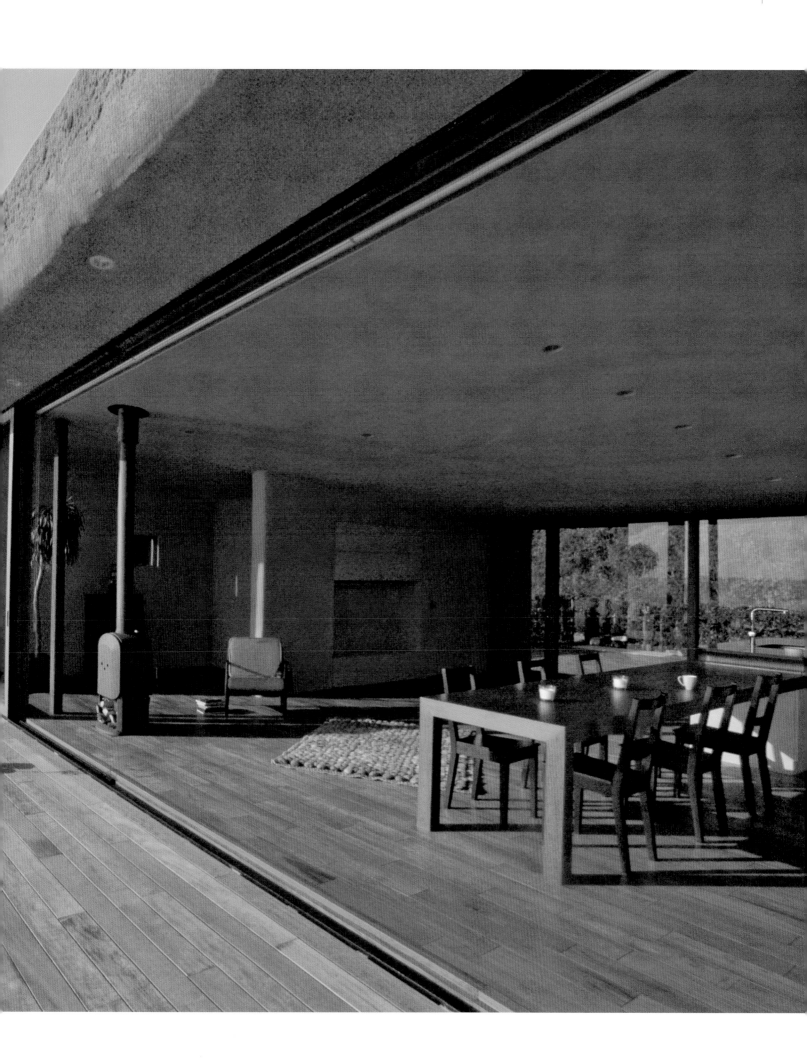

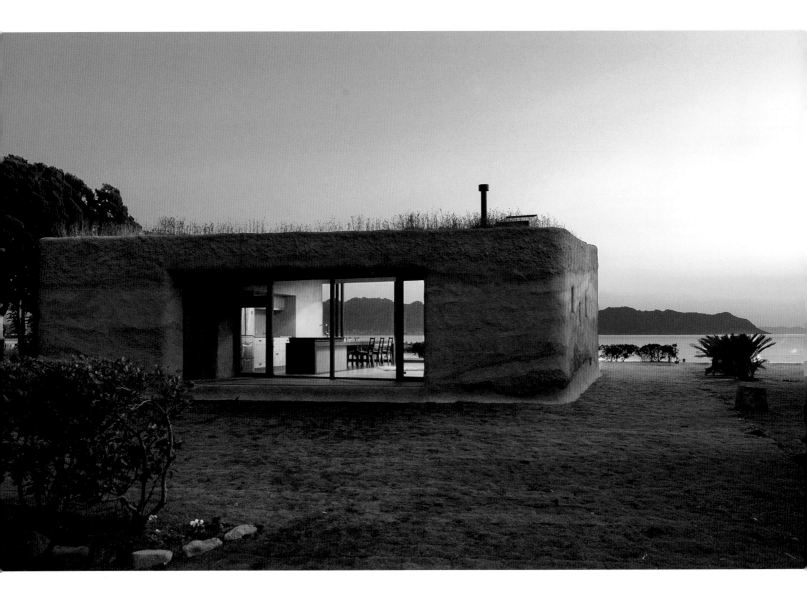

Above The house opens to the hills on one side and to the sea on the other, via floor-to-ceiling sliding glass walls.

Below Soil from the site was used for the exterior walls, where a mix of soil, mortar, cement, and resin was applied as a protective finish against salt damage.

Above The earth-covered roof is designed to grow, blossom, and wane, ever changing with the seasons.

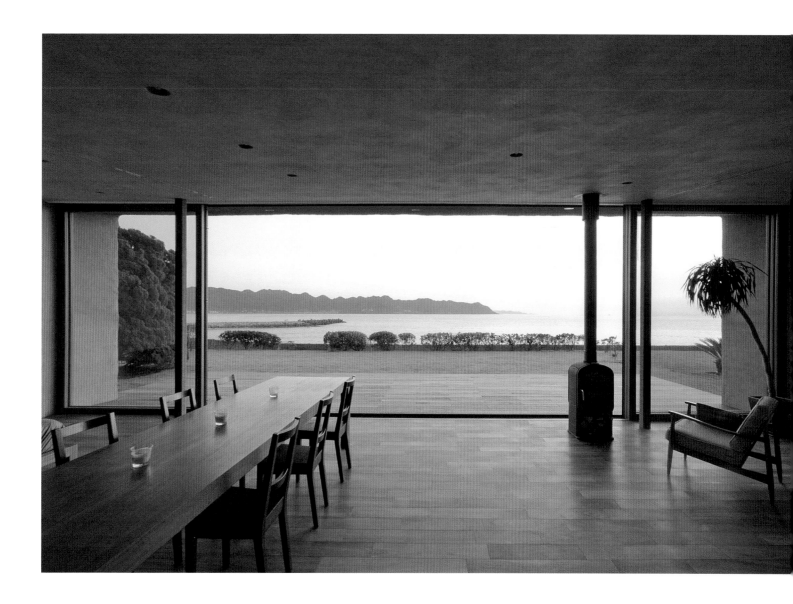

continues from the living area out to the patio, extending the living space towards the sea. A semi-enclosed bedroom also opens to the sea, while the bathroom, toilet, and small storage space are the only closed spaces in the home. The all-white bathroom has a deep skylight, whose ochre side walls echo the color of the earth on the site and the roof.

Nakamura's goal was "to build a house which has a seamless connection between the landscape and the architecture." He achieved this by creating a large room that would enjoy the views and breeze from the sea but would still provide privacy from houses close by on either side. Concepts of privacy within the home are more flexible in Japan because of their small size, and

a long tradition of spaces rendered flexible with the use of wood, paper, and removable sliding doors. This allows the interior spaces of this house to flow into each other.

Wanting to "work with the soil of the garden," Nakamura used earth dug from the site to finish the roof, which he then planted with wild grass. Soil from the site was also used for the exterior walls, where a mix of soil, mortar, cement, and resin was applied as a protective finish against salt damage. Soil also acts as natural insulation, and reduced the cost of exterior sheeting, transport, and even labor, as the clients themselves pitched in digging up the ground and finishing the mud walls. Both economic and environmentally smart, this natural coating is also beautiful

and personalized, giving the house a charmingly earthy profile.

Nakamura calls this house a sort of "gardening architecture," which is a result of interaction among the architect, client, and nature. But in the end, says Nakamura, it is nature that decides the house's ever-changing form, with breezes, birds, and insects that can bring new life to the living roof. In this thinking, House C recalls the concept in traditional Sukiya-style architecture, where the result was a joint venture between the designer, the owner, nature, and time. House C also underscores the recent trend in Japan to rediscover traditional materials and sustainable technologies, and combine them with thoroughly contemporary ideas.

Above The wooden floor continues from the living area out to the patio, extending the living space towards the sea.

Right The house provides continuity with the site through its plan and earth-finished roof, creating an individual profile that is both environmentally friendly and beautiful.

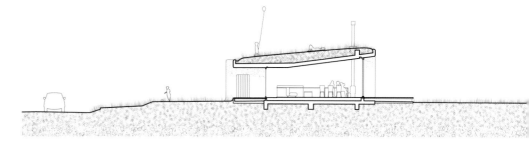

M HOUSE

Architect **architecture w**
Location **Nagoya**
Completion **2005**

Above left The simple cube-like volume of the house contains four highly varied levels.

Below left The rectangular cube of the second level is cantilevered out to create exterior space for an entrance at the lower level.

Below right M house is located on a steep slope in a dense residential neighborhood in Nagoya, the third largest city in Japan.

M house is located on a steep slope in a residential neighborhood in Nagoya, the third largest city in Japan and a major industrial and port center. It was built as a private home for one of the firm's principals, Michel Weenick, who designed the building along with his partner, Brian White. Both American-born and educated architects have worked in Japan for several years, and with M house they faced some typical Japanese architectural issues—how to incorporate views, air, and light into a house on an awkward site in a crowded neighborhood.

The building plot is located at the end of a 2.5-meter-wide dead-end street, which offers panoramic views but also dips down seven meters. On this precipitous site, the architects set out to create a contemporary home for Weenick and his multigenerational and multinational family. Their solution was a four-level structure comprising a half-basement, entry level, second floor, and roof deck. To anchor the house into the site, a hybrid structural system of reinforced concrete,

concrete-encased steel and two three-meter-tall steel trusses was employed. This permitted long sliding glass doors to be used in the north and south walls, thus opening the house up.

The entrance level is designed to be both space-efficient and visually pleasing. A parking area is carved out beneath the cantilevered rectangular cube that comprises the second floor. A shallow decorative pool is located just before the entrance. Finished in silvery gray exposed concrete and galvanized metal cladding, the area has a shimmering quality.

The materials used in the interior, such as exposed concrete floors and walls, white laminate cabinetry, and stone countertops, are deliberately simple and functional. Inside the doorway, the entry-level floor includes two bedroom spaces with scenic views, and a bathroom complete with a well-loved luxury in Japan—a cedar tub—which in this case can be seen through the glass wall next to the pool. The second floor is configured as an open space featuring living, dining, and kitchen

areas. Sliding glass doors open the space to the north and south. A guest room is located in the southwest corner. Locating the living, dining, and kitchen areas on the second floor is not uncommon in Japan, as that is often the only way to get a good view for these spaces.

A redwood roof deck on the top level creates a place for outdoor entertaining and relaxing. A skylight and an open stairwell painted a cheerful yellow help to link the three levels and provide another source of natural light. On the lowest level, an additional retaining wall is used to create space for a small apartment with bathroom and kitchen facilities and sliding doors opening on to a small Japanese rock garden. This independent suite is connected to the upper house by an exterior staircase, thus providing a private but connected living space for ageing parents. Such arrangements are common in Japan for parents who need caring for but also value their privacy. Set in a traditional neighborhood, the house respects traditional values with contemporary flair.

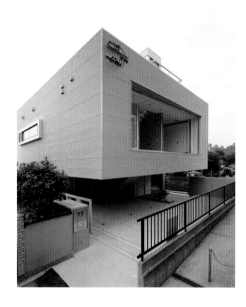

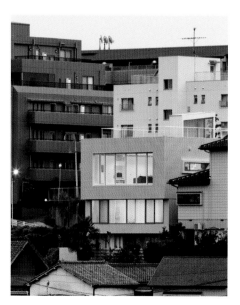

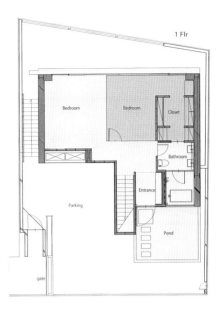

1 Flr

Left The entrance area includes parking and a door-way reached via stepping stones through a shallow decorative pool.

Above The entrance leads into a level featuring bedrooms and a Japanese-style bathroom.

Below The second floor is an open living/dining/kitchen space with views towards both north and south.

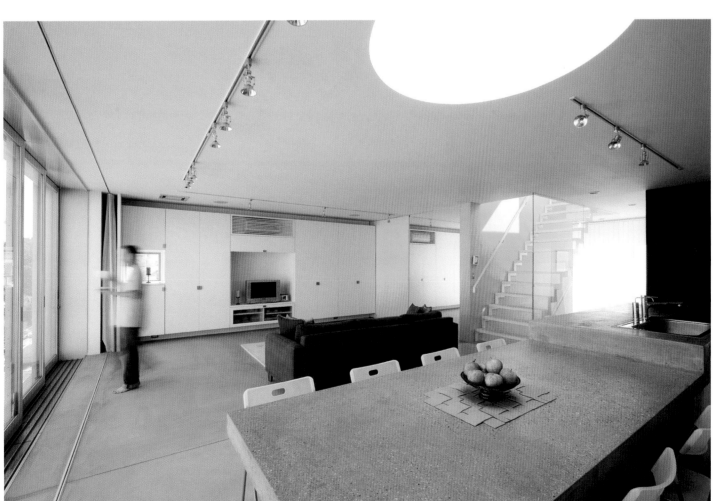

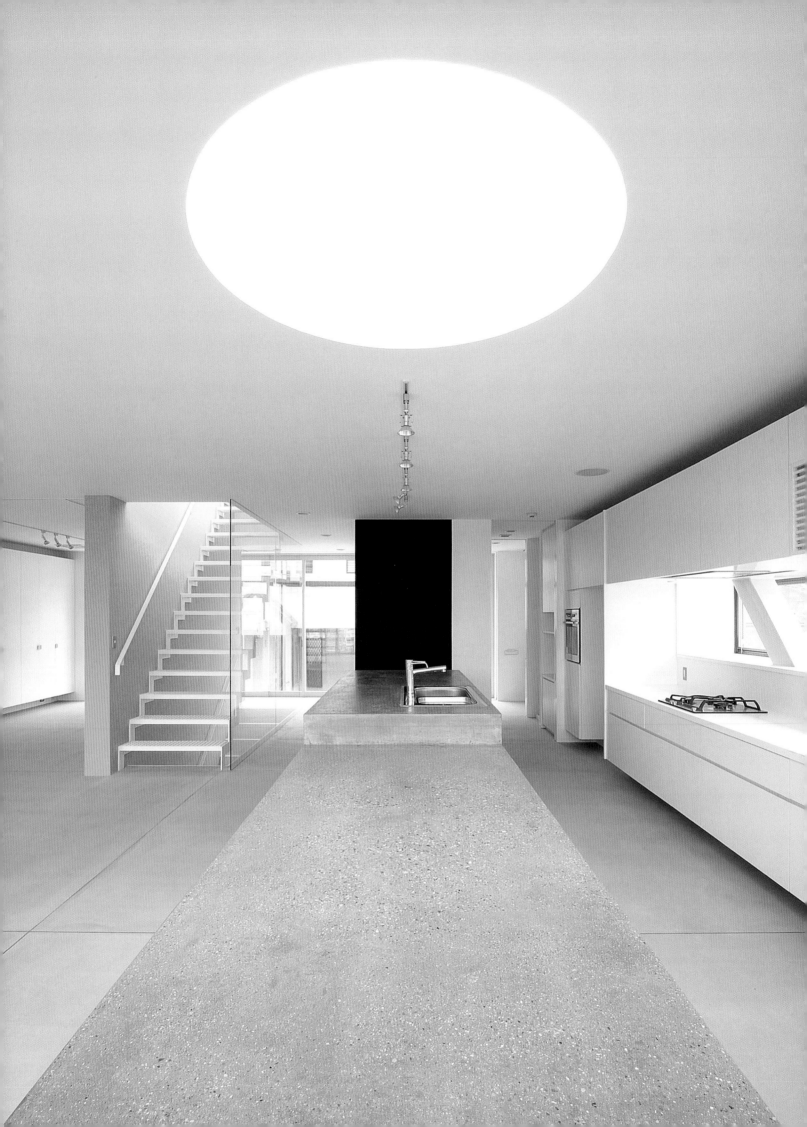

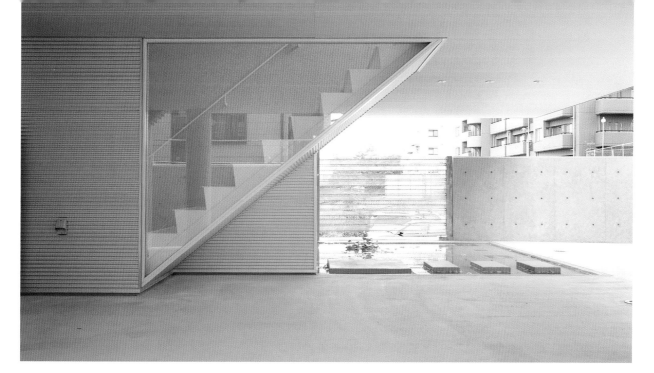

Left A skylight and an open stairwell painted a cheerful yellow help to link the three levels and provide another source of natural light.

Above Finished in silvery gray exposed concrete and galvanized metal cladding, the entrance has a shimmering quality.

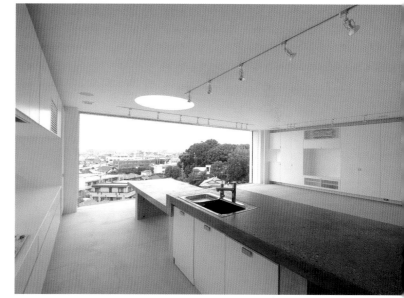

Below The half-basement level has a small apartment that opens on to a Japanese rock garden.

Right The materials used in the interior—exposed concrete floors, white laminate cabinetry, and stone countertops—are deliberately simple and functional.

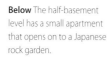

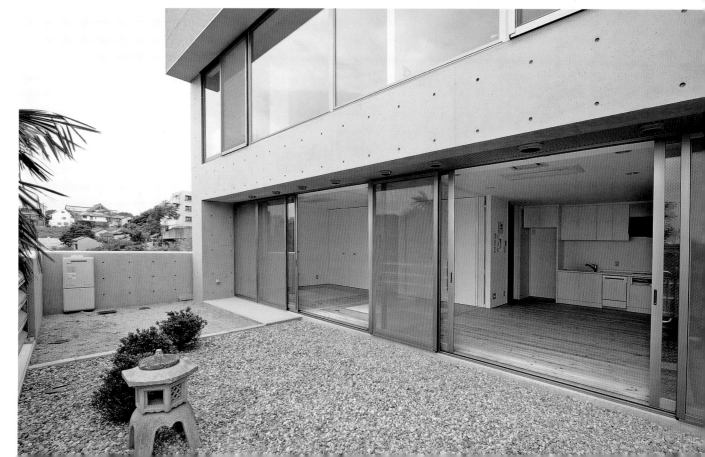

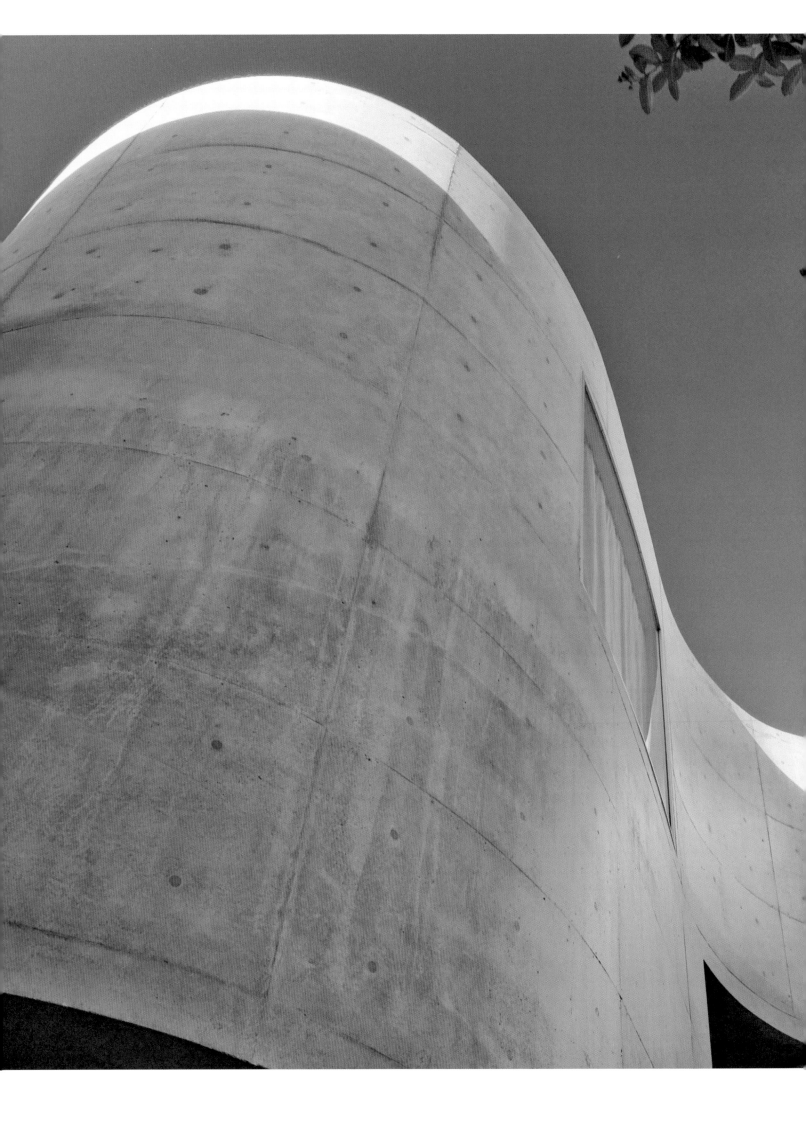

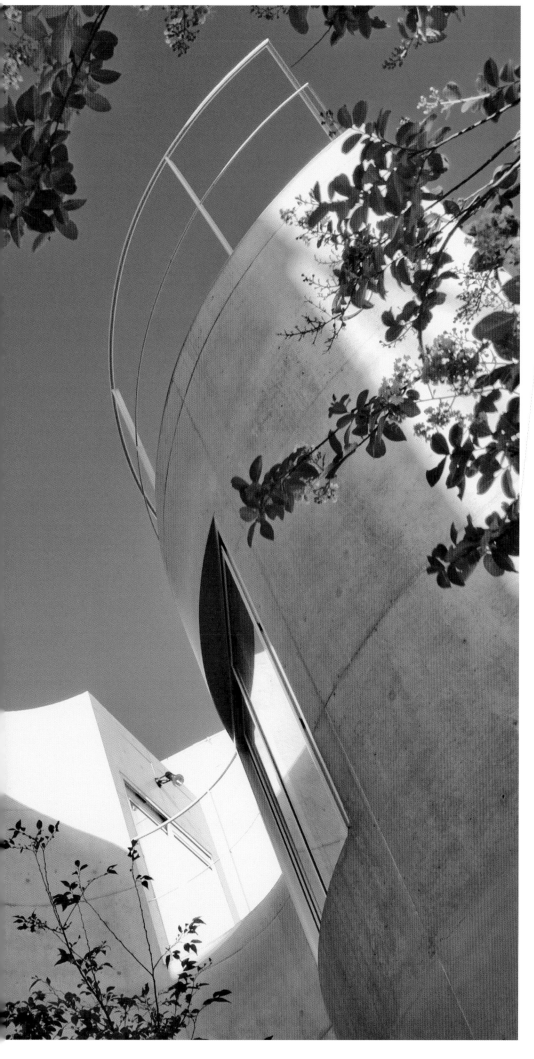

OKURAYAMA APARTMENTS

Architect **Kazuyo Sejima and Associates**
Location **Yokohama, Kanagawa Prefecture**
Completion **2008**

A curvilinear concrete building is a big surprise coming from Kazuyo Sejima, who has become known around the world for her pure geometric white and translucent quadrate forms in which all details are meticulously hidden, producing a sort of iPod aesthetic heavily dependent upon new materials and technology.

The Okurayama Apartments are set in a dense residential area in the historic city of Yokohama, today a suburb of Tokyo. In Japan's crowded cities, apartment blocks usually occupy every inch of space, with only the 50 centimeter setback required, often leaving no space for greenery or places where residents can interact. With this project, the aim was to bring a level of community back into apartment architecture, using form to facilitate a higher quality of life, rather than a higher quantity of real estate space. Explained Sejima: "These are apartments where people can feel more open toward the outside, and where there is at least some kind of communication between the residents." The unique forms of the building itself and each individual apartment have, no doubt, begun a conversation or two between resident and passersby.

Above Four curved lines carve out a series of sinuous inner courtyards within the rectangular plan.

Left The curves of the crisp gray concrete walls create plays of light and shadow.

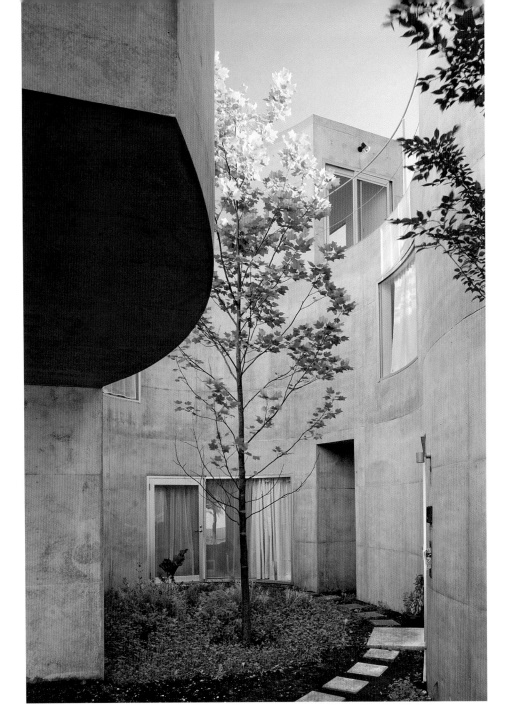

Above The plan creates tiny continuous gardens and passageways outside, and distinctively shaped apartments within.

Below With little room to spare in a dense residential location, Sejima nevertheless finds spaces for greenery.

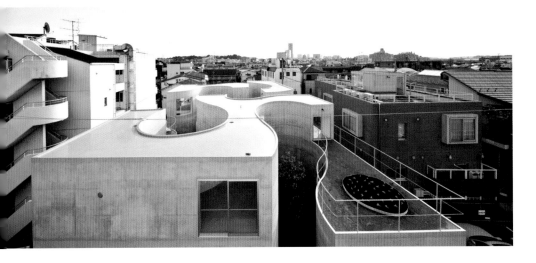

The three-story steel-reinforced concrete volume sits on a 458 square meter site. The building occupies a footprint of 207 square meters and creates a total of 553 square meters of floor space with nine units, each about 50 square meters, an average size for small apartments in Tokyo. Four curved lines carve out a series of sinuous inner courtyards within the rectangular plan, creating tiny continuous gardens and passageways outside, and distinctively shaped apartments within. "Architects may think about how to have a good relation with the surroundings, but just in terms of one building volume. I wanted to bring character to each of the individual apartments," explained Sejima.

This unusual spatial landscape was worked out in Sejima's offices with numerous simple, 1:100 scale diagrams and Styrofoam models before using computers, as is usual for this architect. Discussions centered on searching for a balance between privacy and community. Sejima is perhaps best known as part of the Pritzker Prize-winning duo with Ryue Nishizawa, SANAA. However, she also works independently as Kazuyo Sejima & Associates, as for this project, which she describes as her "most complex shape so far." Okurayama Apartments can also be seen as a counterpoint to Ryue Nishizawa's Moriyama Apartments, a collection of different-sized white cubes scattered around the site with an intent to create interaction.

The curved walls result in plays of light and shadow, while large curved window openings create places where, says the architect, "interiors and exteriors intermingle comfortably and continuously." Each apartment has a unique layout, some on one level, others on two, but all with access to a garden or terrace. The apartments are not divided into rooms, but to facilitate furnishing them, each space has two straight walls. Windows offer a variety of views: garden, sky, curved wall, or the surrounding neighborhood. The goal, according to Sejima, was "to design enjoyable and comfortable living spaces where different spaces can espouse different lifestyles by spreading gardens, bathrooms, bedrooms, and living rooms all over the site three-dimensionally."

Sejima approaches material as a means to an end and as a way to create spatial and aesthetic effects. In the case of Okurayama Apartments, the material is gray concrete and the effect is an organic form like none she has produced before. Explained Sejima: "We conceived of the building as bright, layered housing units with an enjoyable garden." Though these courtyard gardens would be considered far too small to qualify as such anywhere else, they are characteristically Japanese in their innovative use of minute spaces.

Below left Open outdoor spaces aim to create places for neighborly meetings.

Below center Windows offer a variety of views: garden, sky, curved wall, or the surrounding neighborhood.

Below right The three-story volume has a footprint of 207 square meters and contains nine units.

Right Each apartment has a unique layout, some on one level, others on two, but all with access to a garden or terrace.

Bottom The unusual spatial landscape was first worked out with numerous 1:100-scale diagrams and Styrofoam models before it was completed on computers.

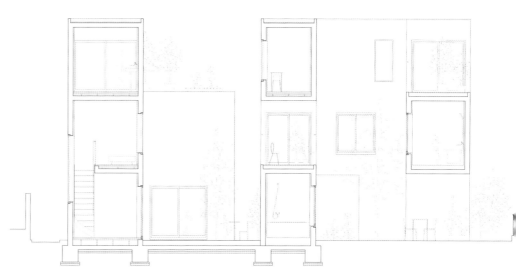

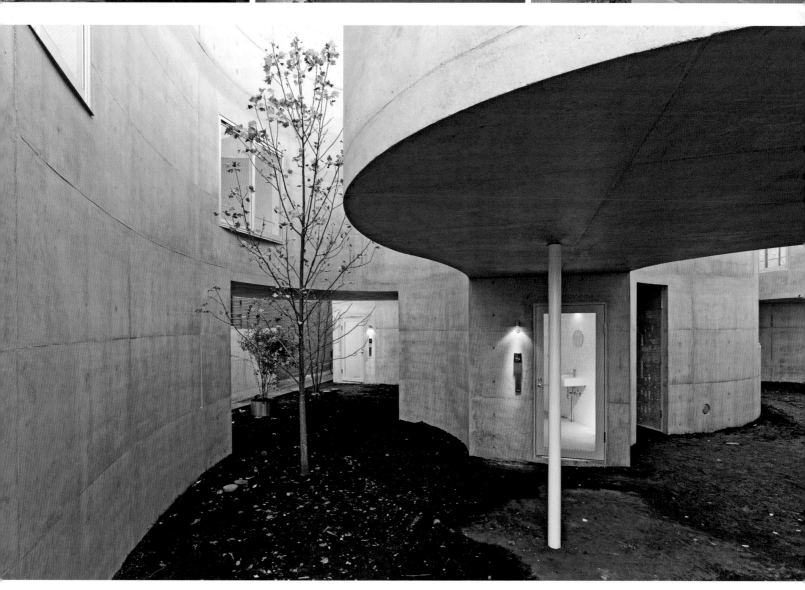

A-RING—ALUMINUM RING HOUSE 3

Architect **Atelier Tekuto**
Location **Kanazawa Prefecture**
Completion **2009**

A low priority during the rush for modernization in the second half of twentieth-century Japan, environmental sensitivity and sustainability were innate to traditional Japanese architecture, and are once again becoming important in the work of a new generation of Japanese architects. A-Ring—Aluminum House 3 is a third in a series of experiments by Atelier Tekuto, with aluminum creating sustainable, energy-efficient housing.

The project was developed by Atelier Tekuto's principal, Yasuhiro Yamashita, in conjunction with Miyashita Laboratory of Kanazawa Institute of Technology. Yamashita's aim was to create a house with "zero operating costs," and to explore aluminum's possibilities as both structure and radiator. His challenges were to use natural energy as much as possible and reduce the cost and environmental impact of heating and cooling with aluminum and geothermal energy.

Aluminum is a fairly new material for Japanese construction, with regulations altered only in 2002 to permit its use in residential buildings. As Japan's *tatekae* (scrap and rebuild) patterns of construction are very wasteful, Atelier Tekuto chose aluminum for its recycling possibilities. According to Yamashita, "Although the manufacture of aluminum requires enormous amounts of electricity, ... the quality of the metal stays stable and it is perfect for practicing the 3R's: Reduce, Reuse, Recycle." Aluminum is also

Above The prefabricated house has an aluminum structure, with a deck plate that includes columns, walls, beams, and slabs as one mold.

Right A-Ring is a third in a series of experiments by Atelier Tekuto using aluminum to create sustainable, energy-efficient housing.

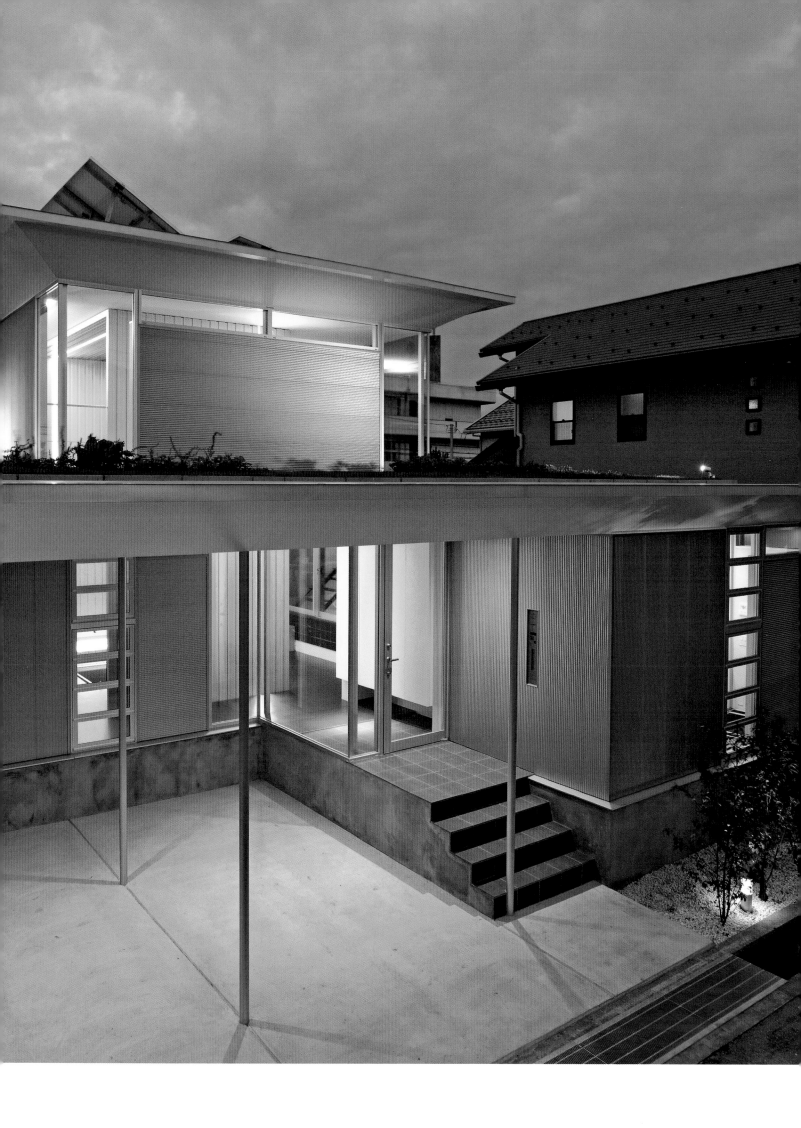

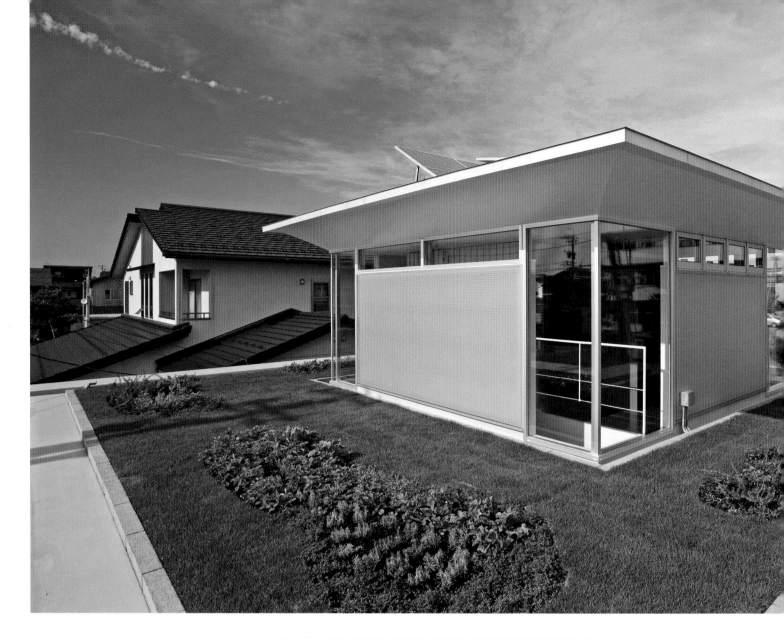

lightweight, ductile, and easy to form. Importantly, its thermal conductivity, radiation, and reflectance can help generate warmth and maintain a steady temperature.

A-Ring is their first building to employ aluminum "rings," which are actually square aluminum frames joined together to form floors, walls, and ceilings for almost the entire structure, with the exception of a concrete basement. In the two earlier projects, designed in 2008 and early 2009, the rings were used in conjunction with a wooden structure, but in A-Ring the aluminum structure features a deck plate that includes columns, walls, beams, and slabs as one mold. According to Yamashita, "the joints are fairly easy to assemble for most carpenters and engineering builders."

The prefabricated house was built for a member of the Aluminum-Ring House Project team and consists of two upper levels and a basement. The ground floor contains living, dining, and kitchen spaces as well as a semitransparent bathroom area formed by a ring of aluminum and sliding glass doors. The kitchen area is also defined by an aluminum ring, as is the bedroom, located on the partial upper floor that opens on to a roof garden.

The whole building is designed to work in conjunction with the environment. The aluminum

structural system acts as a radiator cooling/heating system as well as a conduit for electricity and plumbing, with pipes and wires running inside the hollowed-out aluminum molds and LED lights incorporated into the structure. Outside, a garden fence composed of hanging plants, called the "Green Curtain," forms part of a system that circulates rainwater pumped through pipes in order to heat or cool the home.

Solar panels placed on the upper roof are used

to generate energy for the house, while the rooftop garden acts as attractive natural insulation. Deep projecting eaves on both the ground and upper levels provide shade, while windows are placed with the seasons in mind, maximizing light and warmth in winter and reducing them in summer.

The architects plan to monitor carbon dioxide emissions, power consumption, and the general functioning of A-Ring—Aluminum Ring House and use this data for future projects.

Above Solar panels on the roof generate energy for the house, while the roof garden acts as attractive natural insulation.

Left The hollowed-out aluminum molds also act as a conduit for electricity and plumbing, with pipes and wires running inside, and LED lights incorporated into the structure.

Right The compact three-level plan includes parking, a basement, and a rooftop garden.

Right center The ground floor includes a semitransparent bathroom formed by a ring of aluminum and sliding glass doors.

Bottom The living, dining, kitchen, and even bathing areas are loosely divided by the aluminum rings.

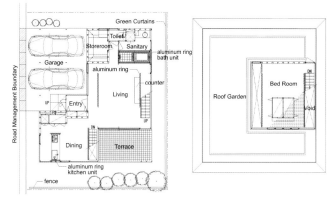

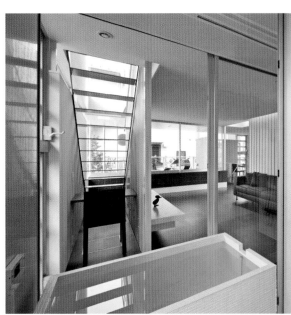

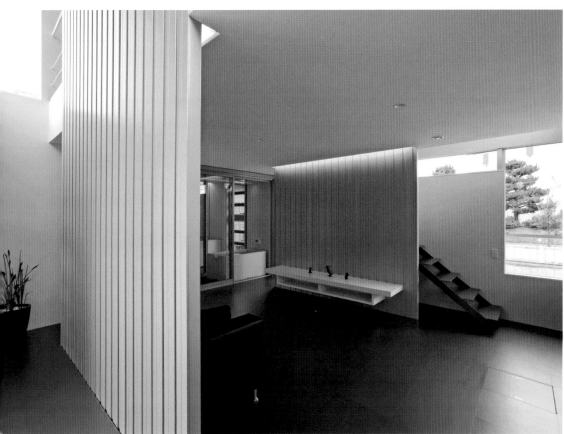

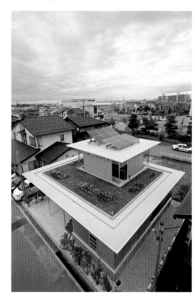

Above Deep projecting eaves provide shade while windows are placed for maximizing light and warmth in winter, and cooling in summer.

C-1 (CURIOSITY 1) HOUSE

Architects **Curiosity & Milligram Architectural Studio**
Location **Tokyo**
Completed **2005**

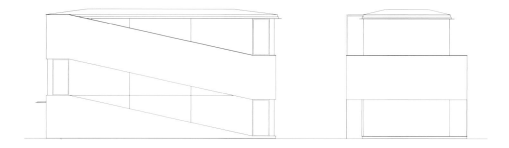

The usual sequence of residential design, proceeding from program to architecture to interior to product design/selection, was compressed into a single act for this house. Curiosity's Gwenaël Nicolas, a French interior and industrial designer who has lived and worked in Japan since 1991, worked in conjunction with Japanese architect Tomoyuki Utsumi of Milligram Architectural Studio, to conceptualize all the elements of the house at the same time. The result is a glass box surrounded by a bold walkway gallery bound with the same design spirit that permeates all things in this house, from the large walls to the light switches.

Unlike many Japanese architects who design buildings to fit the often small or awkward sites, Nicolas designed C-1 before the site was even chosen. Using 3D animation, she imagined the space in cinematic terms, with the inhabitants appearing and exiting as if in a film. Space was to be defined not by floors and walls, but by the movement of people. According to Nicolas, C-1 was "designed like a unique, independent product, a seamless space where architecture and interior furnishings become part of a unique, interconnected emotional experience."

The street presence of the house is a blank, lustrous face: a rectangular box of frosted glass and glossy melamine that glows like a lantern at night. But on its side, the inclined ramp leading up to the entrance creates an unexpected element, incising the house's two stories with a strong diagonal. The super-thin 60 mm-thick floor slabs composed with a 25 mm-steel plate are visible through the glass walls, contributing to the zigzag aesthetics.

Inside, the sloping ramp gallery design assures that there is a higher visual interaction among different levels than in the average house. With echoes of traditional Japanese architecture present in the movable *shoji* screens and *fusuma* doors, views lead from one space to the next, often via uncommon viewpoints and angles.

The glossy smoothness of the textured white melamine-finished exterior is echoed inside. Continuous white surfaces and cleverly placed, muted lighting give the interior an almost otherworldly air, perhaps more expected of a film set or art gallery than a home. The kitchen is designed so as to "not exist." This is achieved by rendering its features and utilities scaleless, using seamless surfaces and a uniform color palette so that the fittings are not visually significant. For example, the tap is a simple metal line of the same color as its surroundings and thus "disappears." Furniture throughout is minimal and designed with a geometric sparseness that echoes the simplicity of the traditional Japanese home, albeit in a highly contemporary fashion.

As architects' clients have known ever since Le Corbusier built his leaky Villa Savoye and Phillip Johnson built his privacy-lite glass house, it is not easy to live in a work of art. Curiosity's beautiful glowing glass box would appear to offer its inhabitants both the chance and the challenge to appear, daily, in a film of their own making.

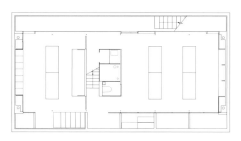

Top The elevation reveals a box wrapped by a slanted walkway gallery.

Above The simple rectangular plan is defined by the walkways that connect interior spaces.

Right Thick 60-mm floor slabs composed with a 25-mm steel plate are visible through the glass walls, contributing to the zigzag aesthetics.

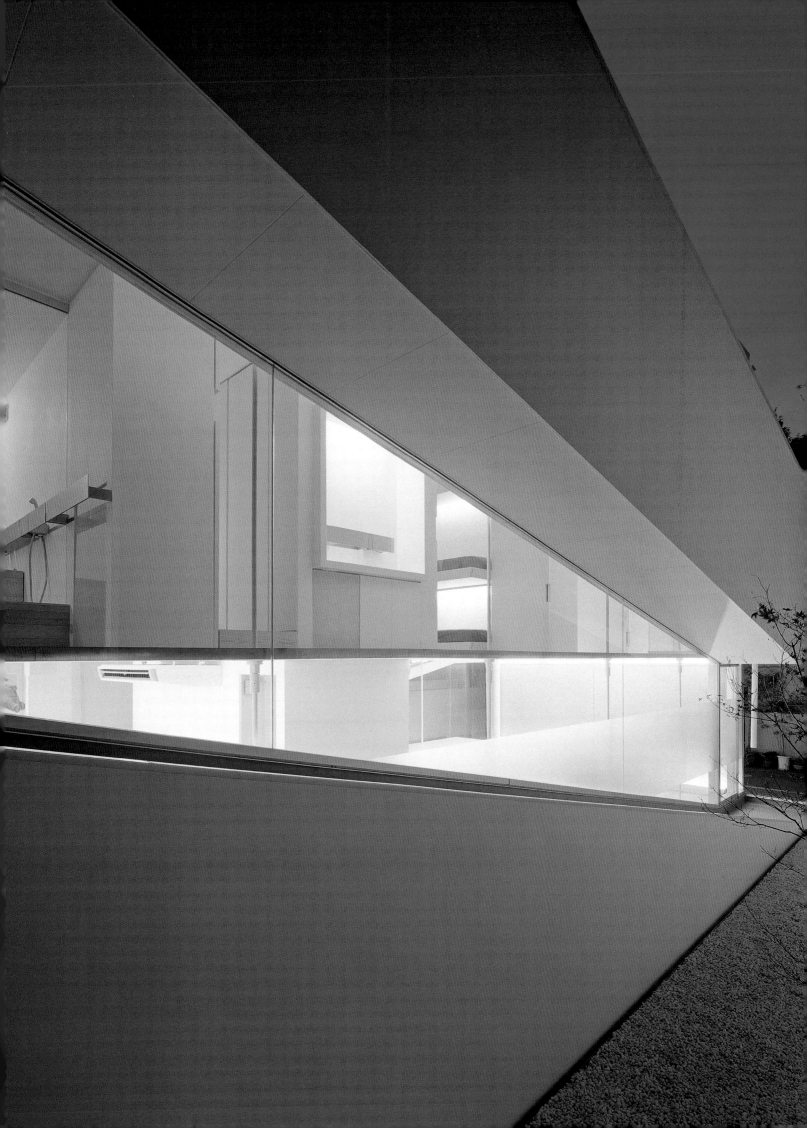

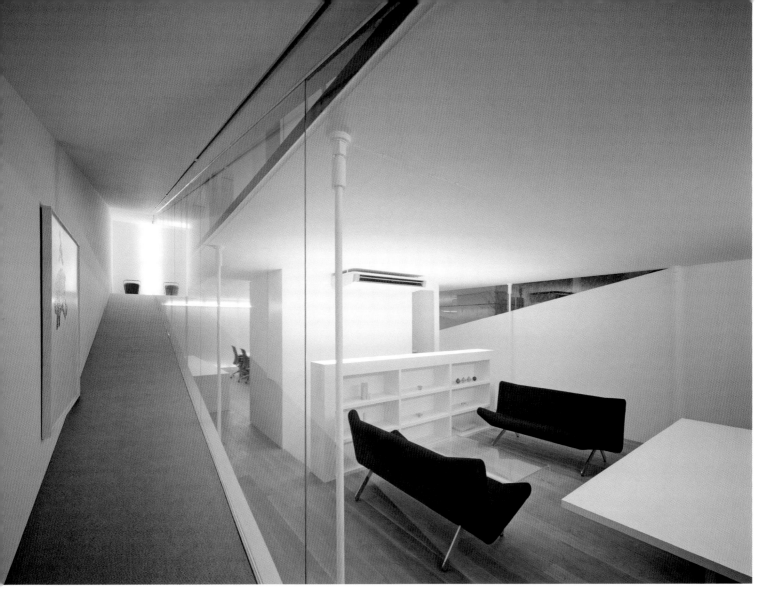

Above Inside, the sloping ramp gallery design facilitates a higher level of visual interaction among different levels than in the average house.

Right The space was conceived in cinematic terms, with the inhabitants appearing and exiting as if in a film.

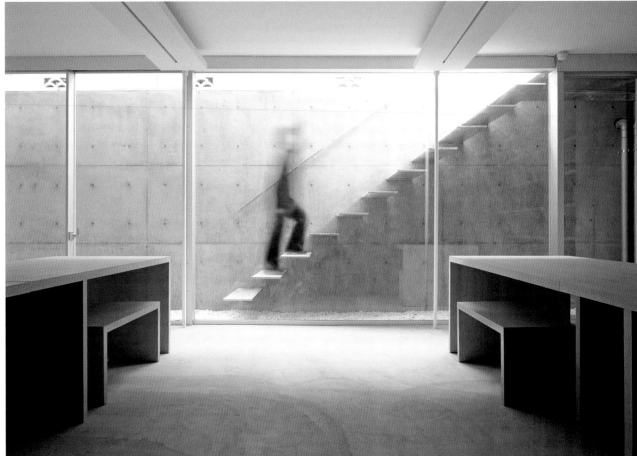

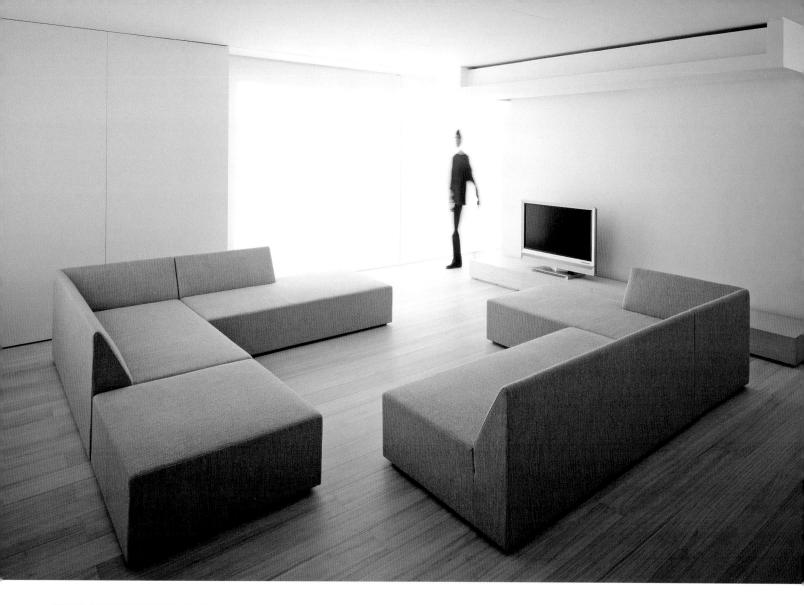

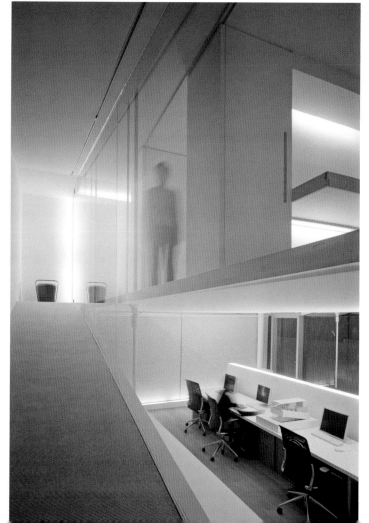

Left Views lead from one space to the next often via uncommon viewpoints and angles.

Below The kitchen is designed so as to "not exist," using seamless surfaces and a uniform color palette so that fittings are rendered visually insignificant.

Above Furniture is minimal and designed with geometric sparseness and a neutral color palette.

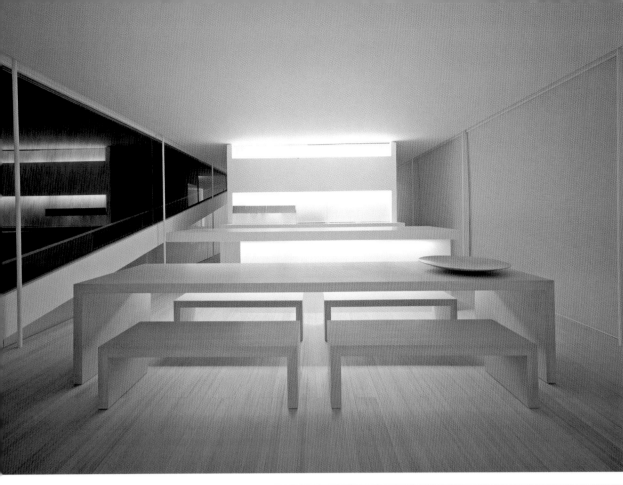

Right The inclined ramp leading from the entrance incises the house's two stories with a strong diagonal.

Far right A small glowing box-like bathroom contains a Japanese cedar tub.

Above The pure lines of the dining area offer a contemporary nod to the simplicity of the traditional Japanese home.

Right Frosted glass and glossy melamine add a film noir quality to vistas.

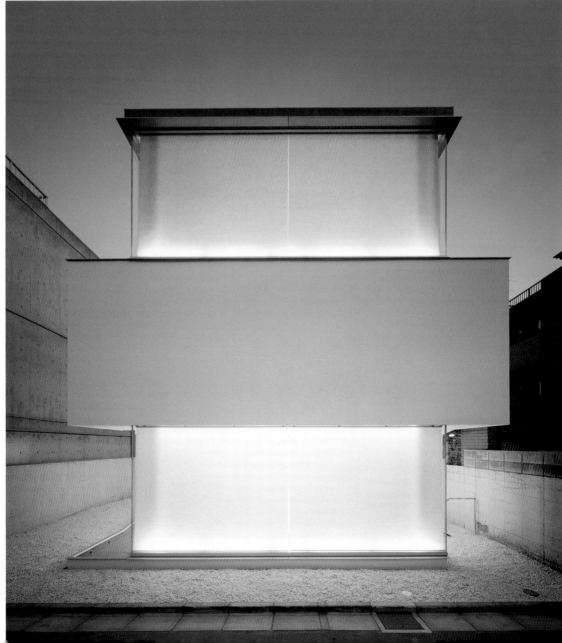

Below The street presence of the house is a blank, lustrous façade that glows like a lantern at night.

JARDIN

Architect **APOLLO Architects & Associates**
Location **Kodaira City, Tokyo**
Completion **2008**

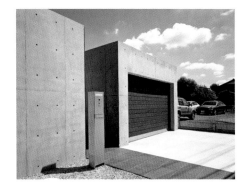

Top The elevation shows the simplicity of a one-level volume, with a small garden area before it.

Above The house presents a minimal façade to the street: a horizontal rectangle of pale gray concrete, with a wide garage door and an entryway.

Below With minimal openings on exterior walls, the interior is opened to natural light and greenery by a glass courtyard.

Satoshi Kurosaki, founder and principal of APOLLO Architects, excels in designing clever, space-efficient houses on remarkably small plots, known in Japan as *kyoshu-jutaku* or micro-homes. This is an ever-growing market segment in Japan where land prices are astronomical, inheritance taxes even more so, and zoning laws severely limit what can be built. While some of these houses may seem unlivably small to someone from abroad, it is equally true that the average American home would seem extremely wasteful to most Japanese.

For Jardin, a home for a couple in their thirties in the suburbs of Tokyo, the client and architect made several interesting choices with regards to space. Instead of using much of the 330 square meter site, the house has a footprint of only 113 square meters. A two-car garage, a rare use of interior space in Tokyo, takes up part of this. While most other people would have built up or under to expand the floor space, the living area here is all on one floor. The front of the house also has a

small gravel garden, another luxury not often seen in such small houses. Yet, in this small home, all of the client's needs are provided for.

The client is a busy professional couple—he an engineer, she the editor of a cooking website. All they asked for was a home where they could relax and recharge: "If possible we would like a cat's lifestyle, just lounging around." Their only other requests were a wood stove and a professional caliber kitchen.

The house presents a minimal façade to the street: a horizontal rectangle of pale gray concrete, with a wide garage door and an entryway. As is popular in Japan, neat formwork marks have been expressed in the exposed concrete. A dark gray slate path through white gravel adds further texture and leads to the main entry, a porous gate of horizontal slats.

The path continues past the gate along an open-air corridor to the house's glass entryway, and beyond into the house's inner courtyard. Surrounded by glass walls, the courtyard brings

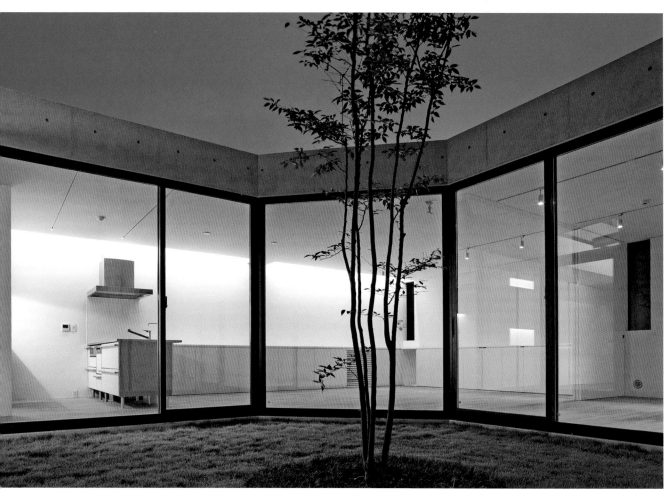

green space into the house. The living/dining/kitchen area opens to the courtyard, as does the master bedroom. A guest room and a bathroom complete the space.

The house looks inward, with only a few narrow windows on the peripheral walls, a common method for creating private space in crowded Tokyo. However, simple floating stairs on the concrete back wall of the courtyard lead up to the roof, which can be used as a terrace in fine weather, giving the residents a choice of complete privacy or a neighborhood view when relaxing out of doors.

With Kurosaki's usual restraint, this contemporary, stylish house is not so much about cost or fashion, but about functional designs created with an eye to environment and the inhabitants' wishes. Said Kurosaki: "One can achieve richness and abundance within a simple design, and boldness and daring in something delicate and fine ... this is not driven by time-based fashion ... but by knowledge and spirituality."

Right A dark gray slate path leads along an open corridor to the main glass entry.

Right center Floating stairs on the concrete back wall of the courtyard lead up to the roof, which can be used as a terrace in fine weather.

Right bottom Though the site offered a space of 330 square meters, the house has a footprint of only 113 square meters.

Below The interior décor of clean lines and minimal detail is designed with refreshing restraint.

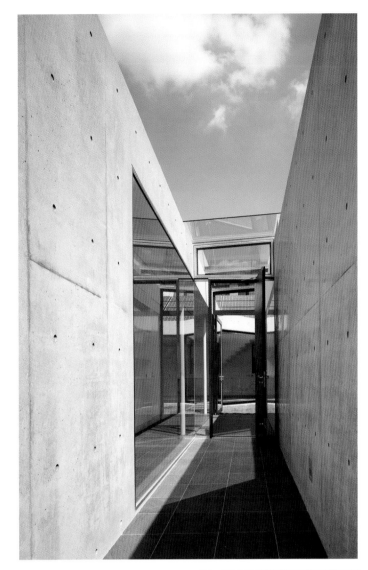

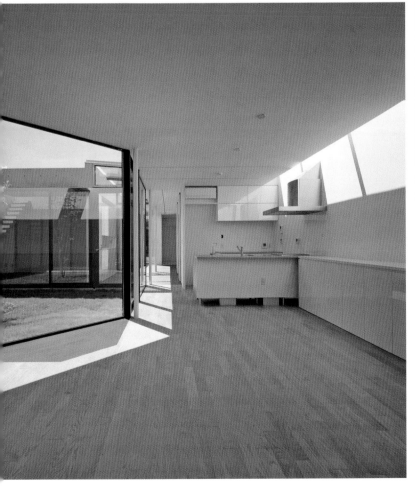

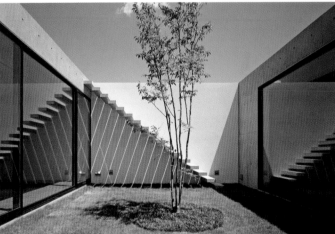

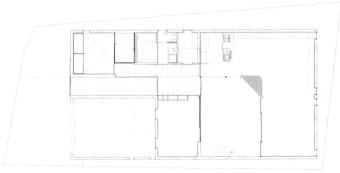

NATURAL CUBES

Architect **EDH—Endoh House Design**
Location **Kawasaki-shi, Kanagawa**
Completion **2008**

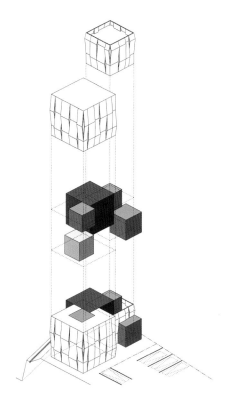

Endoh House Design has made a name for creating distinctive structures within the often-undifferentiated residential landscape of Tokyo. Houses designed by Endoh include Natural Patches, Natural Ellipse, Natural Wedge, Natural Strip, Natural Flex, and Natural Stick. Each one of them playfully manipulates one or more elements to create a living environment that is fun and thought-provoking. In the case of Natural Cubes, it is the color orange and the intersecting cubic spaces that make the design distinctive.

Set in a Tokyo suburb filled with endless low-to mid-rise apartment blocks and cramped, non-descript houses, the lively white, gray, and orange play of surfaces of Natural Cubes stands out. Set near the top of a six-meter-high cliff, the structure can clearly be seen from the distance. Located on a 275-square meter site, this unique apartment building is composed of a series of interlocking cubes, and features six units designed for singles or couples. Each floor plan is different from the others but all occupy approximately 50 square meters. There is a big demand in Tokyo for such small apartments for young people who are opting to live in the city rather than in the suburbs as their parents had done.

The three-dimensional plan is composed of a small black cube between two large white reinforced-concrete cubes whose surfaces are vertically cut and arranged in a weave pattern to create an effect like zigzagging origami paper. This form helps the structure's seismic resistance qualities. There are also three smaller orange cubes—one each on the first and third floors, and another on the inside of the south white cube.

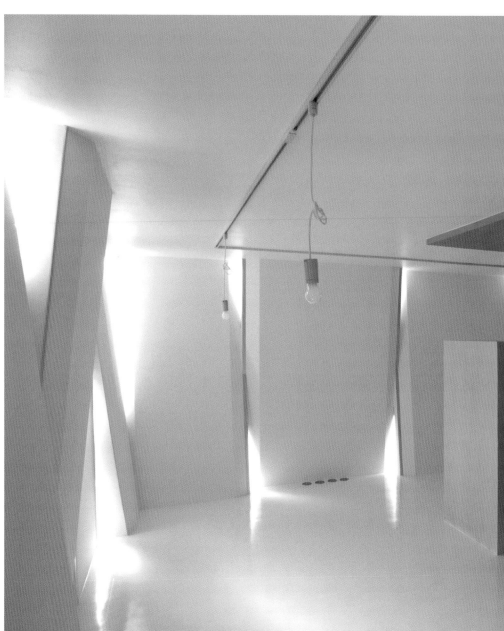

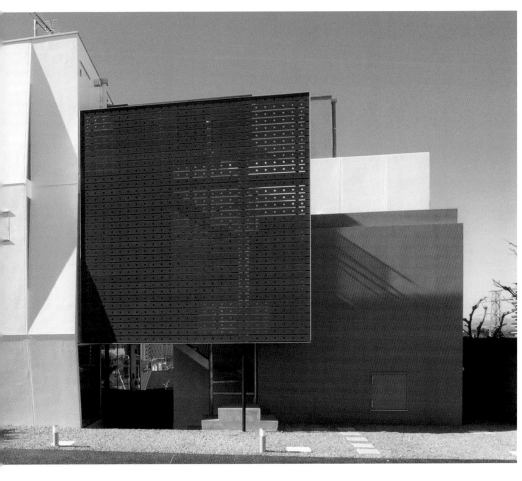

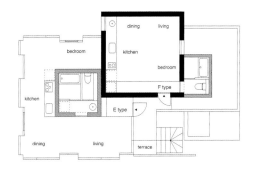

Far left The plan is composed of a small black cube between two large white reinforced-concrete cubes.

Left The exterior is characterized by the intersecting cubic spaces, porous surfaces, and bold use of color.

Above The building is composed of a series of interlocking cubes, and features six residential units designed for singles or couples.

Below left Surfaces inside and out are vertically cut like zigzagging origami paper.

Below right Set near the top of a six-meter-high cliff, the structure stands out among its more conventional neighbors.

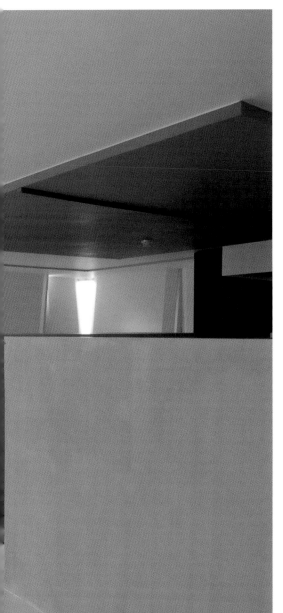

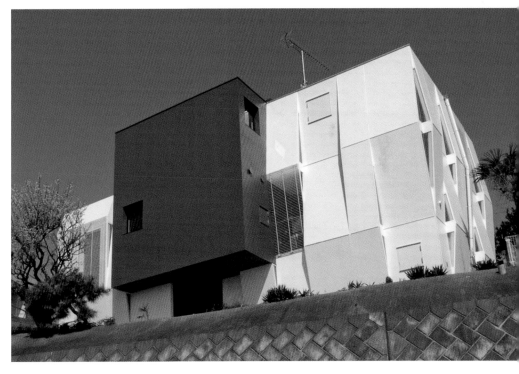

Within each apartment, the space is arranged according to cubes. For example, one apartment is laid out around a central gray/orange kitchen box surrounded by a white living space box that is articulated by the zigzag of the walls and the narrow slit-like windows they create, through which the light pours in. The minimal detailing and the quality of the finishes in the apartment help articulate this imagery.

The interior fit-out is minimal. The kitchen in the small apartments is merely a short slab with a stovetop and a washbasin, with barely space to put any pots and pans. However, in Tokyo, where a huge variety of prepared and semi-prepared foods are the norm for most households, and where entertaining is almost never done at home, young people are spending increasingly less and less time in the kitchen—or inside their homes for that matter.

Endoh's designs are also expressive of the new generation that is not content to conform to the strict social codes of Japanese society, and is willing to express its lifestyle through fashion and architecture, as in the case of Natural Cubes.

GLASHAUS

Architect **Waro Kishi and K. Associates**
Location **Osaka**
Completion **2007**

Seventy percent of the population in Japan lives in urban areas, mostly located on the 25 percent of flat land in this mostly mountainous country. Tadao Ando has called Japan the "condensed world." Perhaps this is the reason for the intense interest in space and the relationship to nature that underscores Japanese architecture.

As in most of Japan, land comes at a premium in Osaka, Japan's second largest city. So when asked to design an apartment building on a 357-square meter site next to Utsubo Park, one of Osaka's rare green spaces, Kyoto-based architect Waro Kishi wanted to provide the maximum amount of living space while taking advantage of the parkside setting.

Glashaus is a fourteen-story 2581.20-square meter reinforced-concrete structure featuring a double-layered, grid-like façade of steel and translucent glass. To make the most of the park view but to avoid a full glass façade that would require year-round air-conditioning, Kishi used a double-skin structure composed of glass louvers and sliding doors. Residents can therefore adjust and open windows, regulating light, heat, and fresh air as they wish.

Large windows also open the back façade, with a varying profile reflecting the distribution and the different plans of apartments. A basic unit consisting of two apartments is composed of an L-shaped cross-section with a ceiling height that goes from 2.5 meters to 3.5 meters, reminiscent of the double-height living areas designed by Le Corbusier in Unite de Habitation (1957).

The apartments feature a wall opening between rooms that can be slid open and closed,

recalling *shoji* and *fusuma* screens that partitioned space but could be easily moved or removed in traditional Japanese homes. Kishi calls this space the "sun room," and notes that it allows the residents to define and alter the character of their homes—open or closed, shaded or brightly lit.

The upper stories contain penthouses, with uniformly high ceilings and panoramic views, the largest of which covers two levels and has an outdoor terrace overlooking Utsubo Park.

While naming a building "glashaus" is somewhat daring as it invites immediate comparison with famous glass houses designed by past masters, the refined geometry and meticulous glass and steel construction of this building are characteristic of Waro Kishi's designs. Fellow architects often call Kishi's work "real architecture" for its Euclidean clarity and refined Japanese sensibility. Highly regarded for its intelligence and integrity, Kishi's architecture tends to eschew avant-garde flash for a quiet modernist harmony.

Above Glashaus is a fourteen story structure of glass and reinforced concrete, recalling modernist aesthetics.

Left The apartments feature a wall opening between rooms that can be slid open or closed.

Right The façade is a double-layered grid of steel and translucent glass that features louvers and sliding doors to help ventilate the building.

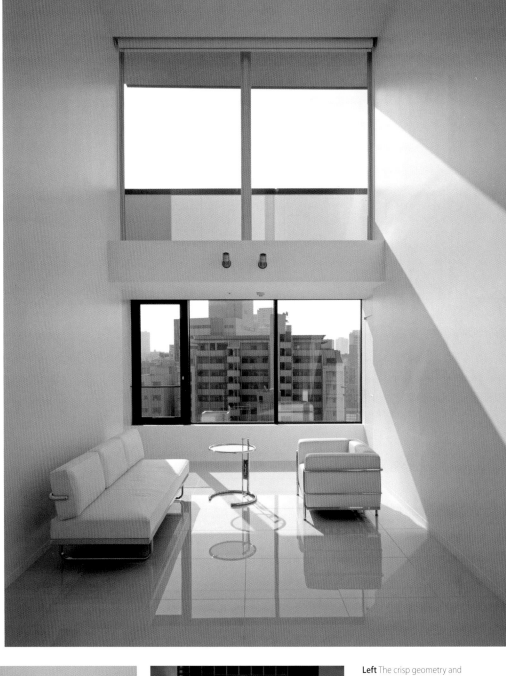

Above A basic building unit consists of two apartments and has an L-shaped cross-section.

Below Sliding partitions recall *shoji* and *fusuma* screens of traditional Japanese homes.

Right Ceiling height varies from 2.5 to 3.5 meters, offering light-filled spaces and city views.

Left The crisp geometry and refined Japanese sensibility of the façade are characteristics common in Kishi's work.

Right The upper stories contain penthouses, with soaring ceilings and panoramic views.

Left A hot tub on the top floor allows panoramic city views.

Above A built-in kitchen is colorfully delineated within a pure white space.

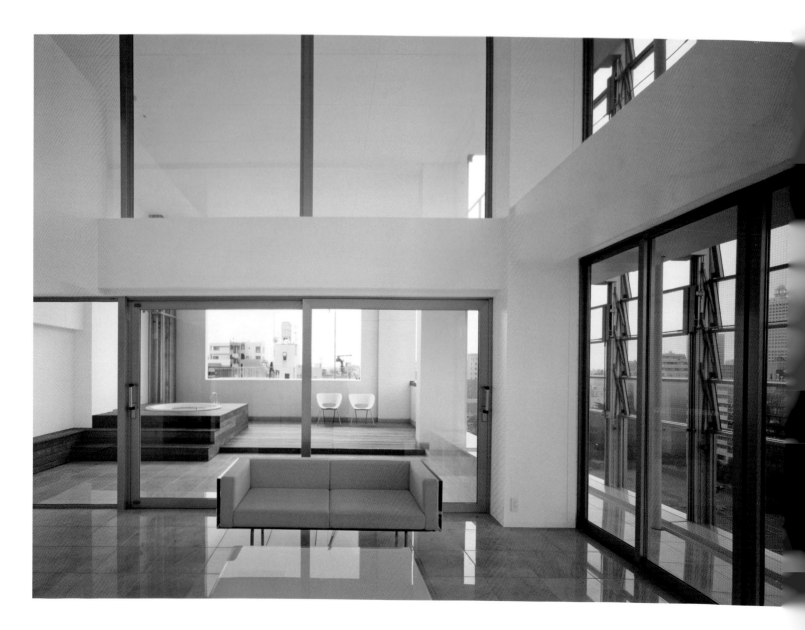

architecture
for culture

The Japanese have a reverence for culture much akin to that of countries such as France or Italy. Few places have such deep collective appreciation of beauty, be it a cherry blossom, the rusticity of a *wabi sabi* teacup, or the nuanced surface of polished concrete. Visiting museums is a popular pastime. When a special exhibit of the sixteenth-century painter Hasegawa Tohaku took place at the Tokyo National Museum in 2010, every day of the exhibit sold out with people waiting in prohibitively long lines to get in.

Like much of the world, Japan too has succumbed to the lure of the "Bilbao effect," with national and local government investing in spectacular cultural venues to promote not only culture but also the local economy and their own political longevity. The results, however, are some world-class art centers found from Tokyo to a small island in the Inland Sea.

The projects and their designs reflect the myriad facets of Japanese cultural interests. There is Japan's own past, well-represented by the elegant updating of traditional Japanese aesthetics at Kengo Kuma's Nezu Musuem and Fumihiko Maki's Shimane Museum of Ancient Izumo. Contemporary art is displayed within the hard-edged modernity of Tadao Ando's 21_21 Design Sight, or with innovative technology in Pelli Clarke Pelli's underground National Museum of Contemporary Art in Osaka. The state of the planet is a growing concern and is explored in the quirky curves of Shuhei Endo's Bubbletecture H, as well as in Hiroshi Sambuichi's Inujima Art Project, which is located in a former factory turned into a model of environmentally sustainable architecture.

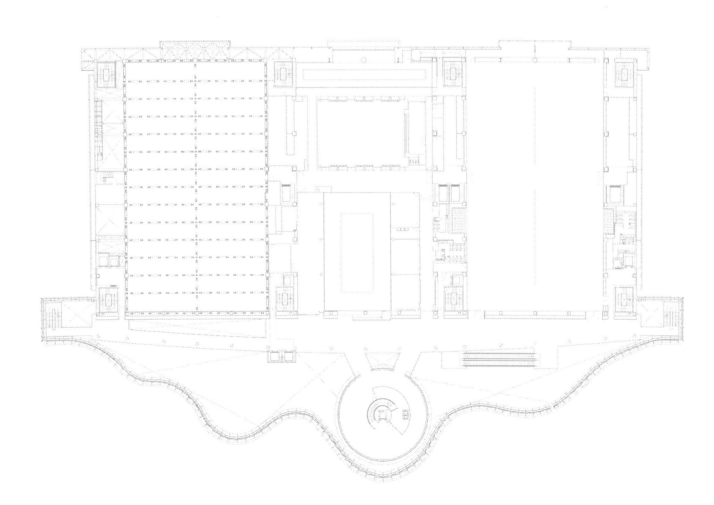

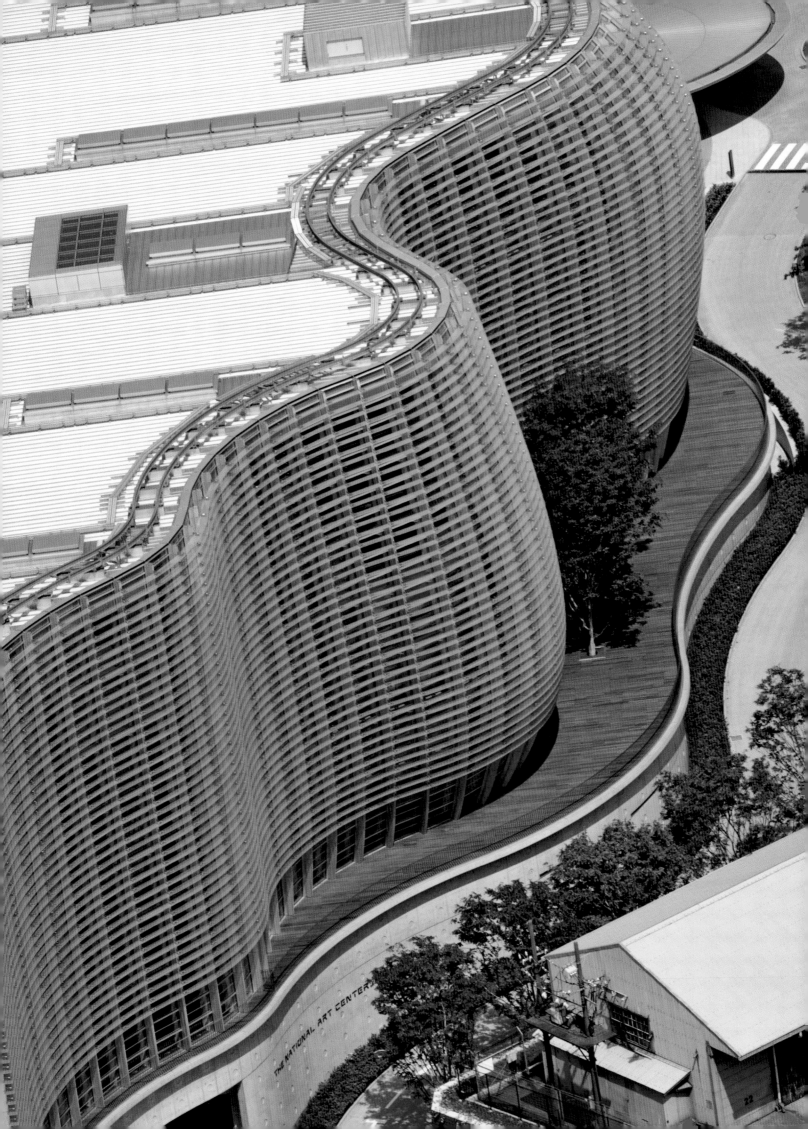

THE NATIONAL ART CENTER

21_21 DESIGN SIGHT

Architect **Tadao Ando**
Location **Tokyo Midtown Complex, Roppongi, Tokyo**
Completion **2007**

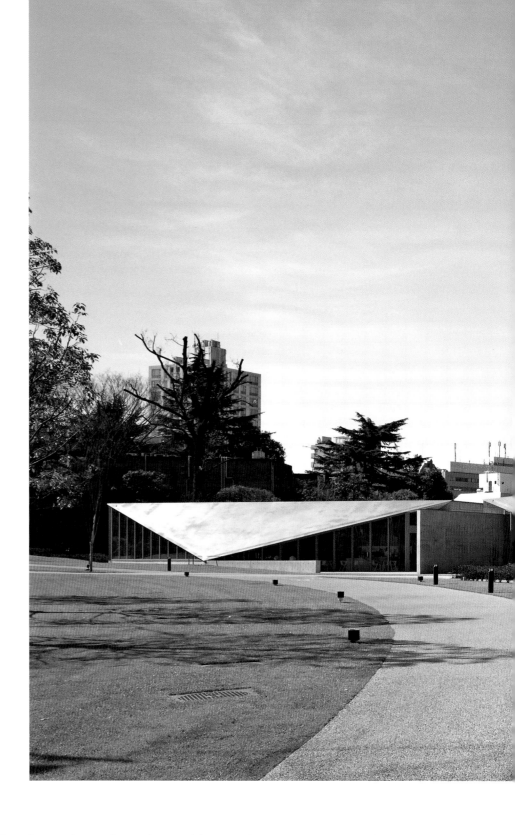

Tadao Ando's 21_21 Design Sight looks like an enormous work of silvery origami set in a green park in the heart of Tokyo. Constructed of smooth finished exposed concrete, steel, and glass, it nevertheless gracefully folds into its surroundings. It is a remarkable work of design, quite appropriate for its function as a gallery exclusively devoted to that end.

21_21 Design Sight is part of the Tokyo Midtown complex (see page 160), located on the former site of the Defense Ministry in the fashionable Roppongi district of Tokyo. The gallery is the brainchild of fashion designer Issey Miyake, who, along with Ando, set out not only to create a space for temporary exhibits on design, but also to inspire the designs of the future.

From the original concept in 2003 to the beginning of construction in 2005, plans for this building went through many alterations, until finally arriving at a design that satisfied the requirements of the site as well as the aspirations of Ando and Miyake. The design was dictated in part by the building regulations of the site, which had been designated as open public space. This meant that much of the structure had to be underground to preserve the elegant landscape designed by the renowned landscape architecture firm EDAW. Thus, the design revolved around the concept of "architecture as landscape."

The artistic inspiration came from Miyake's work of art entitled "A Piece of Cloth," that explored how a single piece of fabric can produce different three-dimensional forms depending on the wearer. 21_21 Design Sight was to be even more adaptable, continually transforming to suit its changing, temporary design exhibits.

Although most of the building's volume is underground, Ando made the most of the building's limited above-ground presence in the form of two single-story elongated trapezoidal structures. Separate but intersecting, the smaller of these geometric spaces is a café while the larger one serves as the gallery entrance. Each is topped with a single steel sheet that drapes to the ground like a fold of origami paper, tapering at the ends to nearly touch the ground. These massive sheets (the larger one spanning 54 meters) required expert craftsmanship and problem-solving during construction. Almost contemporary with 21_21 Design Sight, Ando's other origami-like design is for the Nike showroom in Omotesando.

Above The above-ground presence of 21_21 Design Sight consists of two single-story elongated trapezoidal structures, each topped by a single steel sheet that drapes to the ground like a fold of origami paper.

Right Building regulations dictated that the structure be low and undisruptive of the surrounding landscape, thus much of the building is below ground. Reducing the visual impact of the buildings above ground is also a theme that runs through many of Ando's other museum designs.

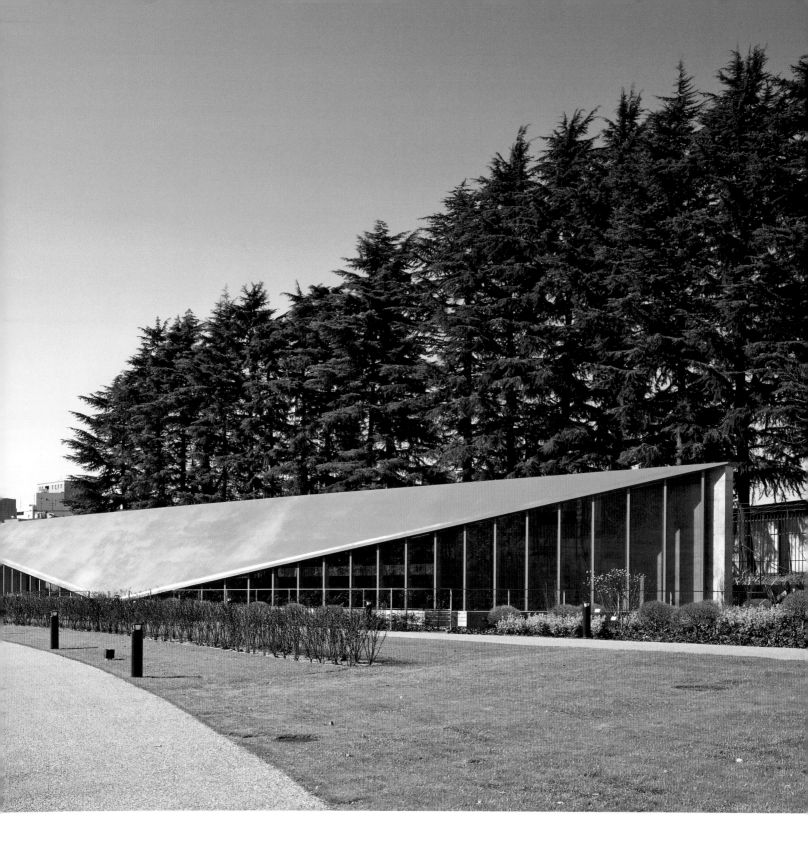

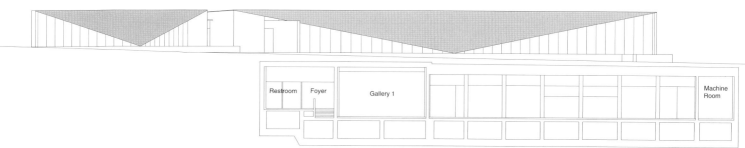

| Restroom | Foyer | Gallery 1 | | | | | | | Machine Room |

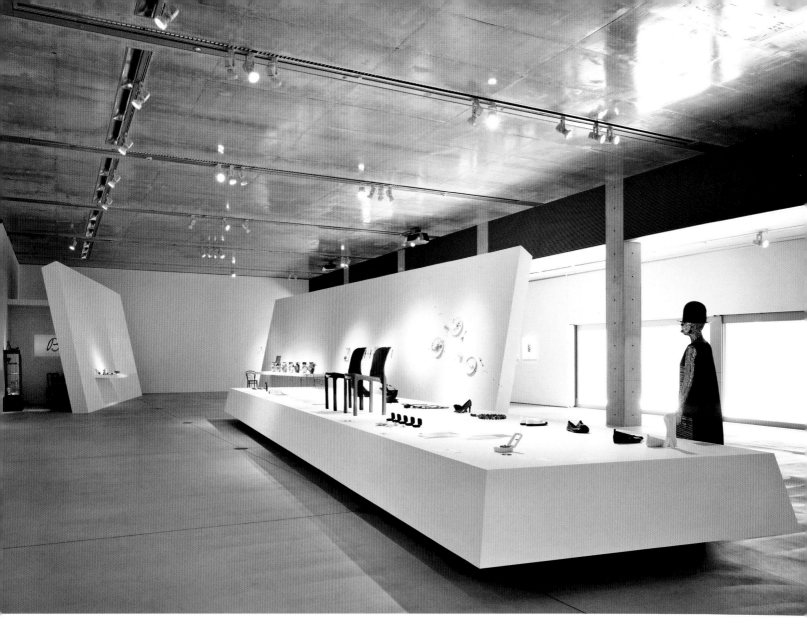

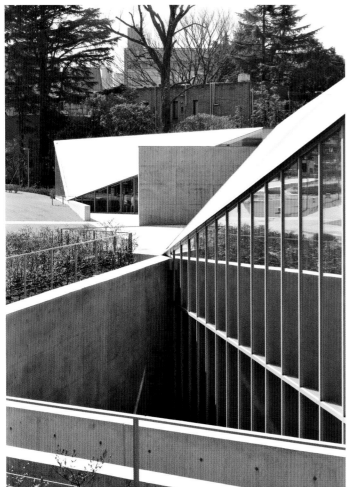

Above The spacious below-ground galleries offer an adaptable space for ever-changing temporary exhibits showcasing contemporary Japanese and international design.

Left A trapezoidal subterranean courtyard with a wall of glass adds an outdoor exhibit space and allows natural light into the galleries.

The angular planes of 21_21 Design Sight seem to sink into the earth, fusing site and building into a single experience and suggesting the remarkably spacious interior volume below. Seen from inside, the roof plane dips down, framing the surrounding park through a glass wall that follows the roof's fall and rise. Below, floating concrete stairs lead to double-height galleries organized around a subterranean outdoor courtyard, also a trapezoidal form. The courtyard not only draws natural light into the lower galleries, but is also often used as an exhibition space and, more practically, to convey large objects to the lower levels. Ando's signature polished concrete defines the space, with its soft gray palette ever changing in the varying light.

Tadao Ando's work is synonymous with clean, eloquently stark spaces usually defined with smooth finished concrete. The clarity of design perfectly echoes the pun intended in the gallery's name: 21_21, a place where people can see design of the twenty-first century with 21_21 vision. Ando's design facilitates this vision with steely crisp exploration of light and space, geometry and nature.

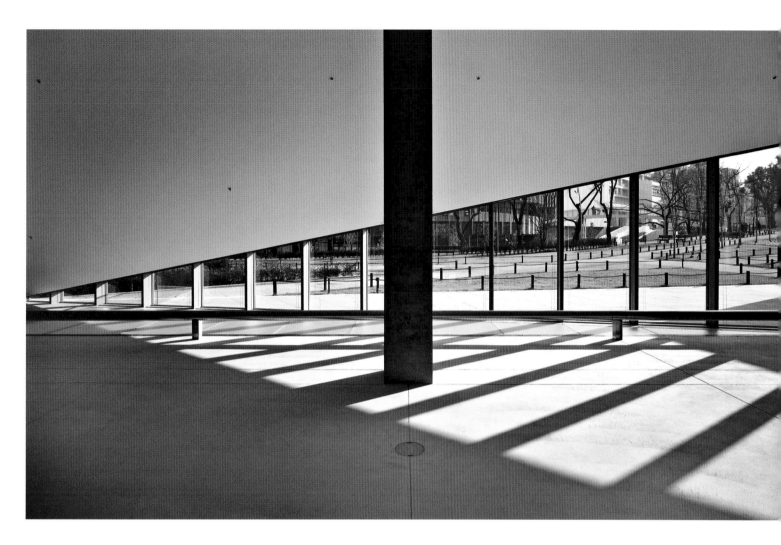

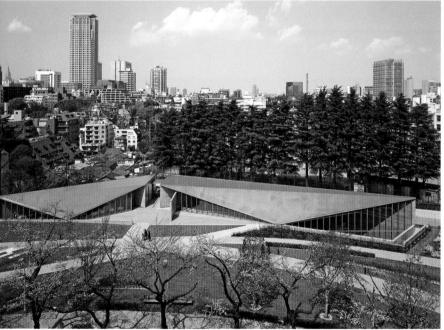

Left The starkly eloquent design resembles an enormous work of silvery origami in the heart of Tokyo.

Above Viewed from inside, the angled roof plane frames the surrounding park through a glass wall that follows the roof's fall and rise.

Below Ando's design adds a gracefully angular element to the more cursive landscape designed by EDAW.

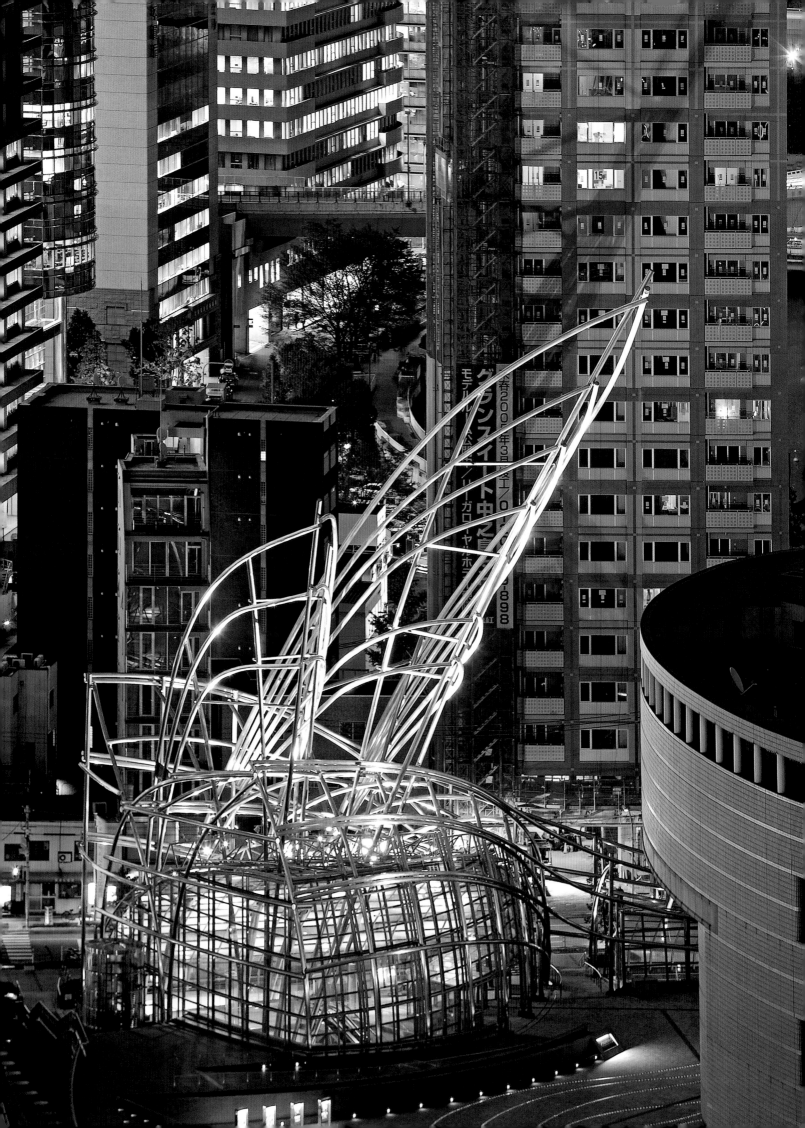

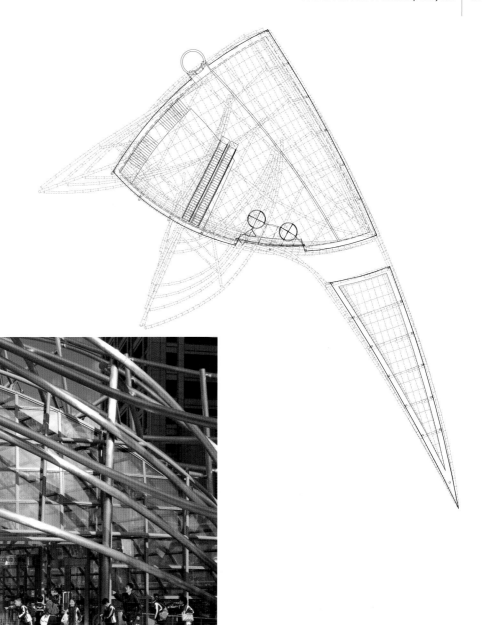

NATIONAL MUSEUM OF CONTEMPORARY ART

Architect **Pelli Clarke Pelli Architects (PCP)**
Location **Osaka**
Completion **2004**

Pelli Clarke Pelli started with a particularly challenging brief for their design for the National Museum of Contemporary Art in Japan's second largest city, Osaka. The city officials wanted to bring the museum, which had been located on the outskirts of the city, into the historic heart of the city as a key element in a revitalization program. However, the site available was a tight, irregular space in a dense urban area on the island of Nakano between the Tosabori and Dojima rivers. The decision was thus made to build most of the 13,500-square meter museum underground, with the entrance lobby as the only above-ground expression. As if that were not challenging enough, the area's high water table meant that the design also had to be watertight.

US-based firm Pelli Clarke Pelli responded to this near architectural dare with an imaginative, highly functional design that both awes and attracts visitors. The firm has a reputation for contemporary and optimistic designs that respond to context. They have designed many of the world's most recognizable buildings, including the World Financial Center in New York and the Petronas Towers in Malaysia. But the Osaka museum was something new for the firm. The museum's visionary director, Shigenobu Kimura, was looking to make an impact and PCP took the opportunity to create something distinctively expressive and experimental.

This is evident from the first glimpse of the entrance to the museum, which is marked by a dramatic sculpture of glass and titanium-covered stainless steel pipes weaving together and rising 52 meters into the sky. It has been likened to the tip of an iceberg, a dragonfly, and even a computer graphic brought to life. But Cesar Pelli himself calls it the "expression of bamboo growing from the ground, reaching for the clouds and swaying in the wind." Regardless of the metaphor, this expressive scribble is a highly appropriate and joyous (nice—I like the use of happy and inspiring words!) welcome to Osaka's premier museum of contemporary art.

Opposite With a dramatic sculpture of glass and steel rising 52 meters into the sky, the museum's entrance provides a glittering addition to the Osaka cityscape.

Top and above left Up close, the entrance is an animated weave of titanium-covered stainless steel pipes and glass.

Above The design features three levels in the form of a reverse L-shape reaching 19.5 meters into the ground.

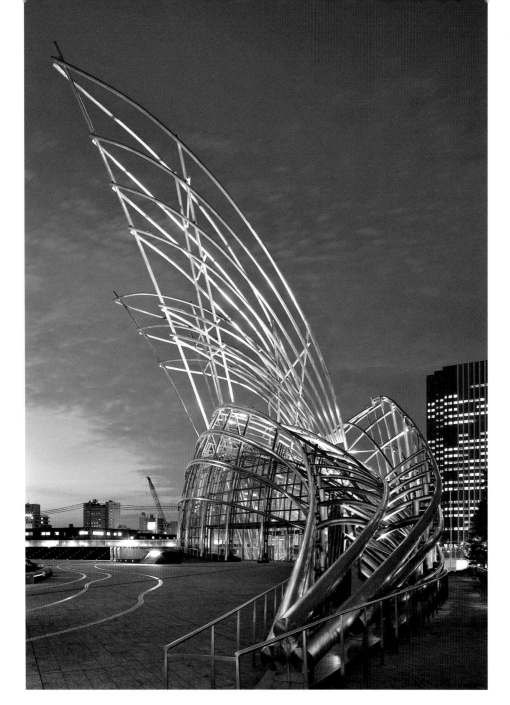

The initial design was not worked out on paper or computer but "intuitively, visually, and by a sense of feel," said PCP partner Fred Clarke, using an immense model that was later used to create digitalized drawings. The final design for the museum itself features three levels in the form of a reverse L-shape. These encompass a public entrance level with a ticketing and information area, a restaurant, gift shop, auditorium, and video exhibits, followed by two floors of temporary and permanent gallery space. Generous use of glass allows natural light to enter the windowless floors below. Due to its location on the coast of earthquake prone Japan, the structure was designed to allow for movement of 100–150 millimeters under wind and seismic forces.

To construct this space 19.5 meters deep into saturated alluvial soil, PCP devised a unique construction method. According to Pelli, "the solution was to sink the museum into the soil like a ship with triple-hull construction, which resists the water's buoyancy by its sheer weight. The building's outermost layer is a vault of concrete; the middle layer is concrete with a rubberized waterproofing membrane; and the third layer is the finished wall of the museum's interior. Chambers run between the three layers, which together are some three meters thick."

Thus, Pelli Clarke Pelli has the distinction of creating perhaps the only museum in the world to be both underground and underwater, aptly nicknamed "the submarine."

Above Cesar Pelli likens the sculptural entrance to bamboo swaying in the wind.

Right With a tight, irregular piece of land with a high water table, the only site available for this building, most of the 13,500-square meter museum had to be both underground and watertight.

Opposite Generous use of glass allows natural light to enter the windowless floors below.

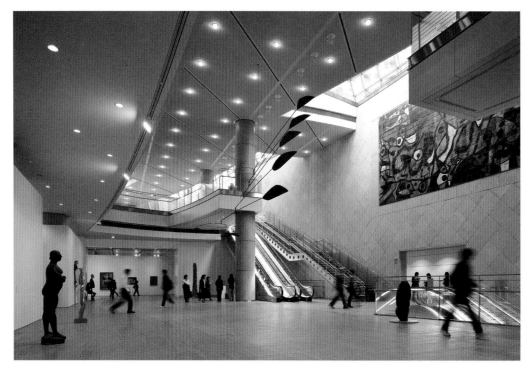

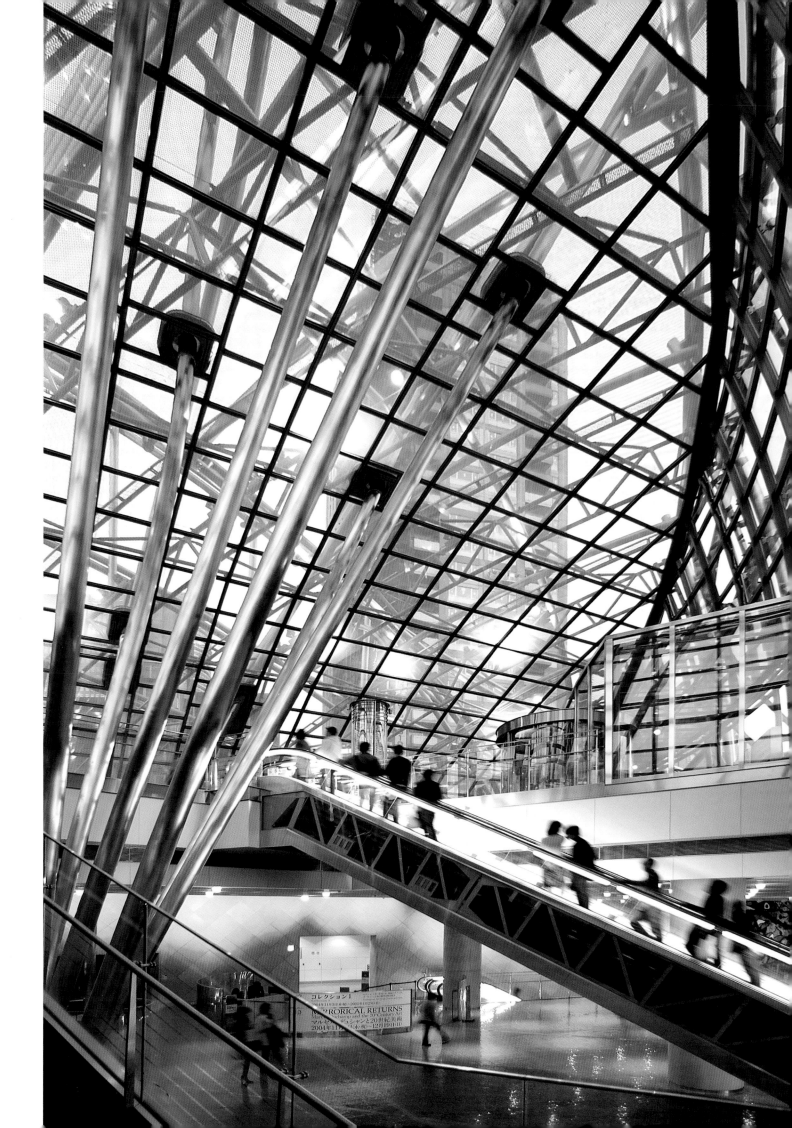



MIHARA PERFORMING ARTS CENTER

Architect **Fumihiko Maki**
Location **Mihara City, Hiroshima Prefecture**
Completion **2007**

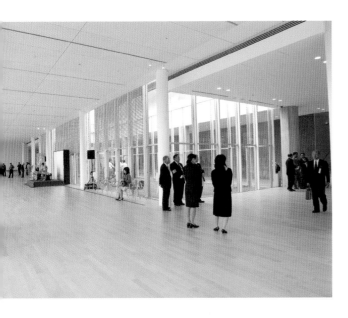

Far left The auditorium is a delicate prismatic space of pale wood, noted for its understated beauty and fine-tuned acoustics.

Left The low transparent foyer is open to the public when not used for events.

Below A silver dome supported by various rectilinear forms creates an elegant collage of geometric forms.

One of the foremost architects, teachers, and theorists of architecture in Japan, Fumihiko Maki is known for his consistent programmatic and contextual rationality, as well as a quiet sensibility. This Pritzker Laureate has created iconic public buildings as well as intimate-scaled projects in Japan, the US, and Europe. His latest project in Japan, the Mihara Performing Arts Center, is an excellent example of his ability to create a place for "solitude in a public space." In Maki's words: "Solitude does not mean being confined to one's own house, but having opportunities for solitary experience within a public place, that enrich the quality of life in the city."

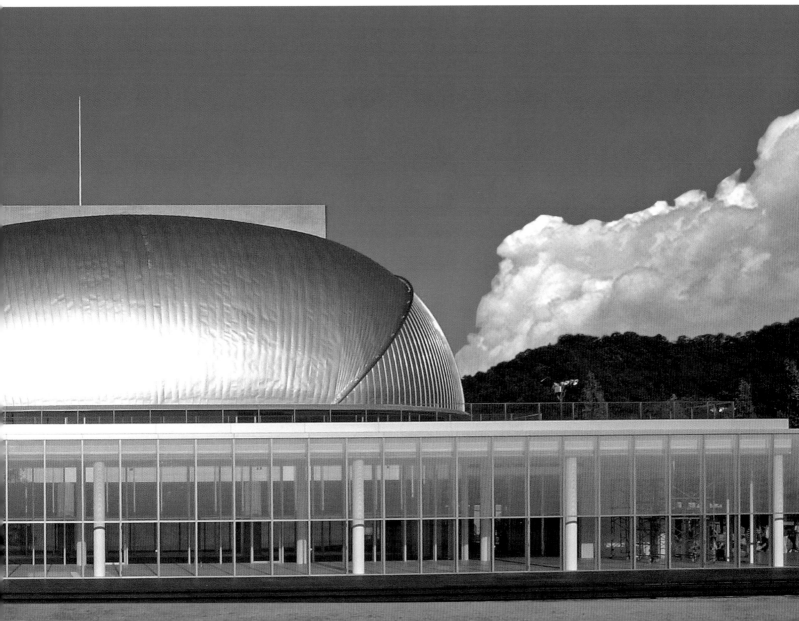

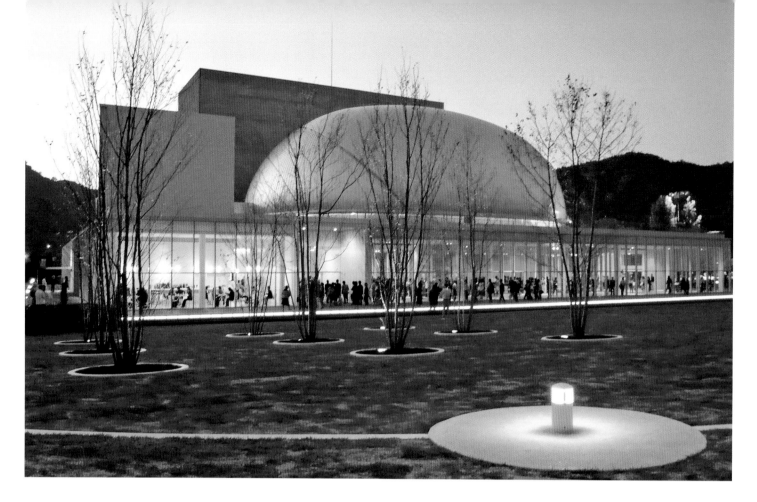

Mihara is a small city located 70 kilometers east of Hiroshima City. The Performing Arts Center is situated in the city's central park alongside a playground and ballpark. In his design, Maki sought to make the 1,200-seat performing arts center a part of this public space, thus joining architecture and community.

The exterior form is defined by a silver dome supported by various rectilinear forms. Maki is noted for organizing architectural space like an elegant collage of geometric fragments, similar to the layered spaces of traditional Japanese architecture and gardens. Here, his inspiration came from a seemingly unlikely source: a full moon-shaped *omochi*, a ceremonial pounded rice cake usually served on a raised tray. The *omochi* is prepared on special occasions like the New Year and Tsukimi, the fall moon-viewing festival. This reference to the gracious tradition of moon viewing is indeed an appropriate reference for a place of individual contemplation of beauty.

Inside, the auditorium is a delicate prismatic space of pale wood, noted for its understated beauty and fine-tuned acoustics. Like the entire complex, it is a highly functional space filled with Maki's refined details that combine traditional craftsmanship with cutting-edge technology.

Along with the auditorium, the facility features a rehearsal hall, practice rooms, and meeting spaces for performers, staff, and the community. To connect these creative spaces with the surrounding community, a low transparent foyer unfolds to the park. This space, which is open to the general public when not used for events, brings the surrounding greenery into the building and the building into the park, creating a dialog between inside and out as well as the Performing Arts Center and the community. The foyer includes a café as well as small inner courtyards that help to illuminate the interior. In fine weather, the courtyards and foyer can be opened to allow fresh air into the structure.

The overall result is unobtrusive and generous architecture that offers spaces where the arts and architectural beauty can be intimately experienced with or without a ticket, with company or in solitude.

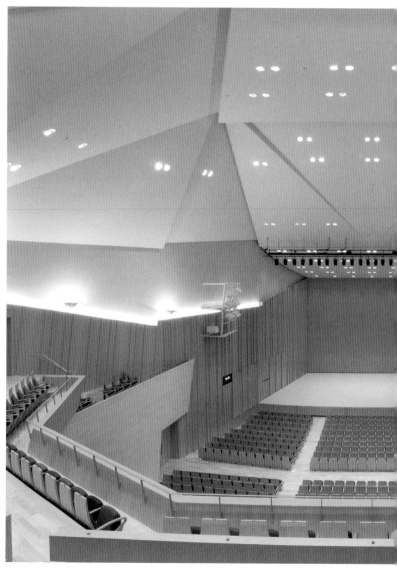

Opposite The design strengthens the dialog between architecture and community by incorporating the 1,200-seat performing arts center into the neighboring public park.

Bottom The auditorium is a highly functional space of refined details that combine traditional craftsmanship with cutting-edge technology characteristic of Maki's work.

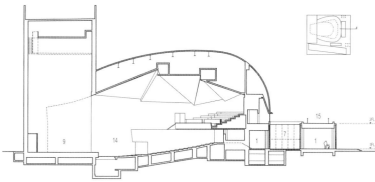

Left The foyer not only connects spaces but is also a destination space for meeting and display.

Below center Section showing the unique silhouette, which was inspired by a full moon-shaped *omochi* rice cake that is prepared on auspicious occasions.

Below The plan evinces Maki's consistent programmatic and contextual rationality.

Bottom In fine weather, the courtyards and foyer can be opened to allow fresh air into the structure.

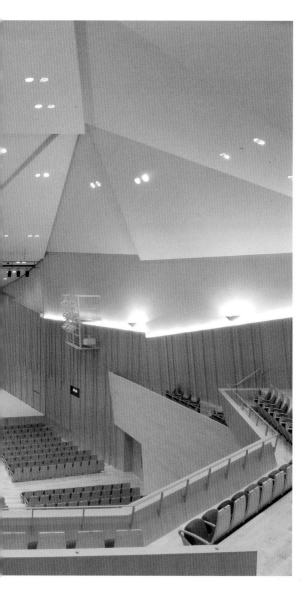

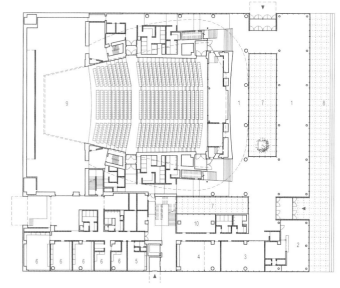

1 Foyer
2 Cafe-restrant
3 Office
4 Meeting room
5 Artists lounge
6 Dressing room
7 Court
8 Deck terrace
9 Stage
10 Volunteers' activities room
11 Rehearsal room
12 Exercise room
13 Lobby
14 Hall
15 Terrace

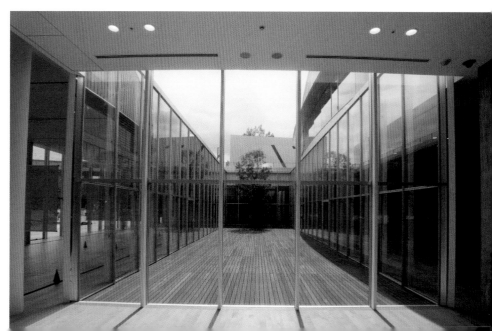

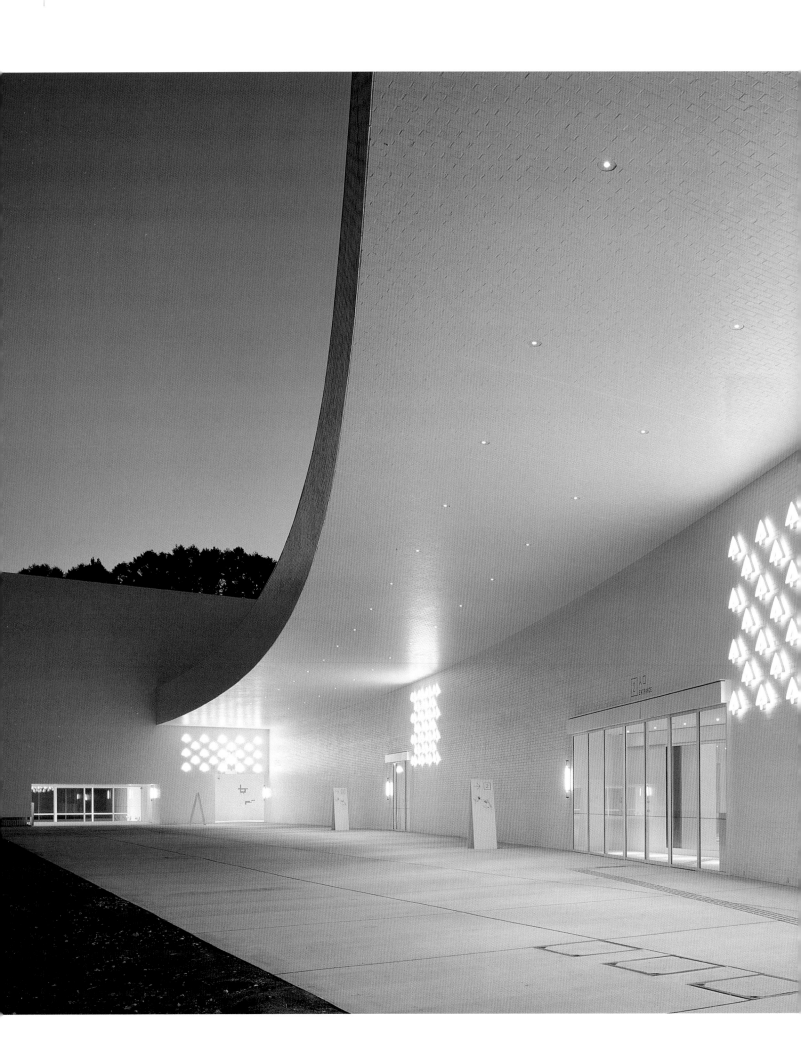

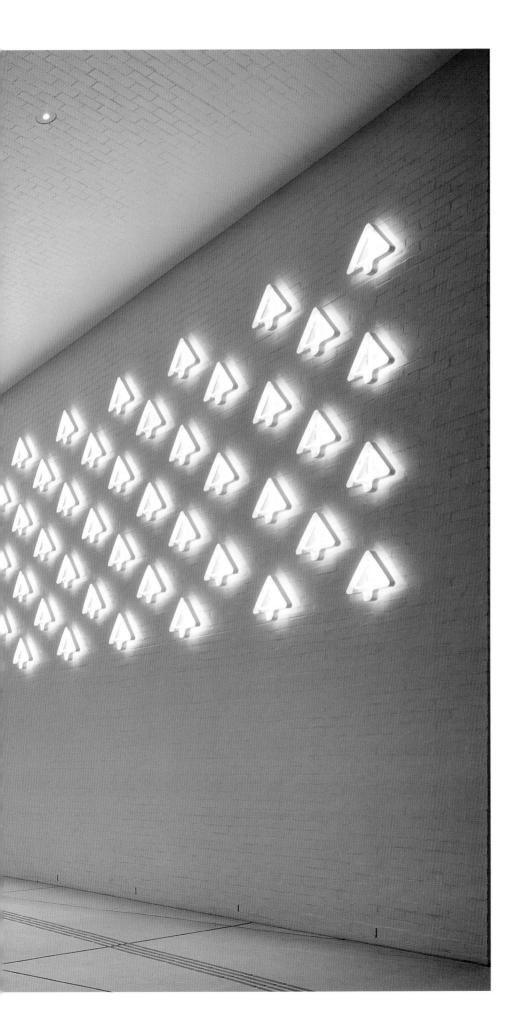

AOMORI MUSEUM OF ART

Architect **Jun Aoki & Associates**
Location **Aomori City, Aomori Prefecture**
Completion **2006**

Located at the northern tip of Japan's main island, Honshu, the Aomori Museum of Art is a showcase for the visual arts as well as theater, film, dance, and music. The Aomori Prefecture government decided to commission a museum next to the Maruyama Sannai Jomon-period Neolithic site, where archaeologists recently discovered evidence of organized agriculture in Japan earlier than had been believed. Required by the competition brief to relate the design to this important archeological site lined with the earthen trenches of past excavations, Jun Aoki developed an innovative theme—to link the museum to its surroundings by echoing these "primitive" earthy elements into the museum, and contrasting them with the cubic white spaces normally found in contemporary museums. His design was selected from among 393 entries.

Aoki achieved this goal by designing the lower levels of the museum in a series of trenches reminiscent of the excavation site next door. Overhanging white volumes are placed above the trenches in a checkerboard pattern, creating alternating exhibition rooms and small spaces that provide visitors with a choice of paths as they wander through the museum.

From a distance, the museum appears to hover above the ground, seamless and white, but as you move closer, its many, more earthy layers reveal themselves. The museum is composed of two rectangular structures that intersect via a series of passages of varying shapes and sizes that lead, in

Left With seven non-prioritized entry points, Aoki's design invites visitors to decide their own route through the museum.

turn, to galleries as equally varied. There are two floors below ground and a two-storied super-structure above. Throughout the building, Aoki employs extensive steel-frame structure, painted and unpainted brick, and rough mortar. The superstructure's exterior is painted white, but its surface is pierced by irregularly placed windows that help relate it with the lower levels formed by rough, earthy, mortar-covered walls.

The spatial organization inside is deliberately random, dotted with gaps, unusual connections, and shifting views. According to Aoki, he devised the program with one overall direction: "Trenches were cut lengthwise and crosswise into the ground to form face-up recesses and protrusions. These were to be then covered with a superstruc-ture whose facedown protrusions and recessions did not fit exactly, thereby automatically creating two different types of spaces. One sort are the white cube spaces in the superstructure, while the other sort are between the ground surface and the bottom of the structure."

According to Aoki, the reason he and many contemporary artists like white cube spaces is because "they have no subjectivity that may con-flict with the works of art." The result of these design ideas is a structure that is flat on top and uneven on the bottom, with an earthen land-scape that is crisscrossed with trenches that echo the Neolithic site next door. In addition to the interior galleries, there are exterior spaces of varying scales and proportions that form open-air galleries. One of these spaces features a sculp-ture by artist Yoshitomo Nara of a giant dog, whose melancholy white form is contrasted by the earthen trench walls around it.

Aoki's design invites visitors themselves to be creative in deciding their route through the museum, as there is not one main entrance, but seven non-prioritized entry points. Inside, also, there is no fixed route for visitors to follow, but rather a maze-like layout that allows visitors to choose the next direction. With few doors or rigid separation of spaces, the galleries and transition points are fluid and change with the needs of the exhibits. For example, the heart of the museum is a large white cubic space (20 x 20 x 20 meters), which displays three tapestries by Marc Chagall that were originally made as stage designs for Tchaikovsky's "Aleko" ballet. These fill three walls, while the fourth wall is mobile and can be low-ered to open on to a small theater.

Aoki's creative museum is both literally and symbolically open to many directions. It looks to both the past and the future, presenting contem-porary art in juxtaposition with the prehistoric past, subtly reminding us of the beauty of the past and just how far we have come.

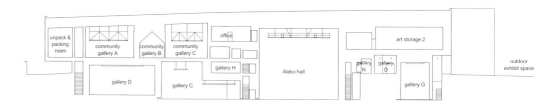

Above left The impact of Yoshitomo Nara's art work is heightened by its display in a stark trench-like exterior gallery.

Left Aoki's plan is a random spatial organization dotted with gaps, unusual connections, and shifting views.

Above From a distance, the museum appears to hover above the ground, a seamless white form.

Right The plan is a composition of two rectangles that intersect via a series of varying sized/shaped passages and galleries.

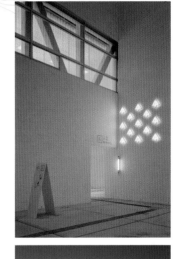

↑ 総合案内 INFORMATION
🛗 シアター THEATER
図書室 LIBRARY
コミュニティホール COMMUNITY HALL
コミュニティギャラリー COMMUNITY GALLERY
ミュージアムショップ SHOP
レストラン RESTAURANT
→ 🚻 ♿
🔒 コインロッカー LOCKERS
← 三内丸山遺跡 THE SANNAI MARUYAMA SITE
縄文時遊館 JOMON JIYUKAN

Left A walk through the museum is also a textural treat, with surfaces varying from smooth museum white to rough, earthy, mortar-covered walls.

Right top The superstructure's white exterior is pierced by irregular and unexpected openings.

Right center Overhanging white volumes are placed above dark passages in a checkerboard pattern.

Right bottom One of numerous trenches that echo the excavation site next door.

THE NATIONAL ART CENTER, TOKYO

Architects **Kisho Kurokawa and Associates and Nihon Sekkei Inc.**
Location **Roppongi, Minato-ku, Tokyo**
Completion **2006**

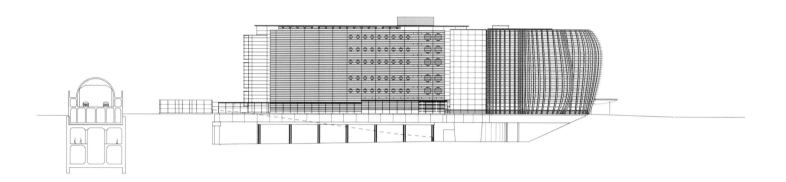

The National Art Center (NAC) stands as the final opus in Kisho Kurokawa's brilliant career. He was one of the founding members of the metabolism movement in the 1960s, and created the plug-and-play Nakagin Capsule Tower (1972), one of the few metabolist structures to be built, which is ironically now slated for destruction. Going on to design many important buildings in Japan and abroad after that, Kurokawa has played a major role in shaping the practice and theory of modern Japanese architecture.

According to Kurokawa, he first came up with the design for the NAC almost twenty years ago, and spent some ten years perfecting every detail through to the design and construction process. His aim was to create the perfect expression of his philosophy of symbiosis—the idea that energy and freshness arise from contrasts and tensions, not from what he has called "dull, flat harmony." Kurokawa considered the project a huge test for himself, to see if his twenty-year-old ideas would stand up to the twenty-first century. And indeed they have, impressively so, as NAC has played a major role in the revitalization of the Roppongi district of central Tokyo, an area that has flourished in the past decade with several major developments. Crowds now flock to the NAC for its changing exhibits and remarkable architecture.

Visitors first encounter the center's undulating façade, which rolls like a bluish-green wave of glass. Lined with layers of horizontal glass louvers, the façade easily catches the changing light, adding to its sense of movement. A wooden patio in front of the façade follows its sinuous line, and faces a small park where numerous trees have been planted with the intention that these will grow into a forest-like area that is visible both from the patio and from inside the atrium.

The structure's design was created using fractal geometry, and the plan is filled with the fluid geometric forms that Kurokawa is known for. Set into the façade is a glass cone from which a wide sheltering disc projects forward, creating an elegantly efficient umbrella storage area. In detail-conscious Japan, it is common for public venues to provide either plaster covers or places to store wet umbrellas, so as to keep interior floors dry.

Within the façade is a huge open atrium awash with natural light, minus the SUV rays that are

Above The plan as well as the elevations of the NAC are rendered dynamic with playful fractal geometry and fluid forms.

Below The façade is animated with layers of horizontal glass louvers that catch the light and add a sense of movement.

Right Set into the undulating façade is Kurokawa's signature glass cone from which a wide sheltering disc projects outward, creating an elegantly efficient storage area for umbrellas.

filtered out. Thanks to the transparent curved façade, the interior's color scheme of cool gray concrete and warm wood alters with the weather and time of day. More pragmatically, the reduced levels of direct sunlight also result in energy savings. The atrium features two more conical shapes, this time huge, upturned, freestanding cones of smooth precast concrete that rise up from the floor looking like surreal plant pots. But instead of flowers, atop these pots sit a chic café on the second floor and an even smarter French restaurant on the third floor, connected to the main floors by bridge-like passageways. Each café enjoys panoramic views over the atrium and the surrounding neighborhood.

Behind the atrium rise three levels of gallery space in a more conventional box-like structure, all connected to the dramatic atrium by open escalators and transparent elevators. The exterior wall of this space is covered with vertical wooden louvers that echo the horizontal glass louvers of the façade. Kurokawa has written eloquently about symbiosis of tradition and modernism, and demonstrated this in this tradition-inspired slatted wood finish, as well as a bamboo garden

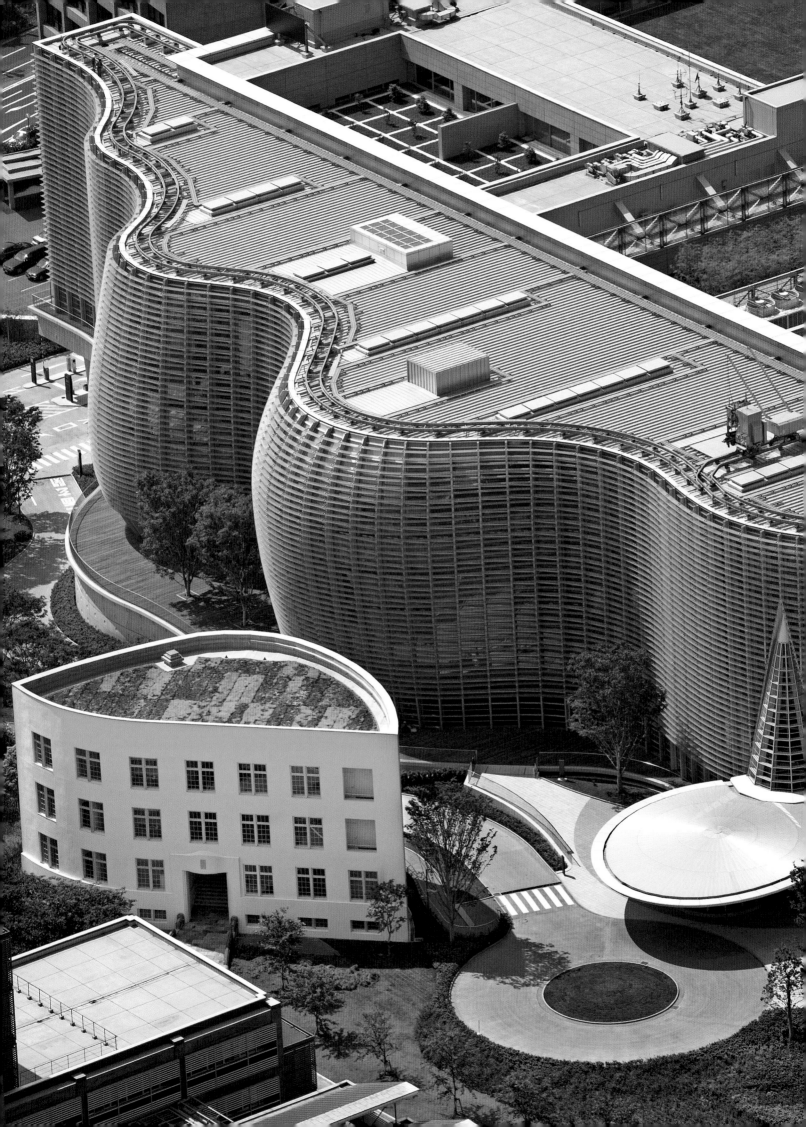

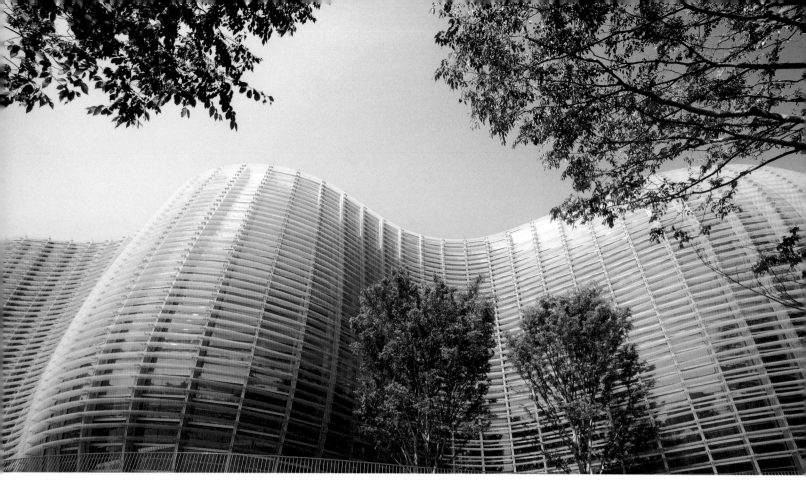

in an open-air courtyard next to the third-floor public art library.

The National Art Center has no permanent collection but is a grand space for temporary exhibits, along with an auditorium, lecture rooms, and offices. It is Japan's largest art gallery with seven 2,000-square meter column-free exhibition rooms created with a structural system composed of numerous cores and super slabs. Perfected by Kurokawa in the Osaka International Convention Center, the interior of the super slabs is used as mechanical space, where air condition-

ing is circulated through the floor pit, resulting in further energy savings. Downstairs, a basement level includes a sizeable shop with a wide variety of contemporary Japanese handicrafts and artisan work, a cafeteria, and a seating area for visitors.

Multilayered in both structure and function, and created with characteristically Japanese attention to quality material and craftsmanship, the National Art Center is an outstanding example of a space designed for public interactions and art appreciation, and a fitting finale to the momentous career of a master architect.

Above The façade glass includes an SUV filter, and fills the interior with natural light, varying the mood and coloring of the atrium according to the weather and time of day.

Below left Aerial view of the sinuous bluish-green façade that is bordered at the lower level with a wooden patio overlooking a park.

Below Behind the atrium is a more conventional box-like structure offering three levels of transformable gallery space.

Right The atrium features two awe-inspiring upturned, freestanding cones of smooth precast concrete that compel viewers into dialog with the architecture.

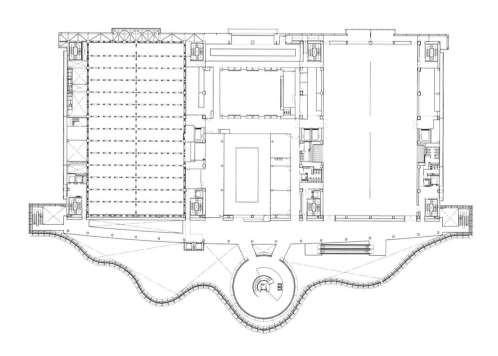

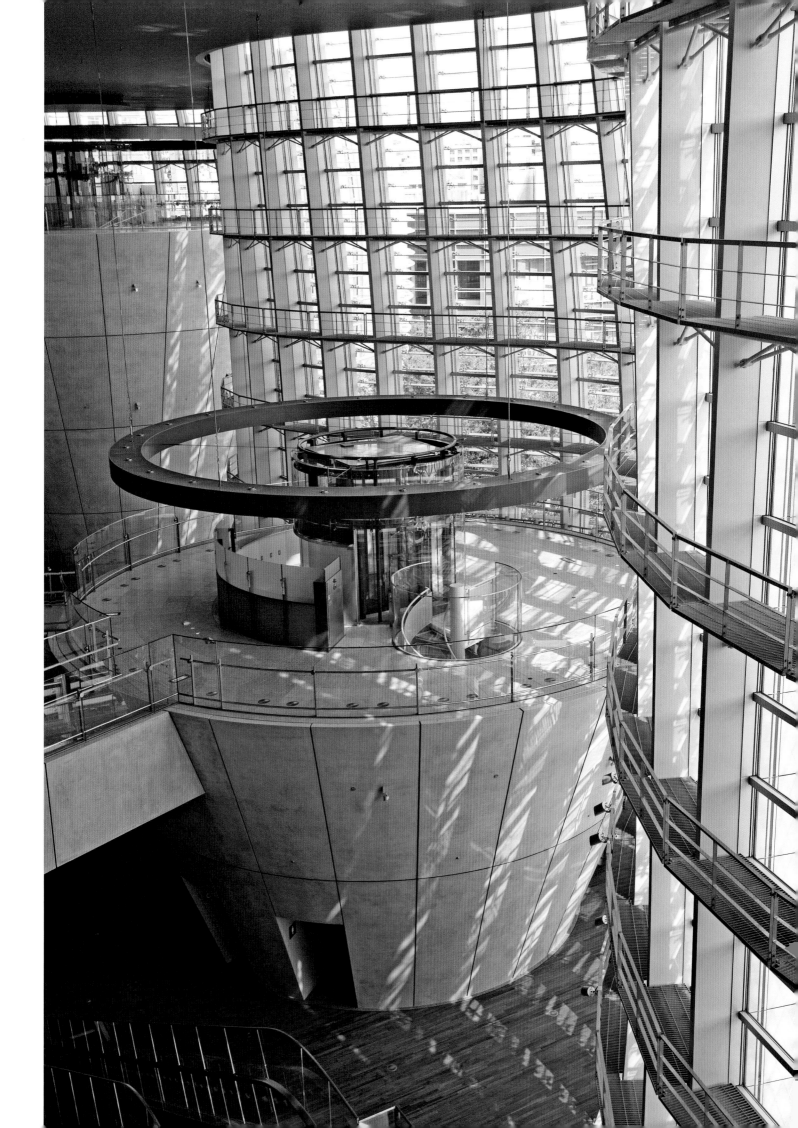

BUBBLETECTURE H

Architect **Endo Shuhei Architect Institute**
Location **Sayo-cho, Hyogo Prefecture**
Completion **2008**

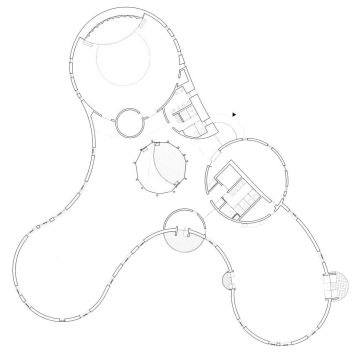

Left Designed to become part of the landscape, the plan is a fluid tripartite form spreading across the terrain.

Right The structure uses earthy, rust-colored steel panels, which have been pre-rusted to protect the steel and soften its visual impact.

Below Inside, skylights and triangular windows light up the domed spaces constructed of pale Japanese cypress.

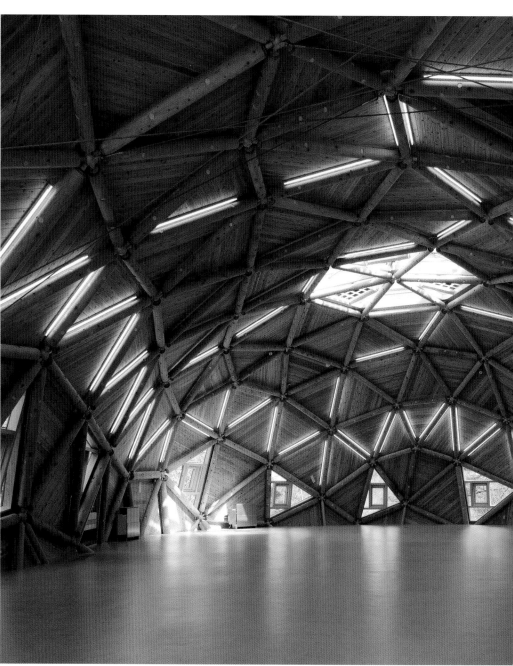

Bubbletecture H is the latest in Shusei Endo's "Slowtecture" series, his architectural answer to the "Slow Foods" movement that encourages a more thoughtful and natural approach to food. Endo's building are designed to grow and mature as natural plants replace cultivated ones, man-made materials gain patina, and the structure settles into the landscape. This kind of long-term view is a rarity in contemporary Japanese architecture where the average building lifespan is rarely more than twenty years.

Set in the mountain region two hours from Osaka, Bubbletecture H is Endo's response to the client's request for a place where people and nature can meet. More specifically, it is a museum space where visitors and residents of Hyogo Prefecture could learn about environmental issues and new "green" technologies.

For this project located on the north slope of a hill, Endo's building is intended to become part of the experience of nature. The roof is planted with moss that will grow to resemble a field, while the rest of the building surface is finished with a warm rust-colored corrosion-resistant steel. From the air, the structure looks a bit like a bulbous tripartite amoeba, a fluid form spreading across the green landscape. "Rounded, curved forms are more continuous and blend in better with nature," according to Endo. The geodesic-shaped domes rise and fall to varying heights like the curves of a hill. Inside, skylights and triangular windows light open domed spaces. Walls and ceiling constructed of pale Japanese cypress wood flow into each other and across various levels of the interior, enveloping the space in a warm natural light.

Blurring spatial boundaries is one of the hallmarks of traditional Japanese architecture, and Endo has developed a reputation for doing this in the contemporary context. His preferred building material is exposed steel, a seemingly immutable material that he does not hide, but

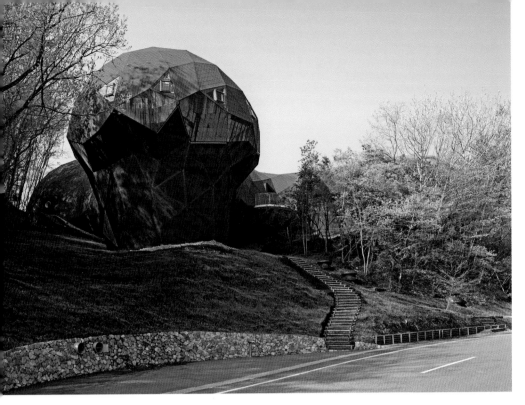

instead manages to transform and dematerialize in a myriad of unexpected ways. In a previous "Slowtecture" project, the Miki Disaster Management Park Beans Dome, located 20 miles west of Kobe, Endo created a huge stainless-steel shell overgrown with grass that looks more like a hill or ancient burial mound than the tennis dome/ emergency center that it is.

With Bubbletecture H, form and function meld much more closely. The structure uses local timber and steel panels, which have been pre-rusted to protect the steel and soften its visual impact. The deep rust color has an earthy feel and works well with the green surroundings. Endo's has thus created a building with the smallest possible footprint, protecting the surroundings and encouraging the contemplation of nature.

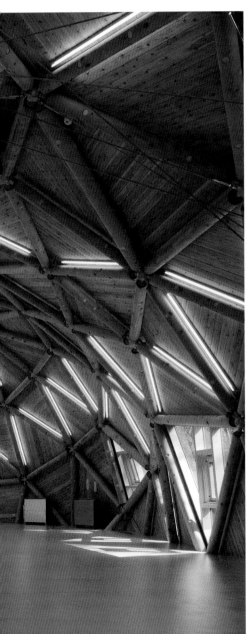

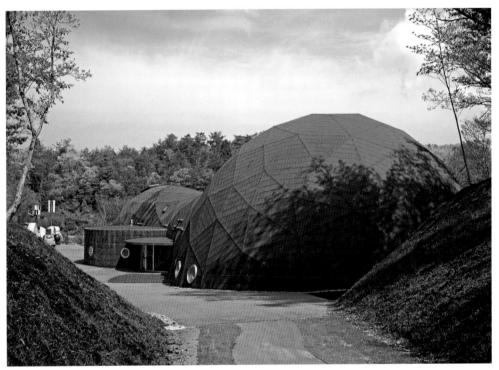

Above The roof is planted with moss that will grow to resemble a field, further blending architecture and nature.

Right The geodesic-shaped domes rise and fall to varying heights like the curves of a hill.

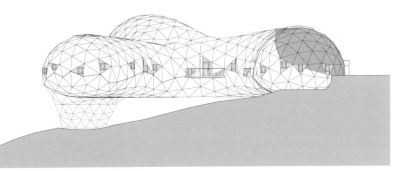

NAKAMURA KEITH HARING MUSEUM

Architect **Atsushi Kitagawara**
Location **Kobuchizawa**
Completion **2007**

Urbane, unconventional, and American, artist Keith Haring was a star of the 1970s and 1980s underground art scene in New York. Therefore, it is surprising to discover that the only museum in the world devoted to his art is found in Kobuchizawa, a Japanese village at the foot of the Yatsugatake Mountains in the southern Japanese Alps.

This unique location was the choice of the client, who had a large collection of Haring's work, and the architect Atsushi Kitagawara. Their initial plan was to base the museum in New York. However they decided that the New York Haring knew no longer existed and so they considered a variety of locations. The choice of Kobuchizawa, an area known more for its natural beauty and as a 7,000-year-old site of the Jomon (the earliest Japanese society) culture, was indeed unusual. Their idea was to place Haring's work in a dramatically different setting—the exact opposite of avant-garde New York—to better appreciate his artistic vision. Says Kitagawara: "When the art is away from home, it can stand out better. It's equivalent to experiencing your own home country more intensely while being abroad." Indeed, there could be no greater contrast between the chaotic energy of Haring's work and the museum's tranquil setting.

Visitors enter the museum along a path through a forest of oak, cherry larch, and pine trees. The museum building itself is built following the gentle slope of the land in a playful mix

Right The museum is built along a gentle slope, with a playful mix of forms, planes, openings, and colors reminiscent of Haring's art.

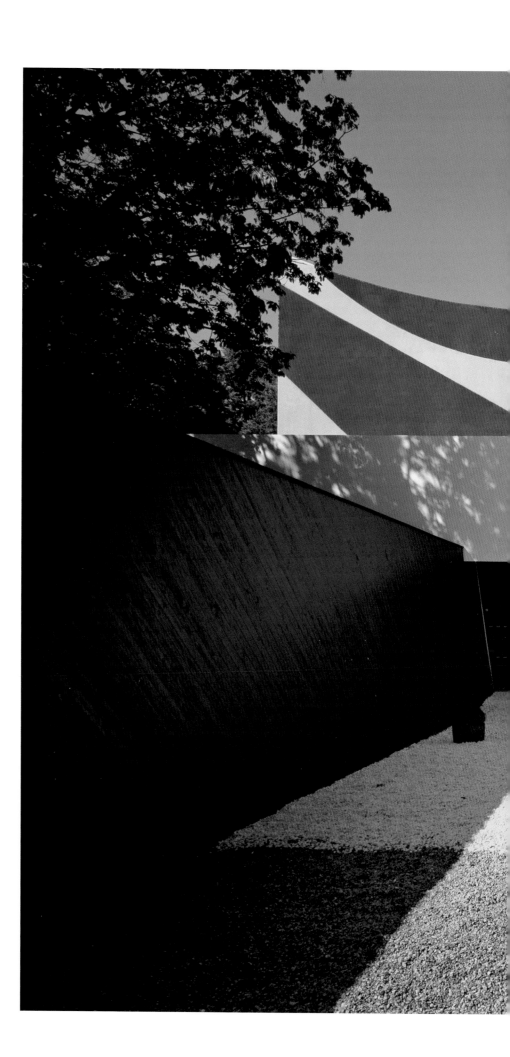

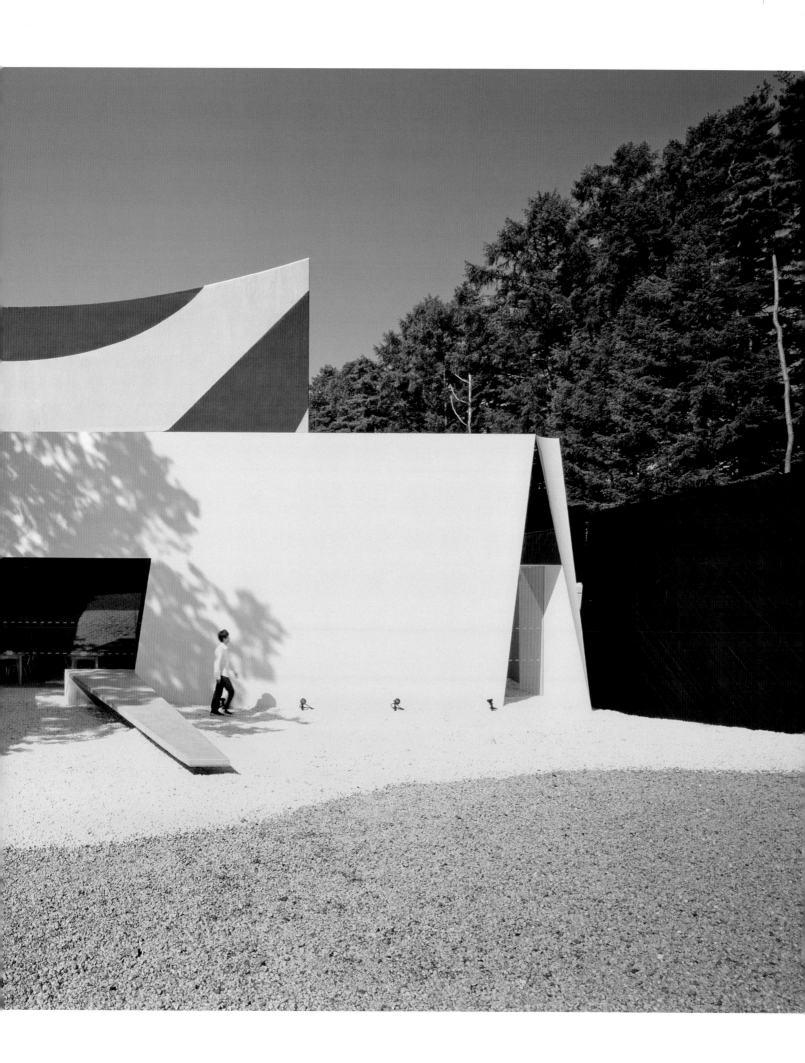

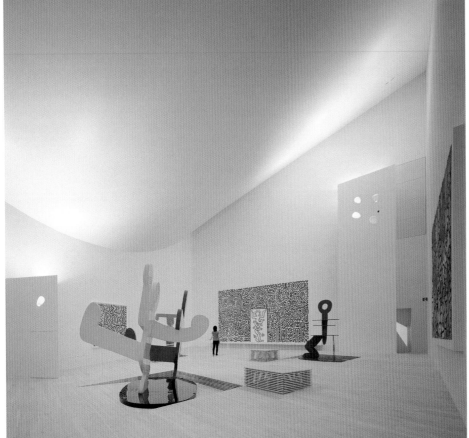

Above The museum sits like an exclamation mark at the culmination of a gently sloping hill.

Left Visual images and music by young Japanese artists complement the visual delights of the galleries.

Left bottom A soaring gallery space echoes the energetic movement of Haring's art.

Right top The galleries are completely enclosed to allow visitors to focus on art.

Far right top The irregular plan is filled with unexpected junctures and lets visitors choose their own route and experience.

of forms, planes, openings, and colors reminiscent of Haring's art. All colors are primary—black, white, blue, and red predominating. Adjacent to the museum building, there is also a decidedly Japanese addition—an *onsen* (hot springs spa)—where museum goers can take a refreshing post-museum soak in tubs of Haring-like shapes.

The interior of the museum is completely closed off from the exterior, with the idea of making visitors forget time and place and focus on the art experience. The route through the museum is based on the client's personal story of Haring and presents each work in the collection as an experience. There are galleries devoted to "Darkness," "Chaos," "Dreams," and so on. Along with Haring's art, the galleries feature visual images and music by young Japanese artists. Throughout, the architecture echoes energetic Haringesque forms—sloping floors, swooping ceilings, and asymmetrical geometric openings in roof and walls.

The route ends at the roof terrace, with picturesque views over forests and snow-capped peaks. According to Kitagawara: "Once on the roof you realize where you are; as if you made a short trip from Kobuchizawa to the underground scene of New York in the 1970s and 1980s." What Haring, a radical and often controversial artist whose career ended abruptly with his death from AIDS at thirty-one, would have thought of this shrine-like museum in a Japanese forest, is anyone's guess. But as a work of architecture, Kitagawara's design has been uniquely successful.

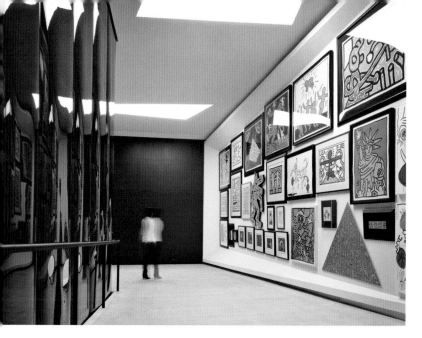

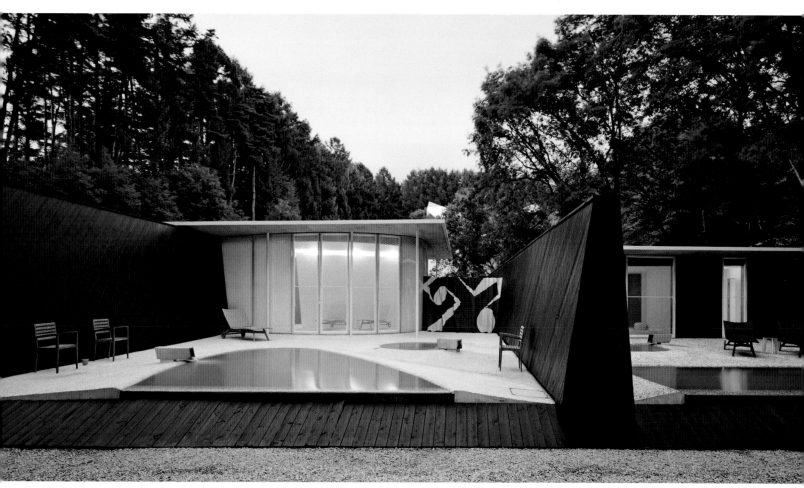

Above The museum includes an *onsen* with hot baths of Haring-like shapes.

Left The museum is designed to stand in symbiotic relationship to its natural surrounding.

Right Haring's primary colors accent the cool grays of an exterior rock garden.

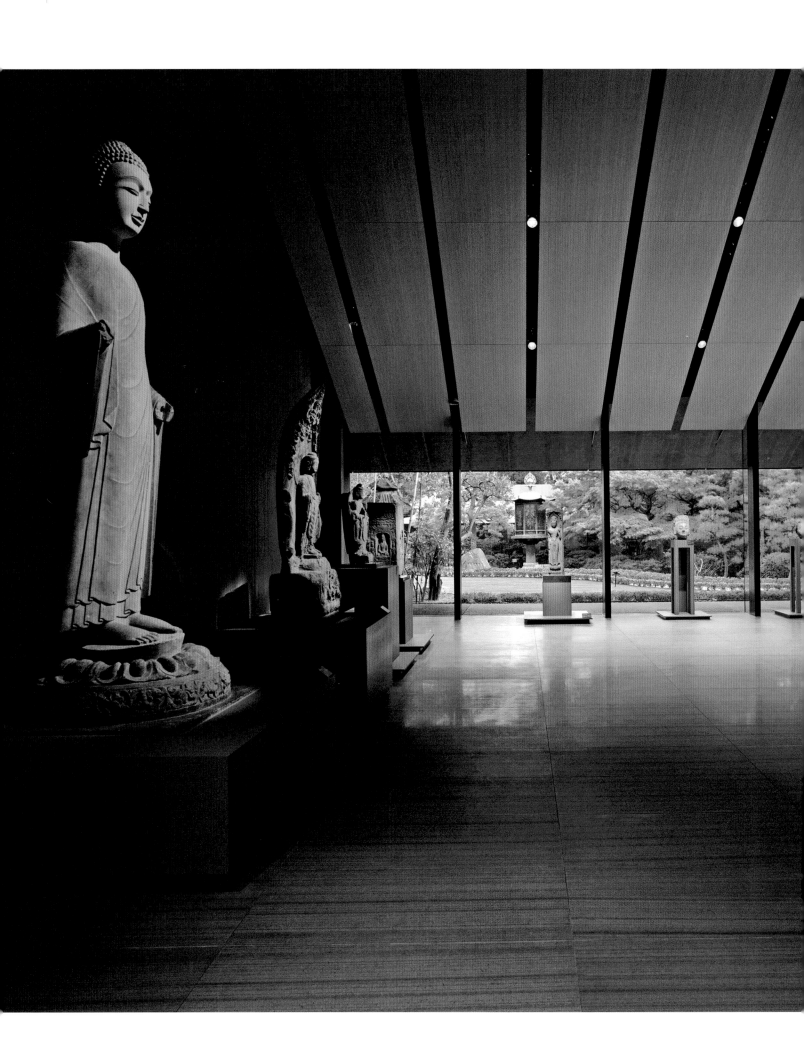

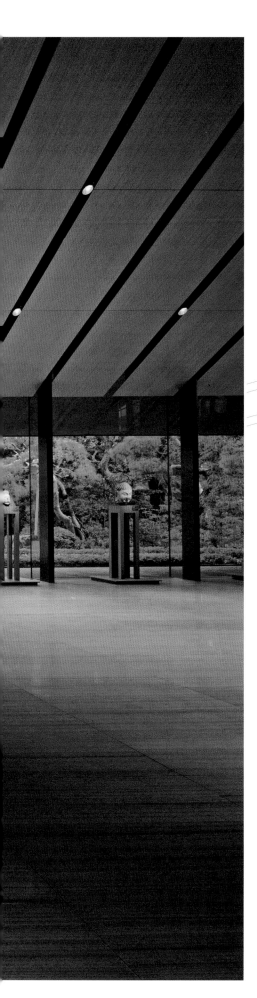

NEZU MUSEUM

Architect **Kengo Kuma & Associates**
Location **Aoyama, Tokyo**
Completed **2009**

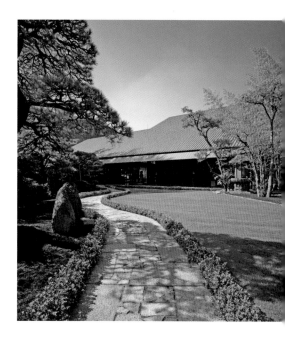

In a three-year renovation of the historic Nezu Museum, located in the smartest neighborhood in Tokyo, architect Kengo Kuma has achieved a subtle balance between past, present, and future, an ability that he has come to be known for.

The Nezu Museum was founded in the private residence of industrialist Kaichiro Nezu to display his collection of Asian art. From its opening in 1941 until closing for renovations in 2006, the museum was popular not only for its impressive collections but also for its extensive wooded grounds containing a picturesque stroll garden culminating in an iris pond at the bottom, and several *chashitsu* (teahouses). During those years, the Aoyama area grew from a genteel residential area outside central Tokyo to the pulsating heart of the fashionable metropolis.

Above The museum's plan is a transformation of the former residence of Kaichiro Nezu, located at a busy Aoyama intersection.

Top right Next to the bustle of Omotesando, the museum is an oasis of tranquility, both in its structure and in its gardens.

Left Thanks to broad glass openings, the museum's Japanese gardens form an atmospheric backdrop to the softly lit interiors of the lofty foyer gallery.

In this busy, trendy area, the architect set out to create something quite the opposite, based upon the spirit of the original building. According to Kuma, the design philosophy of Japan emerging from its humid climate and dense forested landscapes, has developed towards an "unassertive architecture" that does not emphasize its own presence but rather establishes relationships with its natural environment. In his words: "The Japanese people used a big roof to protect architecture from sunlight and to introduce outdoor air into the spaces within. They have created several types of light-controlling screens that allow for comfort without mechanical air conditioning. They also valued the use of vernacular natural materials with minimum intervention. This was in great contrast to twentieth-century architecture that placed importance on the monumentality of architecture and the individual signature of the architect, often times in contradiction to what the natural environment offered."

Kuma's present work explores the possibilities of this "unassertive architecture" in contemporary terms, but architecture that reflects its context and not a homogenous international style. With the Nezu Museum, his aim was to create for the visitor an experience of *wa*, the Japanese concept of harmony. Coming from the energized streets of Omotesando, the museum space is an oasis of tranquility, both in its structure and in its adjacent gardens.

The first view of the Nezu Museum is that of a handsome, tall boundary wall topped by a multi-tiered tile roof of the sort that was typical in the homes of the wealthy during the Edo period. The solidity and dark earthy color of the building's roof and walls, partially obscured by rows of tall leafy bamboo trees, is refreshingly austere in this showy neighborhood. In contrast to these closed

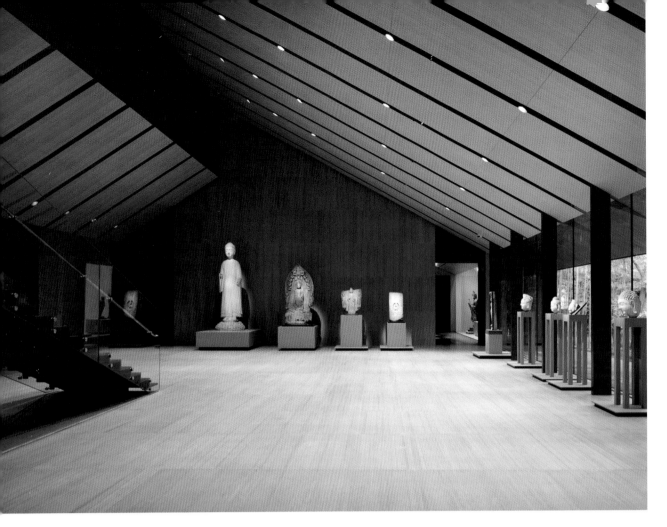

areas, the main entrance opens to an airy, glass-walled pavilion under a steep slanting roof of dark tile and deep sheltering eaves lined with bamboo. The multilayered roof is a crisp, modern interpretation of the swooping traditional Japanese roof and defines the entire structure, creating shade and atmosphere.

Kuma's design mixes new buildings with the renovated original structure to create a multi-functional complex housing archives, administrative and preservation facilities besides public amenities and exhibition space. Kuma has replaced the storehouse and the exhibition wing of the old museum with a new exhibition wing consisting of two stories above ground and one below ground level that is opened to the back gardens by a trench and glass wall. A 1990 annex was transformed into an archives/administration wing for preservation of artifacts. The remains of the Nezu family home—a stonewall and fireplace—are preserved in a café.

The design of the new roof aligns the height and form of the old roof with the new roofs in a

gesture of reverence. The multilayered angles of the roof profile are echoed in interior ceilings, from the lofty entrance foyer to the individual galleries. While the roofs define the volumes, bamboo trees define the atmosphere. Bamboo grows along the street façade and lines the eaves, while the interior surfaces are lined or accented with bamboo and sandstone produced in Qingdao, China, which has a similar texture to bamboo. Pale, warm, and tactile, bamboo adds a scale and a warm Japanese character to the spaces.

The rear of the museum opens on to the vast gardens. This wooded area is a rarity in central Tokyo, and Kuma's design makes the most of it, with broad glass openings to magnificent greenery and views.

In a neighborhood known for its high-profile architecture, Kuma has built a modest home for a spectacular museum—"unassertive architecture" that stands out in its understated elegance, sense of place, and functional beauty.

Above The multilayered roof—a crisp, modern interpretation of the swooping roofs of traditional Japanese architecture—defines the entire structure, creating both shade and a serene atmosphere.

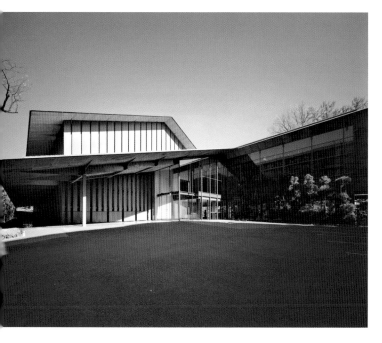

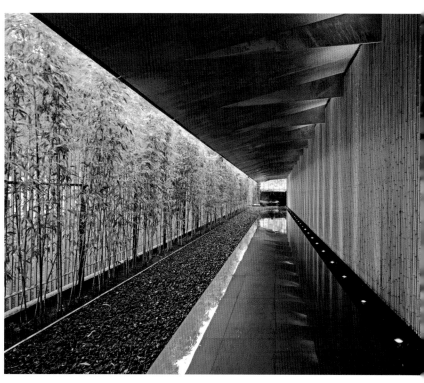

Opposite Interior surfaces are accented with tactile bamboo and a sandstone selected to complement the texture of bamboo.

Above Deep eaves lined with bamboo create shade and a tautly elegant visual experience.

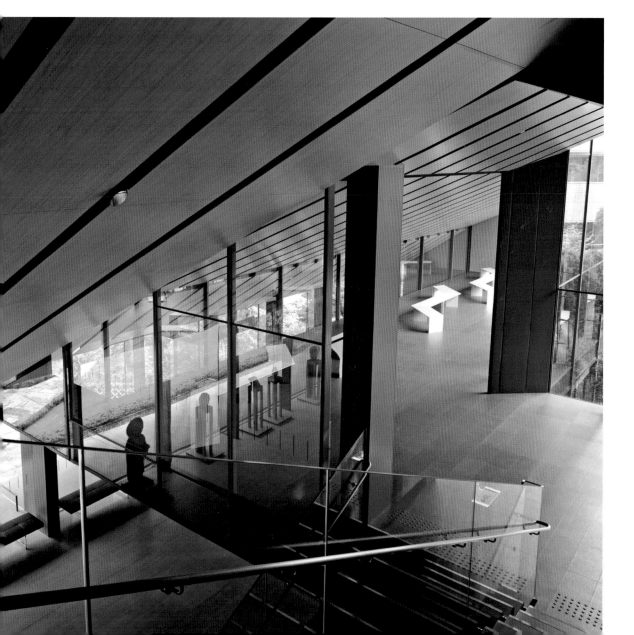

Above A tranquil walkway lined with bamboo marks the transition from street to museum.

Left Glass partitions and stairways create soaring spaces defined by the slanting roofs.

INUJIMA ART PROJECT "SEIRENSHO"

Architect **Hiroshi Sambuichi**
Location **Inujima, Seto Inland Sea**
Completion **2008**

Inujima is a small island in the Seto Inland Sea, just a five-minute ferry ride from Japan's main island, Honshu. From 1909 to 1919 it was the site of a copper refinery. It was a crumbling industrial wasteland when Soichiro Fukutake, a Japanese businessman turned art patron and environment campaigner, purchased the factory site with the surprising intention to create the Inujima Art Project. Fukutake had earlier worked with Tadao Ando to create another high-profile art project on nearby Naoshima Island. At Inujima, Fukutake intended to facilitate a similar cultural and environmental renaissance.

To create the first phase of the Inujima Art Project, which was aptly named "Seirensho" (refinery), Fukutake turned to Hiroshima-based Sambuichi Architects. Known for their eco-centric designs, the firm uses a mix of modern

Above The design incorporates the copper refinery ruins, setting the museum low into the ground next to a 100-year-old smokestack.

Below An entrance of steel is cut into the granite walls.

Right The museum rises just slightly above the ground, and its exterior is characterized by walls of local granite built up to hem in earthen areas of the roof.

technology and traditional concepts and craftsmanship, employing renewable materials and energy sources wherever possible. Principal Hiroshi Sambuichi says his inspiration comes from "the workings of planet earth."

Artist Yukinori Yanagi was asked to create an art installation for the project. Yanagi responded with a piece—"Hero Dry Cell"—composed of found objects from the refinery ruins mixed with those from the home of novelist Yukio Mishima, a vocal critic of Japan's rapid modernization.

The gallery designed by Sambuichi is hardly noticeable from a distance. The old seaside factory ruin still had six smokestacks and some brick walls, which are incorporated into the design. The museum itself sits low between these structures.

The design required minimal building materials to be brought into the island. Instead, recycled or sourced local materials were used, along with natural resources of the sun, wind, heat, and cold.

The tallest smokestack rises from the base of the sprawling T-shaped plan, a placement that allows the nearly 100-year-old smokestack to be utilized as part of a natural ventilation system, pulling air in and out of the galleries, and controlling the interior temperature naturally. In addition, the smokestack and the surrounding structures were also reinforced as to not pose a safety hazard from possible falling debris.

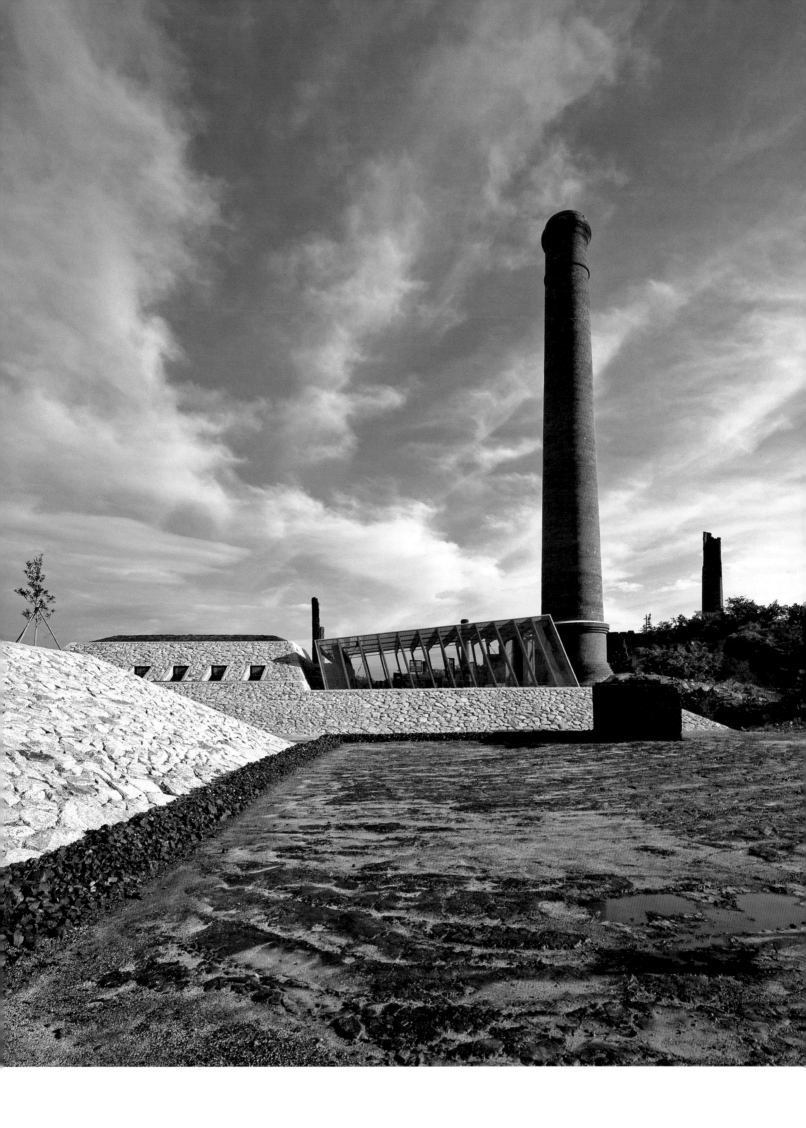

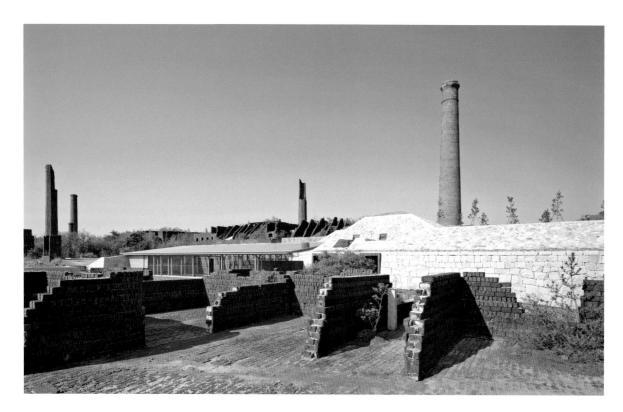

Opposite above Yukinori Yanagi's art installation, "Hero Dry Cell," creates a dramatic space of intense light and shadows.

Opposite below The landscaping was designed to be low maintenance, with indigenous plants left to grow around the site, with only pedestrian paths added between the museum and the ruins around it.

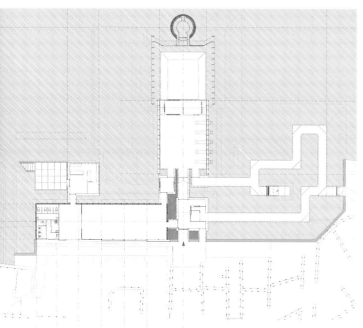

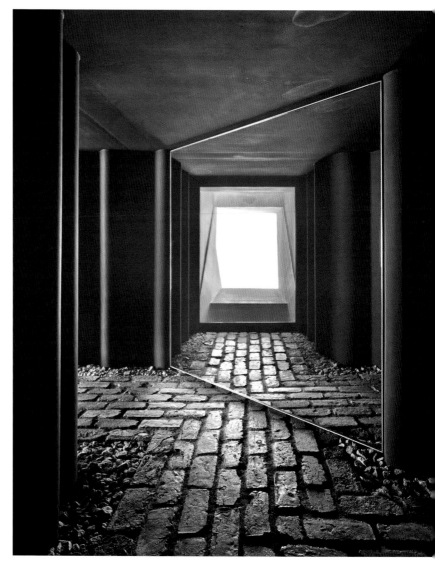

Top The design required minimal building materials to be brought into the island, and incorporates local materials and the ruins of the old factory.

Above The tallest smokestack rises from the base of the sprawling T-shaped plan, and is utilized as part of a natural ventilation system.

Right The Earth Gallery is an 80-meter-long steel-encased underground tunnel.

Rising just slightly out of the ground, the structure's exterior is characterized by walls of local granite built up to hem in earthen areas of the roof. The unmarked entrance of steel is cut into these walls. Inside, a foyer leads into a variety of galleries, each highlighting an aspect of Inujima's natural environment.

The Earth Gallery is an 80-meter-long steel-encased underground tunnel. The gallery leads visitors through a series of corridors lit only by a single window and nine strategically placed mirrors to amplify the natural light. The steel conducts the temperature of the surrounding earth inside, making the gallery naturally cool in summer and warm in winter. Says Sambuichi: "Visitors follow the flow of the air, feeling the effect of ground heat as at passes up to the sky." In contrast, the Sun Gallery is more like a greenhouse, composed of a large glass roof, a wooden frame, and floors of *karami* bricks made from refinery waste salvaged from the sea, which soak up heat.

The Energy Hall is a vaulted wooden space filled with reflected light and warmth. This leads to the Chimney Hall, set just below the smokestack and opened to the sky by a raised wood-frame glass ceiling. Internal doors and windows modulate the flow of air between the galleries. According to Sambuichi: "The building consists of four types of spaces—the Cooling Ducts which use ground heat, the Heating Gallery which utilizes energy from the sun, the Power Hall which utilizes energy from the sun and the ascending air current of the chimney, and the central environment-controlled Main Hall. All these, along with vegetation and the water-cycling landscape, make up the complete facility." Sambuichi Architects was helped in creating these systems by the innovative engineers at Arup Japan.

Landscaping was designed to be low maintenance, with indigenous plants left to grow around the site, with only pedestrian paths added between the museum and the ruins around it. Citrus trees were planted to help filter polluted effluents, with water thus saved reused for landscape irrigation.

Explains Sambuichi: "The client, Mr Fukutake, insisted that the ruins be renovated into a most sophisticated, unprecedented art island serviced only by natural energy." The goal for both client and architect was to create a "new seirensho (refinery) of thought for art and natural resources."

Mr Fukutake has continued to support creative development in Inujima, sponsoring the Inujima Art House Project by Kazuyo Sejima.

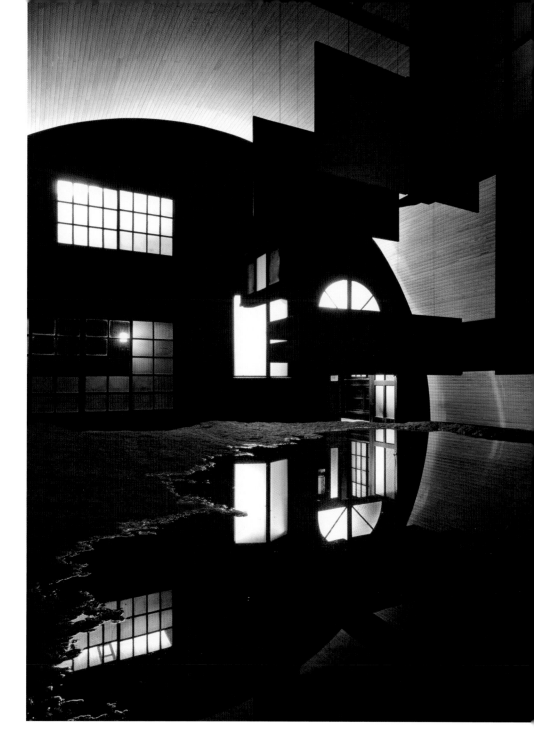

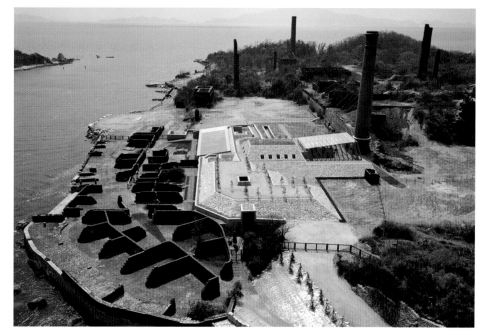

SHIMANE MUSEUM OF ANCIENT IZUMO

Architect **Fumihiko Maki**
Location **Izumo, Shimane Prefecture**
Completion **2006**

For over fifty years, from his youthful membership in the avant-garde Metabolist movement to his 2009 work on the new World Trade Towers in New York, Fumihiko Maki has been a major figure in Japanese and world architecture. With the Shimane Museum of Ancient Izumo, he again demonstrated, with his precise modernist vocabulary, his masterly ability to unite West and East, tradition and innovation, the rational and the spiritual, architecture and landscape.

The region of Izumo played a major role in early Japanese culture. It is the setting for numerous mythologies, an early transit point to Korea and China, and the location of the first and largest ever Shinto Shrine in Japan in the eighth century. Shimane Museum is located next to the site of the Izumo Grand Shrine on six hectares of land at the foot of the Kitayama Mountains.

The museum is large—it has a 11,855-square meter floor area—but compact. Its jagged roof mimics the mountains behind it. The exterior

Left Maki's own hand sketch of the museum plan.

Below The museum is large (11,855 square meters of floor space) but compact, with its jagged roof echoing the nearby Kitayama Mountains.

Opposite The entrance is a three-level pavilion of glass and steel.

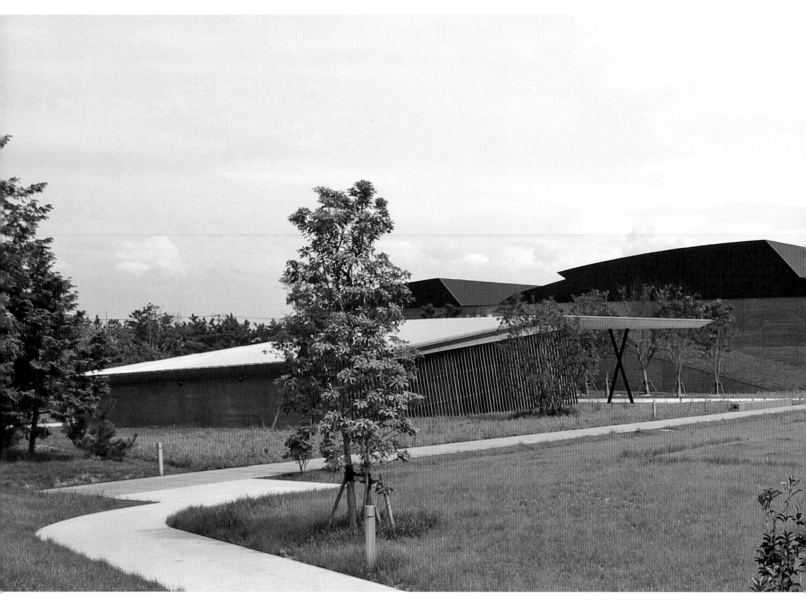

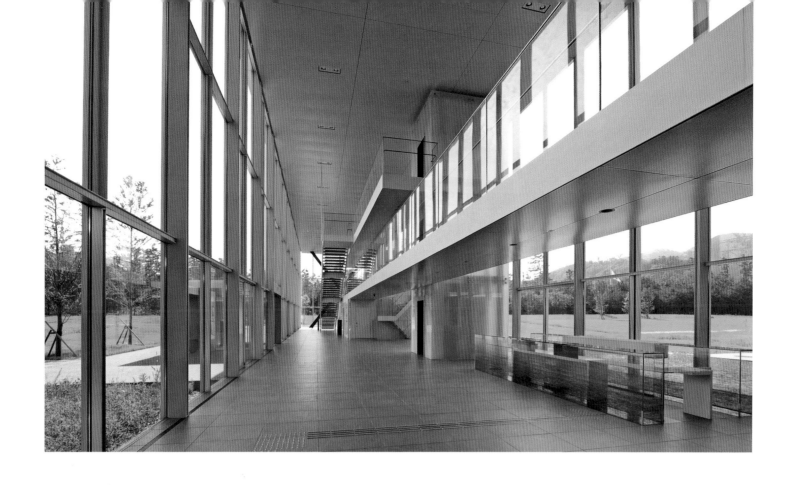
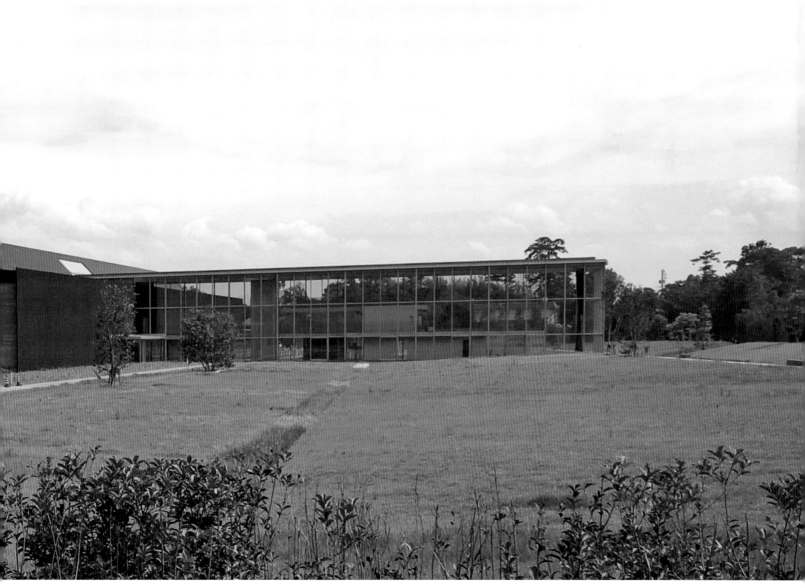

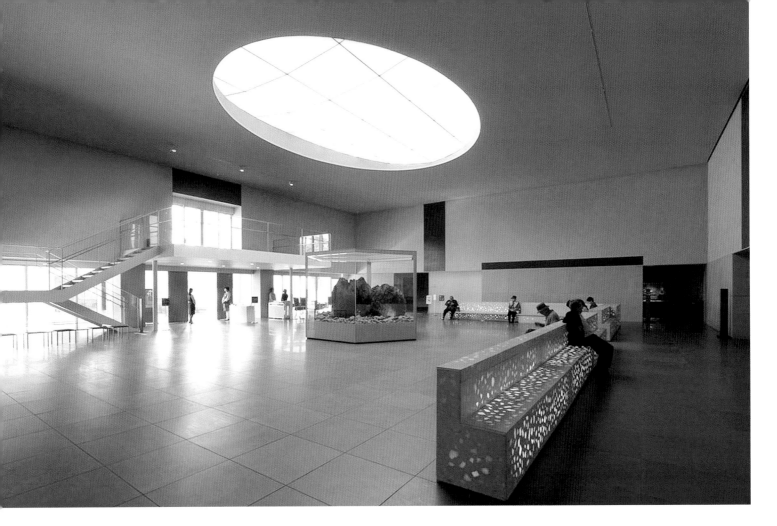

Above The main lobby's minimalist décor emphasizes the display of the Uzu Pillars, believed to be the remains of the original Izumo Shrine, unearthed in year 2000.

Below Maki's contemporary galleries, with their subtle lighting, create a perfect atmosphere for historic exhibits such as these ancient bronzes.

façade is composed of exposed concrete, cedar boards, stainless steel roofing (painted a deep ochre), frosted glass, and Cor-ten steel. It sits respectfully in its landscape, referencing the site's history and natural beauty without obstructing it.

Embedded in the design is Izumo's mythology. The area has a long history of metallurgy, and one local myth tells how the god Kanayoge flew to Izumo on an egret where, after landing in a katsura tree, he introduced "tartara steel" to the local population. So it is a row of katsura trees that leads to the museum's main entrance, a three-level glass pavilion. The trees refer to the myth but also to the spiritual connotations of trees that often line the path to Shinto shrines. Inside the pavilion, a 120-meter-long, 9-meter-high Cor-ten steel wall with a patina but highly contemporary appearance, marks the entry into the museum proper and recalls the area's metalworking past.

The museum's landscaping was designed to create a visual and symbolic connection to the nearby Izumo Grand Shrine and the forested Kitayama Mountains. The Fudoki Gardens that lie to the west of the museum act as a transition zone between the modern museum and its historic surroundings.

A visual continuity between the architecture, the landscape, and history is created by the entry pavilion's transparency. It has a tearoom on the second level, and on the third an observation area offering the only views from the museum of the Izumo Grand Shrine.

Inside, the museum's four exhibition spaces display some of the most important artifacts discovered in Japan, including the timber columns of the eighth-century Izumo Shrine. There are also research facilities, a library, a hands-on workshop, administrative offices, and support spaces.

An intelligent and harmonious blend of architecture, landscape, and history, the Shimane Museum continues the tradition of understated excellence by a master architect.

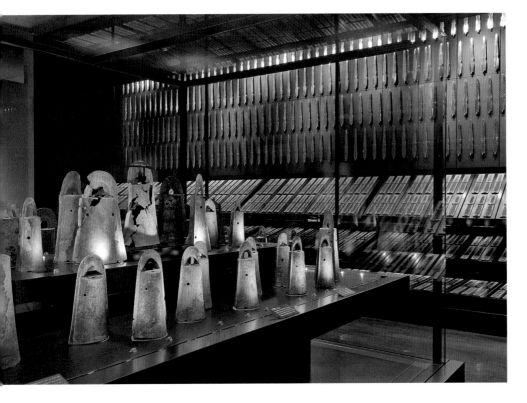

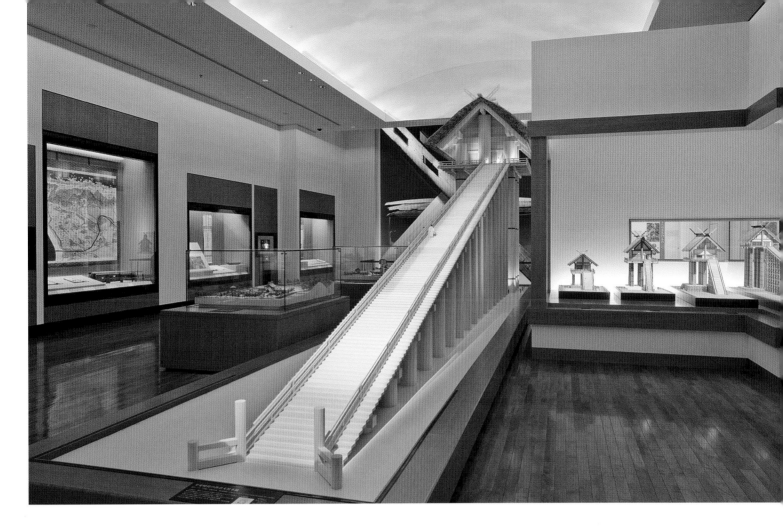

Above A model of the first and largest Shinto shrine in Japan, created in Izumo in the eighth century.

Below A row of Katsura trees, which play a role in local mythology, lead to the museum's main entrance.

Above Crisp, dramatically lit gallery spaces are characteristic of Maki's architecture that blends the rational and the spiritual.

Right The interior is divided into four main exhibit spaces, along with research facilities, a library, a hands-on workshop, administrative offices, and support spaces.

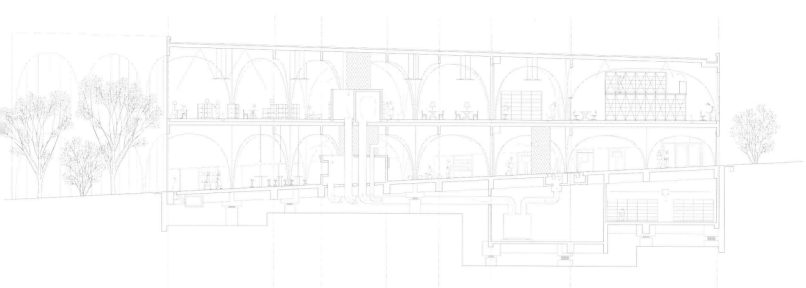

architecture
for learning

It is widely believed that the industrial success of Japan was based upon its strong education system, which is not suitable to drive the post-industrial economy of today. The government has thus made modernizing and internationalizing higher education a priority as one of many strategies towards making Japan competitive in the world once more. This has resulted in a spate of investments in campus buildings as well as some innovative designs.

The important change is a move away from the overly hierarchical system that discouraged individualism and promoted group ethics. Encouraging creativity and the ability to work in the global marketplace is now considered a high priority, as is inclusion of high technology into the campus. Many of the projects included in this chapter reflect these trends. From Tezuka Architects' oval-shaped kindergarten with "happiness" built into the plan to Junya Ishigami's hi-tech university laboratory designed to feel like a "stroll in the woods," learning spaces are being created to open the mind and encourage interaction. Many projects are concerned with the burgeoning field of technology, including Itsuko Hasegawa's forward-looking Techno-Plaza Ota, and several are focused on global perspectives, such as the ADH Architects' light-filled School of Global Studies at Tama University. Some works set out to deliberately add a contemporary note in a historic setting, such as the concrete classicism of Tadao Ando's Fukutake Hall at the University of Tokyo, while others, like Paul Tange's 204-meter-high Mode Gakuen Cocoon Tower, toss aside all conventions and redefine the concept of a place of higher learning.

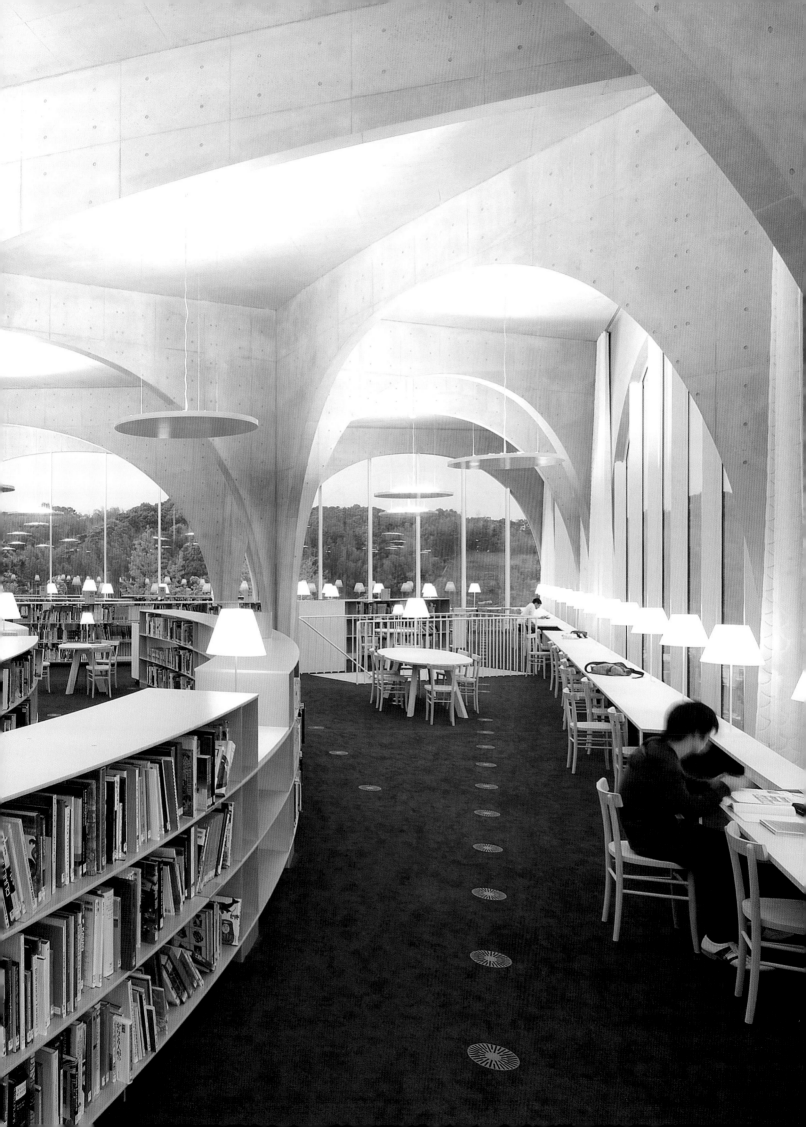

TECHNO-PLAZA OTA

Architect **Itsuko Hasagawa Atelier**
Location **Ota City, Gunma Prefecture**
Completion **2008**

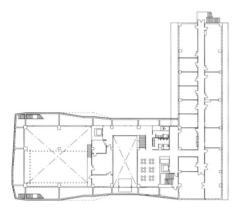

Clear battle lines are drawn between those who believe that independence of academia is sacrosanct, and those who believe that bridging the gap between research and industry is a trigger for innovation and economic development in the future. Located in Ota, a city which is a center for industry and the home of car manufacturer Subaru, Gunma University Graduate School is known for cutting-edge technological research. Techno-Plaza Ota was commissioned to fulfill the goal of bridging the gap between research and development laboratories, and to provide a space for seminars and conferences where students, professors, industry professionals, and the general public can meet.

Combining a modernist sensibility with an expressive use of light, shadow, and form, Itsuko Hasegawa's Techno-Plaza Ota is a distinctive structure ideally suited to its high-tech context and function. The L-shaped building is a five-floor structure. The base wing is designed with a straightforward modernist minimalism, while the longer wing is animated by asymmetrical wraparound balconies. The balconies are cantilevered up to 3.8 meters off the exterior wall and feature undulating plan geometries, the result of exterior staircases that join the floors at different points, changing the line of the balconies at each level.

Above The L-shaped plan shows the simple rectilinear form of the longer classroom wing, while the second segment of the "L" is elaborated by wraparound balconies.

Right Asymmetrical balconies animate the minimalist modernism of the core structure.

Above Evening lights warm up the façade, highlighting yellow walls within the balconies' cool shades of white and gray.

Below Exterior spaces are intended as places for quotidian mingling of students and faculty, now being recognized as an important facilitator of learning.

Left Balconies cantilevered up to 3.8 meters off the exterior wall create extra exterior space.

Below The balcony balustrades are composed of vertical flat steel bars and metal screens perforated with 12-mm circular holes.

Bottom The open balconies are designed to allow fresh air and green views within the school.

Opposite above Section showing how the exterior staircases meet at different points on each floor.

Opposite below Resembling three-dimensional graphics, the balconies symbolize the forward-looking technologies being explored inside.

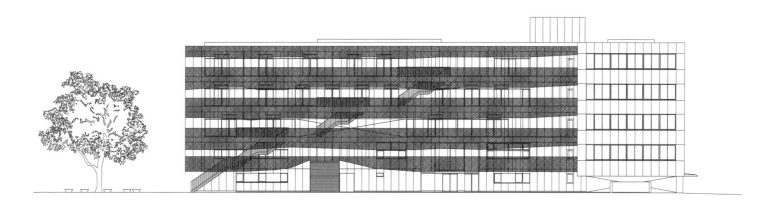

The balcony balustrades are composed of vertical flat steel bars and metal screens that are perforated with 12-mm circular holes. The large open balcony spaces are thus dappled with spots of light as it filters through the metal screens. As this wing of the building stands on land that was formerly used as a park, Hasegawa intended the balconies as a sort of vertical park, creating social places for students and professors emerging from laboratories and classrooms to meet and to enjoy fresh air and light. Informal mingling is considered a crucial part of academic development.

From a distance, the five asymmetrical wrap-around balconies resemble three-dimensional graphics in the making, suggesting the forward-looking technologies being explored inside. At night, the wing's brilliant yellow walls and metallic silver balconies seem to glow, bringing a distinct urban identity to the building.

Itsuko Hasegawa is the first female Japanese architect to gain international recognition, and is herself a professor and generous mentor to many younger architects. She grew up sailing, which has perhaps influenced her explorations of space and form using industrial materials. Important influences on her work include that of her professors, Kiyonori Kikutake and later Kazuo Shinohara, under whom she also worked at the Tokyo Institute of Technology.

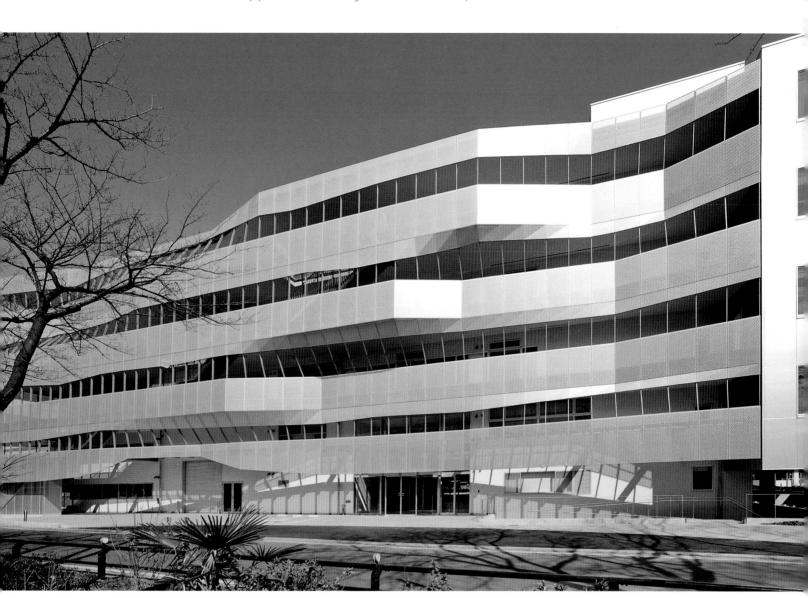

TAMA ART UNIVERSITY LIBRARY

Architect **Toyo Ito & Associates, Architects**
Location **Hachioji City, Tokyo**
Completion **2007**

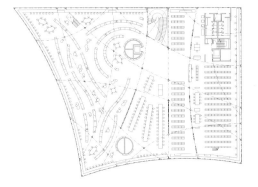

No two Ito buildings look alike because in each project the architect responds to its unique program and context. In the words of Ito: "Architecture has to follow the diversity of society, and has to reflect that a simple square or cube can't contain that diversity." If there is an overall theme to his work, it is a search for balance—between nature and technology, individual and society, utopia and reality, or, as in the case of the Tama Art University Library, geometric form and formlessness. His ability to find this balance has led him to become one of the great urban poets of our time.

The façade of the library recalls a Roman aqueduct. However, no ancient arch ever looked so weightless and free flowing. Steel, reinforced concrete, and custom-made glass are seamlessly fitted together here to create a smooth, taut surface. Each arch varies in height, width, and form, like the Pont du Gard seen through an Alice in Wonderland prism. The arcades seem to gracefully tiptoe in syncopated steps across the space on legs that appear too slender to support a building of concrete and glass. Toyo Ito has indeed used a traditional form—the arch—but in a radically new way.

To create this ethereal structure, Ito worked closely with the well-known structural engineer Mutsuro Sasaki, with whom he has collaborated on several projects, including the one that first brought Ito to international attention, the Sendai

Above The curved walls of the plan lead to the free-flowing divisions of space in the library, and the dramatic exterior.

Right The elegantly weightless façade is utterly modern, but also recalls a Roman aqueduct.

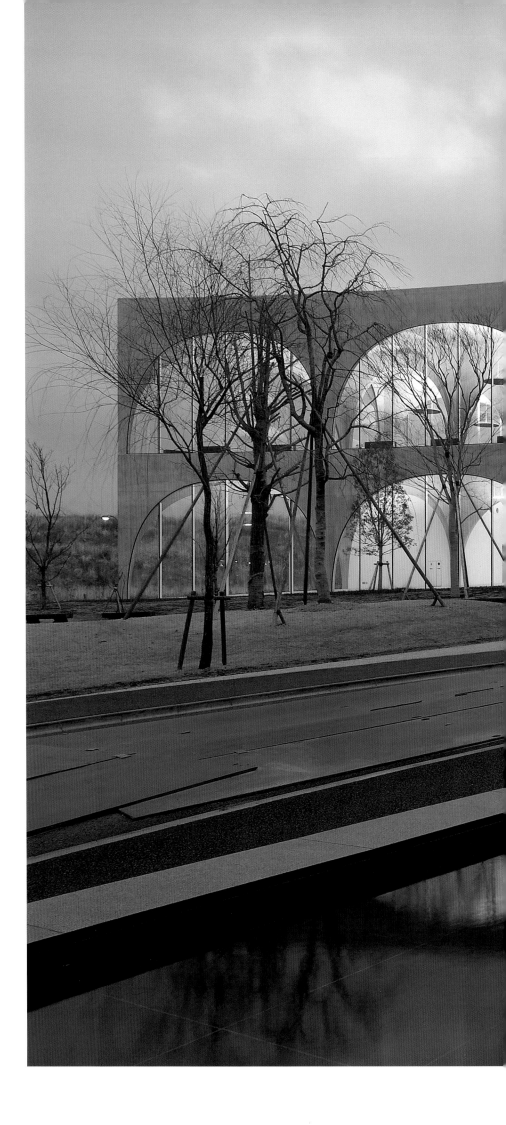

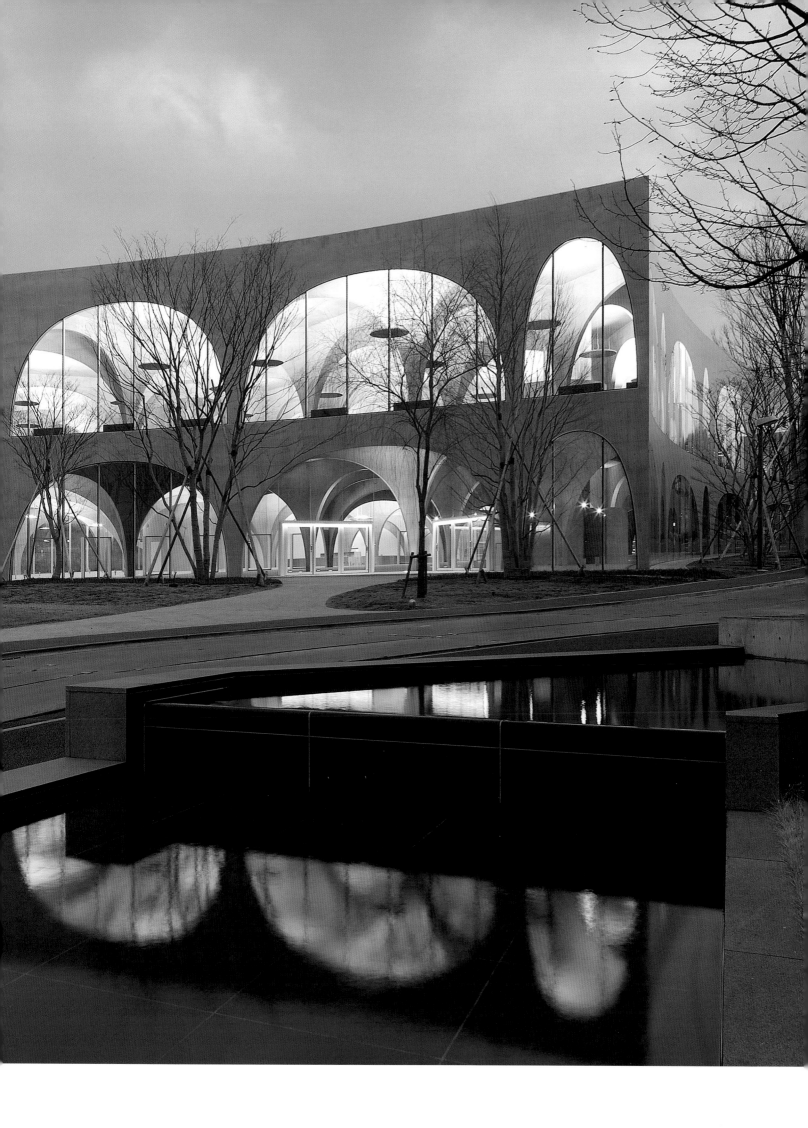

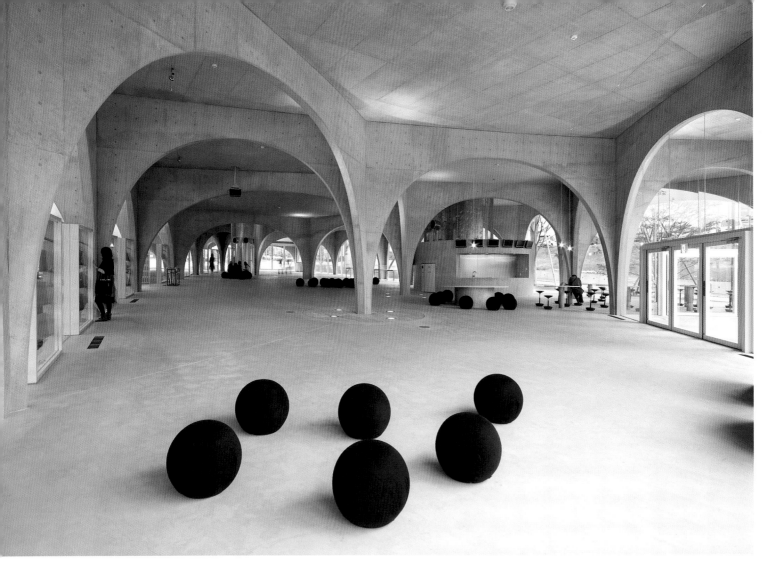

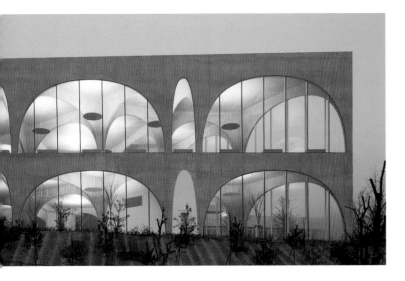

Top The ground floor, which follows the gradient of the gently sloping terrain, is a wide-open gallery space that also acts as an active thoroughfare.

Above Section showing the building's intricate structural system, multifarious arches, and sloping floors.

Left Steel, reinforced concrete, and custom-made glass have been carefully detailed to seamlessly fit together to create a smooth, taut surface.

Mediateque. The pair devised a unique construction strategy for the library. In their words: "The arches are made out of steel plates covered with concrete. In plan, these arches are arranged along curved lines, which cross at several points. It is because of these intersections and arches working in combination that we were able to keep the arches extremely slender at the bottom and still support the heavy live loads of the floor above. The spans of the arches vary from 1.8 to 16 meters, but the width is uniform at 200 mm."

Tama Art University, located in the suburbs of Tokyo, wanted the library to be multifunctional. Its site is highly visible, facing the university's main gate, and so the library needed to look distinguished. The project brief asked for expanded library space as well as space where students and professors could interact outside the classroom since before the library the only other meeting space was the cafeteria.

Ito initially planned to place the library underground, with a single story above ground as a gathering place. However, various factors made this impossible, so the idea was altered to create a "subterranean space above the ground." The resulting design inverted Ito's grotto and features two floors, each with a single large space loosely divided into functional areas by arcades.

The plan is deceptively simple, made up of an undulating grid of delicate arches. The ground floor is a wide-open gallery space that acts as an

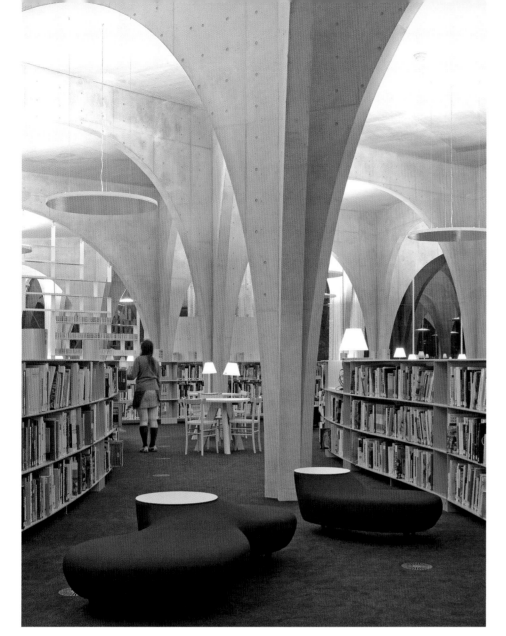

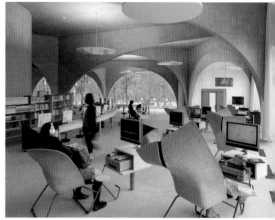

Left top Sinuous shelves and reading tables echo the undulating arches and quadripartite columns.

Left bottom Partitions and the furnishings of the library, mostly designed in collaboration with Fujie Kazuko Atelier, are kept below eye level to preserve the green campus views.

Above The coolish color scheme—gray dotted with black, white, silver, and natural wood—is accented by the colors of books and the seasonal colors visible outside.

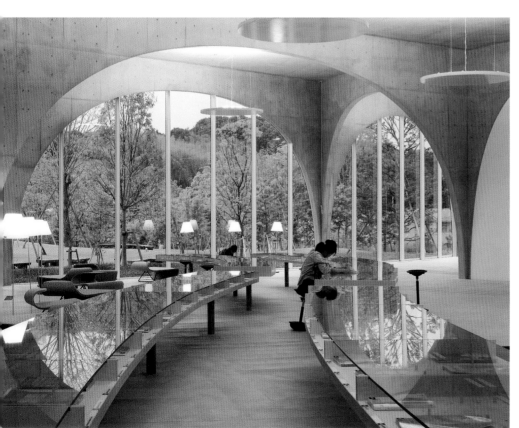

active thoroughfare for those going to the library or simply crossing the campus. The concrete floor follows the gradient of the terrain, creating a gentle slope and the sensation of continuity with the surrounding environment.

This informal space contains the circulation desk, administrative area, media bar, and magazine display area. There are also spaces for teaching, performance, or displaying art work, as well as meetings or simply relaxing between classes. Stairs shaped like a floating curlicue climb to the upper-floor reading area where low shelves filled with art books mix with study areas.

The undulating arches and quadripartite columns define the spatial continuity of the interior spaces, which are further articulated by sinuous shelves and reading tables. On both levels, floor-to-arch windows fill the space with natural light. To preserve the views, Ito kept partitions to a minimum, and the furnishing, mostly designed in collaboration with Fujie Kazuko Atelier, below eye level. The discreet color scheme—cool concrete gray dotted with black, white, silver, and natural wood furnishings—is accented by the shelves of multicolored books and the seasonal colors of the natural environment outside, visible throughout the library.

Ito's library is a luminous space spread out over a skewed plane that encourages personal interaction and creative use of space. Appropriately for a library, it appeals to both the intellect and the eye, with its ingenious structure and alluringly unadorned aesthetic.

KANAGAWA INSTITUTE OF TECHNOLOGY (KAIT) WORKSHOP

Architect **Junya Ishigami and Associates**
Location **Atsugi, Kanagawa Prefecture**
Completion **2008**

The Kanagawa Institute of Technology (KAIT) Workshop was Junya Ishigami's first completed building as an independent architect. Expectations were high as Ishigami's extended family includes such illustrious architecture names as Shinohara, Ito, and Sejima, and this young architect, only thirty-four when the KAIT Workshop was completed, did not disappoint.

Ishigami was asked to design a non-academic space for creative pursuits, a studio facility where students from various disciplines, from engineering to design, could casually drop in and work on individual projects ranging from furniture to robots and anything beyond.

Instead of creating a typical lab-like workspace, Ishigami took inspiration from a highly non-tech idea—to create a studio with the feel of a stroll in the woods, with sunlight filtering through the trees. The result is a simple structure—a single-story glass parallelogram-shaped box that has become the centerpiece of the 32-acre campus located in Atsugi in the western suburbs of Tokyo.

The concept is minimal—an exterior curtain wall of thin glass enclosing a 2,000-square meter single-room space, and an interior scattered with fine columns embedded in a concrete floor. Its main entrance is subtly indicated by an indented doorway and thin steel canopy.

The interior, fully visible from the exterior, is characterized by a forest of 305 columns. The five-meter-high steel pillars loosely organize the interior into fourteen freely arranged open spaces. There is a check-in area marked by a circular counter as well as four multipurpose work spaces, an office-like area for supervisors, a supply shop, and specialized areas for activities such as pottery, woodworking, computer graphics, and machine construction.

All this is organized not by the more typical structural grids or proscribed paths but by the purposeful placement of columns, furniture, freestanding HVAC units, and potted plants.

Daylight flows in from the glass walls and linear openings in the flat roof, with ceiling fixtures and lamps allowing students to work at night. The only opening in the glass walls is the entrance, with ventilation provided via floor and roof vents.

Ishigami has stated: "I wanted to make a space with very ambiguous borderlines, which has a fluctuation between local spaces and the overall space. This allows a new flexibility to emerge, revealing reality rather than shaping it."

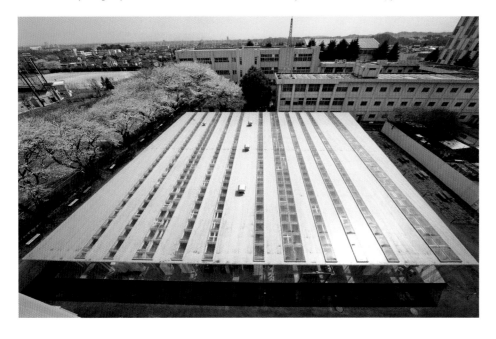

Above The site section above shows the relationship of the KAIT Workshop to its surroundings.

Left The roof, made of a steel deck with wire-reinforced glass inserts, tilts slightly to drain rainwater, and weighs as little as possible to withstand earthquake forces.

Right Inspired by the concept of a woodland stroll, Ishigami designed the interior as a "forest" composed of 305 five-meter-high columns.

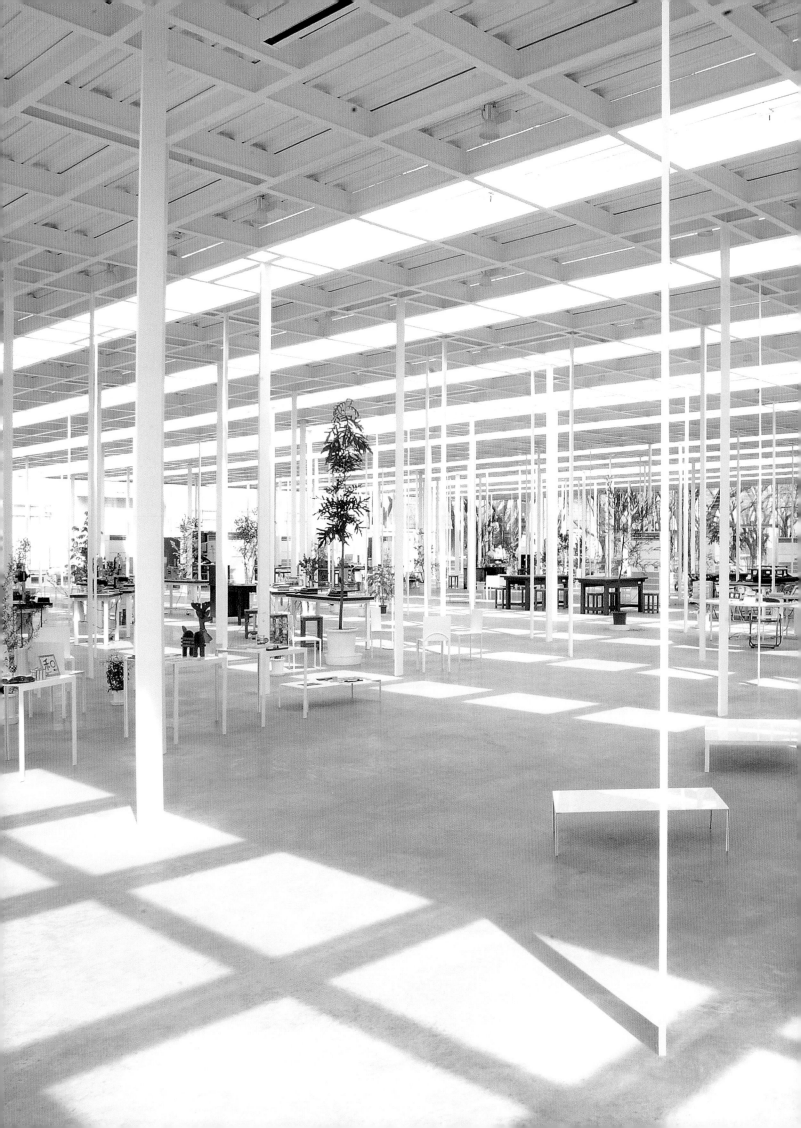

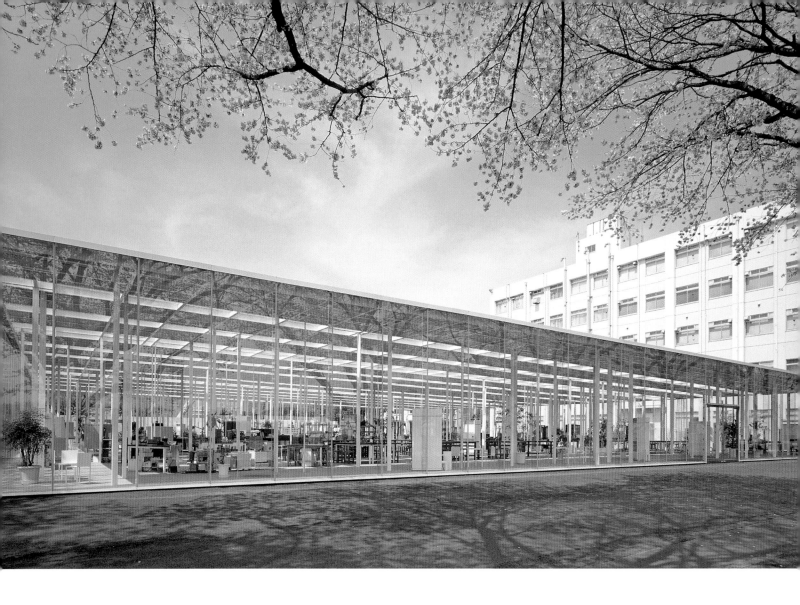

Above Subtly indented doorways in the glass curtain wall lead into the 2,000-square meter single-spaced workshop.

Left As the glass walls have no openings besides the doors, air circulation is provided by roof and floor vents.

The design evolved over three years of experiments and research into the relationships between the columns, a task for which Ishigami developed custom-made software. The columns may seem randomly distributed and arbitrarily shaped but each, cut in various widths from slabs of three different thicknesses, was tailored to the architect's specifications and precisely placed.

Structural engineer Yasutaka Konishi (who had previously worked with SANAA) devised a structural system for Ishigami's complex design, using a conventional two-way roof frame, 42 compression columns for vertical loads, and 263 post-tensioned columns that carry horizontal loads. The roof, made of a steel deck with wire-reinforced glass inserts, tilts slightly to drain rainwater and weighs as little as possible to withstand earthquake forces. The 10-mm glass walls are also as thin as possible, supported by thick glass ribs for vertical stability.

The resultant interior is less laboratory and more ambient space, its fine columns vaguely recalling trees in a forest. Separated only by glass, the surrounding campus greenery acts as a backdrop for the creative pursuits within, a sort of high-tech example of *shakkie*, the Japanese tradition of borrowed scenery. The overall result is a fresh and dynamic blend of architecture and nature, used in the pursuit of fostering interdisciplinary synergy and creativity, the new focus of many universities.

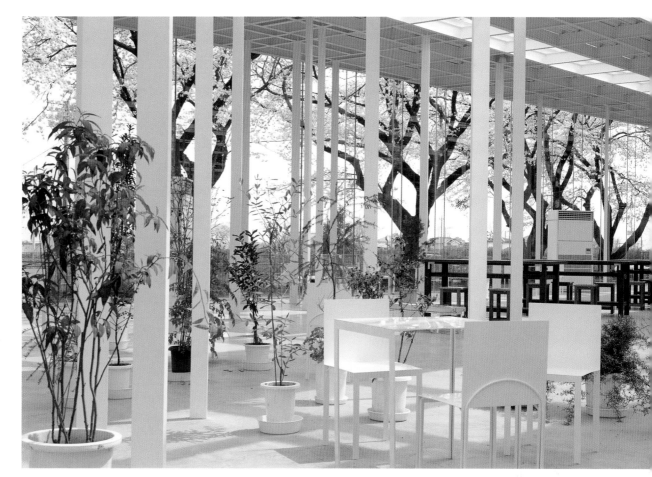

Right The relationship between the columns, each cut in various widths from slabs of three different thicknesses, was worked out by custom-made software.

Below The glass walls add an element of *shakkie*—the Japanese tradition of borrowed scenery—by bringing in the campus greenery as the backdrop of workshop activities.

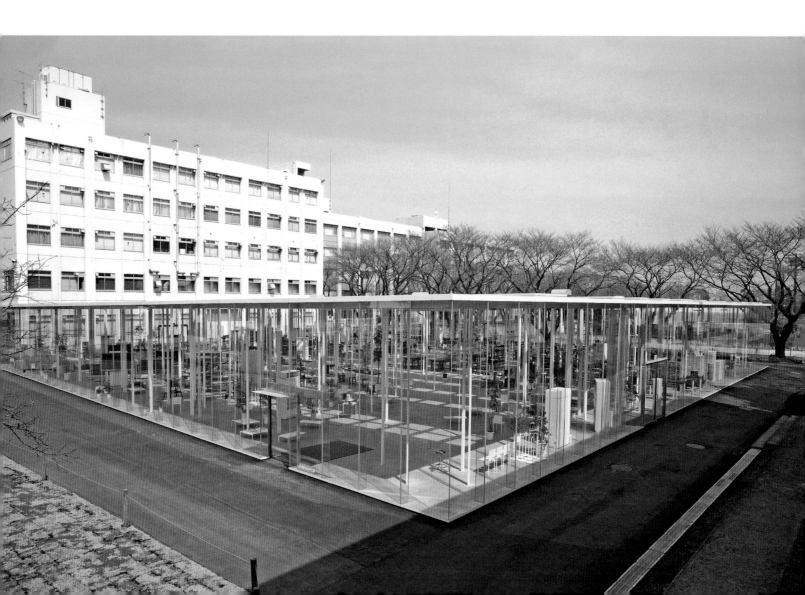

FUKUTAKE HALL, UNIVERSITY OF TOKYO

Architect **Tadao Ando**
Location **University of Tokyo Hongo Campus, Bunkyo-Ku, Tokyo**
Completion **2008**

Left The long and narrow site, and a row of 100-year-old camphor trees, shaped Ando's characteristically minimalist and bold design.

Right The hall's façade is a wall of glass shaded by a deep concrete eave supported by slender concrete columns—a very modern reference to the Sanjusangendo Temple in Kyoto.

Bottom The "Thinking Wall" offers a single opening on to the greenery and the 130-year-old campus dotted with traditional buildings.

The Fukutake Hall, located on the University of Tokyo's Hongo Campus, was commissioned to celebrate the 130th anniversary of the founding of the university. The design of Fukutake Hall is an intriguing presence in a campus that resembles a typical Western university, with big, leafy trees, open courtyards, and buildings constructed in variations of neogothic and art deco styles, historically considered suitable for academic architecture.

By awarding the commission to Tadao Ando, an architect renowned for his crisp, contemporary designs, the university confirmed its recent trend towards modern architecture. The aim was to inspire a new generation of students with a place for interdisciplinary research on information society that looks to the future in both technology and design.

Fukutake Hall is located at the edge of the campus next to the "Akamon" (Red Gate), a traditional Japanese gate dating to 1827 and one of the few extant structures from the Edo period in Tokyo. A bit further away are the Sanshiro ponds and gardens dating back to the early Edo period in 1638, while most other nearby buildings date from the late 1920s. Encircled by this heritage,

Ando's design springs from the geometry of its long and narrow site, 100 meters wide and 15 meters deep, lined by magnificent camphor trees over a hundred years old. In Ando's words: "The design was tackled with the theme of creating a 'place' that would become a new stimulus of the campus, with the hall as a sort of 'buffer zone' between university and city."

The most striking feature of the design is its 100-meter-long monolithic "Thinking Wall" that runs along the front of the hall, built in Ando's signature smooth finished exposed concrete.

According to Ando: "Rather than isolating Fukutake Hall from the rest of the campus, this 'Thinking Wall' is intended to open up a vacant transitional zone between the existing campus and the new building, where students can congregate and engage in lively scholarly interaction." But the wall has received a mixed reception. While its sculptural quality cannot be disputed, it physically separates the hall from the rest of the campus, arguably shutting out rather than encouraging dialog. With no physical or visual connection to the city beyond, Fukutake Hall seems to fall short of Ando's intention to provide a "buffer zone to the city."

Behind the Thinking Wall rests the long, flat-roofed rectangular hall composed of two floors above and two floors below the campus ground level. According to Ando, the design of the façade is inspired by Sanjusangendo Temple in Kyoto, which also has a distinctively long, narrow form.

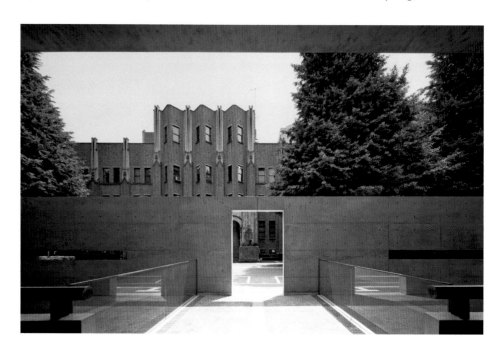

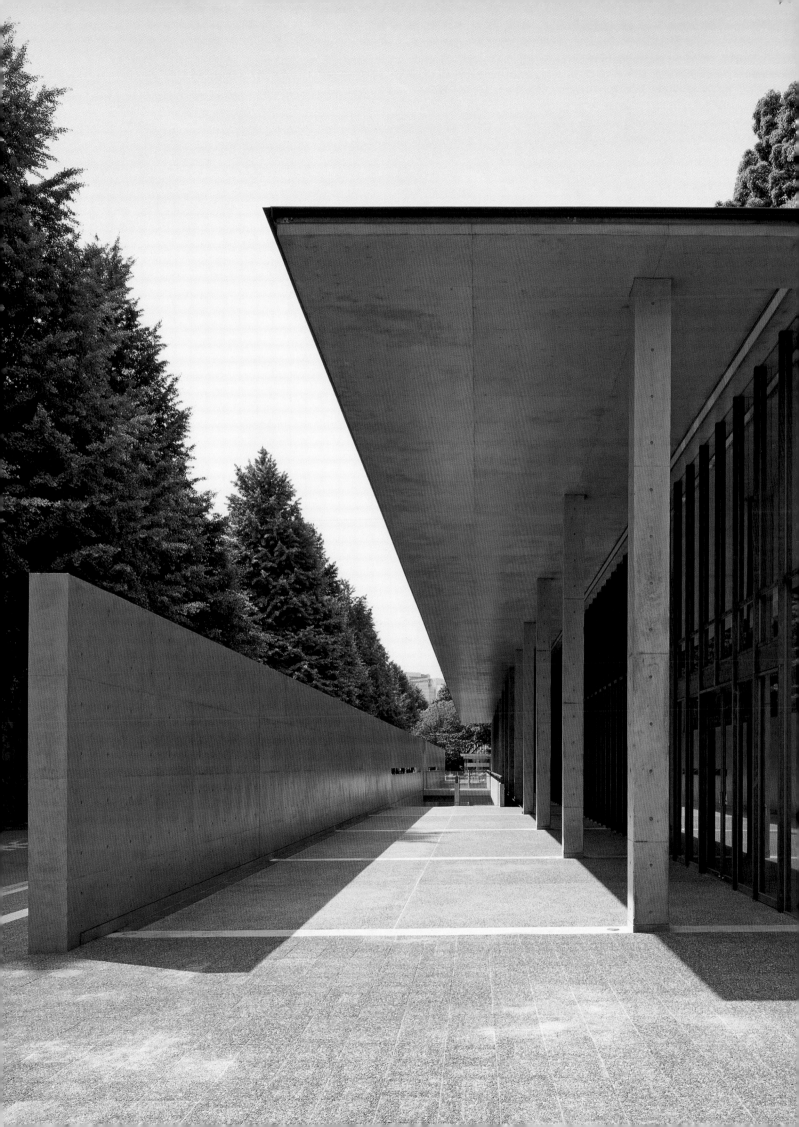

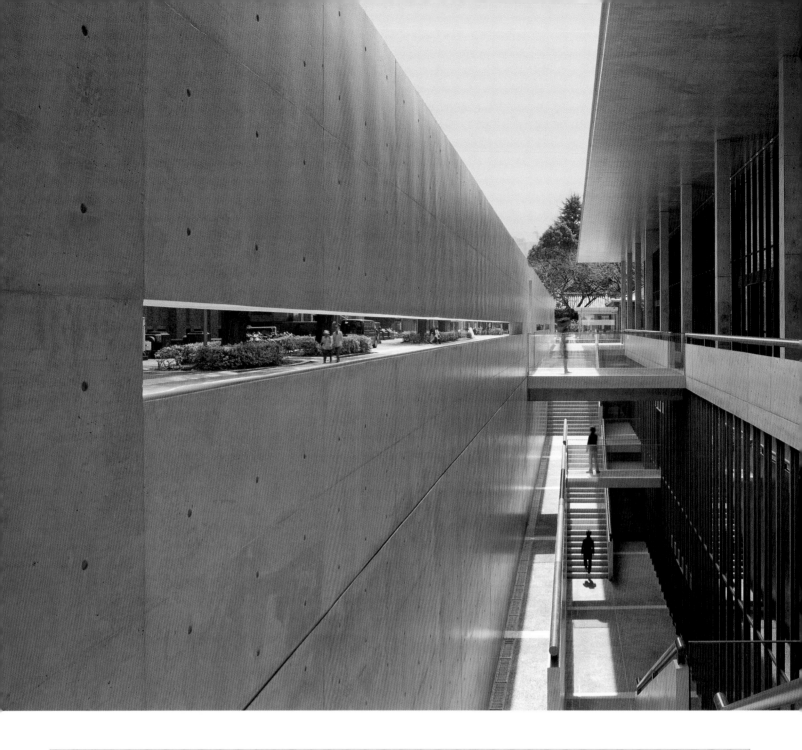

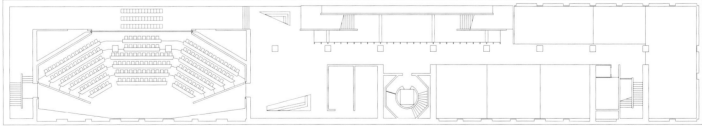

He further explains that the height of the above-ground portion is restricted so as to be lower than the magnificent old camphor trees that line the campus boundary. A similar deference to significant trees is also seen in Ando's design for the Omote Sando Hills complex.

On the other side of the Thinking Wall, the façade of the hall is a wall of glass shaded by a deep concrete eave running the length of the building, supported by slender concrete columns.

The shaded space recalls the Greek *stoa*, a place for meeting and discourse, but updated in glass and concrete. Sunk into the earth, a second glass façade is accessible via exterior staircases and opens up the two lower levels to a patio, while providing them natural light. Inside, Ando mitigates his cool gray palette with a lecture theater for 200 people lined in pale warm wood. Fukutake Hall also holds classrooms and a conference room, along with a reading room and chic café.

Fukutake Hall's exposed concrete and crisp strong forms have an understated classicism and refreshing clarity of line and expression that form an interesting contrast to the heavy brick buildings surrounding it. While the goal of Fukutake Hall was to encourage dialog, Ando has clearly fulfilled this mandate by engendering many debates and discussions on the architecture itself.

Below The colossal 100-meter-long "Thinking Wall," built in Ando's signature smooth concrete, runs along the front of Fukutake Hall.

Bottom The use of light-hued wood creates warm, inviting interiors in this otherwise stark concrete building.

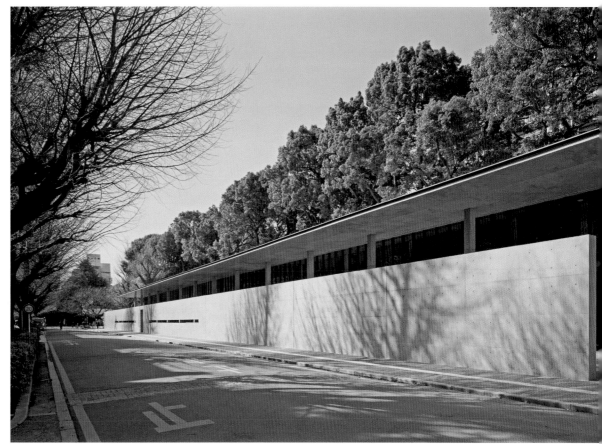

Above Exterior stairs and passageways link the two floors above and two floors below the ground level of the campus.

Left Plan showing the simple organization of the auditorium and classroom spaces.

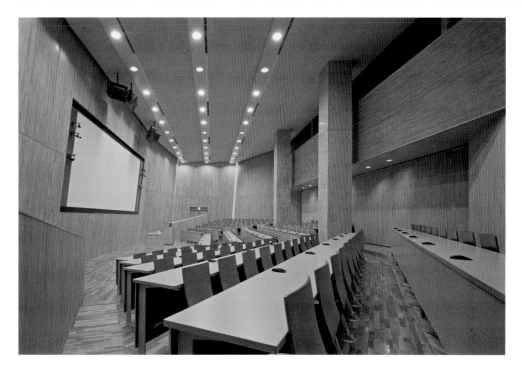

FUJI KINDERGARTEN MONTESSORI SCHOOL

Architects **Tezuka Architects**
Location **Tachikawa, Tokyo**
Completion **2007**

In their designs, Tokyo-based architects Takaharu Tezuka and Yui Watanabe Tezuka consider not only practical aspects but also less tangible qualities, such as pleasure and happiness. As Takaharu Tezuka asked: "To be in a space where people can feel the breeze, the sunlight, the changing of the seasons, where they can forge and nourish relationships with one another. That shouldn't be so complicated, should it?"

The pair were an ideal choice to design a new kindergarten for a Montessori school in a Tokyo suburb. The school's directors were admirers of Tezuka Architects' descriptively named "Roof House," a home where each family member had skylight access to a gently sloping roof that functioned like a communal terrace. So when it came to designing the new school, they simply said: "We want you to make a Roof House for 500 kindergarten pupils."

The old building was a much-loved but falling apart bungalow-style building with a garden, which included large zelkova trees. Thus, there was great pressure to create a structure worthy of the effort of reconstruction but which would also maintain the spirit of the school.

Above The elliptical structure varies in width along its circumference, an irregularity that allows a better use of the space and adds a fluidity to the volumes.

Right The slightly sloping roof terrace offers a fun play space for the kindergarten.

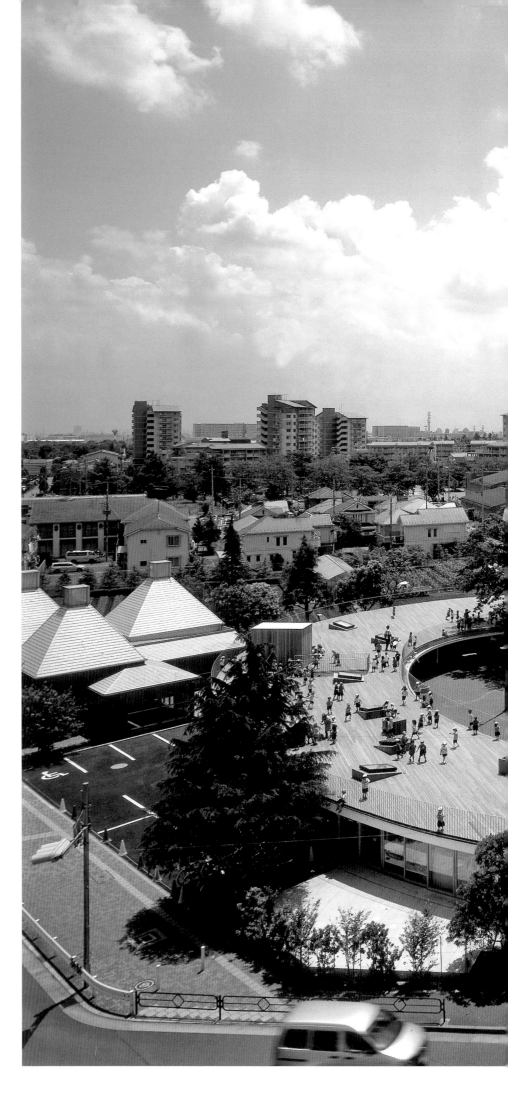

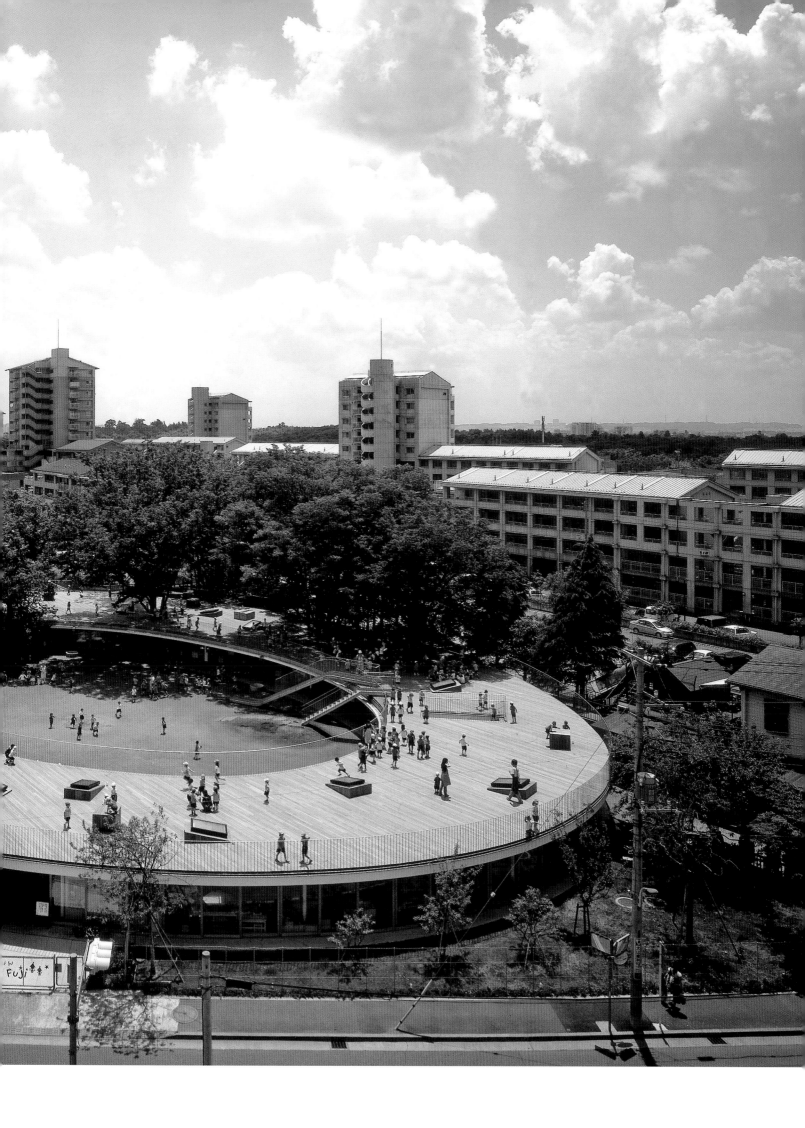

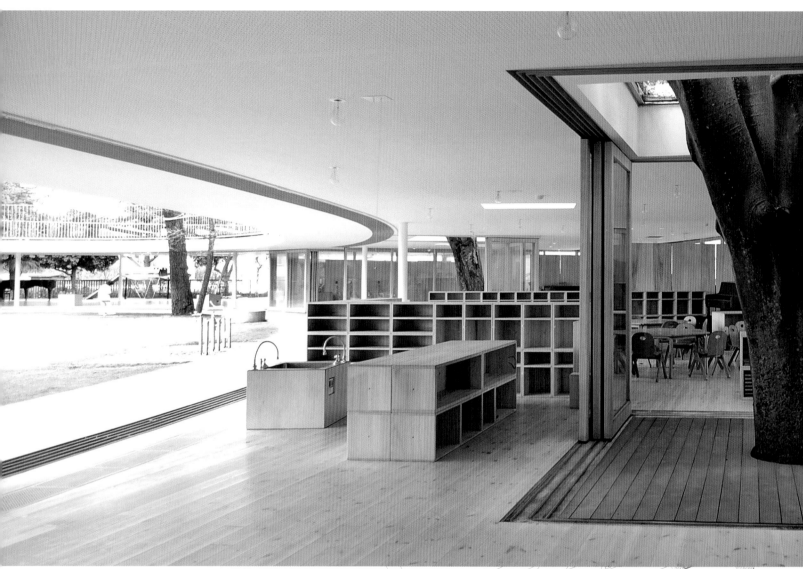

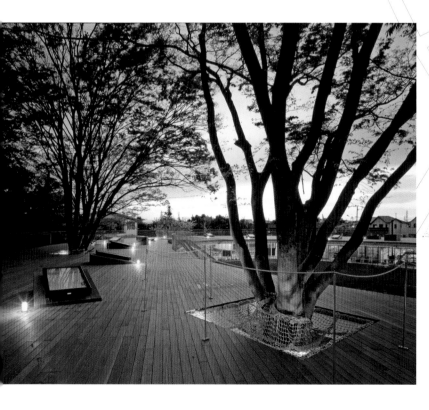

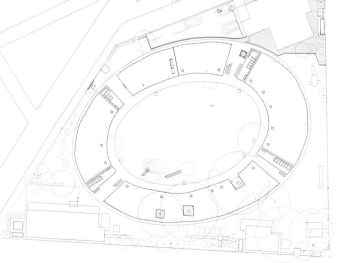

Top Surrounded by sliding glass walls, the single-story structure can be opened for much of the year, creating a dynamic and healthy relationship between interior and exterior.

Above Plan showing the flexible divisions of the interior space.

Left Mature zelkova trees are incorporated into the building, adding a playful natural element.

Right All aspects of the kindergarten were designed as child-friendly, even the ceiling heights, which at 2.1 meters are high enough for an adult but ideal for a child.

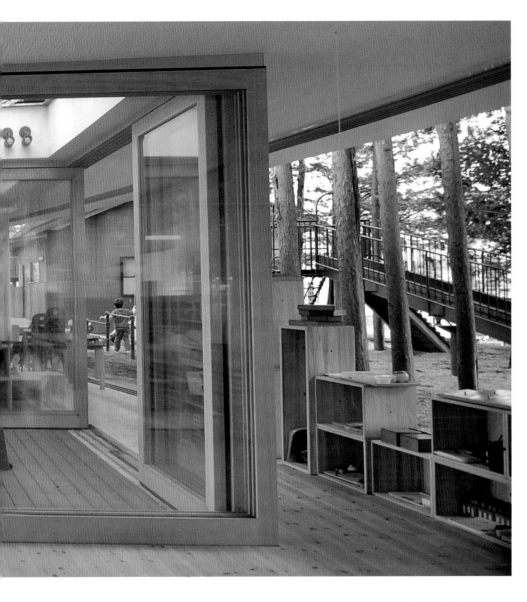

A roof terrace for a kindergarten of some 500 students meant safety issues had to be addressed. An outdoor staircase, short enough not to result in a serious fall, is set upon a small man-made hill in the grass courtyard. And for pure pleasure, a slide can be used to come back down. Slender balustrades, with a maximum spacing of 11 cm, encircle the wooden roof terrace; this width was decided upon after testing to see if children could safely sit on the eaves with their legs dangling between the balustrades.

The whole design is intended to spark the children's imagination. The roof is slightly sloped and encourages children to run and play, peeking down into the school through the many skylights that dot the terrace. The eaves also have an open gutter to drain water and debris from the roof. The water pours out, to the children's glee, via four gargoyles into drainage pans in the courtyard.

But perhaps the greatest delight for the children are the giant zelkova trees that have been incorporated into the circular plan. The trees grow up through the classroom floor via openings in the roof. There, the children can climb and play in the trees protected by netting covering the gap between terrace and tree.

Inside, there are no walls. Instead, piles of moveable, variously sized paulownia wood boxes indicate the space of each class. The box design was invented by Jyo Gakkai, a student organization at the Musashi Institute of Technology (the alma mater of both architects), and was reproduced in soft wood so as to be light enough to move but strong enough so as not to collapse if jumped on. The attractive pale wood boxes are also used to store school books and equipment. Says Yui Watanabe Tezuka: "We believe that there should be no division between functionality and beauty."

The glass walls and numerous skylights provide natural light inside the school. In addition, instead of fluorescent lighting, simple bulbs are used and tuned on and off with strings that hang in the class areas. Each string only controls a few lights as well as a dimmer function, and so its light can be used to illuminate a specific area, creating a focused space.

Even the washbasins have a communal aspect. Group sinks with spout-like faucets were installed to make washing hands a fun, social activity.

Winner of numerous awards, including the AIJ Prize 2009, the Fuji Kindergarten's architecture is that which facilitates not only learning and play, but also hope for the future. As Takaharu Tezuka has said: "If architecture can change the involvement, the architecture can change the child very much. Architecture has that kind of possibility."

With the goal of developing a love of learning as well as happy, sociable individuals, a Montessori School is about learning using the five senses and with a spirit of discovery, ideals that Tezuka Architects built into their kindergarten design.

The architects wanted a space "without dead ends" and thus arrived at a ring-like circular design around an open courtyard. The elliptical structure varies in width as it turns, allowing a better use of space and adding fluidity to the volumes.

Surrounded by sliding glass walls, the one-story structure can be opened for much of the year, creating a dynamic relation between interior and exterior. At 2.1 meters high, the kindergarten's ceilings were intended to be high enough for the average adult and ideal for a child. "Everything is child size," explained Takaharu Tezuka. The low ceiling height also means that activities on the roof terrace can be more easily monitored from the ground level.

MODE GAKUEN COCOON TOWER

Architect **Tange Associates**
Location **Nishi-Shinjuku, Shinjuku-ku, Tokyo**
Completion **2008**

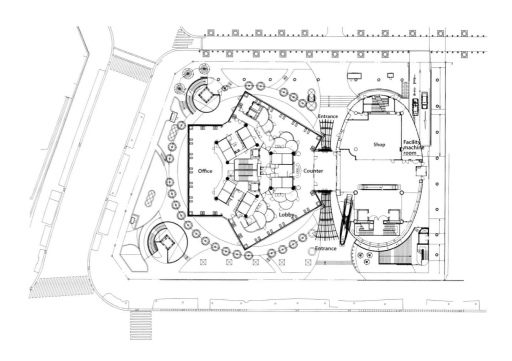

Nothing marks the contrast between architecture in the late twentieth century to that built in this decade than the Mode Gakuen designed by Paul Tange and the nearby skyscrapers in Western Shinjuku designed by his father Kenzo Tange. Kenzo Tange's career spanned the entire history of twentieth-century modern architecture in Japan, and his buildings are steeped in modernist philosophies. Paul Tange, on the other hand, is a product of the contemporary era, where no one philosophy reigns and iconic imagery is demanded by many clients and happily provided by architects empowered with recent computing technologies and new materials.

Mode Gakuen Cocoon Tower is also a unique experiment in educational architecture that would be unlikely in any place other than Tokyo. Rising 204 meters over the Western Shinjuku district of Tokyo, it houses three schools: Tokyo Mode Gakuen (a fashion school), HAL Tokyo (devoted to IT and technology) and Shuto Iko (focusing on medical treatment and care). With four basements, fifty stories and two penthouses, this campus is designed to serve about 10,000 students who arrive from all around Tokyo via the legendarily crowded Shinjuku Station. Instead of the usual horizontal campus, a high-rise campus with a small footprint was the only possible choice in Shinjuku, where land prices are stratospheric and space severely limited.

The tower's distinctive form echoes the "Cocoon" in its name and the fundamental concept of the structure—to provide a nurturing space for students to grow and learn. Tange set out to provide in this tight site not only the necessary classrooms but also the public and social spaces that are critical to the success of a campus, since these are where chance meetings, conversations and ideas flourish. The method adopted to achieve this is described in Paul

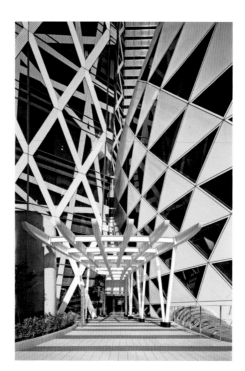

Top The site plan shows the placement of the Cocoon tower and the spherical Annex building.

Above The entrance is located at the junction of the tower and Annex building.

Opposite The tower's "Cocoon" form also reflects its ideological concept—to provide a nurturing space for the approximately 10,000 students from three schools housed in this vertical campus to grow and learn.

Tange's words: "Three rectangular classroom areas on each floor rotate 120 degrees around the inner service core. These rectangular classroom areas are arranged in a curvilinear form from the first floor to the fiftieth floor. The inner core consists of an elevator, staircase and service shafts. The schoolyard-like space, or atrium between the classrooms, is what we call the 'student lounge,' and is approximately nine meters (three stories) high. These atriums are located in three different directions—east, southwest and northwest—in between each classroom area."

Besides the service core, the usable area can only accommodate three classrooms per floor. However, this surprises no one in Tokyo, where "pencil thin buildings" with tiny floor plates abound due to the small size of plots and high real estate values in prime locations. To ease possible congestion in vertical circulation, the different schools in Cocoon Tower are laid out in three parts, an upper, middle and lower tier, each with their own entrance lobbies and student lounges.

The Cocoon's exterior is wrapped in adhesive printed filmstrips on windows to reinforce the idea of a cocoon and to reduce solar loads. Explains Tange: "The elliptical shape permits more ground space to be dedicated to landscaping at the building's narrow base, while the narrow top portion of the tower allows unobstructed views

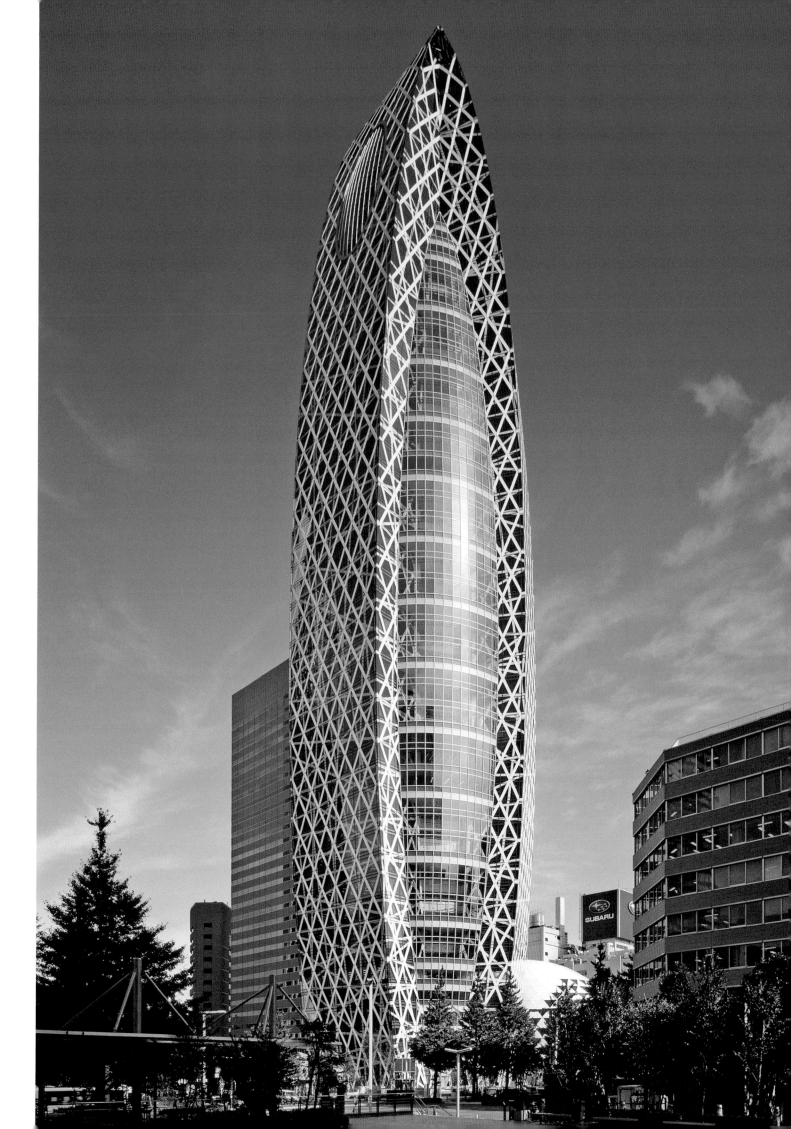

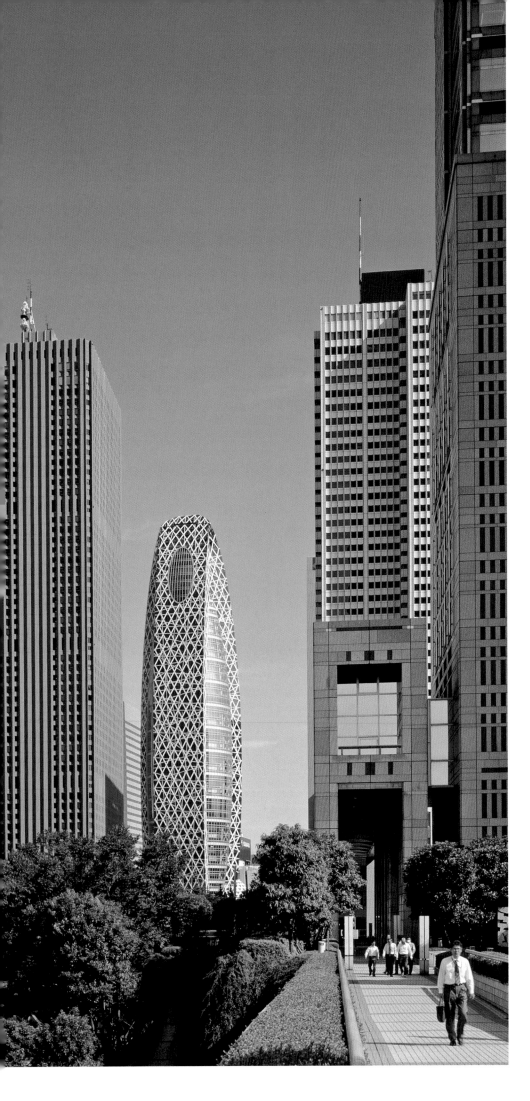

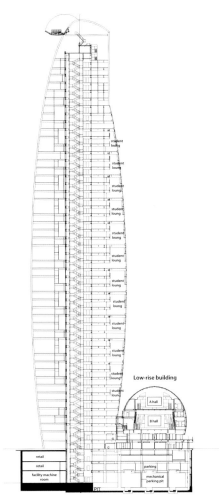

of the sky." As landing space for helicopters on the roof is mandatory for Japanese high rises (in case of emergencies such as fire or earthquake), a retractable roof was devised that opens to provide the required 10-meter-square landing platform, reminiscent of James Bond movies.

Environmental concerns were also addressed in the design. A cogeneration system produces about 40 percent of the building's power and thermal energy. The elliptical shape allows for an even distribution of sunlight, thereby reducing heat radiation to the surrounding area. Complementing the tall cocoon tower is a 30-meter-high elliptical sphere at the base. This is the Annex Building, which contains two large auditoriums, retail space and a car park. The surface of this Annex is patterned by triangular windows.

The Cocoon tower is located in a Shinjuku sub-center business area, home to the first group of high rises built in Japan from the mid-1970s to the mid-1990s. With the "Cocoon," Tange's aim was to revitalize the area with a dynamic new form, its main ground floor hall open to the public, and a troika of schools bringing youth and creativity to a neighborhood of primarily large company offices. The building is a highly successful billboard for the school and a forward-looking experiment in educational architecture.

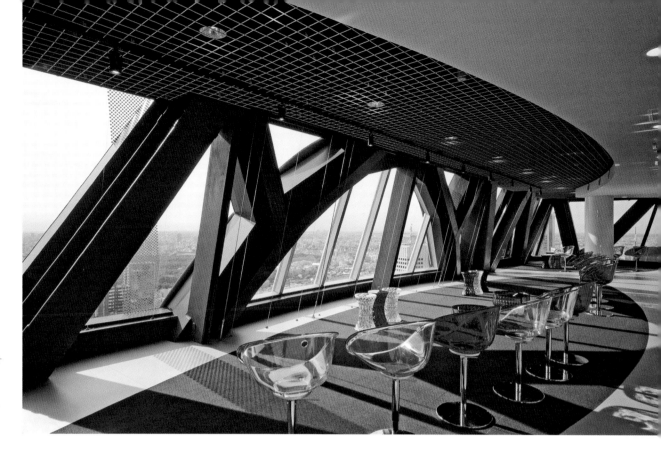

Opposite left Rising 204 meters, the tower's elliptical shape and playful surface stand in sharp contrast to the buildings of Western Shinjuku.

Opposite right Section showing the relatively large inner core devoted to amenities like elevators, staircases and service shafts.

Right The uppermost floors offer spectacular views of Tokyo.

Below The elliptical shape is intended to allow for an even distribution of sunlight, thereby reducing heat radiation to the surrounding area.

Above The triangular grid of the ceiling adds a decorative element to the interior.

Right Nine-meter-high (three-story) atriums function as student lounges.

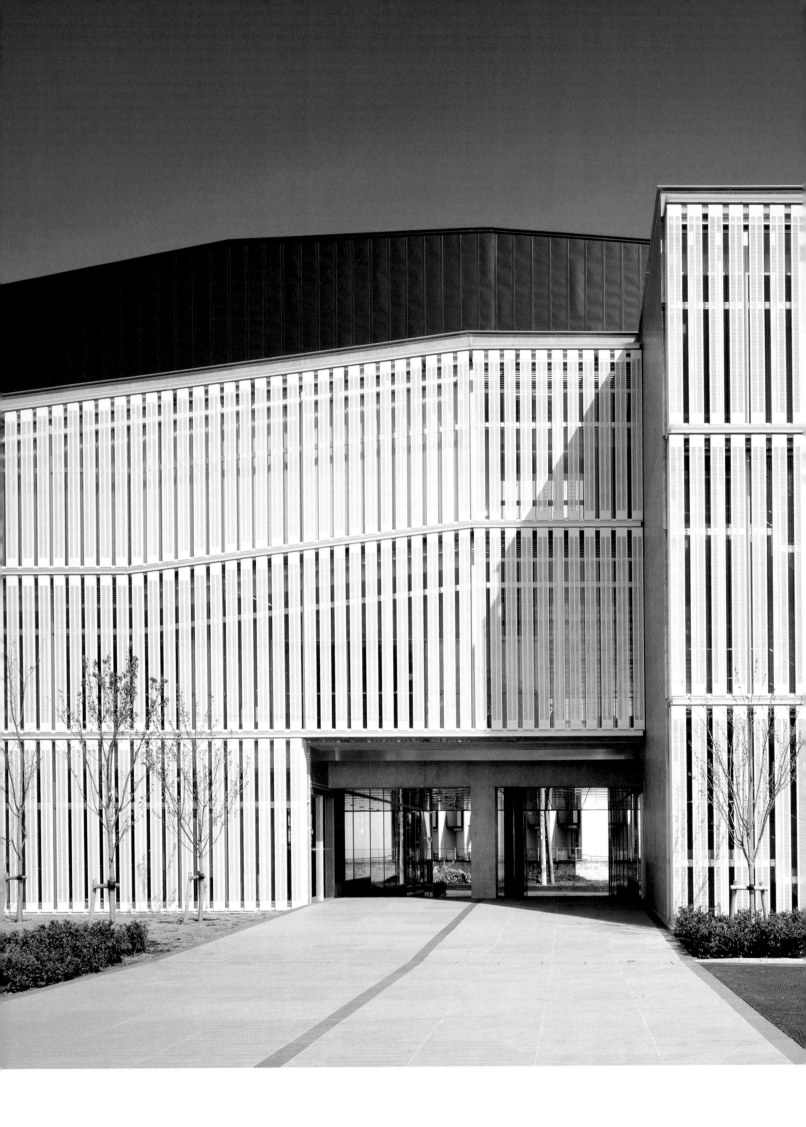

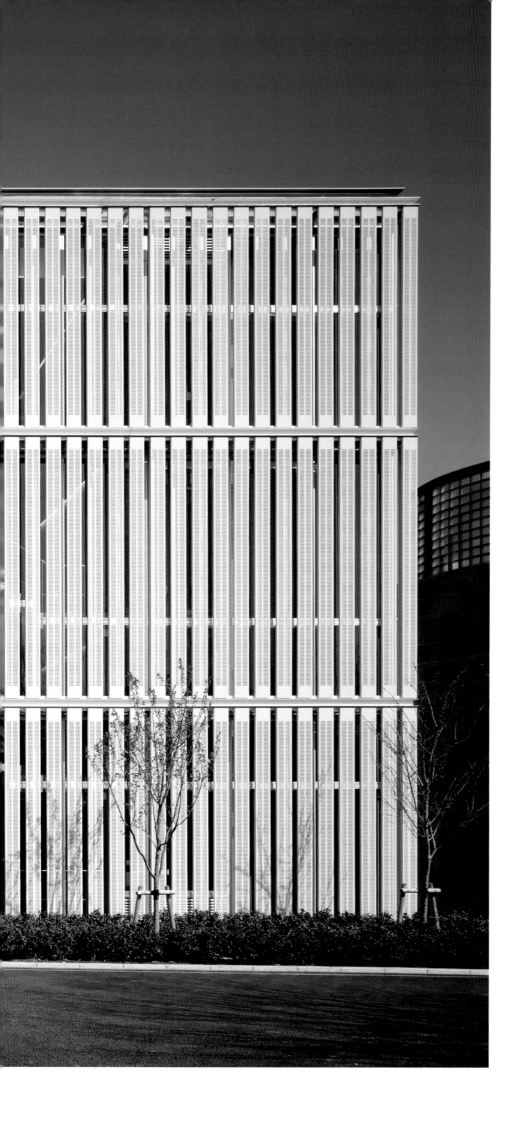

TAMA UNIVERSITY SCHOOL OF GLOBAL STUDIES

Architects **ADH Architects**
Location **Fujisawa, Kanagawa Prefecture, Tokyo**
Completion **2009**

The School of Global Studies is a new faculty at Tama University, which is located in the western suburbs of Tokyo. The school has a Liberal Arts program taught in English, designed to provide Japanese students with a global perspective on Japan and the world.

In their design for the school's main building, architects Makoto Watanabe and Yoko Kinoshita Watanabe, ADH Architects founders and principals, explored the theme of light in all its facets. "Light has a fundamental function of illumination; that is, making things visible," explained the architects. "In this project, we set out to fuse the function and meaning of light." Their concept considered not only the use of natural light in the design but also the creation of space conducive to intellectual enlightenment, that would take light "from inside to outside/from our campus to the global society."

The overall plan is a simple rectangle, but articulated in varied ways. The façade is a crisply controlled composition of irregular and regular elements. Multiple planes and asymmetrical lines are set against rows of vertical white aluminum panels placed before the glass façade, and these are separated by architrave-like horizontal lines. Irregular openings in the slats give a syncopated rhythm to the façade.

The rectangular box of the main entrance cuts through the ground floor of the three-story building, and emerges again from a similarly articulated rear façade to act as the gateway into the campus. The first floor contains the library and a student lounge, while the second floor contains a lecture hall and classrooms. However, the usual arrangement of interior corridors feeding classroom spaces has been reversed here. The third floor is mostly taken up by a large lecture theater

Left The façade is a composition of vertical white aluminum panels separated by architrave-like horizontal lines, set before the glass façade.

whose arching ceiling forms the curve of the building's roof.

The façade's slats envelop the building like a porous screen, allowing diffused natural light inside via glass corridors that line the façade. These transitional corridors also offer filtered views of the exterior campus, connecting and separating interior and exterior space in a somewhat similar manner to the screens and *engawa* verandas in traditional Japanese architecture.

Explained the architects: "From the outside, it is hard to peek in. But from the inside, the view out is fairly open through the perforated screens; thus the users within are very aware of the transparent nature of the building. In the evening, whatever is happening inside manifests itself in silhouette. Similarly, the layout of classrooms surrounded by corridors allows glimpses of student activities from the outside, while providing a buffer zone."

The interior décor echoes the silvery aesthetic of the exterior, using glass, metal and cool colors accented with natural wood to articulate the space. The building's refined modernist lines echo those of Japanese master architects like Fumihiko Maki and Arato Isozaki, the latter with whom Makoto Watanabe worked early in his career.

To more fully articulate the school's spirit, the architects incorporated inspiring quotes from great global thinkers throughout the school. Rubber flooring tiles were imprinted with quotes and then embedded in floors and walls to inspire the students.

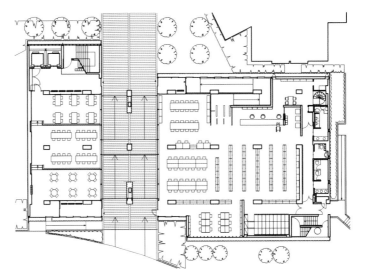

Left The central staircase cuts through the rectilinear plan.

Below left The façade's slats envelop the building like a porous screen.

Below right Irregular openings in the slats give a syncopated rhythm to the façade.

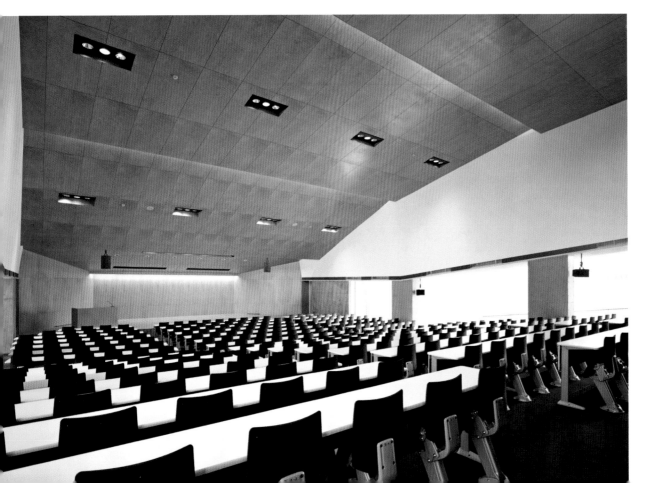

Left The third floor is mostly taken up by a large lecture theater whose arching ceiling forms the curve of the building's roof.

Right A glass corridor leads to a roof terrace.

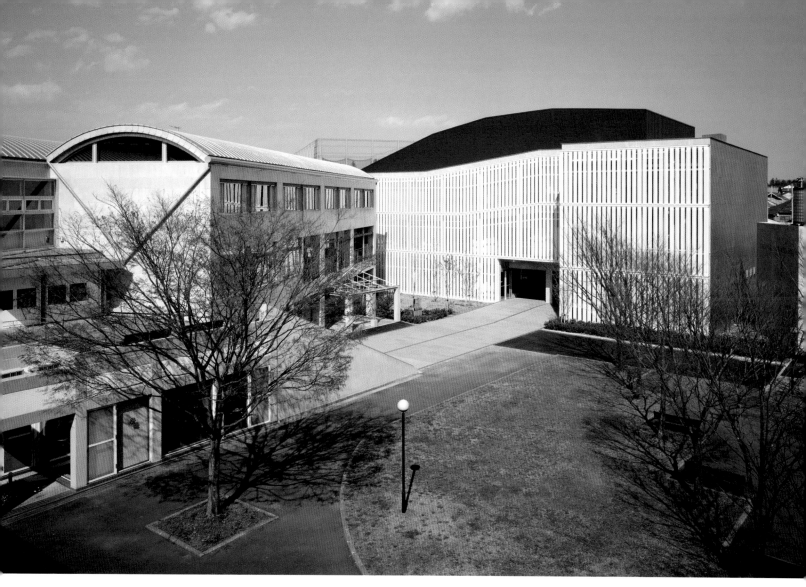

Above The building features refined modernist lines accented with curvatures and asymmetrical patterning.

Below right The interior décor echoes the silvery aesthetic of the exterior, using glass, metal and cool colors accented with natural wood.

Right Diffused natural light illuminates interiors via glass corridors that line the façade.

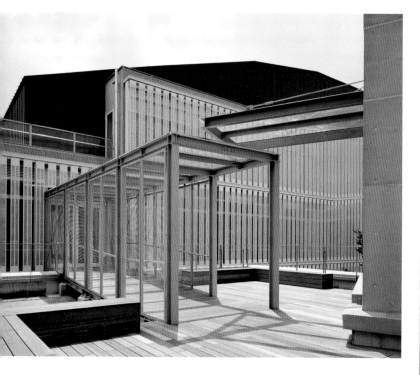

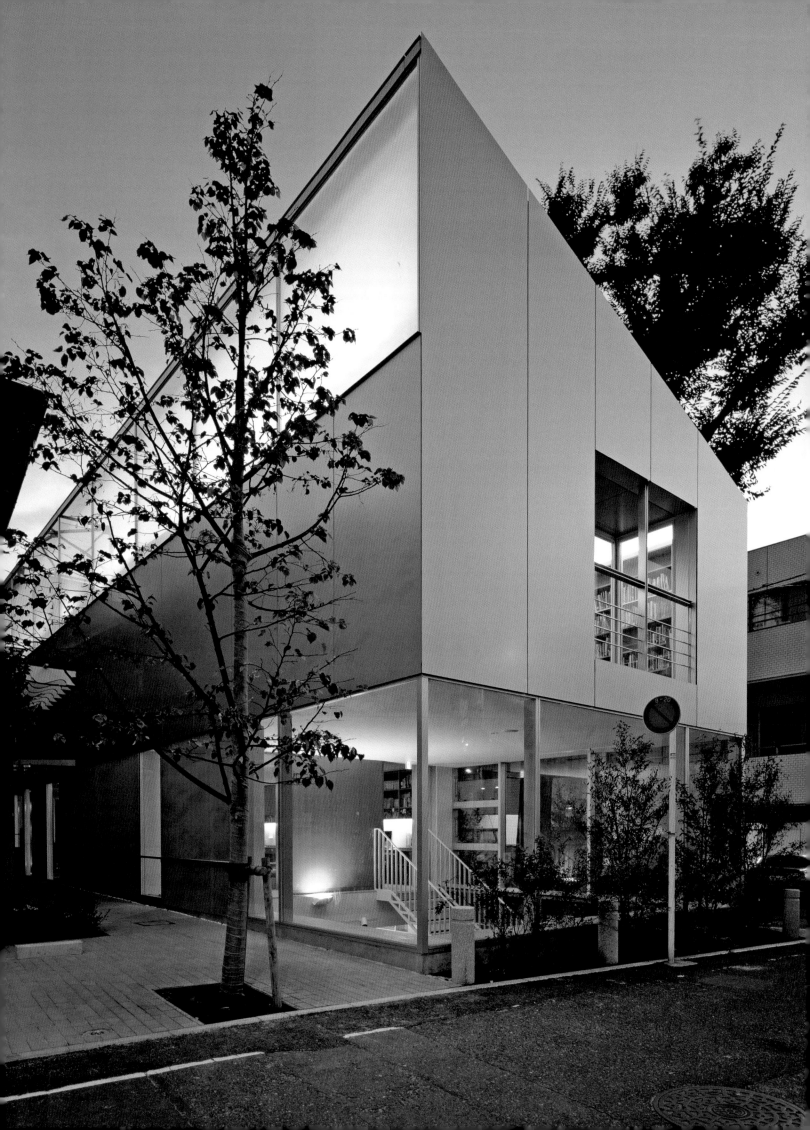

NISHIMACHI INTERNATIONAL SCHOOL YASHIRO MEDIA CENTER

Architects **TOMURO Atelier & Kenichi Nakamura and Associates**
Location **Moto-Azabu, Minato-ku, Tokyo**
Completion **2007**

The Nishimachi International School was founded by the visionary Tane Matsukata, who was also the sister-in-law of US Ambassador and Japanese scholar, Edwin Reischauer. The school was founded in 1949 with the aim of providing Japanese children with an international education, but today provides a mulitcultural bilingual education to around 450 students from over 30 countries studying from kindergarten to grade 9.

The school is located in the densely packed residential neighborhood of Moto-Azabu in central Tokyo. The campus centers on the wooden former residence of the school's founder, that was designed by William Merrell Vories in 1920, which is now a listed historic building. Architect Edward Suzuki designed the first major expansion of the school and added a gymnasium in the early 1980s. The school's library was on the first floor of Matsukata House for many years before it outgrew its space. This was when, on a sliver of land between the Matsukata House and the street where the founding family's horse carriage garage once stood, architects Reiko Tomuro and Kenichi Nakamura were asked to design a new location for the incarnation of the library as a media center.

Building codes, the small site (7 x 20 meters) and respect for context helped formulate the building's design, which easily blends into its residential surroundings, exuding a homey and welcoming rather than institutional feel. This is unlike the image of strict formality that most school libraries in Japan exude. "The design aim was to create an atmosphere of a residential living room that promotes easy access; the reading rooms were to be not too rigid or formal," explained Tomuro and Nakamura. The media center has indeed become a home away from home for budding scholars as every inch is devoted to books, computers and learning.

Opposite Designed with a respect for context, the structure easily blends into its residential surroundings, exuding a homey rather than institutional feel.

Above Section showing the relation of the new media center and the original school building.

Below A subterranean library for younger students is filled with natural light.

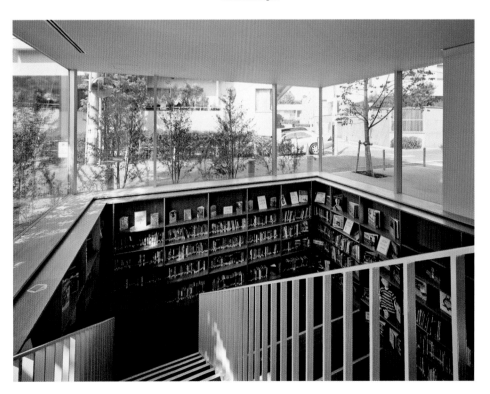

The structure is a simple geometric volume—a long rectangle with a slanting roof—set nearly flush with a street corner, with two floors above and one floor below ground. Its contemporary profile is covered in silvery aluminum panels, echoing the color of the buildings designed by Suzuki. Said the architects: "Our design needed to match the educational principle of the Nishimachi International School by maintaining the distinctive character and the warmth of Matsukata House." The understated simplicity of the design belies the influence of Japan's master architect, Fumihiko Maki, with whom Tomuro and Nakamura worked before started their individual practices.

The media center's three floors provide 1,287 square meters of space that encourages lingering and learning. The ground floor is a circulation and reference area, with sofas for relaxing. The upper floor is a reading area for older students. To keep as much wall space for bookshelves as possible, natural light is provided from above via a high slanted ceiling with a vertical wall of frosted glass, and at the lower level from a large mullioned

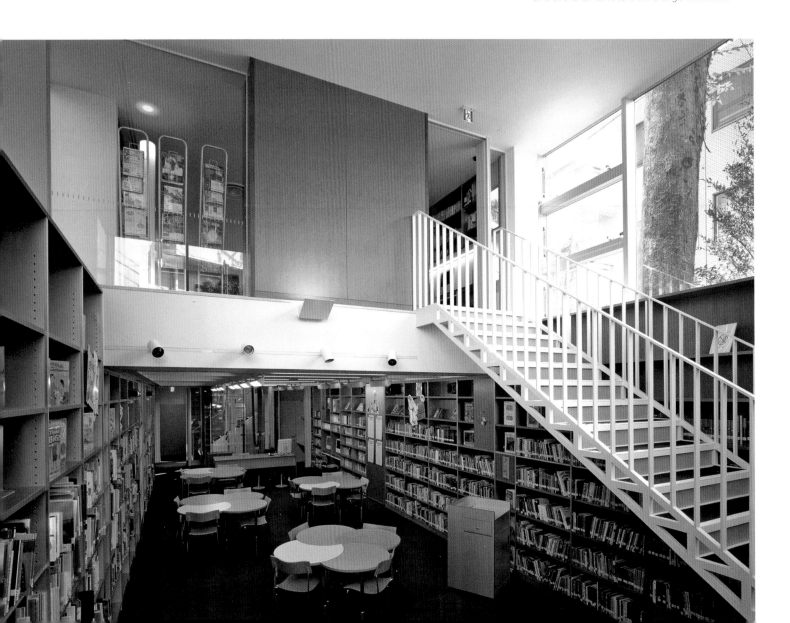

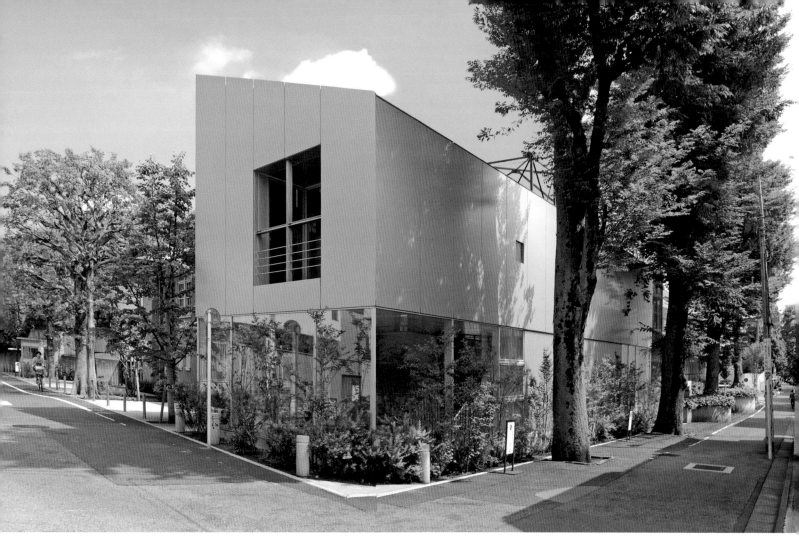

window that doubles as an emergency exit. A glass-encased stair and elevation shaft further illuminates all three levels of the structure.

The lower level is a reading room for younger students. Although a basement level, it does not feel like one as the space opens upward to the ground floor level, which features transparent glass walls on three sides. This column-less glass area is made possible by cantilevering out the structure of the upper floor. The steel and glass frame produces a fine, light skin that opens directly on to street level, creating a sense of openness and space both inside and outside of the building, and contributing positively to the residential area around it. Both reading areas feature comfortable, moveable chairs and tables as well as floor cushions, all intended to welcome young readers.

The slender gap between the walls and the street has been planted with small trees that add a green element to the interior as well as a delicate visual barrier. Large zelkova trees on the site along the side of the building were preserved. The design also incorporates energy-efficient features such as a simple switching damper that lets warm air blow from vents near the floor in winter and cool air from vents near the ceiling in summer.

The resulting building is a precise composition of abstract surfaces that offers a welcoming and highly functional learning space for the children of Nishimachi School.

Opposite above The new library sits next to Matsukata House, dating to the school's founding in the 1920s and now declared a landmark.

Opposite below To maximize usable space, the architects cantilevered out the structure of the upper floor to avoid the need for columns in the lower library.

Above Located in the densely packed but prestigious residential neighborhood of Moto-Azabu, the building sits nearly flush with the street.

Below The sloping roof adheres to sunlight regulations of the building codes, and allows natural light into the upper floor.

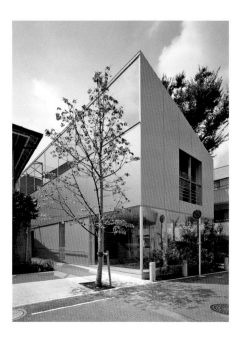

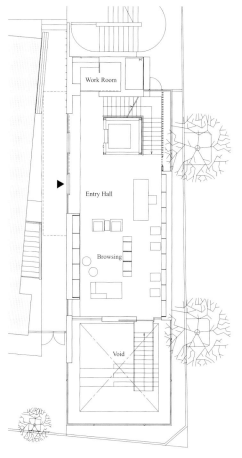

Above The plan snuggly fits into its 7 meter x 20 meter site.

architecture for work

In today's Japan, the architecture for working spaces can surprise. A research laboratory can look as cutting edge as the technologies being designed within, or as serene as a temple. New mixed office and residential complexes are responding to the live/work habits of information entrepreneurs from Japan's new creative class. Megaprojects like Tokyo Midtown are offering new ways to combine work, play and living, providing "salarymen" (or "salary women") with a contemporary "lifestyle." From the office one can walk home, stroll in a garden, shop for groceries or business suits, visit the doctor or a world-class museum or dine on anything from *tapas* to *tempura* without ever leaving the complex.

 Although the Japanese economy has been sluggish since the 1990s, the demand for class A office space has remained strong. In the bubble years, anything built was sure to be rented and profitable, so the focus was not always on quality. Since the bubble, however, higher quality office space is being constructed, and exciting new work environments are being created. In addition to research on earthquake-resistant technologies, the R&D laboratories of large general contractors (*genecon*) have also been producing cutting-edge ideas for work environments, with a view to increasing productivity and encouraging creativity.

 Most Japanese offices are still very hierarchical, with the supervisor usually seated at right angles to the long row of staff desks. Personal real estate speaks of your rank in the company. In general, net space in an open Japanese office is approximately 10 square meters per person compared to 15–20 square meters for foreign offices in Japan. Yet, with evolving technology, fluctuating economies and a new generation of workers, that includes an increasing number of women in professional roles, the way the Japanese work is also becoming less rigid. As lifestyles evolve, so too will the architecture of work.

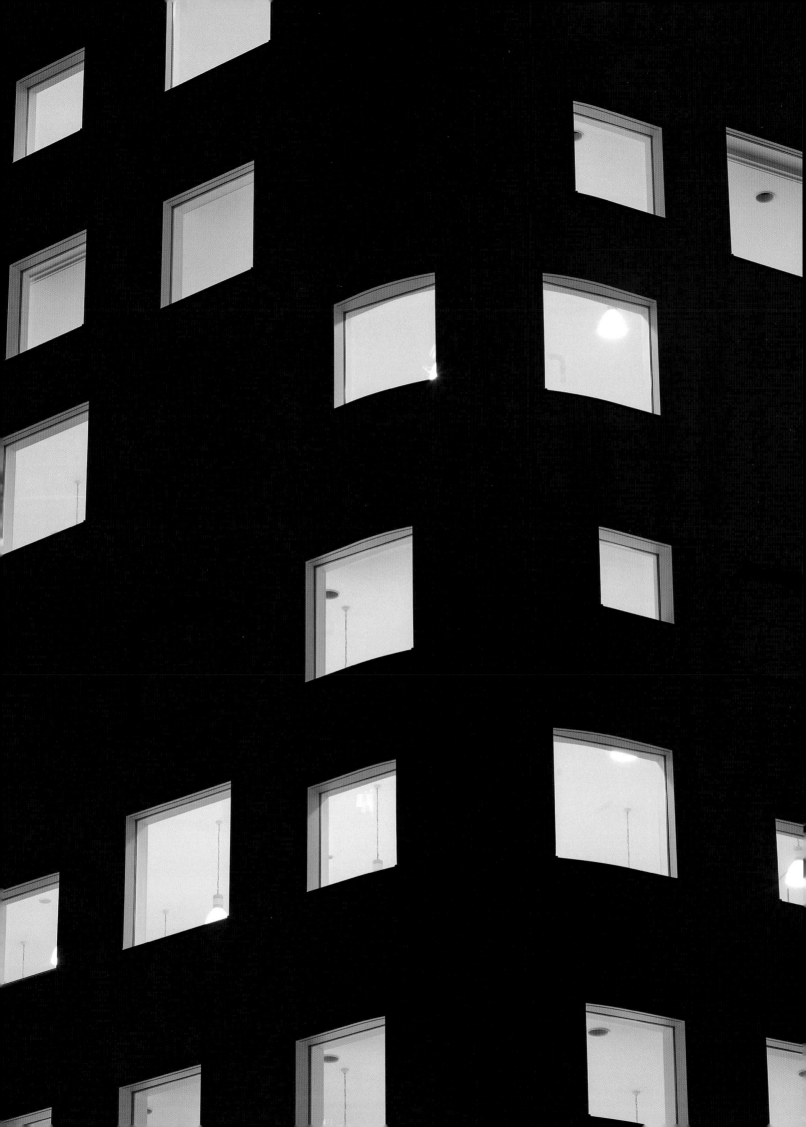

NAMICS TECHNO CORE

Architect **Riken Yamamoto & Associates**
Location **Niigata Prefecture, Japan**
Completion **2009**

Namics is a multinational high-tech company
producing a special paste that is much in demand
for semiconductors used in cell phones and small
electronic devices. To mark the 60th anniversary
of the company's founding, Namics invited four
architects to submit designs to rebuild its research
center in Niigata. The aim was to create architec-
ture symbolic of the company's dynamism that
would inspire further cutting-edge technologies
for which the company has become known.

Namics found this symbolism in the sketch
proposal by Riken Yamamoto, a Yokohama-based
architect known for his creative high-tech public
and commercial buildings. Yamamoto's distinctive
proposal featured a 9,000-square meter, three-
level building. Namics had also specified that
they wanted to open up the building to visitors,
and so Yamamoto's design responded to that
need by making the concept of the building as
easily understood as possible.

The ground floor of the Namics Techno Core is
a wedge-shaped structure opened up by several
narrow outdoor patios that create intervals in
the closed outer wall. It contains the reception
areas, lecture hall, staff room and the company's
research laboratories, which are arranged on
orthogonal grids to facilitate workflow. On top
of the ground floor is what Yamamoto calls the
"refresh floor," a rooftop garden landscaped with
grass and small knolls where staff can take a
break, eat lunch or hold a party in good weather.

Right The middle layer of Yamamoto's three-level structure
is a garden from which spring sinuous office spaces balanced
on slender mushroom columns.

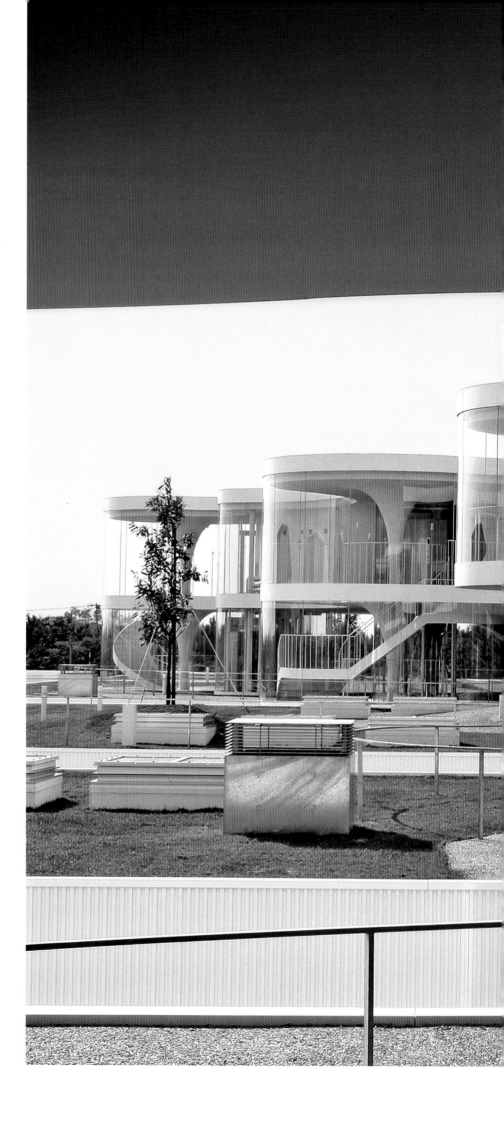

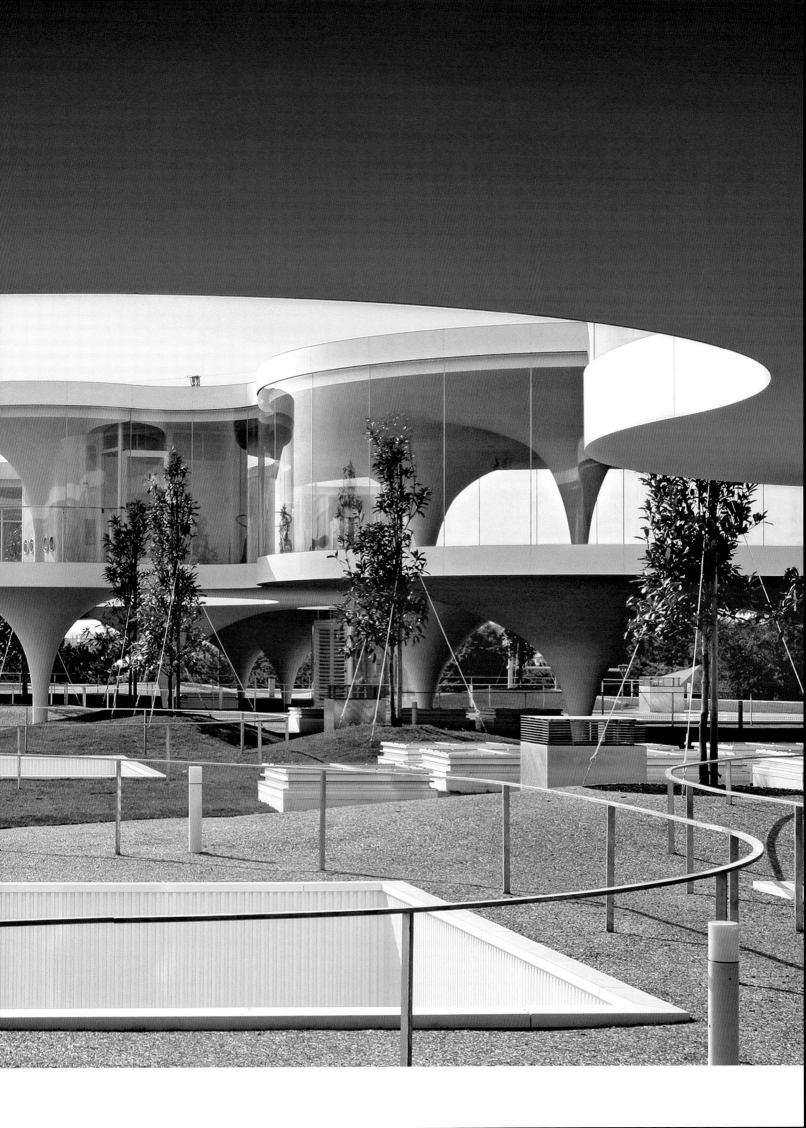

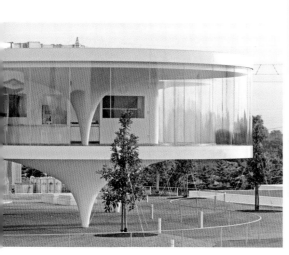

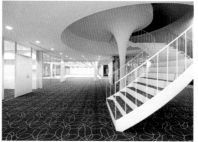

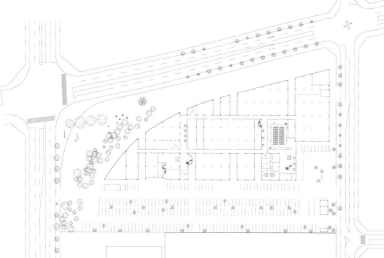

Top left The structurally daring design was intended to reflect the company's own innovative, high-tech outlook.

Top center Arup Japan developed a special construction method to design columns that culminate in very thin pinpoints at their base.

Top right The curvilinear-patterned carpet was created to complement the building's futuristic design.

Left Plan of the rectilinear lower level follows the site geometry.

Below The bird's-eye view of the upper floors presents a fluid image, like a cloud or a spill of water, sitting on a larger base.

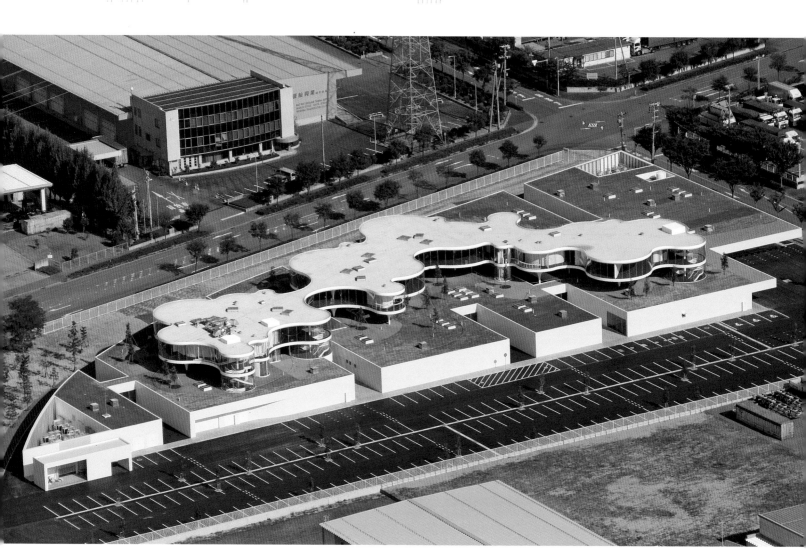

Bottom The large span arches lightly define the interior workspace without impeding the flow of space.

Right The three-level design is organized so that employees pass through the outdoor "refresh floor" several times a day.

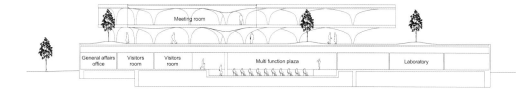

The added layer of grass and wood chips also acts as natural insulation.

The top level is supported by a field of slender "mushroom" columns that create the effect of a roof floating on air. This sinuous space contains offices and meeting rooms as well as the staff kitchen and cafeteria. Yamamoto also designed the carpet with a curvilinear pattern for this floor to echo the architecture. Graceful and futuristic, this floor is, in Yamamoto words, "a brand-new design to reflect brand-new research." Seen from above, the iconic uppermost floor has an almost liquid profile, resembling a *manga* comic drawing of a cloud or a spill of water.

Functionality of the lower and upper floors is organized in such a way that each employee passes through the "refresh floor" several times a day to be recharged by natural elements, recalling the importance given in traditional Japanese culture to the concept of *ma*, or a thoughtful pause between routine activities.

Structure is an important design element in this project. Yamamoto says: "I never separate the structure from architecture while designing. The six by nine-meter grid plan of the lower level is a rigid column-and-beam structure. For the second floor, we sought the help of Arup Japan to develop a construction method that would allow us to make very thin pinpoints for column bases." Arup, the company known for its innovation, developed the supports for the "shoes" of the arches in steel casting that measures a mere 230 mm in diameter, while increasing the spandrel area for structural strength. Although each arch is fragile by itself, its strength comes from being organized into units resembling three-legged tables. The arches are integrated into the interior as dividing walls. Yamamoto's staff remained in Niigata for a year to oversee the precision construction.

Each level benefits from the contrast with the others, from the static white ground floor to the mid-level carpet of green, to the undulating glass curves of the top floor. Crisply geometric and pristine, the ground floor suggests the efficiency of Namics' organization, while the upper levels show the company's creative side and aspirations for the future.

The emblematic building is perhaps the best advertising a high-tech company could ask for. Original, innovative and mixing high function and beauty, it gives a poetic face to technology.

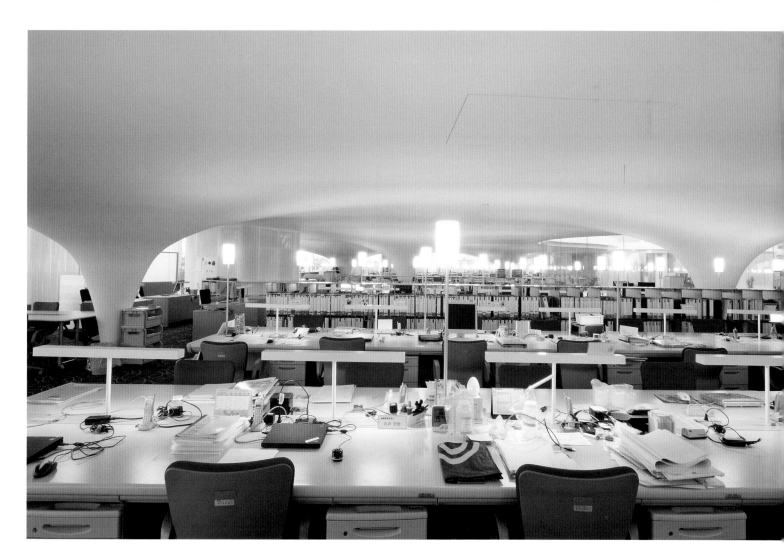

TOKYO MIDTOWN

ARCHITECTS
Master Architects **Skidmore, Owings & Merrill LLP (SOM)**
Design Team **Nikken Sekkei**
Landscape Design **EDAW**
Suntory Museum of Art **Kengo Kuma & Associates**
21_21 Design Sight: **Tadao Ando**
Park Residences: **Sakakura Associates, in consultation with Jun Aoki & Associates**
Commercial Space Design: **Communication Arts Inc.**

Location **Roppongi, Tokyo**
Completion **2007**

With its maze of streets, small irregular building plots, pliant zoning laws that create wildly mixed neighborhoods, and a hyperactive construction industry that insures constant building and re-building, Tokyo has a vibrancy and chaos like no other city. This organic urban fabric, however, is beginning to be altered by a new but growing trend—megaprojects blending commercial, office and residential structures with public outdoor space.

In the 1960s and 1970s, concerns about over-crowding in the city center led to governments encouraging businesses to disperse to various subcenters, and residents to the suburbs. But recent concerns about declining birthrates in Japan and the loss of residential population from central Tokyo, have led to policy changes, with the government encouraging development in the center. Special incentives are now available for large developments that include residential components built within the Japan Railway Yamanote line circle, and are often subsidized. Developers have responded with large-scale projects, such as at Roppongi Hills and Shiodome, the Marounuchi Redevelopment and, most recently, Tokyo Midtown.

Tokyo Midtown is set on the site of an Edo-era *daimyo*'s residence that became a US military post after the Second World War and later home to the Defense Agency. The land was sold to real estate giant Mitsui Fudosan in 2000, who soon began plans for Tokyo Midtown with a phalanx of architects and designers. With the character-istic efficiency of building processes in Japan, the project took less than five years from the drawing board to completion in 2007.

The name "Midtown" is a reminder of the continuing fascination in Japan with New York, also reflected in other projects, such as Time Square in Shinjuku and an Empire State Building-

inspired NTT laboratory in Shibuya. The major American architectural firm Skidmore, Owings and Merrill was given the task of creating a com-prehensive strategic plan for the project. Ironic-ally, besides their extensive experience of large urban design projects, they looked to traditional Japanese gardens for inspiration. Tokyo Midtown's layout was conceptualized somewhat as a rock garden (rather than a Western grid), with a domi-nant boulder surrounded by smaller rocks and a field of moss. However, the New York office of this international firm also brought a New York verticality to this garden: the 248-meter-high, 54-story Midtown Tower tops Kenzo Tange's Metro-politan Government building in Shinjuku as the tallest structure in Tokyo.

Tokyo Midtown brings a Japanese elegance to the otherwise internationally homogeneous building typology of shopping/office/hotel com-plexes. The high-rise's façade is articulated by layered glass with terra-cotta louvers that also help control solar heat gain. The multiple recti-linear patterns thus created help dematerialize the glass, making an allusion to the translucent screens used in traditional Japanese architecture.

Set on 10 hectares of land, Tokyo Midtown has about 563,000 square meters of floor area, includ-ing a central high-rise office/five-star hotel tower surrounded by several low- to mid-rise office and

Above Tokyo Midtown's layout was conceptualized as a Japanese rock garden, with a dominant boulder surrounded by smaller rocks and a field of moss.

Below A metaphoric pebble in the garden in the Midtown Galleria.

Right At 248 meters and 54 stories high, Midtown Tower outstrips Kenzo Tange's Tokyo Metropolitan Government building in Shinjuku as the tallest structure in Tokyo.

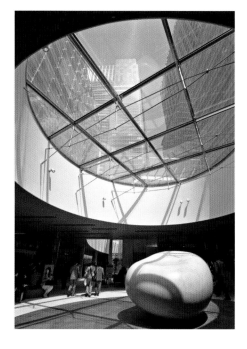

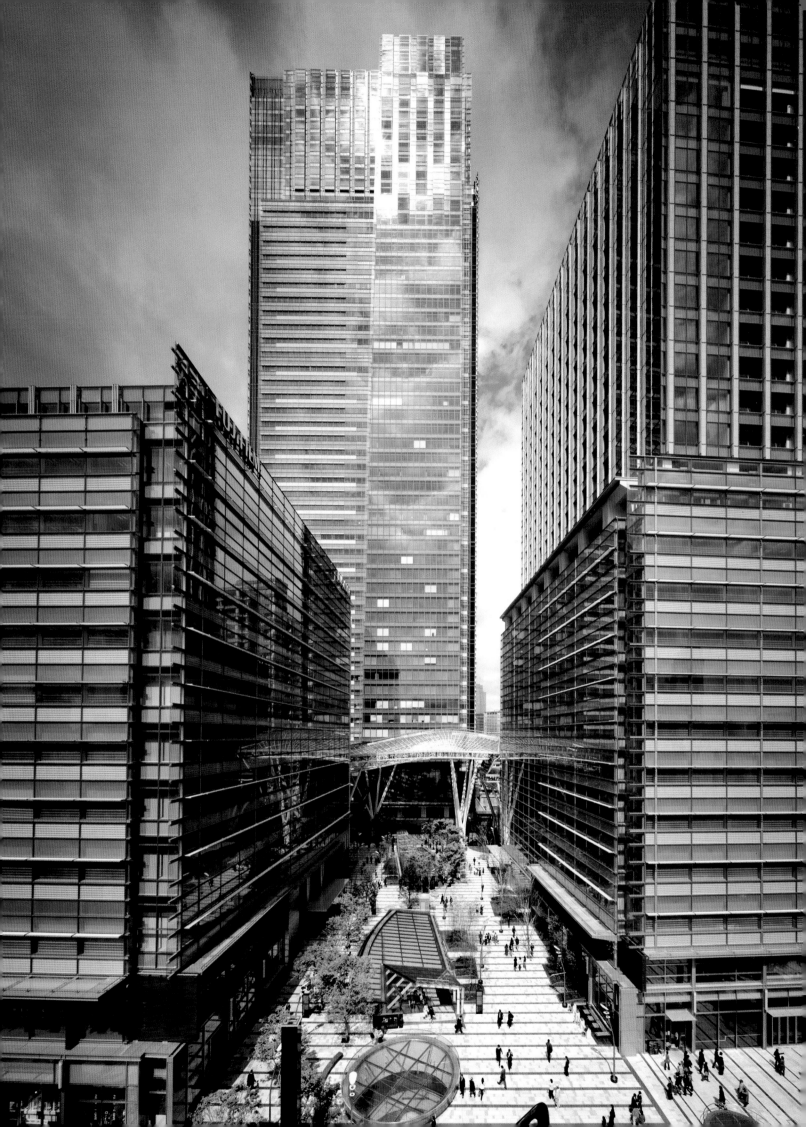

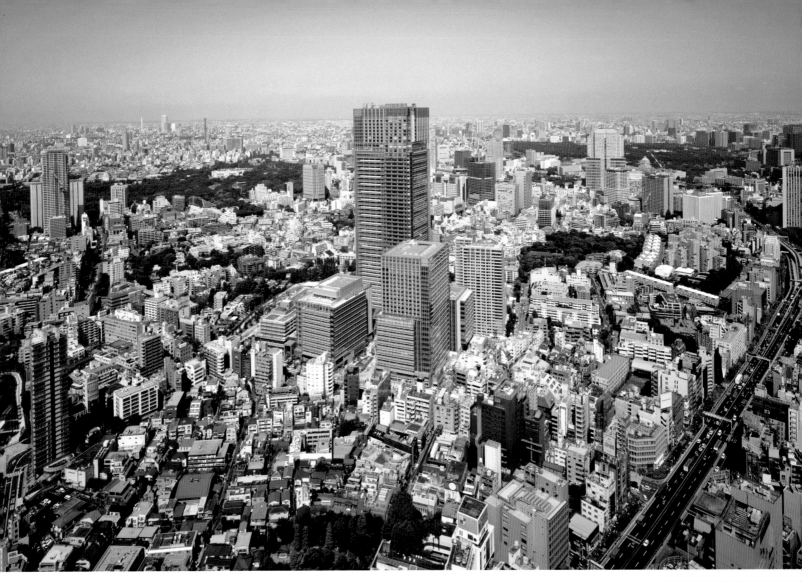

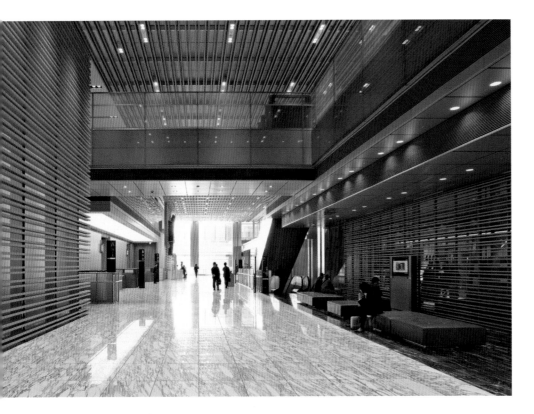

Above Named after the eponymous New York district, Tokyo Midtown rises distinctly above the densely packed but relatively low-rise Roppongi and Aoyama areas in central Tokyo.

Left A mix of contemporary and Japanese aesthetics—wood finishes, water features and faux bamboo—creates a luxurious ambience for the commercial space and atrium of the Galleria.

Right The main plaza is sheltered by a metal net canopy that sits upon tall tree-like columns.

Above Landscape architects EDAW designed the open spaces, with gardens and meandering paths between structures, which immediately become popular in this area that lacked good public spaces.

Below Vertical cross-sections of Tokyo Midtown show the relationship of the tall office/hotel tower, lower residential towers, and retail and public space at the base.

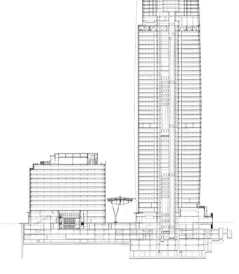

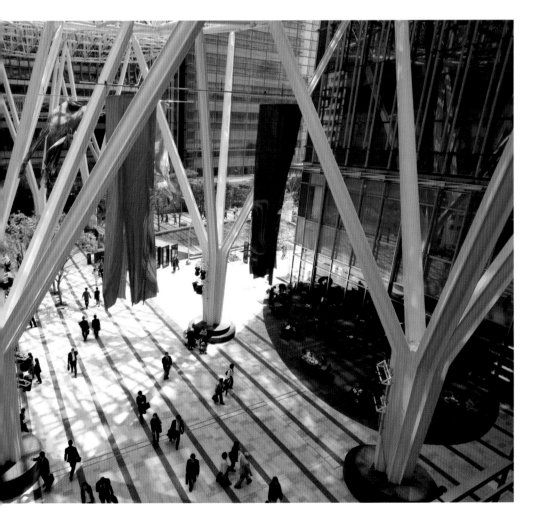

residential blocks, as well as cultural and retail facilities throughout the project. A main plaza, a glass-enclosed shopping arcade (the Galleria) and landscaped gardens are all open to the public.

San Francisco-based landscape architects EDAW designed the open spaces, with gardens and meandering paths leading from the main structures to Tadao Ando's 21_21 Design Sight (see page 82), to the Great Lawn where picnickers and shoppers lounge, as well as to the historic Hinokicho Garden. This garden, which was the property of the Hagi clan during the Edo period before it became a public park, was partially redesigned by the landscape designer Hachiro Sakakibara to fit into the larger scheme. In a city where places to sit and relax outside are hard to find, these green spaces are very welcome, a fact made evident by the crowds that come daily to the park.

The 20,000-square meter Galleria, designed by Communication Arts Inc. and filled with luxury-brand boutiques, mixes Japanese and mall aesthetics. Traditional materials, wood finishes, water and bamboo trees (albeit of plastic) evoke a sense of *wa*, or harmony. The Galleria is also home to the elegant Suntory Museum of Art designed by Tokyo-based architect Kengo Kuma.

How did all these architects work together on such a vast project? When asked to describe his experience of Tokyo Midtown's huge collaborative effort, Kengo Kuma responded with a joke: "At a prisoner-of-war camp, the first thing the Americans do is elect a president; the Germans decide on the rules; and the Japanese? They start a *haiku* party." For Kuma, the group effort, with its many exchanges of ideas during the process of creating a thing of beauty, was like a good *haiku* party. Given the project's open spaces and elegantly calm atmosphere, which offer both a respite from and a healthy contrast to the sometimes overwhelming buzz and crowds of the city, the *haiku* party seems to have been a success.

But while bringing welcome public green space and openness, developments like Tokyo Midtown and Roppongi Hills (a similar project nearby) do sap some of the vitality of the public street and put it inside mega developments that are not truly "public," are policed by the property managers, and are often overtaken for promotions. There is also a concern that developments like this could mark the beginning of the end for Tokyo's distinctively organic small-scale Asian charm. As with every major addition or alteration to the built fabric of a city, the most important question to ask is if projects like this make the city a better place for all its people.

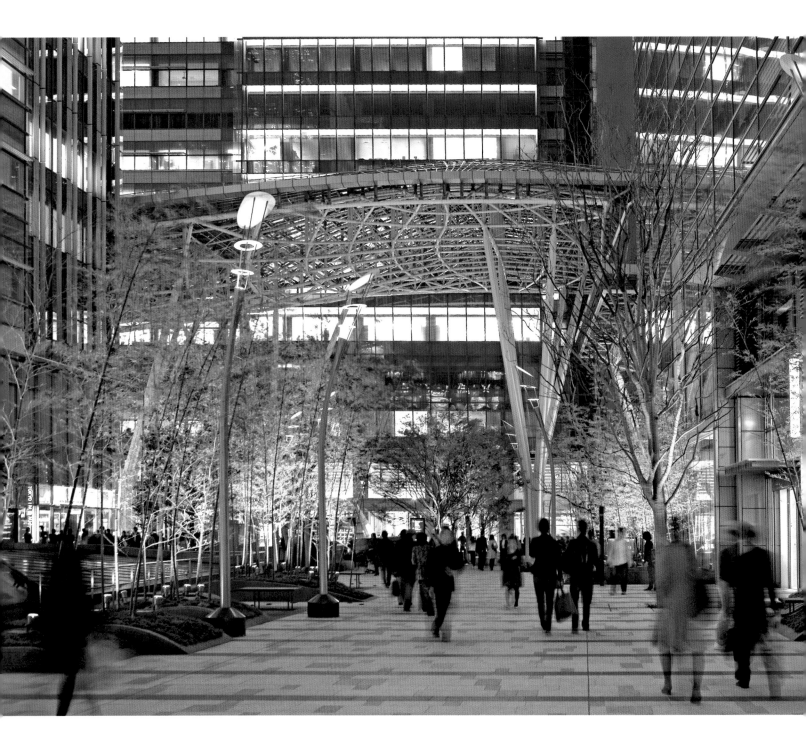

Far left Wood detailing adds an element of warmth to the steel and glass construction.

Left Skylights add natural light to the extensive network of underground passages in Tokyo Midtown.

Left The high-rise's façade is articulated by layered glass with terra-cotta louvers that also help control solar heat gain.

Right Greenery is incorporated throughout Midtown, adding a natural and welcoming element to a busy commercial/corporate complex.

SIA AOYAMA BUILDING

Architect **Jun Aoki & Associates**
Location **Shibuya-ku, Tokyo**
Completion **2008**

As in most of Tokyo, there is a mix of residential and commercial buildings in the area between the youthful bustle of Shibuya and the chic boutiques of Omotesando. So when asked to build a high-rise office building in the neighborhood, Jun Aoki set out to create a structure that did not fit into either category. In Aoki's words, he wanted to make "a building so different from others, looking neither like an office nor a housing complex, but resembling something carved from a white rocky mountain. This seemed to create the best relation to the area, a tower-like monolithic building with a slippery smooth surface."

The SIA Aoyama is indeed like nothing else, with its white mass rising 64 meters and a seamless surface with random openings. Its layout is an irregular, round-cornered pentagon. There are nine floors and seven types of windows, each quadrate with sides of 1.15, 1.45, 1.6, 1.75, 1.9, 2.05 and 2.2 meters. Their placement is both deliberate and arbitrary. Aoki describes the overall pattern as being like a "freehand drawing intended to be as accurate as possible."

The building's unorthodox form, openings and lustrous white surface stand out in the sea of conventionally designed, frequently drab concrete or tile-covered buildings around it. The seamless surface has been achieved by much effort in hiding and smoothing the usual construction details that are visible on most other buildings. The white paint was carefully blended with gray and purple shades to avoid glare. It is a not an edifice that blends into its surroundings but rather one that stands in subtle, smile-inducing contrast to it.

Aoki set out to make "the building feel like an object by widening the distance between people

Above Each side of the nine-story building presents a different composition of frameless openings.

Below There are seven types of quadrate windows of varying sizes whose placement is both deliberate and arbitrary.

Right The 64-meter structure has a seamless white surface of unorthodox openings that stands in subtle, smile-inducing contrast to its more conventional neighbors.

and space." This, however, does not detract from the functionality of the architecture. According to Aoki: "This architecture is simply a bit further out from reality, creating a new atmosphere that is inorganic but at the same time organic, orderly but disorderly, hard but soft, a reality that is free from the restriction of dichotomy between the two." It may come as no surprise that Aoki once thought to study literature and become a poet, before turning his artistic talents to architecture.

Aoki raised the ceiling height to five meters, which is relatively high for Japan. This allows abundant natural light to enter each floor even with minimal or high windows. It also enabled Aoki to scatter windows across the building surface with artistic abandon. Earthquake-resistant reinforced concrete allowed wall thicknesses to be reduced by half, creating generous tall spaces with harmonious proportions.

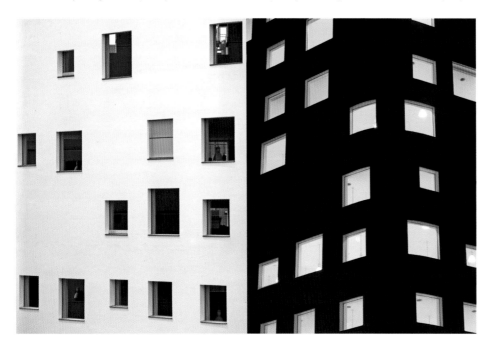

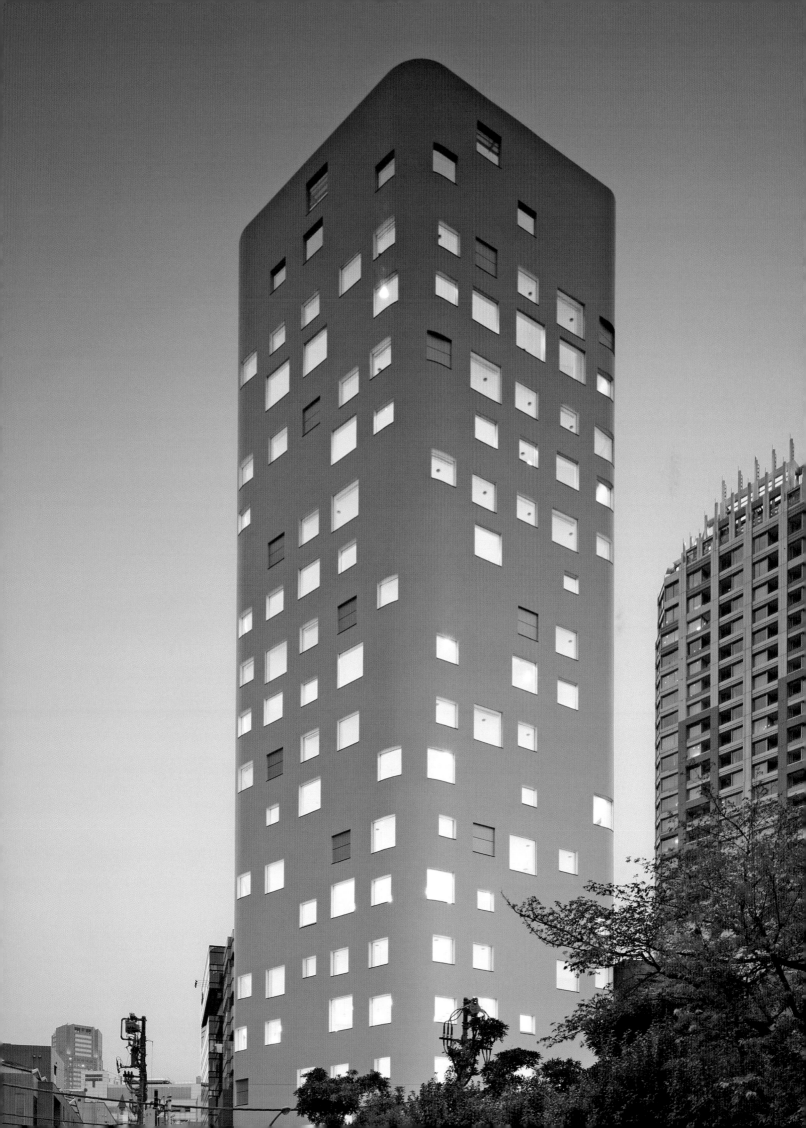

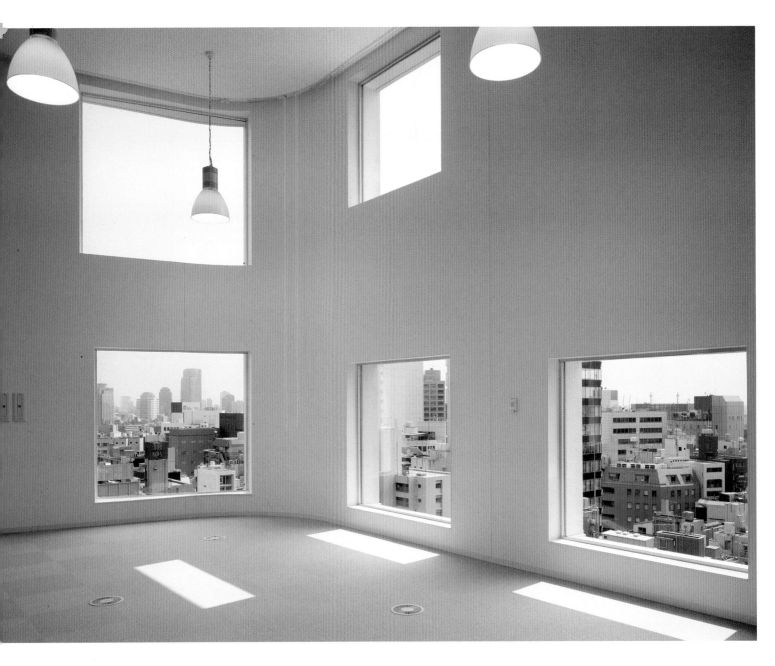

Above The five-meter ceiling heights are generous for Japanese office interiors, and allow abundant light into the interiors.

Far left The playfully artistic scattering of windows creates expressive interior spaces.

Left Functional spaces, like stairwells, share the overall smooth white skin and aesthetic.

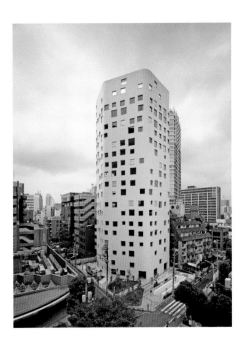

Left : The plan of the tower is an irregular, round-cornered pentagon layout.

Right For the exterior, white paint was blended with gray and purple shades to avoid glare.

Below Earthquake-resistant reinforced concrete enabled wall thickness to be reduced by half, creating generous tall spaces with harmonious proportions.

F-TOWN BUILDING

Architect **Hitoshi Abe**
Location **Sendai, Miyagi Prefecture**
Completion **2007**

Above F-Town's plan shows its site-hugging footprint.

Below Sections showing the articulated building mass with distinct profiles that maximize the small site.

Opposite Wedged into a tight corner and surrounded by the ubiquitous wires of Japanese urban landscape, F-Town nevertheless adds a highly creative presence to an unexceptional corner.

After receiving his masters at SCI-Arc (Southern California Institute of Architecture) and at a stint in the LA office of architect Coop Himmelb(l)au, Hitoshi Abe, one of Japan's leading young architects, returned to Sendai having won, at the age of thirty, a competition for the Sendai World Cup stadium.

Abe has been called culturally ambidextrous, as his ideas have found an audience on both sides of the Pacific. While he uses standard Japanese measurements based on *tatami* mat dimensions, he does not adhere to any overriding paradigm or system conceptually, perhaps as the result of his international education. While the vast majority of design-oriented architects have offices in Tokyo,

Abe made the uncommon choice to base his practice in Sendai. This has contributed to Sendai emerging as one of the centers of contemporary architecture in Japan, boasting works by renowned architects like Kengo Kuma, Toyo Ito and, of course, Abe himself. He moves frequently between Los Angeles (where he is presently chair of the Department of Architecture and Urban Design at the University of California at Los Angeles) and Sendai, where he heads the architectural design laboratory at Tohoku University.

One of Abe's latest projects is the restaurant and bar building F-Town, set at a corner of a new, growing entertainment district east of Sendai's main train station. These types of restaurant/bar complexes, usually covered in loud, colorful signboards and neon lights, are widespread in Japan. However, with this building Abe has created an uncommonly serene response to the vibrant urban chaos of the Japanese commercial street.

Known for structural expressionism, Abe conceived of the building as a stack of six two-story cubes interspersed with void spaces, each cube meeting at different levels in a rhythmic fashion. In Japan, where sites can be tight and

legal restrictions limiting, designers usually begin with calculating the permissible building envelope, and then work inward. Abe uses his cubes to form a highly articulated building mass with a distinct profile while also maximizing the site's permissible built-up area.

To this spatially complex and structurally innovative design, Abe adds a distinctive surface, an element found in most of his projects. A monolithic exterior cladding has also become the contemporary method of choice to make buildings stand out in chaotic urban environments in Japan and elsewhere. The exterior cladding of F-Town is composed of two types of autoclaved lightweight concrete (ALC) panels, which are most commonly found on warehouses and low-cost structures, but here are used to create an impression of an intricately carved exterior. Rich in relief and geometric pattern, the panels cover underlying concrete and details, creating a remarkably consistent exterior wrapping. The panel design was the result of a collaboration with graphic designer Asao Tokolo, who has worked with Abe on earlier projects.

In response to the client's request to keep the interior space flexible for future tenants, the interiors were left completely open. By adding stairs in the void spaces between boxes, Abe has created the option of two-story shops or restaurants, which could also connect directly to the space above or below. There is also the future option of adding a spiral-shaped staircase loop around the building's parameter to further facilitate circulation between floors.

Spaces at each floor vary in ceiling height, giving each floor a different street exposure. A street-level lobby offers the basic amenities, an elevator and two sets of stairs reaching all levels. Plumbing and ventilation ducts have been incorporated in the 45-cm-thick floors. Overall, with its unique profile and patterned surface, F-Town succeeds in making a strong but quiet statement in the busy street.

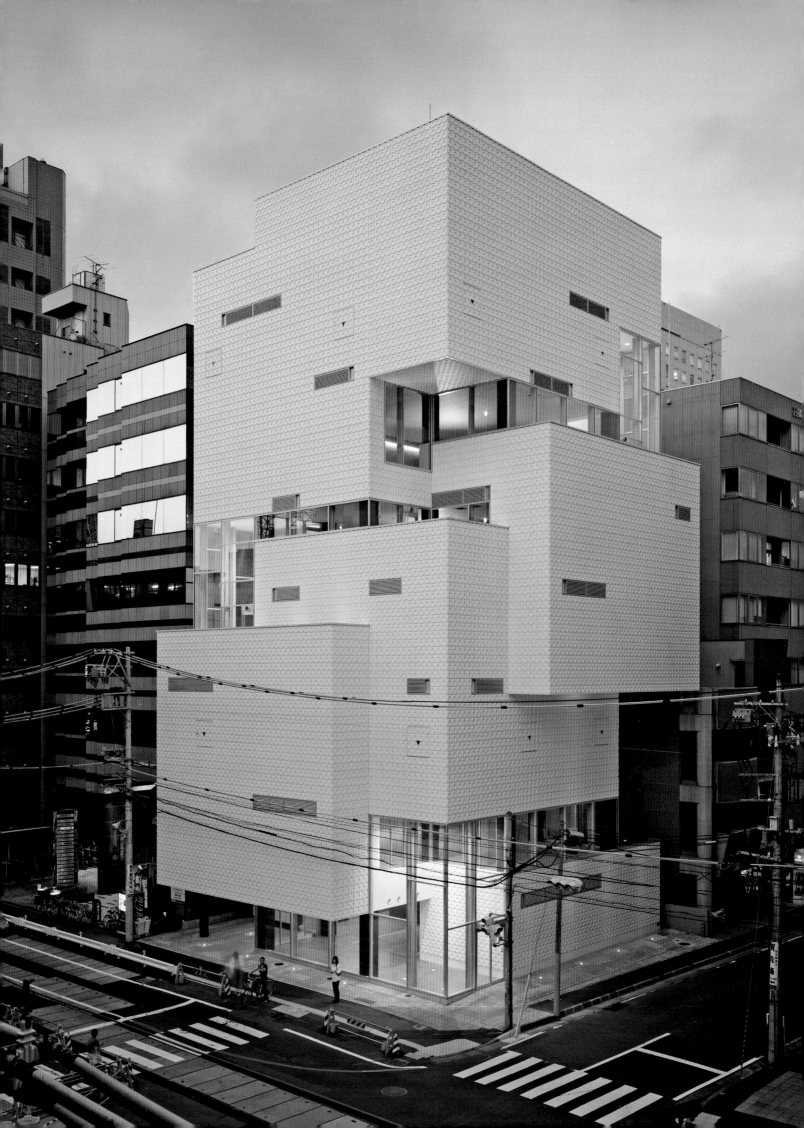

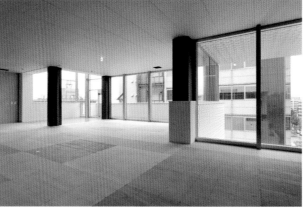

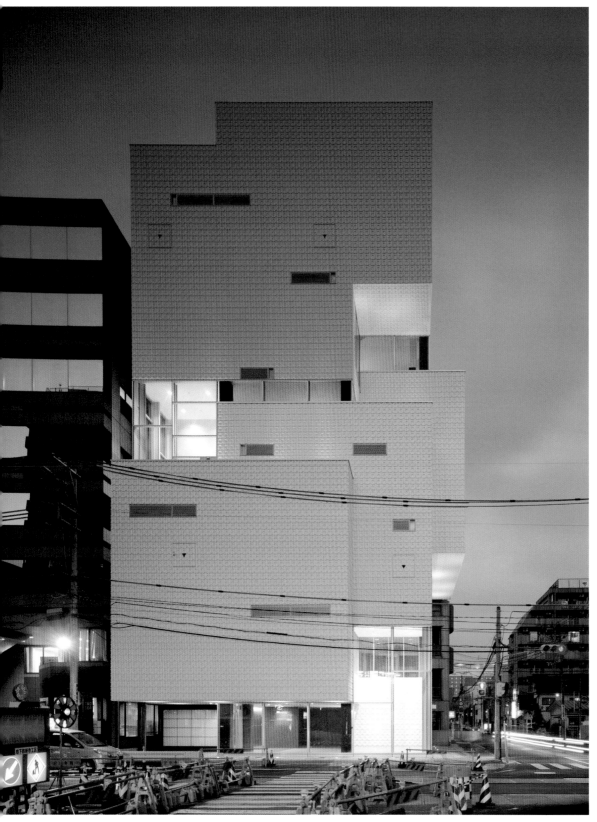

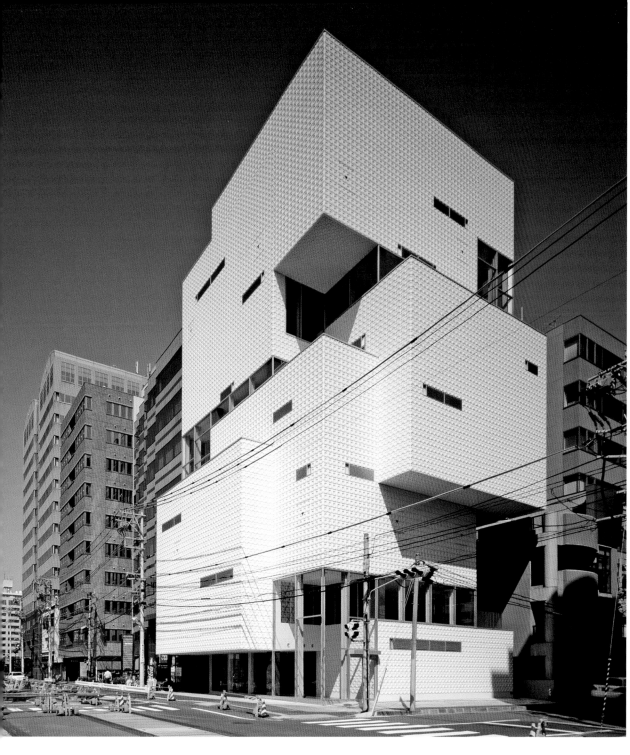

Left Abe conceived of F-Town as a stack of six two-story cubes interspersed with void spaces, each cube meeting others at different levels in a rhythmic fashion.

Below left By installing stairs in the void spaces between boxes, Abe created the option of two-story shops or restaurants.

Below The exterior cladding is composed of two types of autoclaved lightweight concrete (ALC) panels, used to create the impression of an intricately carved exterior.

architecture
for consumers

The architecture for consumerism in Japan is at the cutting edge in the world. An average Japanese consumer has a highly developed aesthetic sense, demands high quality goods and is willing to pay for them. This has resulted in a very high quality of retail architecture, shopping environment and packaging.

Multinational brands of luxury goods also take Japan very seriously since it continues to contribute a large part of their revenue. New marketing strategies are often tested here before they are rolled out in other fashion capitals of the world. Brand-name architects and eye-catching design are used to enhance and promote a brand, whether selling watches or cars, diamonds or designer clothing. This "brandtecture" has helped redefine Ginza and Omotesando—the grand boulevards of Tokyo—as consumer meccas. Here, the young, the fashionable and everyone else flocks to see and be seen on Tokyo's most stylish streets.

With their remarkable façades—from Toyo Ito's trees of glass and concrete to Herzog & de Meuron's shimmering prism, to MVRDV's urbane rhomboids, these buildings act as giant advertisements for high-end brands and exude an aura as rich, urbane and ever youthful as the consumers of Japan. Interiors also compete to be equally enticing, such as Shigeru Ban's Nicolas G. Hayak Center's moving pods and living green wall, and Herzog & de Meuron's all-white Prada interior fitted with high-tech gadgetry to help make spending money an exciting pastime for the pampered consumer.

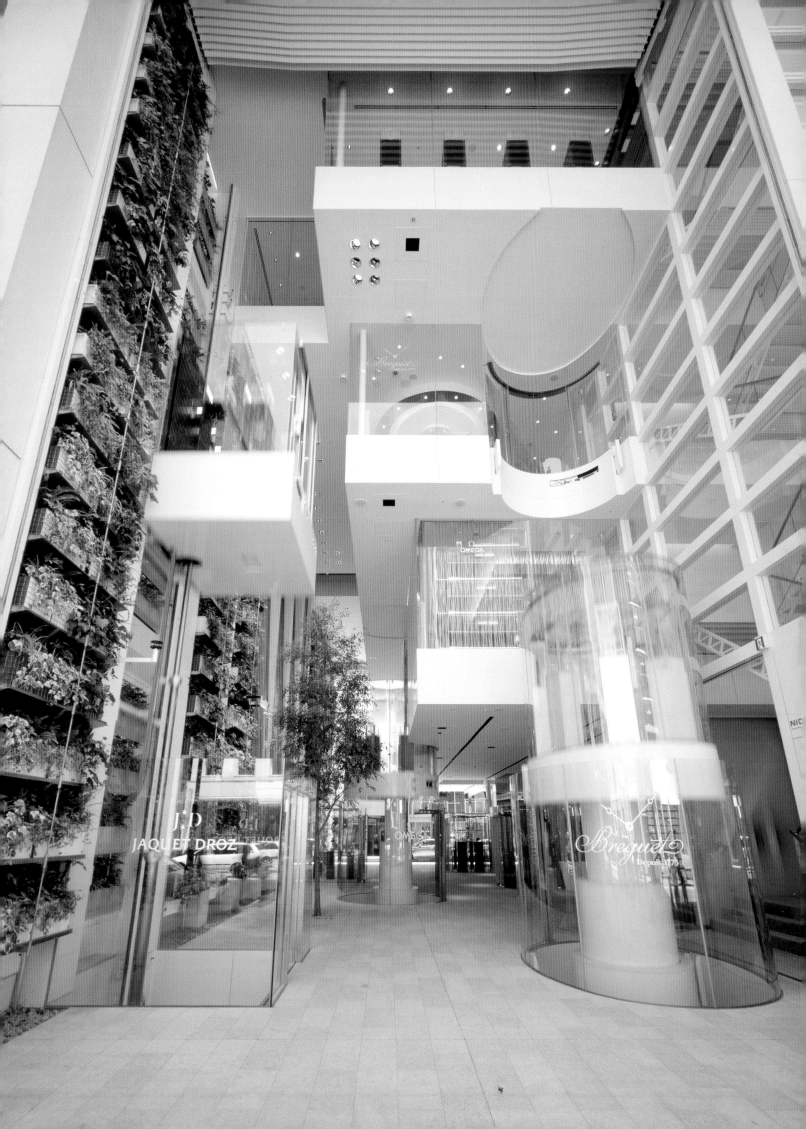

Audi Forum Tokyo

THE ICEBERG

Architect **cdi (creative designers international)**
Location **Harajuku, Tokyo**
Completion **2006**

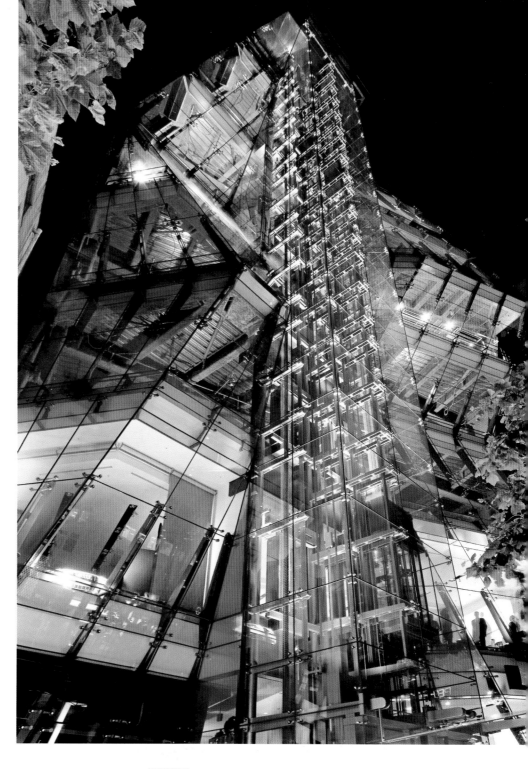

Technological advances in the past decades have made glass the material of choice for much of modern architecture, creating a new language of light, spatiality and dematerialization. Similar advances have also been made in other construction materials, which along with computer technology enable architects today to push the boundaries of architectural form.

The Iceberg is a product of this new experimentation. Its transparent blue-green zigzag façade is a distinct presence on a busy street in Harajuku, Tokyo's epicenter of youth fashion and culture. This neighborhood, along with adjacent Omotesando, is filled with trendy retail shops that over the past decade have entered into a one-upmanship with their neighbors, each seeking to make a more distinct architectural statement to further their brand image. This is not an easy task in an area dotted with buildings by greats such as Toyo Ito, Tadao Ando, Kenzo Tange and Herzog & de Meuron. Yet, that precisely was the aim of the Iceberg's client, the car manufacturer Audi, who asked for a building that would be like an abstract glass sculpture and stand out in the colorful, chaotic streets of Harajuku. The Tokyo architectural firm cdi (creative designers international), directed by Benjamin Warner and Hiroyuki Yoshikawa, responded by creating a dynamic blue crystalline iceberg.

The façade of the Iceberg is composed of two interacting prismatic forms and a long vertical glass box containing an elevator offering vertiginous views. The client had asked for minimum structural presence on the façade in order to maximize views. The designers responded with a façade supported on steel cantilevered arms, which spring out of the floors and ceilings, thus minimizing the intrusion of structure, as well as glazing transoms and mullions.

The result is a surprisingly buoyant façade

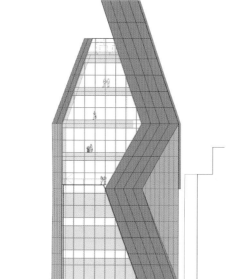

Above A glass elevator shaft climbs the height of the façade, revealing the inner workings of the elevator and offering splendid views of busy Harajuku.

Left A cross-section of the Iceberg shows the relationship of the façade element to the rest of the building.

Opposite Composed of interacting prismatic forms, the façade is supported on steel cantilevered arms that spring out of the floors and ceilings.

Audi Forum Tokyo

Audi Forum Tokyo

Left The ground floor showroom provides a dramatic setting for the cars on display.

Below The glass door of the car elevator opens on the façade in a futuristic gesture that often makes pedestrians on the street stop to look.

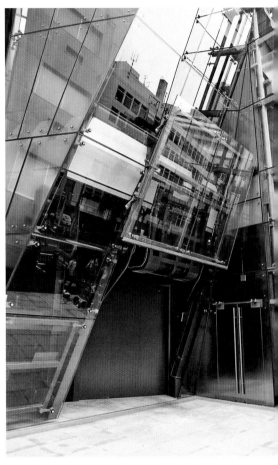

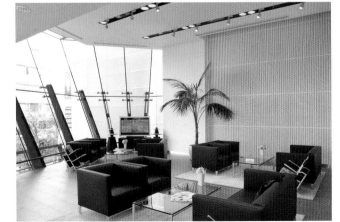

Left Interior spaces, like this meeting area, are rendered dramatic by the slanting glass façade.

suggesting an emergent iceberg reaching up-ward, with a strong verticality that pulls the eye up to the tip. Inside, the car showrooms and offices enjoy open views of the busy streets. Light catches the façade, changing with each vantage point thanks to a silver interlayer on the glass's oblique surfaces to highlight the jagged form.

The interior features a basement and six stories served by escalators and two transparent eleva-tors. To appeal to potential Audi buyers and all lovers of gadgets, a high-tech glass garage-like door opens from the façade's ground level, like the entrance to a starship, allowing cars to enter and exit.

This building is also a good example of what can be called "façadetechture." While the front façade sets it apart from its peers on the street, the same care and money has not been dedi-cated to the rear façade, which is much like the other buildings on the street.

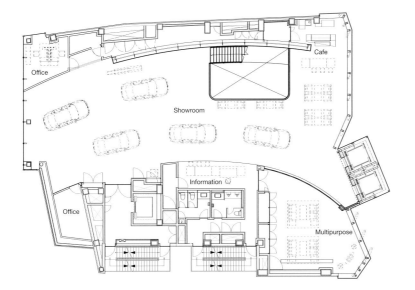

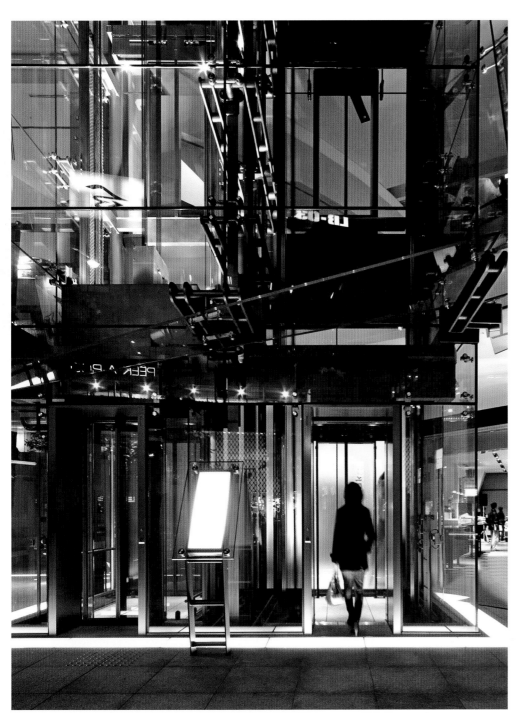

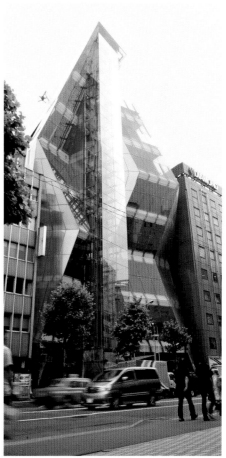

Top The ground floor plan of the showroom shows the easy access and egress needed for an ever-changing display of cars. The transverse section shows the inner circulation of the building.

Left The glowing transparency of the façade turns the elevator into a joyride looking over the Harajuku consumer area.

Above The dynamic form stands in contrast to its more conventional neighbors, and stretches the imagination of this area already known for creativity and innovation.

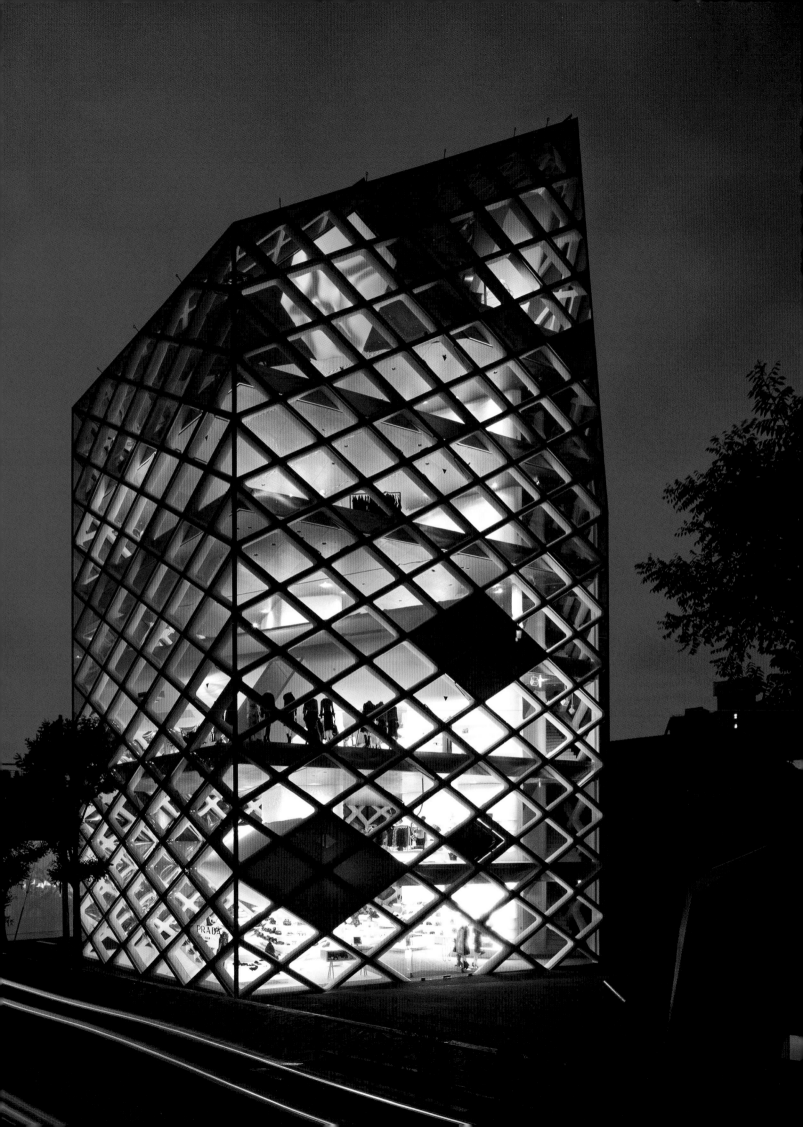

PRADA AOYAMA EPICENTER

Architects **Herzog & de Meuron**
Location **Minami-Aoyama, Minato-ku, Tokyo**
Completion **2003**

Since it was built seven years ago, Herzog & de Meuron's Prada Aoyama Epicenter has lived up to its name. Its soft prismatic form remains the architectural epicenter of the Aoyama/Omotesando area, Tokyo's most fashionable neighborhood, dotted with luxury brand stores housed in structures designed by the biggest names in architecture today. You could say that the Italian fashion brand Prada's building is to Aoyama/Omotesando what the Guggenheim Museum was to Bilbao in putting it on the architectural pilgrimage map and spurring a spate of construction around it, every new project trying to outshine Herzog & de Meuron's masterpiece.

Prada is located in the part of Aoyama that is crowded with fairly uniform mid-rise buildings. Herzog & de Meuron, whose most recent work includes the "Bird's Nest" Stadium for the Beijing Olympics, set out to open up this dense space with a light structure and an atypical approach to Tokyo sites. In a 953-square meter site, the architects used only a 369-square meter footprint, utilizing the remaining space as a rare Euro-style plaza but with a Japanese twist—the concrete surface is slanted, forming an origami-like prismatic knoll upon which they have attempted to grow moss, a much-loved plant material in Japan. "Tokyo is a city where not a single building relates to its neighborhood, and every building fills its whole site," Jacques Herzog has said. "We took a chance in creating a little space outdoors, like in European cities."

For the structure, they devised a tall, narrow, five-sided sculptural shape placed on the corner of the site. This prismatic glass box is composed of flat, concave and convex diamond-shaped glass planes, resulting in a building that shimmers during the day and glows like a magic lantern at night. According to Herzog & de Meuron: "The building's form could be interpreted in different

ways—like a crystal or a simple house with a pitched roof, depending on the angle from which the building is seen."

The architects have noted that this was their first building "to forge structure, space and façade as a single unit." The exterior forms a transparent structural shell and the interior space is just as fluid. Hollow diamond-shaped tubes are used for both structure and style. Their smooth profiled volumes function as fitting rooms and display areas that seamlessly connect interior space. All details echo the soft profiles of the façade. Combined with the all-white color scheme, the seven floors seem to flow into each other. White carpet, walls and fiberglass furniture embedded with LED lights or covered with fur provide a chic backdrop for display. The changing rooms have glass walls that can be fogged by pressing a button on the floor, and are equipped with computers that can

Opposite Despite its transparent simplicity, the Prada Aoyama Epicenter is one of the most complex buildings in Japan in terms of its structure, glazing and fire safety regulations.

Above Cross-section showing floor distribution and connectivity via geometric tubes, stairs and an elevator, departing from the traditional static arrangements.

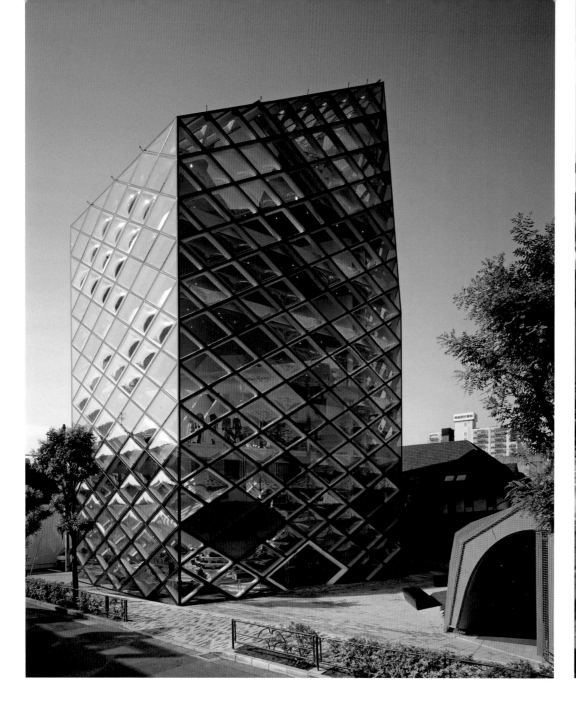

help you see your back, as well as the availability of a different color or size of the garment you are trying on.

The building, according to the architects, is all about perception—looking, viewing and exhibiting. Views into and out of the building are unfettered, altered only by the window curves and glazing which distorts images, as if seen through fun house mirrors. Yet, the building's playful form and effects do not conceal its technical virtuosity. According to the architects: "In terms of structure, glazing and fire safety regulations, the building ended up being one of the most complex structures in Japan."

The Prada flagship store in Tokyo is part of the brand strategy of Prada. While using the power of architecture to promote a brand or a political/religious concept is as old as the history of civilization itself, it is the fast-paced consumer focus that is the new driving force behind architecture. Where this will lead to is the subject of a vibrant global debate.

Above The molded glass prism composed of flat, concave and convex diamond-shaped glass planes offers Alice in Wonderland-like views into the multifloored shop.

Right Asymmetrical plan of a boutique floor responds to the site and lends dynamism to the building.

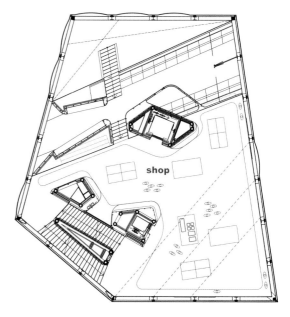

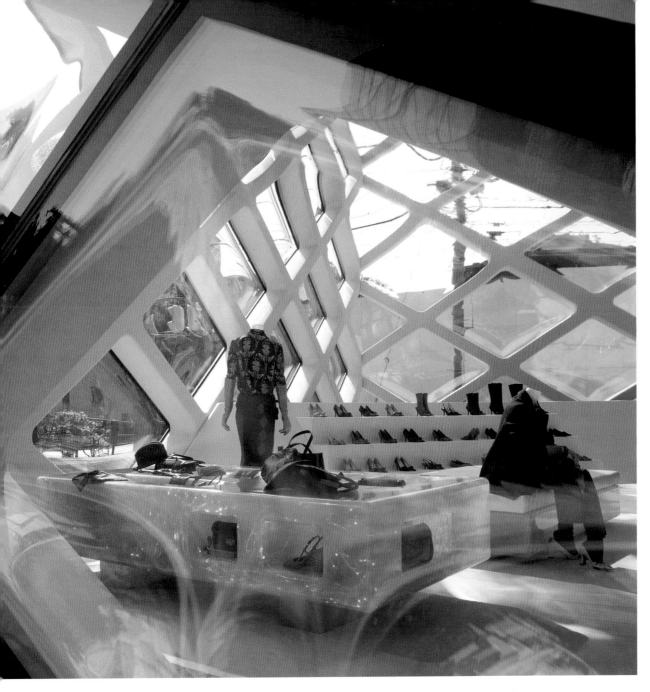

Left The window curves and glazing look on to the traditional roofs of residential buildings that coexist in Aoyama, along with its many contemporary boutiques.

Right Smooth, diamond-shaped tubes function as fitting rooms and display areas that seamlessly connect interior space.

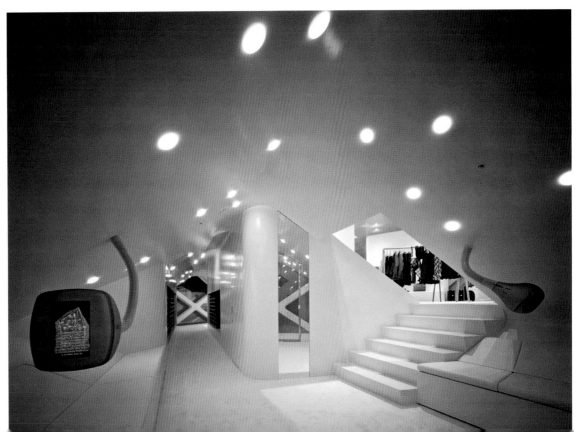

TOD'S OMOTESANDO

Architect **Toyo Ito & Associates, Architects**
Location **Jingumae, Shibuya-ku, Tokyo**
Completion **2004**

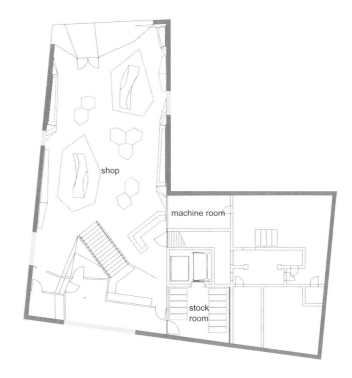

shop

machine room

stock
room

Right The L-shaped plan reflects Tod's irregular building site that wraps around an older building.

Below The graphic arboreal pattern is robustly formed by 300-mm-thick concrete and flush-mounted frameless glass that permits concrete floors to span 10–15 meters without internal columns.

Opposite A wintery view of Omotesando's renowned zelkova trees that echo the concrete branches of the architectural surface.

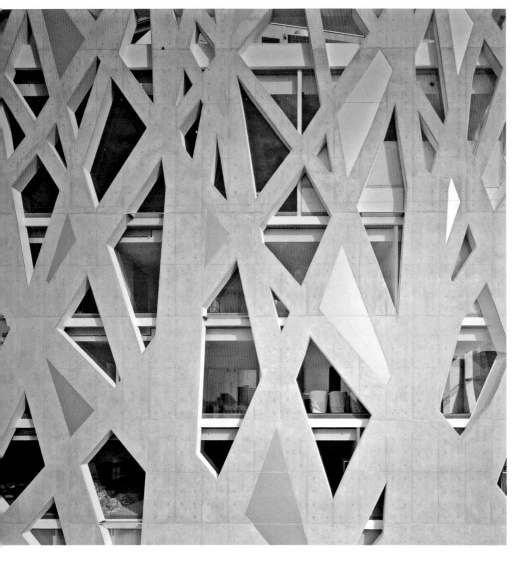

The Aoyama area of Tokyo is dotted with flagship luxury boutiques designed by some of the biggest names in architecture. When commissioned to design a building for the Italian shoe and handbag brand TOD's on a prime location along the chic Omotesando Avenue, Toyo Ito knew he wanted to create something more than just another ingenious jeweled box.

In Ito's words: "'Brandtecture' was something new. Where previously we had always pursued social values in architecture, in the world of fashion, cultural worth and indeed everything comes down to economic value." But with TOD's, Ito managed to merge the two concepts, creating what is for many the most vivid architectural presence on a street of architectural stars.

The site is L-shaped, with only narrow street frontages on the Omotesando and a side street. In order to create a unified volume and link the building to its context, Ito enveloped the structure in an exterior designed to echo Omotesando's most famous attribute—the row of tall zelkova trees that run its length. The surface is covered by concrete crisscrosses that evoke the branches of nearby trees. This graphic arboreal pattern—formed by 300-mm-thick concrete and flush-mounted frameless glass—is also a remarkably robust structural system that allows concrete floors to span 10–15 meters without any internal columns.

This distinct structure required refined construction techniques with great precision in building molds, inserting steel reinforcement and welding. Ito has noted that for this project

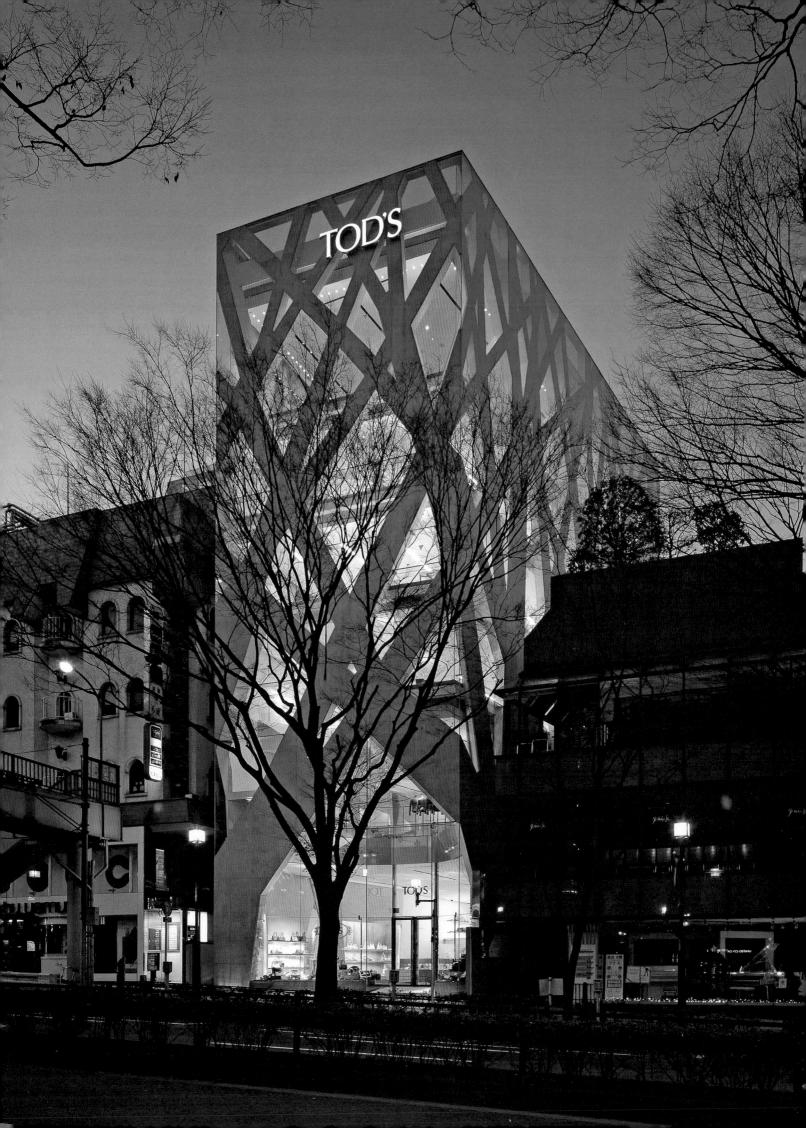

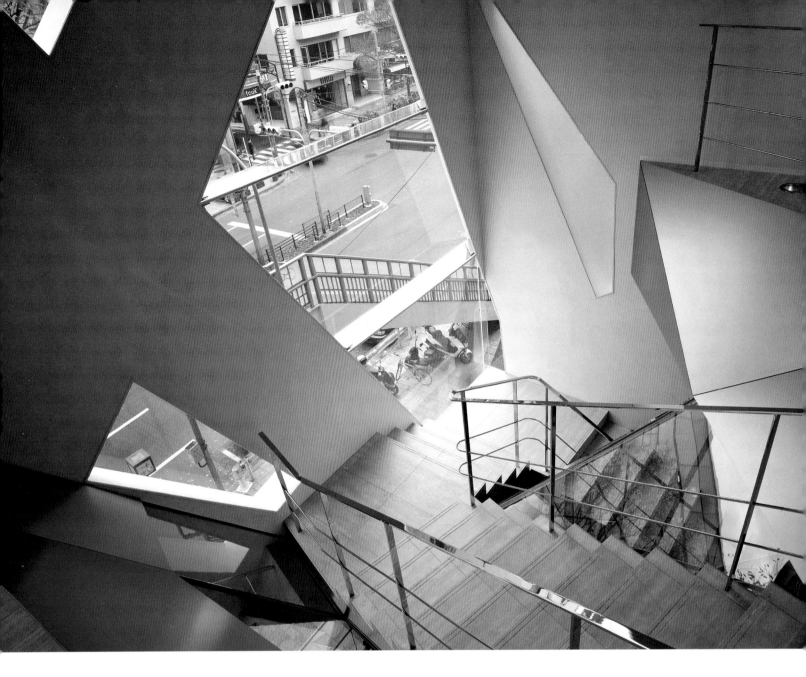

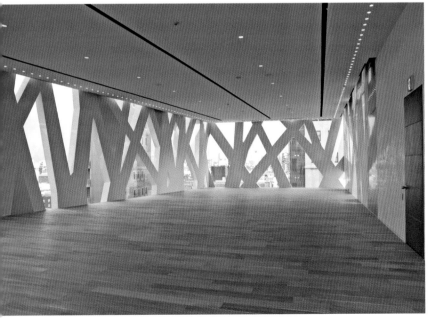

Above The ratio of openings rises with each floor of the building, reflecting the function of each level, from the shop on the ground floor to offices and a multipurpose space used for meetings and parties on the top floors (left).

Below Cross-section with a zelkova tree, the defining element of Omotesando Street.

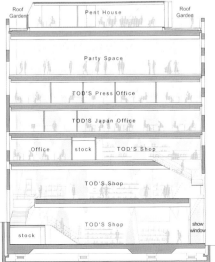

Roof Garden

Pent House

Roof Garden

Party Space

TOD'S Press Office

TOD'S Japan Office

Office stock TOD'S Shop

TOD'S Shop

TOD'S Shop

show window

stock TOD'S Shop

Omotesando st.

the more advanced the computer-aided design work and structural analysis became, the more he relied on the skill of the craftsmen, a fact that holds true for most of his projects.

Ito consciously chose to build in exposed concrete in contrast to the "glass architecture" of most recent structures on Omotesando. The strength of the concrete became part of the expression of the building. Starting from the inherently rational structure of the tree, Ito devised a flow of forces based on branches that become thinner and more numerous as they go up. The ratio of openings rises with each floor of the TOD's building, reflecting the function of each level, from the shop on the ground floor to offices and a multi-purpose space used for meetings and parties on the top floors. Inside, floor heights vary based on use, but each space is filled with natural light filtered through the arboreal design and with city views through architecturally abstracted nature.

By rejecting the traditional distinction between wall and opening, line and plane, two and three

Left The entire structure is enveloped in crisscrossed branches, even the back side.

Below Inside, natural light filtered through the arboreal design lights up each floor. Branch-like qualities are also featured in shop displays.

dimensions, Ito creates an expressive abstraction. The resulting architecture of Tod's Omotesando is a successful mix of concreteness and abstraction, building and nature, culture and commerce. Even those with no interest in $700 shoes are drawn to the geometric, arboreal appeal of Ito's TOD's building, which adds a breath of fresh air to a busy commercial street.

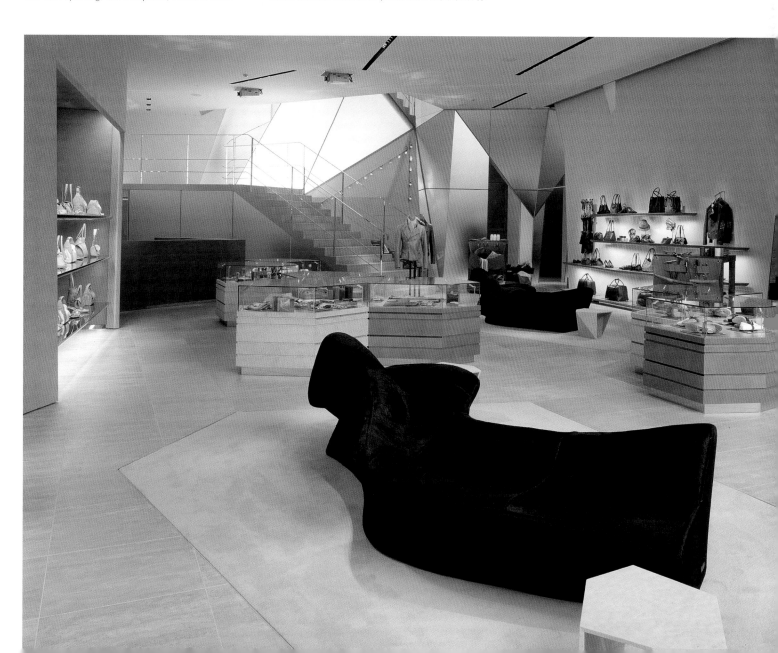

NICOLAS G. HAYEK CENTER

Architect **Shigeru Ban**
Location **Ginza, Tokyo**
Completion **2007**

In designing the Swatch Group's Tokyo headquarters, Shigeru Ban took inspiration from both an unusual and obvious source—clockworks. The Nicolas G. Hayek Center (named for the company's founder) is composed of a series of moveable parts that work together like a finely crafted Swiss watch.

The Swatch Group needed space for both their corporate offices and seven shops for their leading brands. After purchasing a much sought after plot on the grandest boulevard in Ginza, Tokyo's high-end shopping district, the corporation invited top architects to present designs. Despite completely rewriting the brief, Ban's unique plan won.

In a 474-square meter site, Ban accommodated 5,679 square meters of floor area, including two basements, fourteen stories and a one-story penthouse topped by a wavy steel roof. Ban organized the building as a stack of three- and four-story volumes, each with its own retractable shutters. The innovative structural system is Ban's latest experiment with moveable façades and his largest use of glass shutter technology.

The façade is composed of four multistoried atriums that can each be fully retracted in good weather. To add to the alfresco feel, Ban employs a vertical garden, filling the entire north wall with greenery from ground floor to roof. The plants vary from floor to floor, as designed by the landscape architect Toru Mitani. With the addition of potted plants and trees, the atriums take on the character of outdoor terraces.

The ground floor atrium is continuous with the street and dotted with trees that seem to sprout from its floor. The client had originally asked for two stories per floor, each with street frontage. Ban instead scattered the seven boutiques from the first basement level to the fourth floor, with each shop accessed from the ground floor atrium

by a dedicated elevator, itself a mini-showroom for its brand designed by Ban and other top designers. Thus, all boutiques share the premium ground floor street frontage, which is animated by the smooth rise and fall of pod-like elevators as clients visit individual boutiques. In the clustering of smaller-scale shops off the street front, Ban echoes the long tradition of small-scale shops that once lined the streets of Ginza, albeit in a very contemporary fashion.

A second set of conventional elevators and stairs hug the south wall of the entire fourteen-story building. Yet another box-like elevator occasionally pops up from the ground level's floor to ferry cars down into the underground garage. To accommodate both Ban's many atria and elevators and the client's demand for extra high seismic resistance, engineer Ryota Kidokoro of Arup Japan came up with a technically and symbolically apt system to strengthen the building's Swiss cheese-like structure. Kidokoro stiffened the first floor slab but loosened four upper level ones, perching them on rubber bearings. Detached from the main frame, they counteract seismic forces by sliding back and forth like a pendulum. Aptly named as the Self Mass Damper

Top Three-dimensional cross-section of Ban's clockworks-inspired plan

Above The entrance atrium features seven "showroom" elevators that take customers to timepiece boutiques spread over several levels.

Right The façade is composed of four multistoried atriums that can each be fully retracted in good weather.

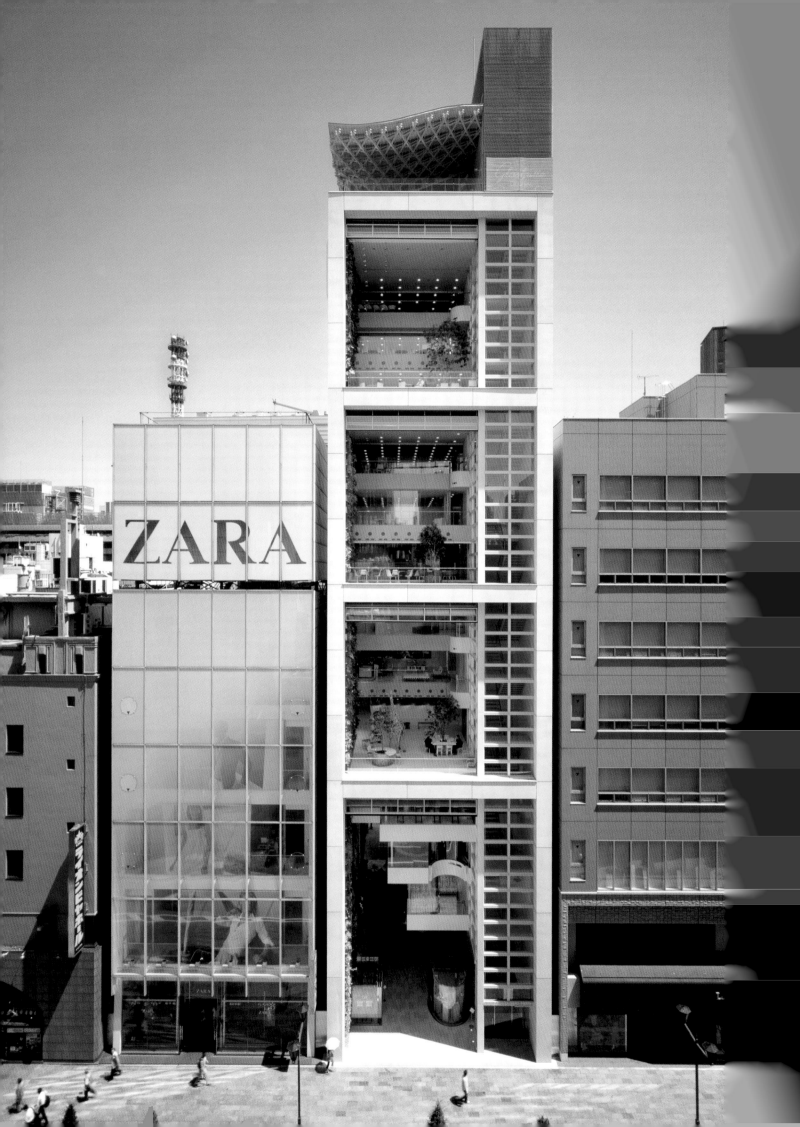

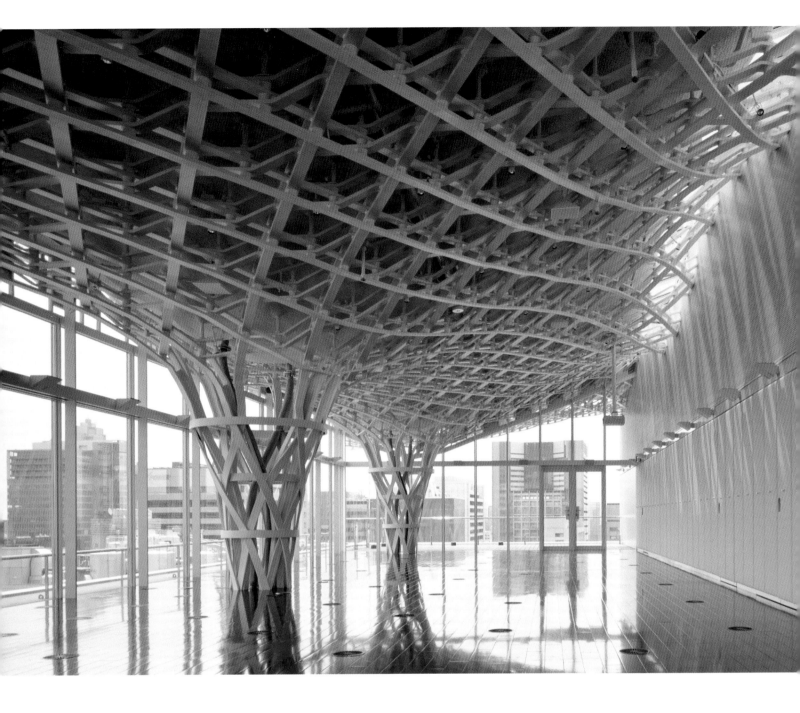

Reception Workshop Customer Service

EV1 EV2

Top A wavy, woven steel roof adds movement to the penthouse space.

Above Behind the atriums, the structure is divided into conventional floors. A sample plan is shown here.

(SMD) system, the newly developed damping system resulted in the reduction of seismic design forces by up to 35 percent.

Behind the atriums, the structure is divided into conventional floors. Above the commercial first four floors are three floors for customer service, followed by six floors of offices, topped by an events hall that allows panoramic views of Tokyo. The upper floor atriums function as lounges and waiting areas to the offices behind. The corporation reception space on the eighth floor is designed in a bold red and white color scheme, the shared colors of the Japanese and Swiss flags.

Ban is known for his innovative designs, ranging from the paper tube structures of his early career to vertical gardens and moveable walls that can give a sense of expansiveness to even small homes. With the Nicolas G. Hayek Center, Ban had an equally innovative client, and the combination has resulted in a building that surprises even the most jaded shoppers in Tokyo.

Left Atriums feature live trees and vertical gardens designed by landscape architect Toru Mitani. Such gardens bring greenery to otherwise intensely built-up areas.

Below A car elevator emerges from the ground floor to take cars to an underground parking lot, a luxury in this very tight site.

Above A reception area behind the atrium.

Left Opening on to the sidewalk, the entrance area blurs the boundary between retail and public space.

DE BEERS GINZA BUILDING

Architect **Jun Mitsui & Associates**
Location **Ginza, Chou-ku, Tokyo**
Completion **2008**

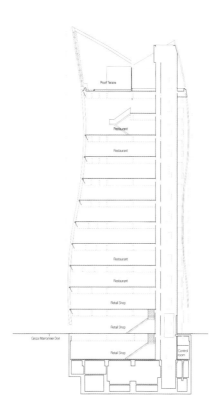

Below The grid pattern of specially finished stainless steel and aluminum window frames is arranged horizontally to accentuate the play of light off the rolling surfaces.

Right Side cross-section showing the façade curvature and floor distribution.

Below right The plan of each floor is different due to the irregular line of the façade.

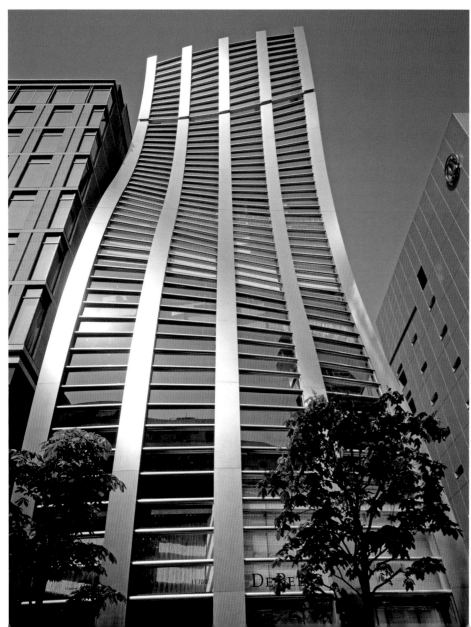

The boulevards of Ginza, Tokyo's glitziest shopping district, are lined with "brandtecture" and "startecture." It takes a lot to get noticed in this neighborhood of grand retail names and grander architectural gestures, but Jun Mitsui has devised an innovative way to do this for the De Beers Building. Although situated just off Ginza's main boulevard, the De Beers Building manages to catch the eye with its distinctive curving steel and glass façade. Its surface shimmies up, rising with vibrant curves among a sea of regular box-like buildings, embodying yet another variant of the contemporary trend toward "façadetecture."

Architect Jun Mitsui was commissioned to design the structure's glamorous façade, while De Beers in-house designers organized the interior that includes two basements and eleven floors, with the ground floor devoted to the sales of De Beers' finest jewels. Companies such as De Beers sell their choice products to discerning and brand-conscious shoppers in Japan, who consume about 25 percent of all undiscounted luxury goods sold worldwide. Special salons are set up to receive important customers, and to enable them to shop in private.

While it would have been unthinkable to the purists among the modernist, metabolist or even post-modernist architects who focused on the philosophical underpinnings of their work, commissioning architects to simply design façades is not uncommon in today's consumer-oriented world, particularly in the field of high-end retail design. The interior arrangements of these stores are left to practitioners of the soft science of luring and engaging potential consumers to buy ever more.

According to Mitsui, the façade's fluid and flexible form came from various inspirations, among them the idea of "light in motion," "the beauty of the female silhouette" and, appropriately for a building for De Beers, the world's most famous purveyor of diamonds since the nineteenth century, the "shimmering reflection of a diamond." The curtain wall undulates as it rises. A grid pattern of specially finished stainless steel and aluminum window frames is arranged

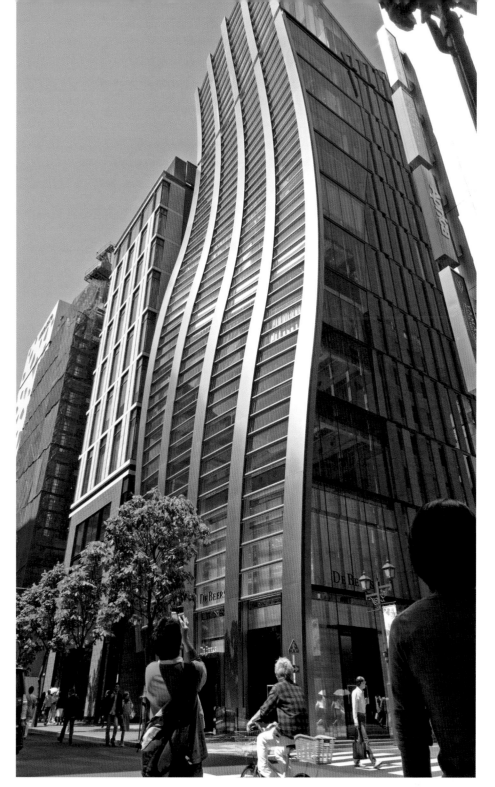

horizontally to accentuate the play of light off its rolling surfaces. Current computing technologies and new materials that make these curves possible were unavailable as recently as a decade ago. At its 48-meter-high peak, the profile of the building juts up like a cut diamond, just above the level of the surrounding buildings.

As the building sits on a corner, the side façade is also articulated, but with a unique elongated checkerboard pattern of glass alternating with polished and unpolished stone. With its glittering waves and bijou surface, the De Beers Buildings is in many ways a jewel box for the precious gems inside, and representative of the high-end consumer culture of today.

Left The distinctive curving steel and glass façade is an eye-catching example of both "façadetecture" and "brandtechture."

Left below The side façade is articulated with an elongated checkerboard pattern of glass with polished and unpolished stone.

Below Silvery side entrances are cut into the buildings bijou-like surface.

Bottom The street level entrance of the De Beers boutique, the world's most famous trader of diamonds since the nineteenth century.

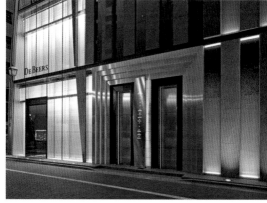

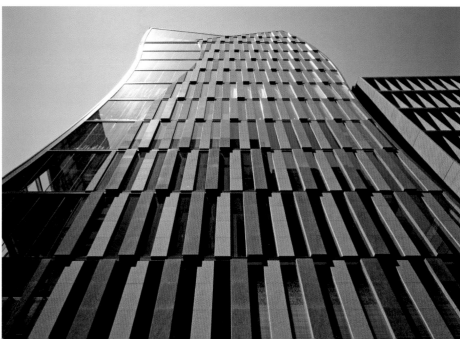

GYRE BUILDING

Architect **MVRDV**
Location **Omotesando, Shibuya-ku, Tokyo**
Completion **2007**

Right Side cross-section showing the multilevel design with its spiral circulation pattern.

Below Gyre's seven levels are composed of five irregularly stacked box-like volumes.

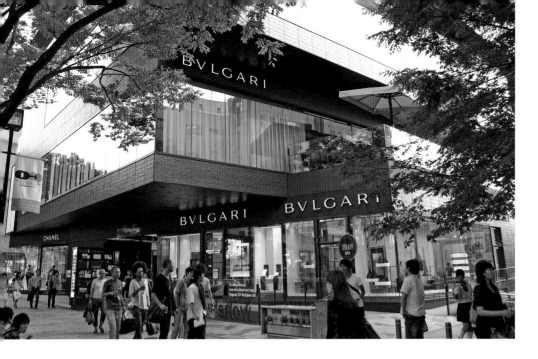

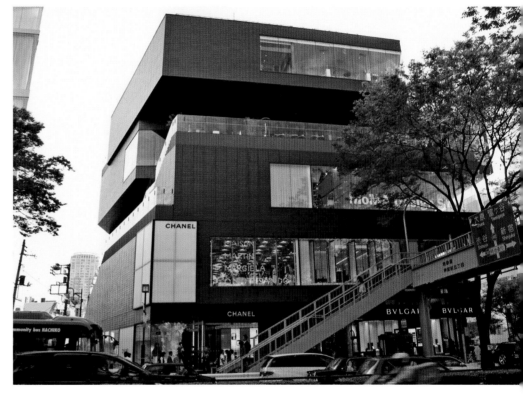

Omotesando, Tokyo's most fashionable boulevard, is awash in architectural beauties—refined contemporary structures designed by some of the world's best known architects to showcase the world's most luxurious brands. With lustrous "skins" of fine glass and polished surfaces, their façades act as giant advertisements for high-end brands. In the words of Jacob van Rijs, the architect in charge of the Gyre Building project: "They are the architectural equivalent of supermodels, but like supermodels, their beauty can be intimidating. Can a new building compete with them and make a statement? Can a new building strive to be more than merely decorative?"

When asked to design a retail space for prestigious brands like Chanel, Bulgari and the MOMA Design Store in a prime location on Omotesando, the architects decided that their building would be different than its neighbors. Instead of the delicate beauties around it striving for the "white cube aesthetics," the Gyre has strong black and dark surfaces. However, the real difference is in the way that this building relates to the street. Instead of a formidable façade that may discourage the less wealthy buyer to even enter, Gyre is stepped back from the street and invites the pedestrian to come in and explore its various floors using a vertical system of street-like circulation paths. In this urbanist attitude, Gyre is closer to Kenzo Tange's Hanae Mori building (1979) on the same street, and Fumihiko Maki's Spiral building (1985) a bit further. However, along with this openness, MVRDV needed to also create an iconic exterior since with neighbors designed by the likes Toyo Ito, Tadao Ando and Herzog & de Meuron, nothing else would suffice.

Their solution was a seven story, 30-meter-tall building composed of five stacked boxes with an open atrium in the middle. Each floor is slightly rotated around a central core, creating terraces and outdoor walkways and giving the building a sense of spiraling movement as well as its name. These terraces and outdoor walkways act as vertical "streets" up two façades of the building and lead to various retail spaces. They are landscaped with small trees and punctuated with welcome places to sit.

The Gyre's surface is covered in rectangular ceramic tiles that lend the surface a dark understated gloss and add to the building's overall sculptural quality. Having created a distinct silhouette on the avenue, MVRDV kept the façade relatively modest, with shop window-sized openings on each level, which can be used as doors, windows or for signage, allowing the brand-name stores to express themselves as they wish.

When comparing the Gyre to its neighbor, the shimmering white glass Dior building by celebrated Tokyo architects SANAA, MVRDV has called the pair "Beauty and the Beast." Yet, it is just this masculine, earthy Dutch austerity that makes the Gyre Building a pleasing contrast to its fashionable neighbors.

Top left Each floor is slightly rotated around a central core, creating terraces and outdoor walkways and giving the building a sense of spiraling movement as well as its name.

Top right Plan showing the layering spaces of the Gyre Building.

Above Rectangular ceramic tiles lend the surface a dark understated gloss and add to the building's overall sculptural quality.

Below A glass-walled café perched over bustling Omotesando provides unparalleled views of the parade of high-style shoppers below.

architecture
for the city

Japan has some of the most densely populated urban areas in the world, yet visitors often marvel at the cleanliness, efficiency and civility of its streets. Its transport system is world class and often held up as a model of efficiency and environmental sustainability. Yet, urban design concerns have been underprioritized in the recent past. Most building decisions are informed by irregular building sites and tight building envelopes allowed by zoning laws, rather than a sense of responsibility to enhance the public experience of the city. The result is a dynamic mix of residential, commercial and retail land uses, which lend to Japanese neighborhoods their human scale and unique charm, but can also add a measure of visual chaos not found in other Japanese visual expressions.

Projects in this section have been selected for their positive public attitude, and their effort to define and revitalize civic spaces. Kumiko Inui's Monument at a *shinkansen* (bullet train) station is a successful example of recent commissions awarded not to the usual large construction companies but to a young architect by large public and semi-public organizations aiming to improve public spaces. Using local lumber to support local industry and add a green element to a piece of urban infrastructure, Naito Architects also uses a train station as a starting point for urban renewal; while Riken Yamamoto's Fussa City Hall provides not only a stimulating architectural space for the workings of government but also provides a focal point for civic pride. Architecture is a civic art, and good buildings must be good citizens too.

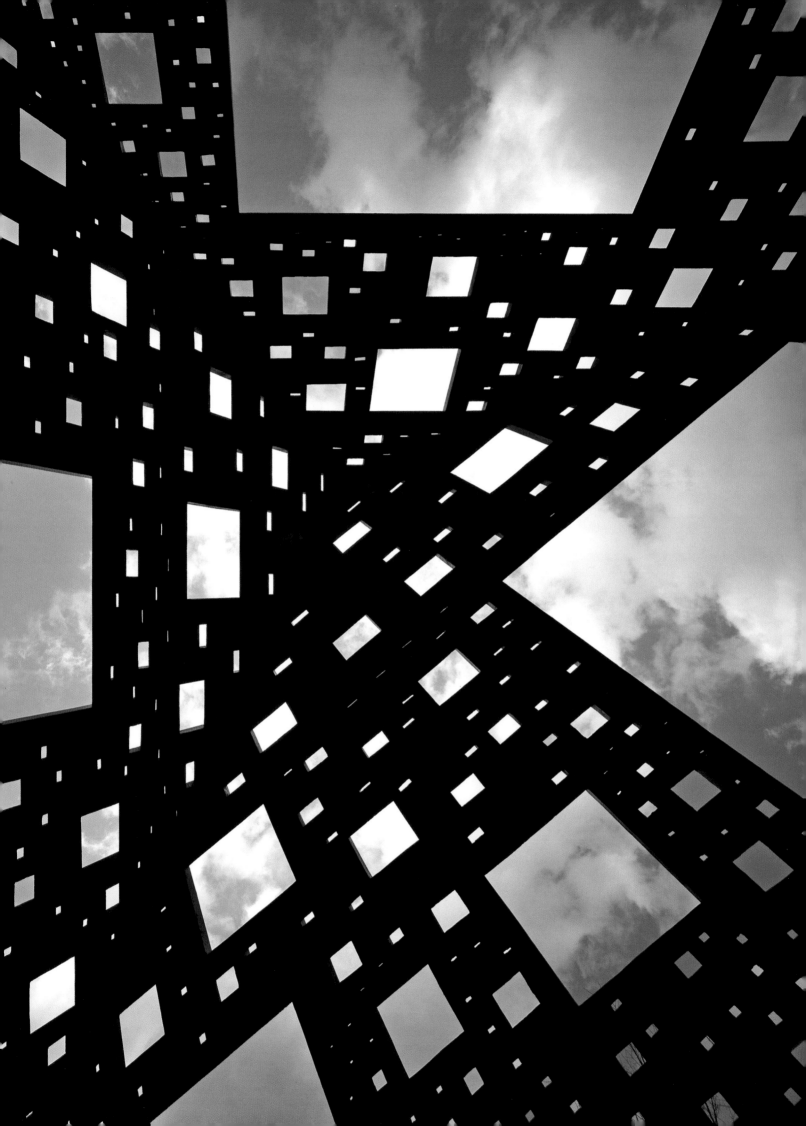

FUSSA CITY HALL

Architect **Riken Yamamoto & Associates**
Location **Fussa City, Tokyo**
Completion **2008**

Right Plan of Fussa City Hall.

Below The design features two low towers whose red brick tile façades seem to spread across the lawns like the flounces of a summer skirt.

When Riken Yamamoto won an international competition in 2004 to build the new city hall of Fussa at the northern edge of the greater Tokyo metropolitan area, he set out to create a symbol of the synergy possible between the government and its citizens. Yamamoto says: "In my opinion, building a city hall is a chance for the local government to speak to its citizens and tell them how it plans to build the local community. If a city hall is going to be there for 100 years, then it is necessary to think about the citizens now, and a 100 years from now."

Yamamoto was originally asked to organize the construction of the new city hall around the old one, which was to remain in use until the new hall was ready. However, Yamamoto wished to use the entire site so as to keep the buildings low rise and to create a seamless relationship between the buildings and the surrounding park. The final design occupies the entire site, dominated by two low towers whose red brick tile façades seem to spread across the lawns like the flounces of a summer skirt. The result is a highly distinctive aesthetic in which the rigid geometry of the towers' glass and brick façades permeate the park around them.

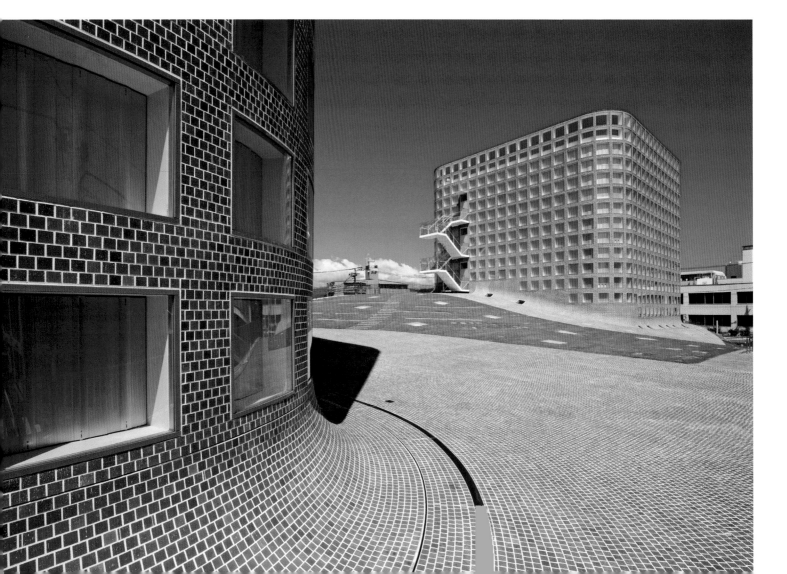

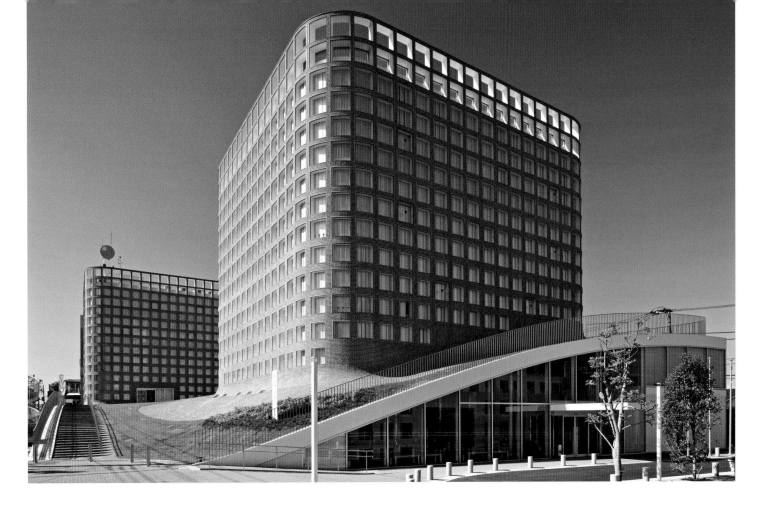

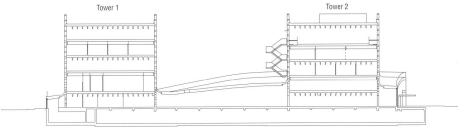

Tower 1 Tower 2

Above Using flowing seamless lines and wraparound windows, Yamamoto set out to create a symbol of the synergy possible between the government and its citizens.

Left Cross-section of the buildings' elevation.

Below A version of the exterior grid rendered in white has been employed to create a flowing, porous interior, organized to offer ample office and civic assembly space.

Fussa City Hall consists of three components—a forum, a hill park and two towers. Located on the ground level, the forum's glass façade leads into a multipurpose public space. As the main entrance and location of various government service counters, it is here that most of Fussa's citizens enter the town hall. The forum is covered by the gently undulating topography of a hill park that complements this public space. The surface of the "hill" dips down to connect to the ground at two points, thus structurally acting as a shell. The park between the two towers is scattered with a loose pattern of plantings, brick lines and rectangular windows that allow natural light into the forum below. The two square towers with rounded corners seem to emerge from the hill park. Each tower's broad surface, spanning 21.5 meters, is covered with a rigid grid of square windows that seamlessly curve with the wall. Windows set at various levels disguise the interior layout that is loosely organized into four floors, providing ample office and assembly space.

Precast concrete, a high-performance, seismic-resistant material, is used for the floor slabs and the outer skin structure. The columns and beams of the outer skin become thinner as the towers rise, lightening their appearance. The top two window levels are a mere façade that surround an open roof space. These three different elements are united by the distinctive finale of a "skirt" of red brick tile that gently spreads out on the lawn, dotted with variously sized windows that act as skylights in the forum below. The expression of the building's surface is thus transformed into a playful and moldable skin.

Highly functional and iconic, Fussa's City Hall succeeds in contributing to the civic pride of the residents of Fussa City.

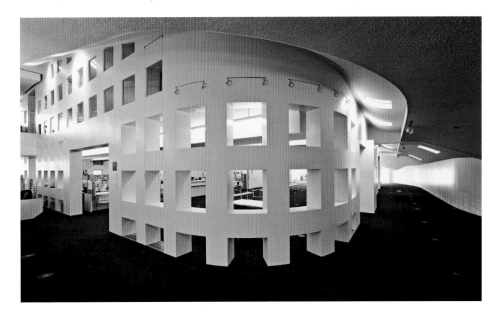

HYUGA CITY STATION

Architect **Naito Architects & Associates**
Location **Hyuga City, Miyazaki Prefecture**
Completed **2008**

Since the 1960s, a steady flow of people have poured out of Japan's provinces and into its main cities, leaving many regional towns and cities to a slow decline. However, numerous public projects, from new museums to train stations, have been undertaken in recent years to spark revitalization. Despite its status as capital of Miyazaki Prefecture in the southern island of Kyushu, Hyuga City has seen a similar decline. Local officials have initiated revitalization of the city center with various infrastructure and planning projects highlighting the region's natural resources. Known for its large *sugi* (Japanese cedar) forests and timber industry, Hyuga's plans center around the use of cedar, an approach that can both bolster the local timber industry and bring a much needed natural element into its building designs.

One of the important infrastructure initiatives to ease congestion in the city involved elevating 1.7 km of Japan Rail line that passed through the city center causing congestion. The new train station required for this change was designed by Tokyo-based Naito Architects, who have designed several train stations, including the recent Kochi Station in Shikoku and the Asahikawa Station in Hokkaido.

Hiroshi Naito, the firm's principal, is known for technically advanced but culturally and environmentally sensitive architecture. According to him: "Architecture is the form through which we endeavor ... to respond to and coexist with our environment. Its details should therefore inevitably reflect the character of the landscape in which it stands." His quiet, elegant structures are designed for durability, an uncommon but much needed trait in the *tatekae* (scrap and build) culture of Japanese construction. This was also the kind of approach needed by a city looking to rejuvenate its environment in the long term and give it a distinctive local character.

Hyuga station has a two-level steel-frame structure comprised of a raised, covered train platform and a public concourse below. A large laminated cedar roof covers the elevated railway bridge, which arcs down on either side to steel-framed curtain walls of glass. Light also enters via a long narrow skylight along the lengthwise axis of the roof. Underneath the railway bridge, an open public concourse is sheltered beneath a ceiling of cedar planks supported on numerous slender steel columns.

Seen among its chaotic surroundings typical of train stations in small Japanese cities, the structure appears light, transparent and almost delicate. However, inside, the use of exposed timber gives the structure a warm, robust quality. Travelers on the platform can view the surrounding city through the long wall of windows, but the structure's expressive focus is without a doubt the elegant cedar canopy above, constructed of varying girder depths.

Large roofs are often a strong feature in Hiroshi Naito's buildings, as they are in traditional Japanese architecture. Even with this relatively simple shed-like frame, the roof displays the strength, precise joinery, craftsmanship and graceful lines that recall roofs and ceilings of Shinto or Buddhist temples. Although constructed in a contemporary steel framework, the station also echoes the soaring train stations of the age of rail. Hyuga Station is thus a good mix of modern function, local material and design references to local industry, traditional architecture and the long history of the railways in Japan.

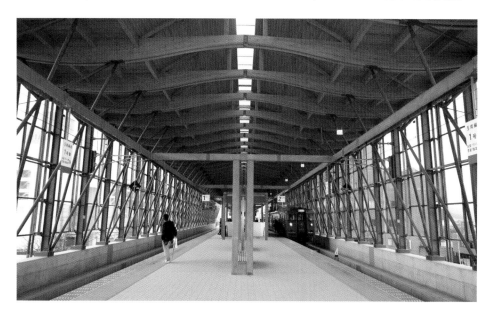

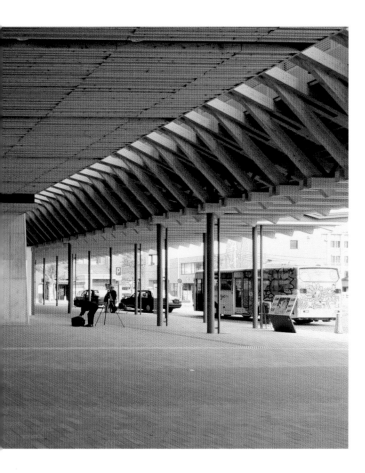

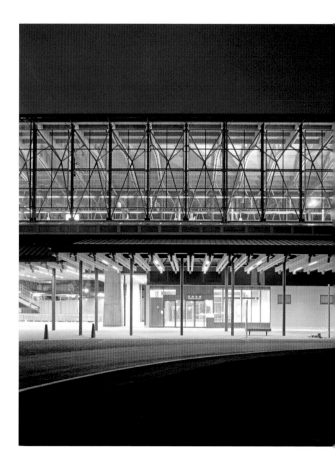

Left Naito has used *sugi* (Japanese cedar) in the station's construction for its structural and aesthetic qualities, and to refer to the local timber industry. The ground level public concourse achieves a balance of openness and warmth.

Right The two-level steel-frame structure is composed of a raised, covered train platform and a public concourse below.

Opposite below A cedar roof covers the elevated railway bridge, with natural light provided by steel-framed curtain walls of glass and a long narrow skylight along the lengthwise axis of the roof.

Below In its busy urban setting, the transparency of the station allows travelers to enjoy city views from the platforms.

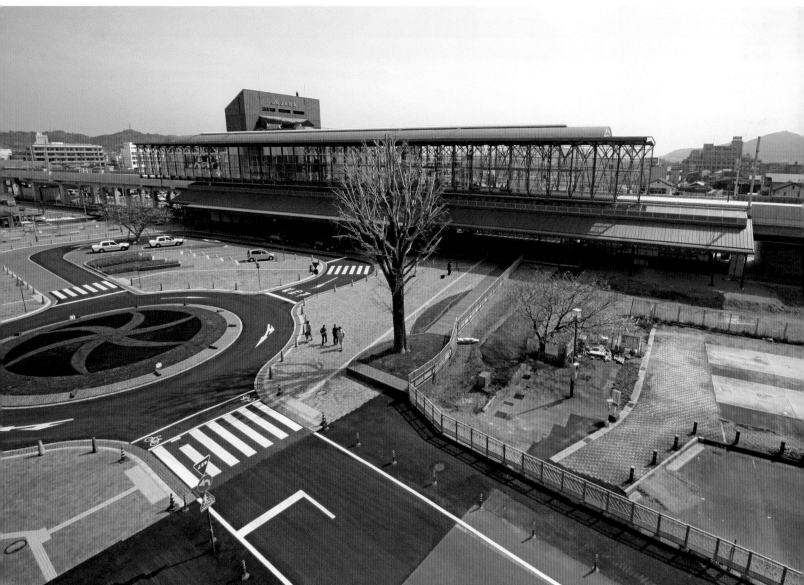

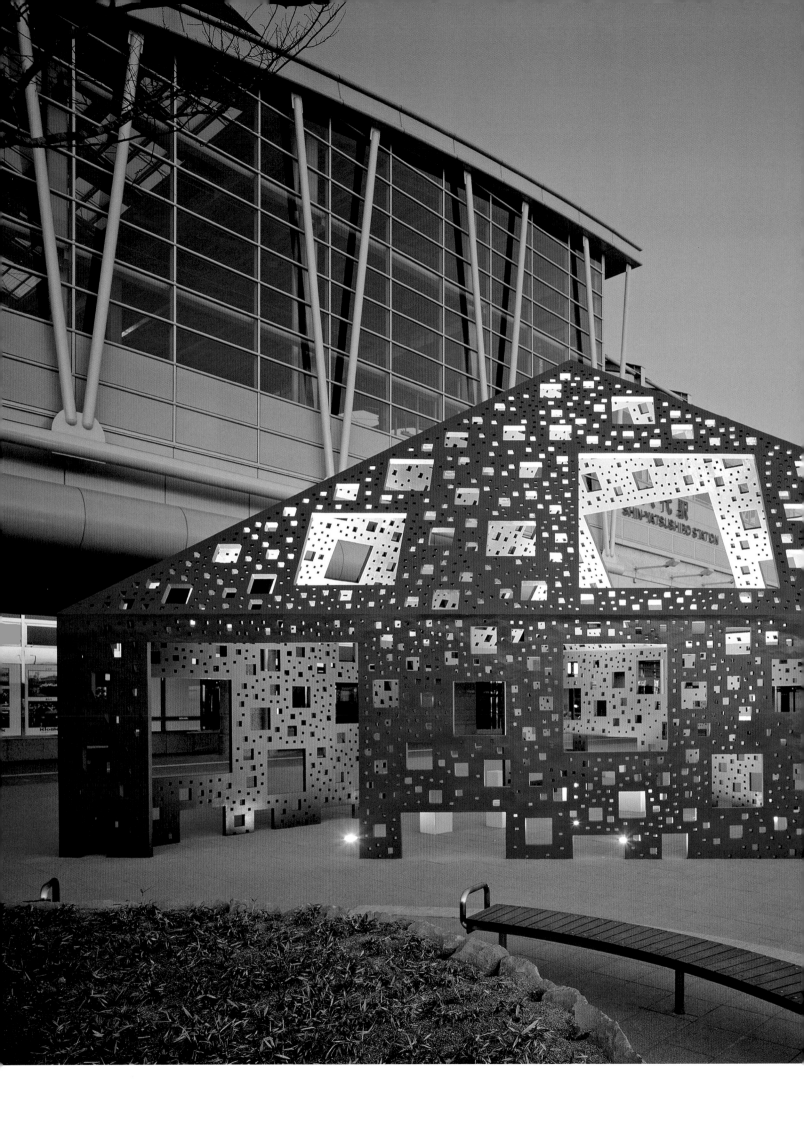

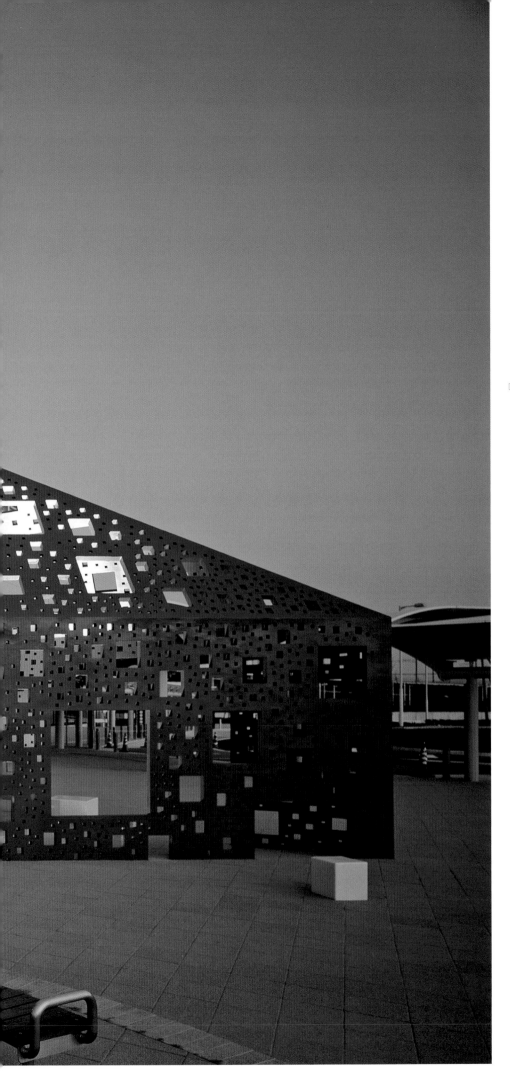

MONUMENT AT SHIN-YATSUSHIRO

Architect **Kumiko Inui**
Location **Yatsushiro, Kumamoto Prefecture, Kyushu**
Completion **2006**

This picturesquely porous pavilion stands before a *shinkansen* station in the town of Yatsushiro, in the southern Japanese island of Kyushu. Built to celebrate the opening of the new high-speed train station, it serves as a waiting area for travelers, especially those with umbrellas.

This whimsical pavilion is the design of young architect Kumiko Inui. Establishing yourself as a young architect is no easy task, even for those like Inui with a Yale degree and four years experience in the office of Jun Aoki. As an independent architect, she first made a name as a designer of intricate façades featuring visual puns or optical illusions, such as for the Dior building in Ginza. She brings a similar sensibility to the Monument at Shin-Yatsushiro, which was her first independent commission.

The pavilion is shaped like a pitched-roof house with a triangular plan and an asymmetrical roof, with square holes of varying sizes cut into the glass-reinforced concrete walls and roof. From a distance, it looks like a crooked house from Alice's Wonderland. The sense of enchantment continues as one gets closer and the structure seems to dematerialize. Explained Inui: "I conceived an object that, because of the limits of resolution of human vision, appears from a

Above Inui's elegantly understated but playful plan.

Left The pavilion's delicately porous surface offers a whimsical foil to the station's conventional solidity.

distance to be a house and from close up to be a lace-like perforated structure." Her intention was to create a monument that bridged the gap between the train station and the surrounding countryside: "I thought that a monument which, depending on the distance, seems to be connected in some way both to the countryside and to the station was appropriate."

From inside the pavilion, the surrounding landscape is viewed through the frame-like holes. Says Inui: "Perhaps because the holes are in various sizes, it does not feel as if one were looking at a single continuous landscape through the holes, but that separate, fragmented landscapes are pressing in on one from all sides—a condition that might be called the fragmentation of the landscape."

The Monument at Shin-Yatsushiro is an example of the commissions that are starting to be given to young architects by Japan Railway as well as other large public and semi-public organizations in Japan. The result is healthy competition, and some daring and interesting designs. This is a welcome change from the past where iconic projects, large and small, were usually given to large construction companies in design-build contracts.

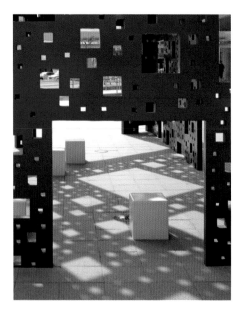

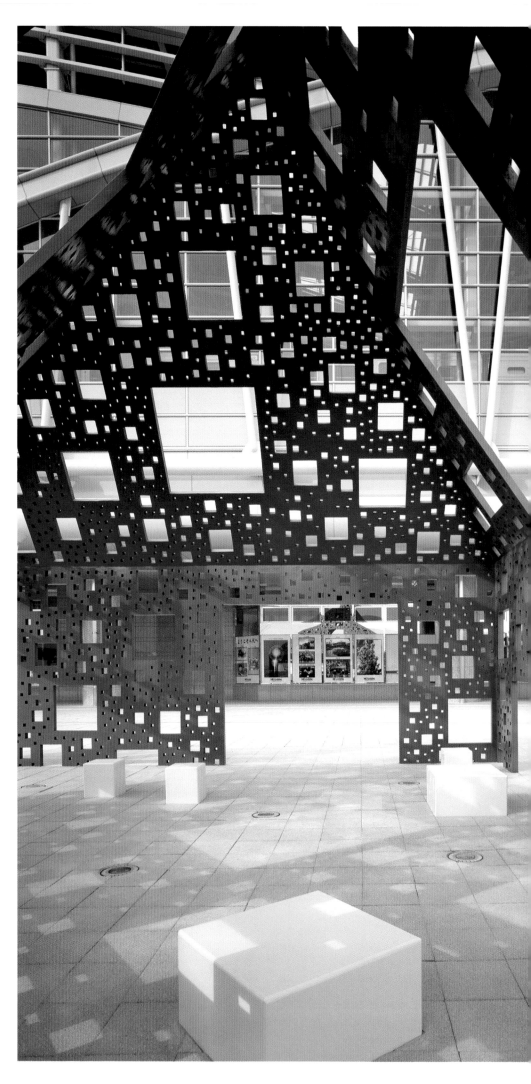

Above Randomly placed seats offer train travelers a resting place, and continue the intrigue of the structure.

Right The project is one of a number of commissions given by Japan Railway to young architects, which are adding elements of artistry and vitality to public transport spaces.

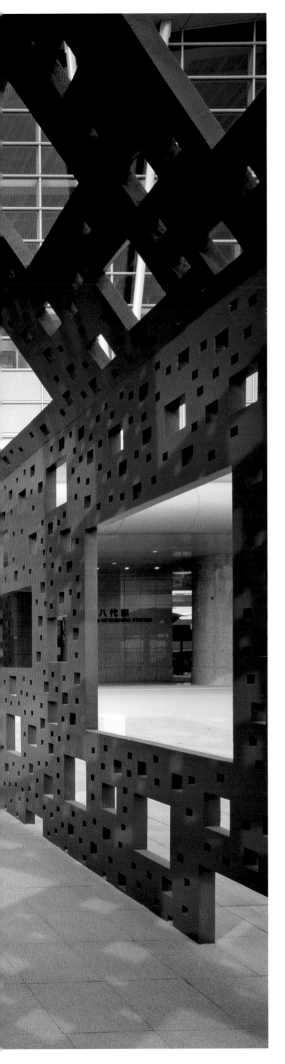

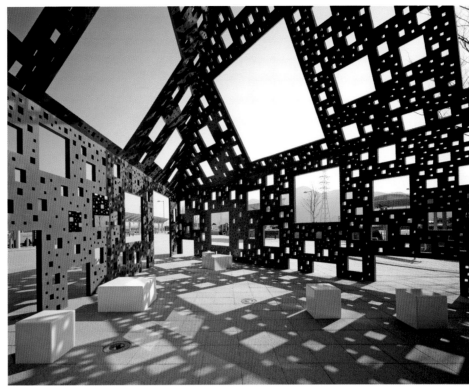

Above From inside the pavilion, the surrounding landscape is viewed through the frame-like holes in the sides and roof.

Right Cross-section of the pavilion.

Below The pavilion is shaped like a pitched-roof house, but with a triangular plan and asymmetrical roof.

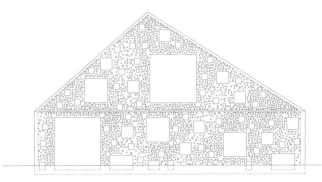

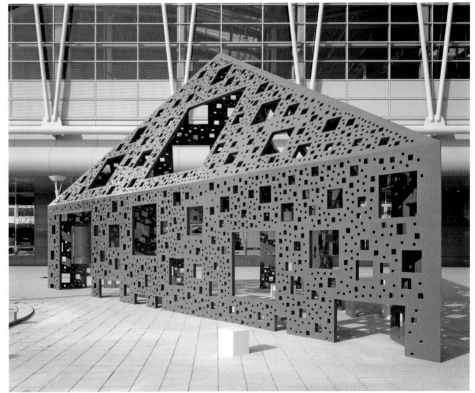

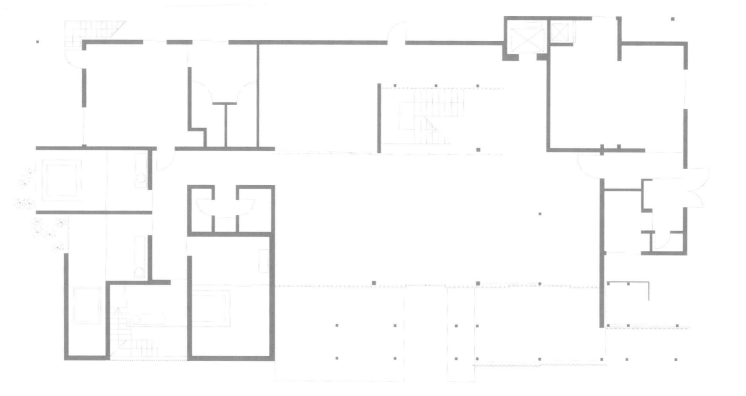

architecture
for renewal

Relaxing is a serious business in Japan. Whether soaking in a *hinoki* cypress wood tub of an *onsen* (a hot springs spa and inn), skiing with a crowd in the mountains of Hokkaido, or simply slipping into a blue and white *yukata* (cotton robes provided at many hotels) to relax and admire a stroll garden, the hardworking Japanese are as particular about their leisure time as they are about their work. The projects featured in this chapter all offer special spaces for recreation and relaxation.

The projects presented here are also examples of a laudable new trend in Japan—renovation of older buildings. In a country where still-robust buildings are often destroyed to make way for something more modern or profitable, a new openness to renovations reflects the realities of a more sober economic era but also a growing concern for the environment. Kda's redesign of a tired 1980s high-rise ski resort not only saved the expense, pollution and waste of rebuilding but also added a contemporary and more contextually sensitive solution in an area of natural beauty.

Concerns about whether and/or how the past is preserved are also finally entering the public dialog. In Japan, where a tradition of wood architecture meant that structures were frequently rebuilt as they rotted or burned, and where earthquakes and war have seen many cities reduced to rubble more than once—Tokyo itself was flattened twice in the past century—there has not traditionally been the same concern with building or preserving for posterity as in the West. Today, often thanks to publicity campaigns by preservationists, many historic buildings are avoiding the wrecking ball. In the case of the International House of Japan, renovations carried out by Mitsubishi Jisho Sekkei saved an important historic building from destruction, at least for the time being. Developers are still eyeing this modernist gem and its acclaimed Japanese garden situated on prime real estate. In other cases, historic buildings are given a full but sensitive remake, as in Kengo Kuma's elegant update of a century-old *onsen*.

TOMAMU TOWERS

Architect **KDa (Klein Dytham architecture)**
Location **Tomamu, Hokkaido**
Completion **2007**

Tomamu Towers rise unexpectedly above the forest-covered mountains of the alpine resort of Tomamu in Hokkaido, the northernmost of Japan's big four islands. Situated in an outdoor recreation area popular for golfing, hiking, rafting and skiing, these twin forty-story hotel towers are not what one expects in this sparsely populated area of natural beauty. Built during the economic boom of the 1980s, they stand 121 meters tall—so high that in winter the cloud layer is often lower than the uppermost floors, which can seem to float above the clouds.

Twenty years after they were constructed, the towers were in need of recladding and the resort complex's new owners, Hoshino Resorts, asked Klein Dytham architecture to develop an external color scheme for them. KDa had previously worked with Hoshino Resorts in renovating the Risonare Resort in Kobuchizawa, a project that resulted in their well-known Leaf Chapel, the Brillare wedding reception hall and the Moku Moku Yu bathhouse.

KDa's main goal was to reduce the impact of the towers, so they decided to use camouflage as a strategy. However, the ever-changing environment of this four-season resort made this a challenge. Since nothing could be done about the out-of-context extraordinary size of the towers, KDa instead decided to make the most of it with a bold, cheery color scheme that gives the towers a somewhat surreal contemporary look.

With this clever design, KDa lives up to its reputation for dealing with unusual design challenges. The Tokyo firm's European expatriate principals, Astrid Klein and Mark Dytham, both came to Tokyo in the 1980s to work with Toyo Ito, going on to found KDa in 1991. From the moment they began practice, they took every opportunity to work, from tiny projects to temporary works to unusual renovations that blur the boundaries between architecture, communication media and advertising. Their work is often part performance, with elements of fearlessness and freedom that perhaps arise from their outsider, *gaijin* status.

In this case, their solution was to camouflage one tower with a winter theme in a blend of black, gray and white, and the other tower with a summer theme in two shades of green and white. KDa's aim was to lighten the buildings' mass, not make them disappear, and so a few red panels, inspired by Christmas tree decorations, were added to liven things up. These flashes of red also blend well with the vibrant colors of fall in Tomamu. The overall effect is a bit like a pixilated image of colorful geometric forms dancing against the forest backdrop.

The renovation of older buildings is not a common event in Japan. The average lifespan of a building in Japan is about twenty years as *tatekae* (scrapping and rebuilding) is the most usual approach for aging buildings. KDa's creative renovation of the towers is one of the few such projects in Japan. The massive Japanese construction industry is not geared toward renovation, so a Canadian company specializing in external insulation was brought in to realize the project.

Although the Tomamu Towers are in many ways monuments to the insensitive building practices of Japan's boom years, their upbeat, modern renovation has made them not only an unusual landmark but also a positive example of the possibilities of well thought out, imaginative and creative renovations.

Below Dappled in greens and grays, the multicolored towers echo the changing seasonal colors of their landscape.

Right Featuring flashes of red inspired by Christmas decorations, the pixilated design lightens the 121-meter buildings' mass and pulls a 1980s built resort into the twenty-first century.

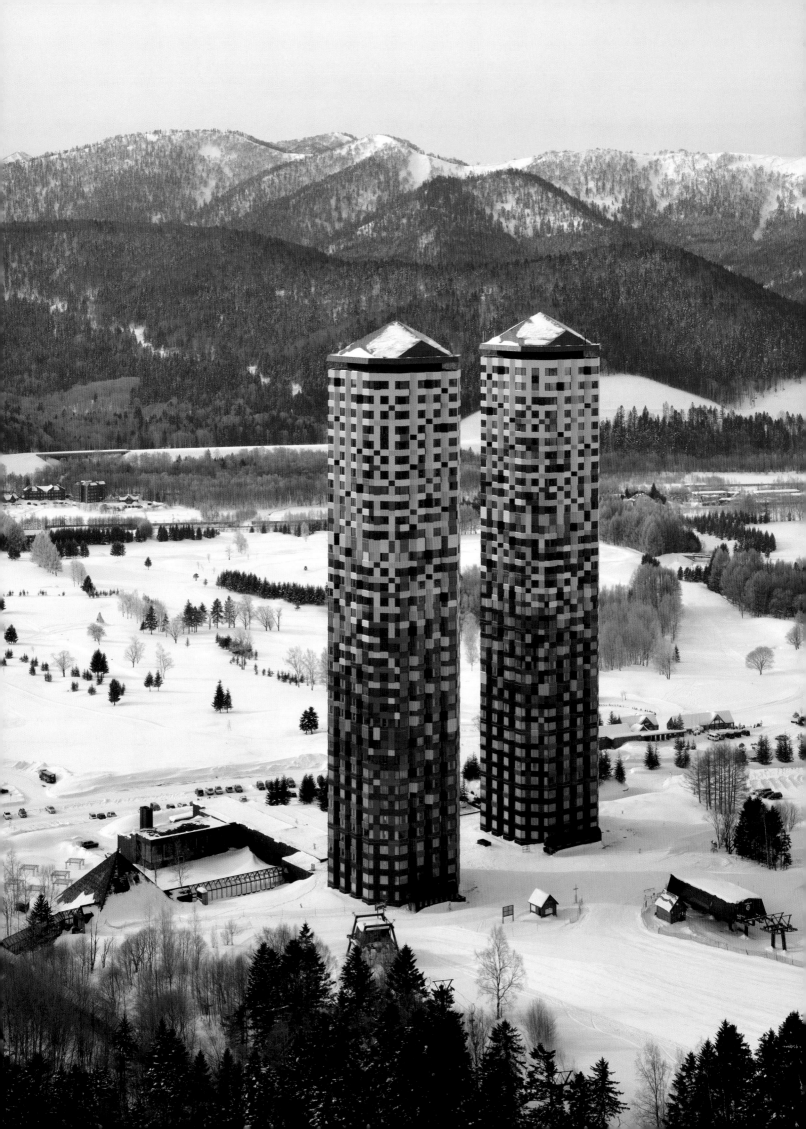

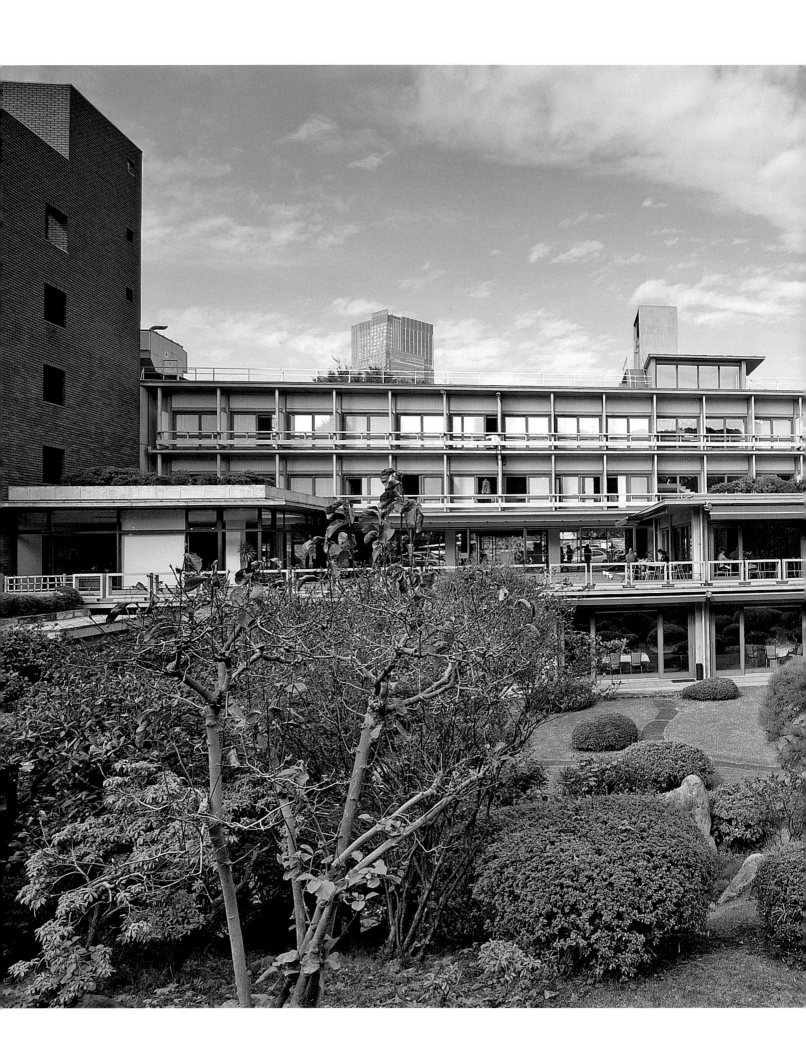

INTERNATIONAL HOUSE OF JAPAN

Architects **Kunio Maekawa, Junzo Yoshimura and Junzo Itakura (1955); Renovation—Mitsubishi Jisho Sekkei Inc. (2006)**
Location **Minato-ku, Tokyo**
Completed **2006**

The idealism and optimism of post-war modernist architects was matched by philanthropists like John D. Rockefeller III, who believed that artistic and intellectual exchanges between countries would help make the world a better place. It was with this aim that Rockefeller founded three centers of cultural exchange—the International House of Japan in Tokyo, the India International Center in New Delhi and the Asia Society in New York. Quite appropriately, foremost modernist architects in these countries designed the buildings housing these organizations. While the buildings in New York and New Delhi endure, the International House of Japan building was slated for destruction in 1990. This is not surprising in Tokyo, where high land prices, a hyperactive construction industry and a preference for the new result in most aging buildings being demolished rather than renovated. This has often been the case even with architecturally significant buildings, such as Frank Lloyd Wright's Imperial Hotel, destroyed in 1968. But a growing awareness of environmental and urban preservation issues by the public and architects alike is resulting in renovations of Japan's older buildings.

The International House of Japan (IHJ) is an exceptional example of mid-twentieth century modernism built in 1955 from a joint design by architects Kunio Maekawa, Junzo Yoshimura and Junzo Itakura. It was enlarged in 1976 according to plans by Maekawa, who himself was a student of Le Corbusier, the teacher of Kenzo Tange and a major post-war figure in Japanese architecture.

Left The International House of Japan represents the height of modernist architecture, and yet the delicacy of its material expression, the horizontality of its façade and its clean lines also echo traditional Japanese architecture.

The building is one of 100 modernist buildings on the DOCOMOMO list (Documentation and Conservation of building sites and neighborhoods of the Modern Movement). Nevertheless, in the 1990s it was aging and in need of repairs, including a seismic resistance refit. The initial plan was to knock down and replace the structure. Luckily, a campaign to save the IHJ was launched by the Architectural Institute of Japan, reflecting a new trend in Japan—renovation of aging buildings—which occurred between 2004 and 2006.

The IHJ stands on the site of an Edo-era feudal residence that over the centuries had seen grand imperial events. The last residents had been the notable Iwasaki family. After the Second World War, all that remained on the site was the residence's garden. However, investigations during the 2004–6 renovations revealed that the compressed soil base of the Iwasaki residence was still present under the IHJ. Thus, a design was devised that would preserve this archaeological site within the renovated structure.

Renovation decisions were considerate of the modernist character of the architecture as well as the functioning of the building over its fifty-year life. Twenty-first century usage required up-to-date mechanical systems, redesigned guest rooms, a new basement auditorium and wider entrances. However, important elements such as the exterior cladding were preserved.

The adjacent Japanese garden was also part of the renovation plan. Following Japanese traditions of "borrowed scenery," the 1955 modernist building had been designed to work in harmony with the surroundings, with broad windows making the garden part of the interior experience. The garden itself was designed by well-known Kyoto landscape artist Jihei Ogawa in the style of the Momoyama period (late sixteenth century) and early Edo Period (early seventeenth century), while the placement of the building in relation to the garden was based on a motif from a Heian-period (794–1185) scroll painting.

For the preservation of both the historic garden and the modernist structure in 2006, the IHJ was awarded the Architectural Institute of Japan Prize and registered as a National Physical Cultural Heritage.

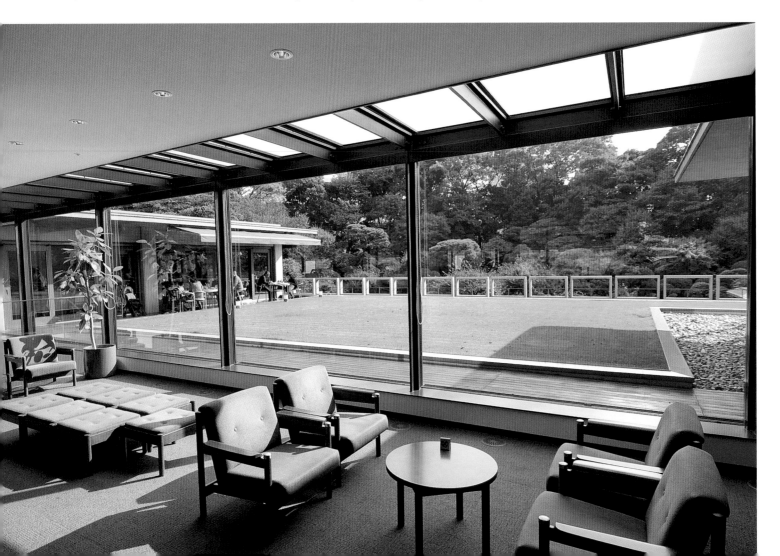

Left top The Japanese gardens were integral to the renovation plan, which retained the strong visual link between interior and exterior spaces.

Left bottom Green rooftops and terraces echo the adjacent Japanese garden designed by well-known Kyoto landscape artist Jihei Ogawa, and let the interior and exterior flow into each other in a quintessentially Japanese way.

Right A fine example of mid-century modernism jointly designed by architects Kunio Maekawa, Junzo Yoshimura, and Junzo Itakura in 1955 the IHJ was saved from planned demolition and renovated by Mitsubishi Jisho Sekkei bewteen 2004 and 2006.

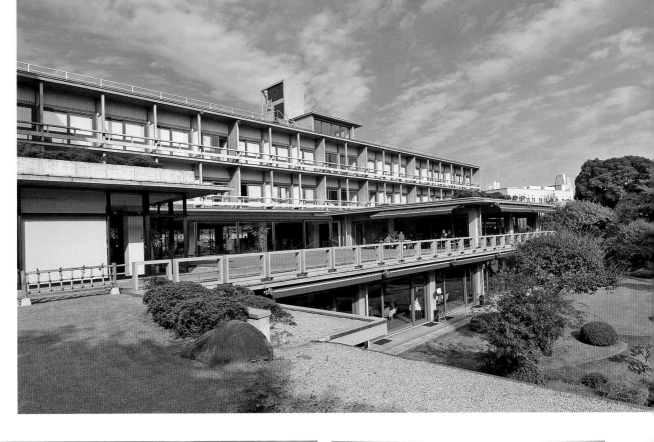

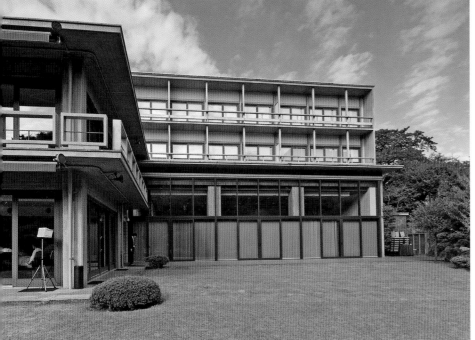

Above The IHJ's interiors were updated while maintaining a crisp Japanese modernism as well as a more traditional architectural play of light and shadow.

Above Contemporary usage required numerous internal and structural updates. However, all renovations and additions were done in the spirit of the original building.

Right Cross-section of the IHJ's recent renovation.

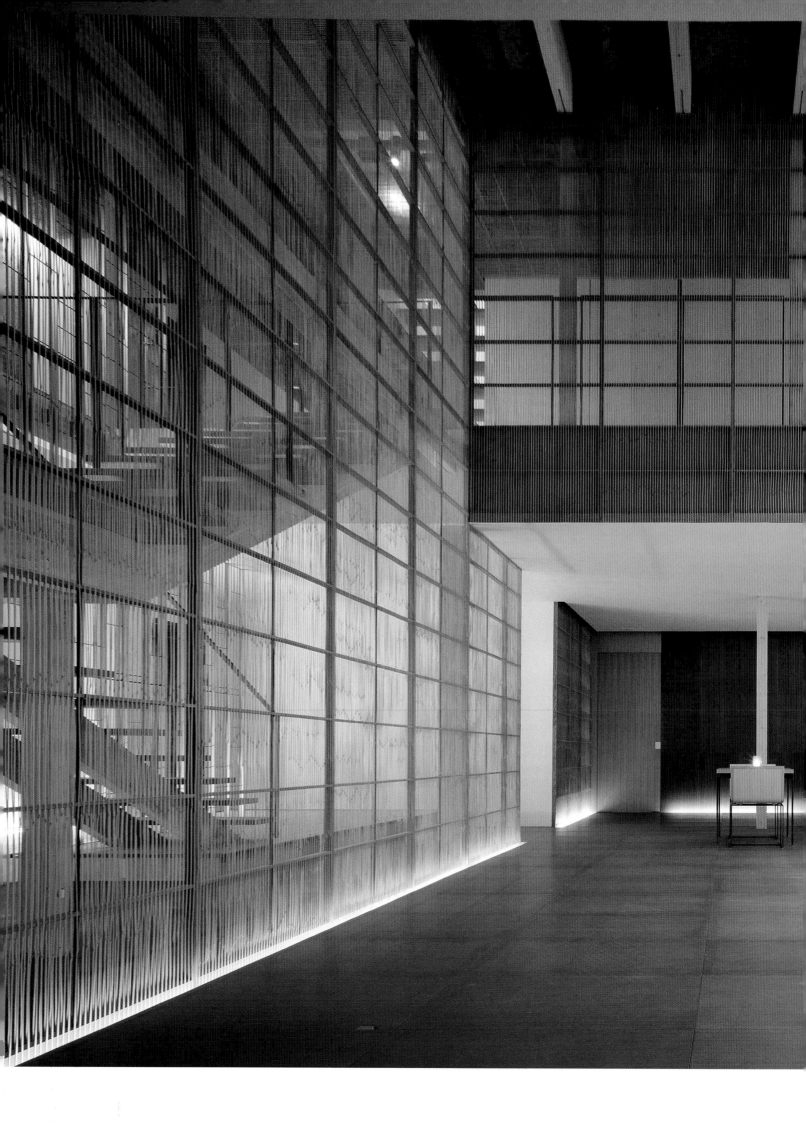

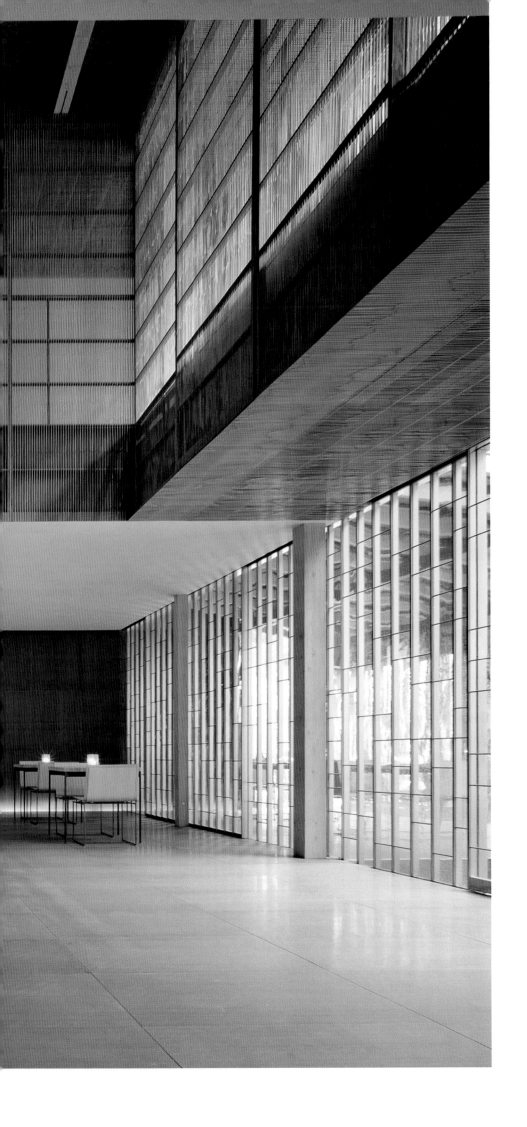

GINZAN ONSEN FUJIYA

Architect **Kengo Kuma & Associates**
Location **Ginzan Onsen, Obanazawa, Yamagata**
Completed **2006**

Ginzan Onsen is a mountain resort town in northern Japan that is famous for its *onsen* (hot springs) and historic *ryokan* (traditional inns). Visiting a *ryokan* is a wonderful tradition in Japan that enables weary city dwellers to leave their shoes and worries at the door, slip into a *yukata* (Japanese robe) and spend the weekend relaxing, eating elegant *kaiseki* meals and soaking in *onsen* baths.

In the center of this well-known spa town, Kengo Kuma took on the task of renovating the 100-year-old Fujiya Ryokan located on a street lined with thirteen other inns. Each *ryokan* has undergone renovations but the street retains a historic quality and draws tourists as well as crews filming historic-themed TV plays and movies.

Fully aware of the need to respect site and tradition, Kuma nevertheless set out to design a thoroughly contemporary inn in the heart of a historic town. He began by completely dismantling the existing building and then reassembling it using both old and new wood. The practice of dismantling wooden buildings (which were assembled with precise wood joints without nails) in order to restore or move the structure has a long tradition in Japanese architecture, a remarkably "green" concept.

Above The updated Fujiya Ryokan remains in context with its historic surroundings thanks to Kuma's respect of the original silhouette and use of traditional materials.

Left The extraordinary two-story lobby atrium glows with light filtered through delicate *sumushiko* (fine bamboo screens).

Keenly aware of the need to remain in context, the architect kept the original silhouette and traditional post-and-beam construction. According to Kuma: "Japanese Architecture has traditionally emphasized the harmonious relationship with the place it sits on more than the monumentality of the architecture itself. In Japan, the design philosophy leaned towards an 'unassertive architecture,' which did not emphasize its own presence, but rather established relationships with the complex ground forms and diverse and beautiful natural environment in the vicinity."

The redesigned façade reflects the local traditions of whitewashed stucco and natural wood, but is expressed with a modernist vocabulary. Fine wooden screens articulate the façade, creating the impression of elegance and fragility, an admired quality in traditional Japanese architecture. Kuma explained that he "wanted to retain the continuity of the old façade while introducing a new spirit and modern amenities."

To add a new sense of transparency and connection between the street and the lobby, larger windows and a sliding glass entry door were added. A local craftsman produced the glass door using a traditional French glass blowing technique called *dalle de verre*. Set under deep wooden eaves and before reflecting pools, the doors create a shimmering effect and blur the boundaries between exterior and interior. Inside, the glass casts a pale blue-green light, creating an aqueous effect quite appropriate for an *onsen*.

The elegantly restrained exterior belies the remarkable spaces within. Most unexpected is the two-story lobby atrium enveloped in soft golden light filtered through delicate *sumushiko* (fine bamboo screens). These screens are found throughout the inn and are made up of a remarkable 1.2 million slender slats of bamboo and wood, all the work of craftsman Hideo Nakata. All light sources, either windows or lights, are hidden from view, creating diffused, soft and expressive light throughout.

Kuma's designs have regularly used this technique that the architect calls "particularization," meaning the use of numerous thin elements, or slats, as a means of partitioning space but allowing flow of space between inside and outside. Other good examples of this are in the Ando Hiroshige Museum (2000) and the Suntory Museum (2007). With a myriad of fine screens, the inn's spaces take on gentle, veil-like layers that arouse curiosity and recall traditional Japanese *shoji* screens. Explained Kuma: "The concept of layers I have developed works both in time and space, ... a layered effect with fine filters." The entry is flanked by a café and sitting area. The upper story has eight guest rooms, each ten *tatami* mats in size. Modern chairs, tables and sofas designed with a Zen minimalism by Kuma are the only furniture.

Overall, the design of Ginzen Onsen Fujiya exudes the simplicity, lightness and sense of place that have become expected qualities in Kuma's work. Says Kuma: "In my work I attempt to bridge the traditional and the innovative, as well as the local and the global." With this *ryokan*'s design, he also achieves that rare balance between past and present, reinterpreting a historic inn into the architectural language of the twenty-first century.

Below An elegant cedar tub bathed in steam and natural light diffused by fine slatted wood.

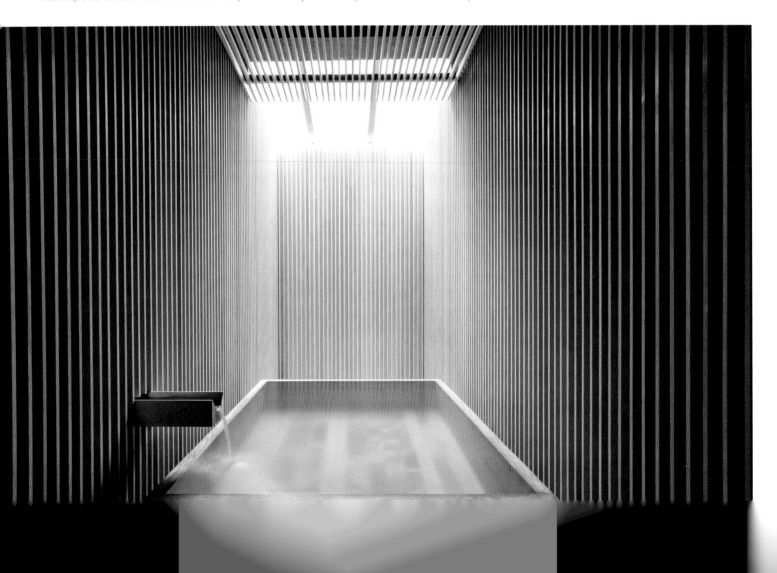

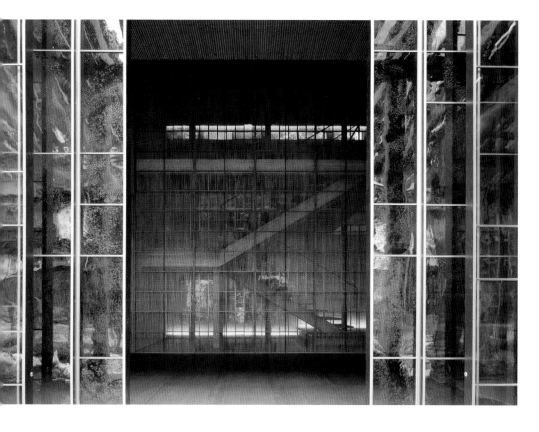

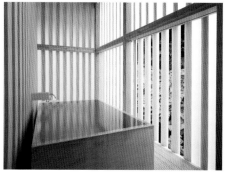

Left A sliding glass entry door, made by a local craftsman using a traditional French glass blowing technique called *dalle de verre*, adds a sense of transparency and connection between street and lobby.

Above Bathing while viewing nature is considered the ultimate luxury in Japan. This bath brings in the views of the mountains through its floor-to-ceiling slatted windows.

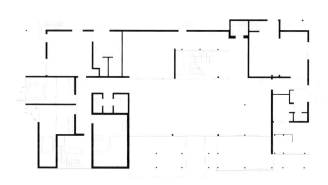

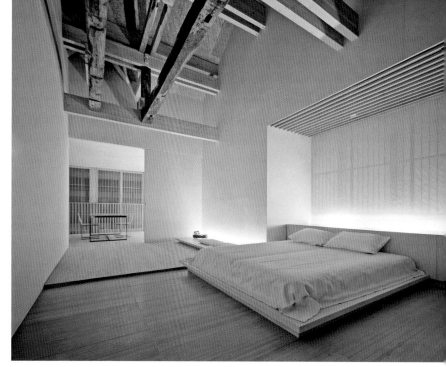

Above Plan and cross-section showing the new renovations.

Right center While the exposed sculpturesque roof beams recall a *minka* farm house, the rest of the bedroom exudes the same simplicity, lightness and sense of place found in all other parts of the renovated *ryokan*.

Right The redesigned façade reflects the local traditions of whitewashed stucco and natural wood that ground the *ryokan* to its surroundings.

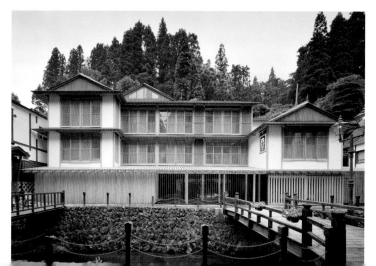

ARCHITECTS

ADH Architects
http://home.att.ne.jp/kiwi/adh/works.html

ADH principals are husband and wife team Makoto Shin Watanabe and Yoko Kinoshita Watanabe. They have received numerous awards, including a JIA Award for Best Young Architect in 2000, Best Energy Conservation Award from the Ministry of Economy, Trade and Industry in 2003, and in 2001 both were elected as Arata Isozaki & i-Net Architects.

Makoto was born in Maebashi in 1950 and received his MA from Kyoto University. He worked at Cambridge Seven Associates (1979–80) and Arata Isozaki & Associates (1981–95) before establishing ADH Architects with Yoko Kinoshita in 1987. Since 1996 he has been a professor at Hosei University, and both he and Yoko have taught at the University of Texas, Austin (1994), and at Washington University, St. Louis (2003).

Yoko was born in Tokyo in 1956 and graduated from Stanford University. After receiving her MA from Harvard, she worked at Shozo Uchii Architect and Associates until establishing ADH Architects with Makoto Watanabe. Since 2007 she has been a professor at Kogakuin University. She has also taught at the AA School, London (1993), Nihon University (1993) and the Shibaura Institute of Technology (1995). From 2005 to 2007 she was an Urban Design Team Leader for the Urban Renaissance Agency, Tokyo.

APOLLO Architects & Associates
www.kurosakisatoshi.com

Apollo Architects & Associates was founded in 2000 by Satoshi Kurosaki. He was born in Kanazawa in 1970 and graduated from the Department of Architecture, Meiji University, in 1994. He worked with Sekisui House and Forme Architexts before starting his own practice. Since 2008 he has been a lecturer at Nihon University. Kurosaki has a growing reputation for clever designs of small houses in crowded urban Japan. His recent works include Apartment House HB (2007), Tepe (2008) and Damier (2009), all in Tokyo.

architecture w
http://arcw.com/

architecture w was founded by two American architects, Michel Weenick and Brian White, in 2001 and operates from three offices, in Nagoya, Tokyo and Portland, Oregon. Weenick graduated from the University of Texas in 1987 and established an office, NGO Architecture, in Nagoya in 1994. White received his M.Arch. from Washington University in St. Louis and began his own practice in Oregon in 1999. Since joining forces in 2001, the firm has created numerous projects in Japan and the USA, including MF Apartments (2004) and Hill House (2006), both in Nagoya, and has received several awards, such as an AIA (American Institute of Architecture) Award in 2004 and 2005.

Atelier Tekuto
www.tekuto.com

Yasuhiro Yamashita founded Atelier Tekuto in 1991 in Tokyo. He was born in Kagoshima in 1960 and graduated in architecture from the Shibaura Institute of Technology where he also received a Master's degree in 1986. Yamashita has won several awards, including the Good Design Award in 2005, and the ar+d award for emerging architects under 45 by UK journal *The Architecture Review*, in 2009. His notable works include Lucky Drops House (2005), the Nakdong Estuary Eco Center in Korea (2007), Reflection of Mineral House in Tokyo (2006), a series of Aluminum-Ring Houses in various locations in Japan (2008–9) and Jyu-ko in Fukushima Prefecture (2010), which was a renovation of a 120-year-old *minka*, a traditional Japanese vernacular dwelling.

Atsushi Kitagawara Architects
www.kitagawara.co.jp

Born in Nagano Prefecture in 1951, Atsushi Kitagawara completed his M.Arch. at the Tokyo National University of the Arts in 1977. In 1982 he founded Atsushi Kitagawara Architects. He has taught at several Japanese institutions and has been a professor at the Tokyo University of the Arts since 1982. His notable works include the Gifu Academy of Forest Science and Culture (2001), Kaisho Forest View Tube (2005) and the Inariyama Special Education School for Children

(2007). He has won numerous awards, including the AIJ award (2002), the Innovative Architecture International Award from Italy (2006), AIA Japan Professional Honor Award (2008) and the Top Prize at the JIA Grand Prix in 2009 for the Keith Haring Museum.

cdi (creative designers international)
www.cdias.co.jp

Cdi's founder and managing director, Benjamin Warner, graduated with a BA in architecture from Brighton Polytechnic in the UK. He came to Japan in 1981 as an assistant architect for Masayuki Kurokawa and in 1987 received his MA from the Tokyo Institute of Technology. In 1988 he joined Richard Rogers Partnership in London. He returned to Tokyo and in 1993 founded cdi, a design office specializing in architectural and interior design. He is a visiting lecturer at the Tokyo Institute of Technology and Niigata University. Cdi's works in Tokyo include the v28 Building (2004), the Shirokane Igax Building Tokyo (2008) and Portofino (2008).

Chiba Manabu Architects
www.chibamanabu.jp

Born in Tokyo in 1960, Chiba Manabu received his architectural education at the University of Tokyo, where he now serves as an associate professor. He worked at Nihon Sekkei Inc. from 1987 to 1993 and then became the principal of Factor N Associates (1993–2001). He was the principal architect for campus planning at the University of Tokyo from 1993 to 1996 and a research associate of Tadao Ando from 1998 to 2001. He founded Chiba Manabu Architects in 2001. He has received numerous awards, including the JIA Best Young Architect Award in 1998, the Design Vanguard 2004, the 21st Yoshioka Award, the Good Design Award in 2005 and 2006 and the AIJ Award for Architectural Design in 2009. His works include the award-winning Japan Guide Dog Center "Fuji Harness" in Shizuoka Prefecture (2006), Studio Gotenyama (2006), Stitch (2008) and Kif (2009), all in Tokyo.

Curiosity Inc.
www.curiosity.jp

Curiosity's principal, Gwenaël Nicolas, was born in France in 1966. After studying interior design at the École Supérieure d'Arts Graphique et d'Architecture d'Interieure (ESAG, 1984–8), he completed a Master's degree in Industrial Design at the Royal College of Art, London, in 1991. In the same year, he moved to Japan, where he established his firm, Curiosity Inc., in Tokyo in 1998. He has designed interiors for international brand-name clients such as Issey Miyake, Sony and Tag Heuer. His first houses were built in the early 2000s.

EDH — Endoh Design House
www.edh-web.com

Born in Tokyo in 1963, EDH's principal, Masaki Endoh, received his M.Arch. at the Tokyo University of Science in 1989. He worked at Kazuhiko Namba + KAI Workshop (1989–94) before establishing own office, EDH (Endoh Design House), in 1994. He has been a lecturer at several Tokyo universities and since 2008 has been an associate professor at Chiba Institute of Technology. He has received several awards, including an AIJ commendation for the house Natural Slats in 2004, a Good Design Award for the apartments Natural Ellipse in 2004 and for the house Natural Patches in 2009.

Edward Suzuki Associates
www.edward.net

Edward Suzuki was born in Saitama Prefecture in 1947. After receiving his B.Arch. from the University of Notre-Dame, USA, in 1971, he worked for O&W Architects in Tokyo from 1972 to 1973. Upon receiving a Fulbright Scholarship, he completed his M.Arch. at Harvard in 1975, where he worked with Buckminster Fuller and Isamu Noguchi. From 1975 to 1976 he worked with Kenzo Tange in Tokyo, before establishing his own office in 1977. He has been a visiting professor at the Rhode Island School of Design and Harvard. He has won several awards, including the Good Design Award in 1995, 1998, 2000 and 2003, and the Chicago Athenaeum Museum of Architecture and Design International Architecture Awards

(2007). His notable projects include the Japan Railway East Shin-Toshin Station (2000), N House in Tokyo (2000), Eddi's House in Nara (2003) and GAMO Nagoya (2007).

Endo Shuhei Architect Institute
www.paramodern.com

Born in 1960 in Shiga Prefecture, Endo Shuhei received his Master's degree from the Kyoto City University of Art in 1986. He worked with architect Osamu Ishii before setting up his own practice in 1988. He is presently a professor at the Graduate School of Architecture at Kobe University. He has received numerous awards, including the Good Design Award in 2005 and an AIJ award in 2006 and 2008. Known for sculptural, often biomorphic work, his projects have included Rooftecture O-N in Nara (2006) and Slowtecture in Miki-City, Hyogo Prefecture (2007). Upcoming projects include the Guangzhou Cultural Center in China (completion 2011).

Fumihiko Maki
www.maki-and-associates.co.jp

After studies at Cranbrook Academy of Arts and Harvard University's Graduate School of Design, Fumihiko Maki worked in the offices of Skidmore Owings & Merrill, and Sert Jackson and Associates in the United States in the 1950s and 1960s. He then returned to Japan and became a founding member of the metabolists, an avant-garde group of Japanese architects. He established Maki & Associates in Tokyo in 1965 and has gone on to international acclaim, winning numerous compe-titions and awards, including the Pritzker Prize in 1993. Major projects include the National Muse-um of Modern Art, Kyoto (1986), Yerba Buena Gardens Visual Arts Center in San Francisco (1993), TV Asahi Building in Tokyo (2003), MIT Media Arts and Science Building in Massachusetts (2009) and Tower 4 of the World Trade Center in New York (completion 2012).

Herzog & de Meuron
email: info@herzogdemeuron.com

Jacques Herzog and Pierre de Meuron were both born in Basel in 1950. They studied with Aldo Rossi at the ETH in Zurich, where they received

degrees in architecture in 1975. They founded their now internationally renowned firm, Herzog & de Meuron, in Basel in 1978. Some of their celebrated works include the Tate Modern in London (2000), the Allianz Arena in Munich (2005), the De Young Museum in San Francisco (2005), the Caixa-Forum Madrid (2008) and the "Bird's Nest" Stadium for the Beijing 2008 Olympics. They were awarded the Royal Gold Medal 2007 by the Royal Institute of British Architects (RIBA). Current projects include a major addition to London's Tate Modern, due to be completed in 2012.

Hiroshi Nakamura & NAP Architects
www.nakam.info/english/index.html

Hiroshi Nakamura was born in Tokyo in 1974 and completed the Master's course in the Department of Architecture at Meji University in 1999. From 1999 to 2003 he was chief engineer at Kengo Kuma & Associates. In 2003 he founded Hiroshi Nakamura & NAP Architects. He has received numerous awards, including the Good Design Award in 2004 and 2006. Some of his notable projects include House SH, Tokyo (2004), Lanvin Tokyo Boutique in Ginza (2004), Gallery Sakura-noki, Nagano (2007) and Dancing Trees, Singing Birds in Tokyo (2007).

Hiroshi Sambuichi
email: samb@d2.dion.ne.jp

Born in 1968, Hiroshi Sambuichi graduated from the Department of Architecture and Engineering at the Tokyo University of Science. After working at Shinichi Ogawa & Architects, he founded Sambuichi Architects in 1997. He is currently a lecturer at Yamaguchi University. His work has received several awards, including the Canada Green Design Grand Prix Award (2001), a com-mendation from the ar+d Award (2003), the 19th Yoshioka Award (2003), and the Detail Prize 2005. His notable works include the Miwa Craft Potters Building (2001), Air House in Hagi (2003), Stone House in Shimane (2005) and Base Valley House in Hiroshima Prefecture (2009).

Hitoshi Abe

www.a-slash.jp

Born in Sendai in 1962, Hitoshi Abe completed his architectural training in America, receiving his M. Arch. degree from SCI-Arc in Los Angeles. He worked in the LA office of COOP HIMMELB(L)AU from 1988 until 1992, when he started his own practice, Atelier Hitoshi Abe, in Sendai, after winning the competition to design Miyagi Stadium. He taught at the Tohoku University in Sendai from 1994 to 2007, as well as at the Miyagi National College of Technology and the University of California at Berkeley where he was the Friedman Professor. Since 2007, has been professor and chair of the UCLA Department of Architecture and Urban Design. Abe has received numerous awards in Japan and internationally, including the 2007 World Architecture Award for SSM/Kanno Museum. Phaidon Press published a monograph titled *Hitoshi Abe* in 2009.

Itsuko Hasegawa Atelier

www.ihasegawa.com

Born in Shizuoka in 1941, Itsuko Hasegawa graduated from the Kanto Gakuin University in 1964. She worked in the office of metabolist architect Kiyonori Kikutake at the Tokyo Institute of Technology from 1964 until 1969. From 1971 to 1978 she worked for Kazuo Shinohara, and in 1979 founded Itsuko Hasegawa Atelier. She has been a lecturer and visiting professor at several universities in Japan and abroad, including Harvard (1992~), Kanto Gakuin (2001~) and the University of California, Berkeley (2004). She was elected an honorary member of RIBA in 1997 and a Fellow of the AIA in 2006. Her noted works include the Yamanashi Fruit Museum (1995), the Niigata Performing Arts Center (1998) and the Suzu City Performing Arts Center, Ishikawa (2006).

Jun Aoki & Associates

www.aokijun.com

Born in Kanagawa Prefecture in 1956, Jun Aoki graduated from the Department of Architecture at the University of Tokyo in 1980 and completed his MA in the same department in 1982. He worked at Arata Isozaki & Associates from 1983 to 1990 before establishing Jun Aoki & Associates

in 1991. His notable works include "H" (1994) for which he received the Tokyo House Prize (Aoki randomly assigns a letter to each of his house designs and hopes to complete 26, covering the entire alphabet); the Fukushima Lagoon Museum (1999) for which he received the Architectural Institute of Japan Annual Award; and the Aomori Museum of Fine Arts (2006). He has lectured at numerous universities, including the Japan Women's University and the Tokyo National University of Fine Arts and Music. The first compilation of his works, *Jun Aoki Complete Works [1] 1991–2004*, was published by Inax Publishing in 2004.

Jun Mitsui & Associates

www.jma.co.jp

Born in 1955 in Yamaguchi, Jun Mitsui completed his M.Arch. at the University of Tokyo in 1978. After working for Okada Architects and Associates from 1978 to 1982, he attended Yale University, receiving his M.Arch. in 1984. Upon graduation, he worked for Cesar Pelli & Associates, Inc. until 1992, when he became the principal of Pelli Clarke Pelli Architects Japan and founded Jun Mitsui & Associates. He has lectured at universities internationally and been a visiting professor at Niigata University. His latest project is the new Haneda International Airport terminal (2010).

Junya Ishigami and Associates

www.jnyi.jp

Junya Ishigami was born in Kanazawa in 1974 and studied in the Architecture Department of the Tokyo National University of Fine Arts and Music, graduating in 2000. He worked at the office of Kazuyo Sejima and Associates from 2000 until establishing Junya Ishigami and Associates in 2004. He participated in the 2008 Venice Biennale, and although he only has a few completed projects, he is already considered among the most promising architects of his generation. Ishigami is also a product designer, and his "low chair" and "round table" are in the collection of the Pompidou Center in Paris.

Kazuyo Sejima and Associates

www.sanaa.co.jp

Born in Ibaraki Prefecture in 1956, Kazuyo Sejima received her M.Arch. from the Japan Women's University in 1981. She worked at Toyo Ito & Associates from 1981 until 1987, when she established Kazuyo Sejima and Associates. Since 1995 she has collaborated with Ryue Nishizawa as part of the internationally acclaimed duo, SANAA, who were awarded the Pritzker Prize in 2010. She is presently a professor at Keio University. She was recently appointed the director of the 2010 Venice Architectural Biennale. Notable projects include the 21st Century Museum of Contemporary Art in Kanazawa (2004), the New Museum in New York (2005) and the Serpentine Pavilion in London (2009), all completed as part of SANAA. Sejima is presently working with Nishizawa and Imrey Culbert on the new Louvre-Lens (completion 2012).

KDa (Klein Dytham architecture)

www.klein-dytham.com

After graduating with Masters' degrees from London's Royal College of Art, KDa principals, Astrid Klein and Mark Dytham, came to Tokyo to work at Toyo Ito & Associates. They went on to found KDa in Tokyo in 1991. The firm is a multidisciplinary design practice active in the design of architecture, interiors, public spaces and installations. Their notable architectural works include Leaf Chapel in Kobuchizawa (2004), Uniqlo Ginza in Tokyo (2005) and Moku Moku Yu Onsen, also in Kobuchizawa (2006). The firm won the Nekkei New Office Award in 2007 and the British Business Award in 2008. Both Klein and Dytham frequently lecture in Japan and abroad and founded the popular Pecha Kucha evenings, regular meetings of young designers to exchange ideas (www.pecha-kucha.org).

Kengo Kuma & Associates

www.kkaa.co.jp

Born in 1954 in Kanagawa Prefecture, Kengo Kuma graduated from the University of Tokyo, Department of Architecture, in 1979. He was a visiting scholar at Columbia University in 1985–6. He established the Spatial Design Studio in 1987

and Kengo Kuma & Associates in 1990. He was a professor at Keio University from 2001 until 2009 when he became a professor at the graduate School of Architecture at the University of Tokyo. A prolific architect known for his contemporary use of Japanese architectural traditions, his past works include the Great Bamboo Wall Guesthouse in Bejing (2002), One Omotesando in Tokyo (2003) and the Nagasaki Prefecture Art Museum (2005). His projects currently underway include the Asakusa Tourist Information Center in Tokyo (2008~) and the Granada Performing Arts Center in Spain (2009–13), with Spanish firm AH Asociados.

Kisho Kurokawa and Associates
www.kisho.co.jp

Born in Nagoya, Kisho Kurokawa (1934–2007) received his B.Arch. from Kyoto University (1957) and his M.Arch. (1959) and Ph.D. (1964) from Tokyo University, under Professor Kenzo Tange. In the 1960s, Kurokawa first found fame as a founding member of the metabolist movement and went on to become one of Japan's most acclaimed architects. He has received a myriad of awards and honors, including life fellowships from the Architectural Institute of Japan and the Royal Society of Arts (UK). A prolific author, he published over 100 works on architecture, including *The Philosophy of Symbiosis*, which was translated into several languages. Just a few of his major works in Japan include the Nakagin Capsule Tower, the National Bunraku Theater and the Hiroshima City Museum of Contemporary Art. His notable projects abroad include the Kuala Lumpur International Airport and the New Wing of the Van Gogh Museum, Amsterdam (1999).

Kumiko Inui
www.inuiuni.com

Kumiko Inui was born in Osaka in 1969. She graduated from the Tokyo University of the Arts in 1992 and completed her Master's degree at Yale University School of Architecture in 1996. Upon graduation, she worked for Jun Aoki & Associates until establishing her own office in 2000. She is currently a lecturer at the University of Tokyo, Waseda University and Tokyo University

of the Arts, and frequently lectures abroad. She has won several awards, including the Architectural Record Design Vanguard (2006) and the 24th Shinkenchiku Prize for her Apartment I (2007). Other projects include the exterior design of Dior Ginza in Tokyo (2004) and Small House H in Gumma Prefecture (2009).

Milligram Architectural Studio
www.milligram.ne.jp

Tomoyuki Utsumi founded Milligram Architectural Studio in 1998. Born in Mito in 1963, Utsumi received an MA from the Royal College of Art in London as well as the University of Tsukuba, Japan. After working at Taisei Corporation's Design Division, he established his own practice. Utsumi is also a lecturer in architecture and urban design at Keio University and Nihon University.

Mitsubishi Jisho Sekkei
www.mj-sekkei.com

Mitsubishi Jisho Sekkei is a leading Japanese urban planning, architectural design and engineering firm. It originated as a part of Mitsubishi Estate, a general contractor in business in Japan since the 1890s. They designed the Mitsubishi #1 Building, the first modern office building in Japan in 1894. Mitsubishi Jisho Sekkei became a subsidiary company in 2001. It has major works throughout Japan and has won awards for specific projects, including Japan's tallest building, the Yokohama Landmark Tower (1993), the Nihon TV Tower in Tokyo (2003), the Osaka Securities Market Office Building (2004), and for several projects in the redevelopment of the Marunouchi district of Tokyo in the 2000s.

MVRDV
www.mvrdv.nl

MVRDV was founded in Rotterdam in 1993 by architects Winy Maas, Jacob van Rijs and Nathalie de Vries and is presently a leading international firm working in the fields of architecture, urbanism and landscape design. The firm has received many honors, including several nominations for the Mies van der Rohe Award for Contemporary European Architecture and the World Architecture Awards. Some of their notable works include

the Dutch Pavilion for the World EXPO 2000 in Hanover, WOZOCO in Amsterdam (1997), Sanchinarro Mirador in Madrid (2005) and the Why Factory in Delft (2009). They are currently involved in varied projects, including a market hall in Rotterdam, a culture plaza in Nanjing in China, and several large-scale urban master plans for places such as Oslo and Paris.

Naito Architects & Associates
www.naitoaa.co.jp

Born in Yokohama in 1950, Hiroshi Naito completed his B.Arch. in 1974 and his M.Arch. two years later, both at Waseda University. From 1976 to 1978 he worked at Fernando Higueras Architects in Madrid and from 1979 to 1981 at the offices of well-known metabolist architect Kiyonori Kikutake in Tokyo. In 1981 he established Naito Architects & Associates. Since 2001 he has been a professor at Tokyo University. He has received numerous awards, including the Togo Murano Award and the Grand Prix of the International Academy of Architecture, both for the Makino Museum of Plants and People, and the Japan Railway Award. His notable recent works include the Bashamachi Station in Yokohama (2004), the Shimane Arts Center (2005) and the Toraya Tea House, Kyoto (2009).

Pelli Clarke Pelli Architects (PCP)
www.pcparch.com

Pelli Clarke Pelli has produced some of the world's most recognizable buildings. Cesar Pelli founded the firm (as Cesar Pelli & Associates) in 1977, the same year he became dean of the Yale University School of Architecture. The firm's name was altered in 2005 to reflect the contributions of the firm's other principal architects, co-founder Fred Clarke and Rafael Pelli. The firm's myriad awards include the AIA Firm Award in 1989. Cesar Pelli was chosen as one of the ten most influential living architects by AIA in 1991, and was awarded a gold medal for lifetime achievement in 1995. In 2004 the firm was awarded the Aga Khan Award for Architecture for the Petronas Towers, Kuala Lumpur. Their renowned works include the World Financial Center in NYC and the International Finance Centre in Hong Kong. Current projects

include the Transbay Transit Terminal in San Francisco, the Osaka-Abenobashi Station in Osaka and Porta Nuova Garibaldi in Milan.

Riken Yamamoto & Associates
www.riken-yamamoto.co.jp
Riken Yamamoto was born in Beijing in 1945. He graduated from Nihon University's Department of Architecture in 1968 and completed his M.Arch. at the Tokyo National University of Fine Arts and Music in 1971. He founded Riken Yamamoto & Field Shop in 1973. He was a professor at Koga-kuin University from 2002 until 2007 and later became a professor at the Yokohama Graduate School of Architecture. He has won numerous awards, including the Prize of Architectural Institute of Japan (2002), Good Design Award (2005) and the Building Contractors Society Prize (2008). Major works include the Shinonome Canal Court in Tokyo (2003), Yokosuka Museum of Art (2007), Guan Yuan in Beijing (2008~) and Odawara Public Hall (2009~).

Shigeru Ban Architects
www.shigerubanarchitects.com
Born in 1957 in Tokyo, Shigeru Ban studied at the Southern California Institute of Architecture from 1977 to 1980. From 1980 to 1982 he studied under John Hejduk at the Cooper Union School of Architecture, where he graduated in 1984. He worked in the Tokyo office of Arata Isozaki (1982–3) and founded his own firm in 1985. He is well known for his ephemeral structures using re-cyclable materials, such as the Paper House in Yamanashi, Japan (1995), the Paper Refugee Shelter for the United Nations High Commission for Refugees (1999) and the Nomadic Museum, New York (2005). His latest projects include disaster relief housing in Haiti (2010) and the new Pompidou Center in Metz (2010).

Skidmore, Owings & Merrill
www.som.com
Founded in Chicago in 1936, Skidmore, Owings & Merrill is today one of the world's largest architectural and engineering firms, currently engaged in 1,320 projects worldwide. Their specialty is high-end commercial buildings, and they have built some of the tallest buildings in the world, including the Sears Tower in Chicago (1973) and the current tallest building, the 828-meter Burj Kalifa in Dubai. Throughout their history, the firm has received over 800 awards, including the Architecture Firm Award from AIA in 1962 and 1996, the only firm to be so honored twice. Their current projects include the One World Trade Center in New York and the NATO Headquarters in Brussels (completion due in 2012).

Sou Fujimoto
www.sou-fujimoto.com
Sou Fujimoto was born in Hokkaido in 1971. He graduated from the Department of Architecture at the University of Tokyo in 1994 and established his own architectural practice in Tokyo in 2000. He is currently an associate professor at the University of Tokyo and a lecturer at Tokyo University of Science and Keio University. He has won many prizes, including the Japan Institute of Architect's Grand Prix 2007. A monograph about him, *Sou Fujimoto: Primitive Future*, was published by INAX Publishing in 2009. His recent projects include the Children's Center for Psychiatric Rehabilitation in Hokkaido (2006), House O in Chiba (2007) and Final Wooden House in Kumamoto (2008).

Suppose Design Office
www.suppose.jp
Suppose Design Office's principal, Makoto Tanijiri, was born in Hiroshima Prefecture in 1974. Tanijiri graduated from Anabuki Design College in 1994, after which he worked for Motokane Architect Office until 1999. He worked at HAL Architect Office from 1999 until 2000, when he established his own firm in Hiroshima and now also has a second office in Tokyo. Tanijiri has received num-erous awards, including a JCD (Japan Commercial Design) Award in 2002, 2003 and 2004, 2005, 2007 and 2009. He is currently a professor at the Anabuki Design College. Notable works include House at Ohno in Hiroshima (2004), House at Kamiosuga in Hiroshima (2008) and House at Buzen in Fukuoka (2009).

Tadao Ando
www.tadao-ando.com
Born in Osaka in 1941, Tadao Ando educated himself as an architect, largely through his travels in the United States, Europe and Africa (1962–9). He founded Tadao Ando Architect & Associates in Osaka in 1969. He has won international acclaim and numerous competitions and prizes, including the Pritzker Prize in 1995. His celebrated works include Awaji Yumebutai, Awajishima (2000), the Modern Art Museum of Fort Worth, Texas (2002), the Chichu Art Museum, Naoshima (2003) and the Punta della Dogana Contemporary Art Center, Venice (2009). Ando was a visiting professor at Yale (1987), Columbia (1988) and Harvard (1990), and from 1997 was a professor at the University of Tokyo School of Engineering, Department of Architecture. He was named Professor Emeritus in 2003 and University Professor Emeritus in 2005, both at the University of Tokyo.

Tange Associates
www.tangeweb.com
Paul Noritaka Tange is the president of Tange Associates, a Tokyo architecture firm founded in 1946 by Japan's most renowned architect, Kenzo Tange. He was born in Tokyo in 1958 and attend-ed Harvard University where he received his BA in 1981 and M.Arch. in 1985. He has worked at Tange Associates since 1985 and became its president in 2003. The firm has eight offices worldwide and has completed over 300 projects in 30 countries, with numerous awards, including a Good Design Award for the Mode Gakuen Tower (2009). Recent major projects include the West Kowloon Arts and Cultural District, Hong Kong, (2004~), Dongguan International Financial Tower in China (2005~) and Carnel Hall in Rolle, Switzerland (2008~).

Terunobu Fujimori
www.iis.u-tokyo.ac.jp/cgi/teacher.cgi?prof_id=fujimori&eng=1
Born in 1946 in Nagano Prefecture, Terunobu Fujimori graduated from the Department of Architecture and Building Science, School of Engineering at Tohoku University in 1971. In 1978 he completed his Ph.D. in Architecture at the University of Tokyo. He is a professor at the Univer-

sity of Tokyo's Institute of Industrial Science and is a noted historian of modern Japanese architecture. He began to design his own buildings in 1990, creating the Jinchokan Moriya Historical Museum, Chino City, Nagano. Since then his original designs incorporating traditional Japanese techniques and materials have brought him awards and international praise, including an AIJ award for Design in 2000 and an exhibition of his work at the Venice Biennale in 2006. His notable works include Chashitsu Takasugian (Too High Tea House), Nagano Prefecture (2003), the Lamune Onsen (hot spring baths), Oita Prefecture (2005) and Yakisugi House, Nagano (2009).

Tezuka Architects
www.tezuka-arch.com

Tezuka Architects is a husband and wife team, Takaharu Tezuka and Yui Tezuka. They have won many awards, including the 18th Yoshioka Award, the JIA best Young Architect Award in 2002 and the JIA Award and the AIJ Prize, both in 2008 for Fuji Kindergarten. Their notable projects include the Matsunoyama Natural Science Museum (2003), the Temple to Catch the Forest (2007) and, most recently, Pitched Roof House (2009).

Takaharu Tezuka was born in 1964 in Tokyo and graduated from the Musashi Institute of Technology in 1984. After he received his MA from the University of Pennsylvania in 1990, he worked at Richard Rogers Partnership until 1994, when he established Tezuka Architects with Yui Tezuka. He is currently an associate professor at the Department of Architecture, Musashi Institute of Technology.

Born in Kanagawa in 1969, Yui Tezuka graduated from the Musashi Institute of Technology in 1992. From 1992 to 1993 she studied under Ron Herron at University College London. Takaharu and Yui Tezuka were visiting professors at the Salzburg Summer Academy as well as at UC Berkeley in 2006. Yui is currently a lecturer at Toyo University and Tokai University.

TNA — Takei-Nabeshima Architects
www.tna-arch.com

Makoto Takei (born 1974) and Chie Nabeshima (born 1975) founded TNA in 2005. Their noted projects include Ring House in Karuizawa (2006), Mosaic House at Meguro-ku in Tokyo (2007) and Stage House in Karuizawa (2008). They have won numerous prizes, including a Wallpaper Design Award (2008), the Detail Award (2009) and the JIA award (2010).

Takei graduated from Tokai University's Department of Architecture in 1997 and was part of the Tsukamoto Laboratory at the Graduate School of Science and Engineering at Tokyo Institute of Technology. He worked with Atelier Bow-Wow from 1997 to 1999 and with Tezuka Architects from 1999 to 2004. He is currently a lecturer at Tokai University, Musashino Art University and the Tokyo University of Science.

Chie graduated from the Department of Architecture and Architectural Engineering at the College of Industrial Technology, Nihon University, in 1993 and worked at Tezuka Architect from 1998 to 2005. She is currently a lecturer at Hosei University.

TOMURO Atelier + Kenichi Nakamura and Associates
email: rtomuro@sc4.so-net.ne.jp
www1.parkcity.ne.jp/knaa/

Reiko Tomuro is the principal of TOMURO Atelier, which she founded in Tokyo in 1996. Born in Tokyo in 1959, she graduated from Cornell University's College of Architecture, Art and Planning in 1983. From 1983 until 1996 she worked for Maki and Associates. Her major works include House in Karuizawa (1997), interior work at the Tokyo American Club (2001) and Morihiro Residence (2005).

Kenichi Nakamura was born in Yokohama in 1958 and completed the Master's program at Tokyo University in 1983, continuing his studies at Cornell University in 1983–4. He worked for Maki and Associates from 1983 until 1998, when he established his own practice in Tokyo. Since 2002 he has been a professor at Chubu University. His major works include House in Kinuta (2004), Seki Kodomo Clinic (2007) and the Embassy of the Republic of Pakistan in Tokyo (2008).

Toyo Ito & Associates, Architects
www.toyo-ito.co.jp

Toyo Ito was born in Seoul, Korea, in 1941. After graduating from the University of Tokyo's Department of Architecture in 1965, he worked for Kiyonori Kikutake. In 1971 he established his own office, Urban Robot (URBOT), which was renamed Toyo Ito & Associates, Architects in 1979. He has received numerous awards, including the AIJ Prize (1986, 2003), a Golden Lion for Lifetime Achievement at the 8th International Architecture Exhibition NEXT at the Venice Biennale (2002), a Gold Medal from the Royal Institute of British Architects (2006), and the 6th Austrian Frederick Kiesler Prize for Architecture and the Arts (2008). He is an honorary fellow of AIA and RIBA and Professor Emeritus at London City University. His notable works include the Sendai Mediatheque (2001), Mikimoto Ginza 2 in Tokyo (2005), Meiso no Mori Funeral Hall in Gifu Prefecture (2006), the Taichung Metropolitan Opera House (2009) and the Main Stadium for the World Games 2009 in Kaohsiung, Taiwan.

Waro Kishi + K. Associates/Architects
www.k-associates.com

Born in 1950 in Kanagawa Prefecture, Waro Kishi graduated from the Department of Architecture, Kyoto University, in 1975. He established his own firm in 1981 and in 1993 founded Waro Kishi + K. Associates. Kishi was a visiting professor at the University of California, Berkeley, in 2003 and at the Massachusetts Institute of Technology in 2004, and is currently a professor at Kyoto Institute of Technology. He has won several awards, including an AIJ Award for Architectural Design in 1996. His notable works include the Meridian Line Akashi Ferry Terminal in Hyogo Prefecture (2003), Luna-Di-Miele in Tokyo (2004), Paju SW Office in Seoul (2004) and the Azabu Juban Project in Tokyo (2008).

ACKNOWLEDGMENTS AND CREDITS

We owe a huge debt of gratitude to Sarit B. Schwarz, an architect/writer now practicing in California, who helped with the initial research and organization of this book when she was living in Japan. Brian Bachman also assisted with the research. Monique Desthuis Frances read parts of the manuscript and helped to refine it. We are very grateful to the photographers as well as the copyright holders of the photographs listed below for allowing us to use their work in this book. The page numbers locating their work are given, and can be identified by the abbreviations a=above; b=below; c=center; l=left; r=right.

We would also like to acknowledge the help of Sytse de Maat and James Adson, both researchers of contemporary architecture and urbanism in Japan, whose assistance went beyond the photographs that are included in this book. Last but not least, we wish to express our sincere gratitude to the many more people, too numerous to mention here, who gave freely of their time and talent to help realize various stages of this book.

Geeta Mehta and Deanna MacDonald

p. 6
Photographer: David Lloyd (AECOM/
 David Lloyd)

p. 16
Photographer: Terunobu Fujimori

p. 19
Photographer: Terunobu Fujimori

pp. 22–5
Photographs © Daici Ano

pp. 26–9
Photographs © Masao Nishikawa

pp. 44–7
Photographs © Iwan Baan

pp. 58–9; p. 60a; p. 61al, ac, ar
Photographs © Jim Adson

p. 60b; p. 61b
Photos © Iwan Baan

pp. 62–5
Photographer: Toshihiro Sobajima

pp. 82–3; p. 84b; p. 85a, b
Photographer: Mitsuo

p. 84a
Photograph © Nacasa & Partners

pp. 86–9
Photographs © Jeff Goldberg/Esto

pp. 98–101
Photographer: Koji Kobayashi

p. 112b; p. 114a, b
Photographer: Daichi Ano

pp. 112–13; p. 115a
Photographer: Katsuhisa Kida

p. 115b
Photographer: Makoto Yamamori

pp. 126–9
Photographer: Nacasa & Partners

pp. 134–7
Photographer: Mitsuo

pp. 150–2; p. 153b
Photographer: Toshiharu Kitajima

pp. 160–1; p. 162b; p. 163b; p. 164al, ar
Photographs © Shinkenchiku-sha

p. 163a; p. 164b; p. 165
Photographer: David Lloyd (AECOM/David
 Lloyd)

pp. 192–3
Photographs © Naoomi Kurozumi

p. 194
Photographer: Sytse de Maat

p. 195
Photographer: Jim Adson

pp. 210–13
Photographer: Jim Adson

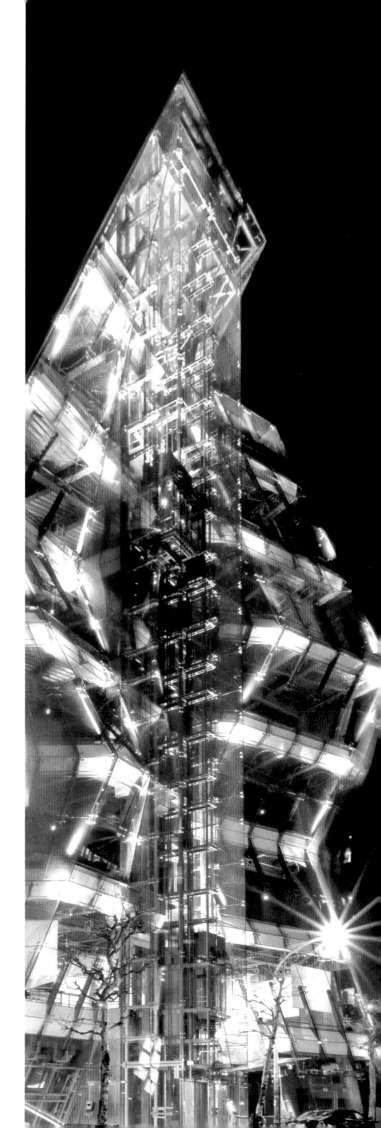

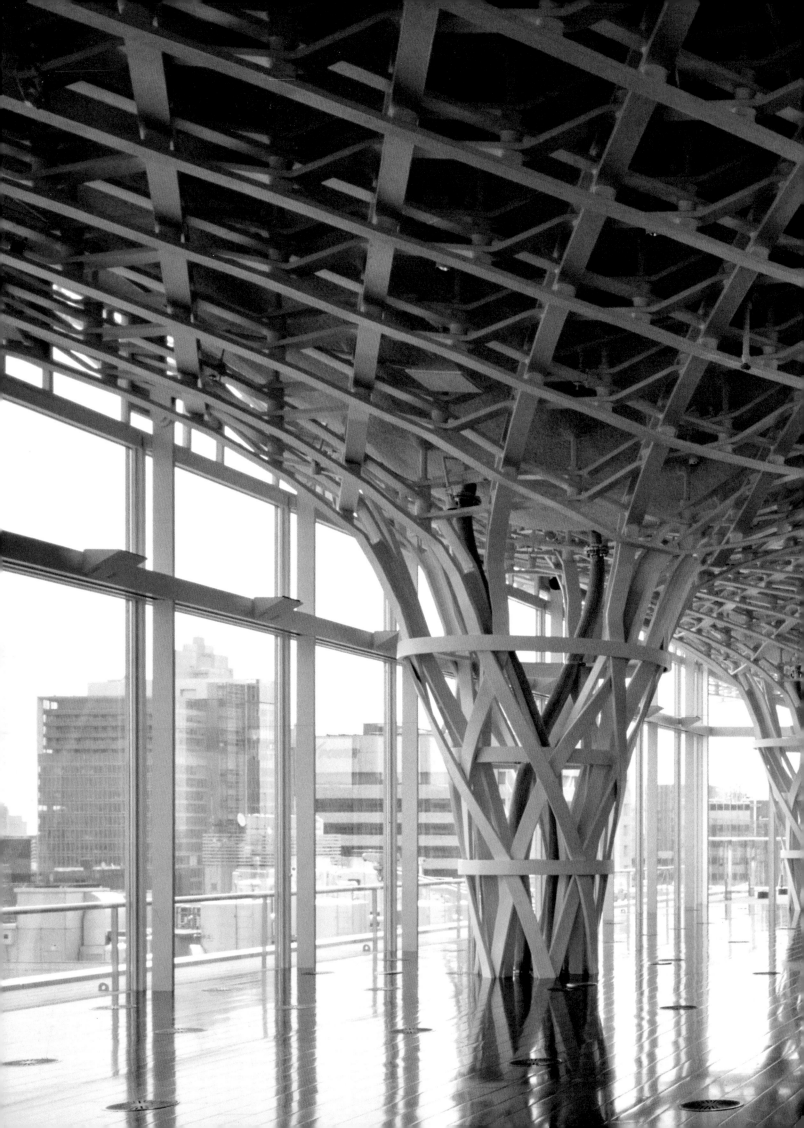